The American Canvas

Paintings from the Collection of
The Fine Arts Museums of San Francisco

The American Canvas

Paintings from the Collection of The Fine Arts Museums of San Francisco

By Marc Simpson, Sally Mills, and Jennifer Saville

HUDSON HILLS PRESS • NEW YORK

In association with The Fine Arts Museums of San Francisco

The Ralph J. Weiler Foundation has supported the publication of *The American Canvas* through a generous grant to The Fine Arts Museums of San Francisco.

First Edition
© 1989 by the M. H. de Young Memorial Museum of
The Fine Arts Museums of San Francisco
All rights reserved under International and Pan-American
Copyright Conventions.
Published in the United States by Hudson Hills Press, Inc.,
Suite 1308, 230 Fifth Avenue, New York, NY 10001-7704.
Distributed in the United States, its territories and
possessions, Canada, Mexico, and Central and South America by
Rizzoli International Publications, Inc.
Distributed in the United Kingdom, Eire, Europe, Israel,
and the Middle East by Phaidon Press Limited.
Distributed in Japan by Yohan (Western Publications
Distribution Agency).

Editor and Publisher: Paul Anbinder
Senior Editor: Virginia Wageman
Editorial assistance: Publications Department, The Fine Arts Museums of San Francisco
Indexer: Gisela S. Knight
Designer: Gilda Hannah
Composition: U.S. Lithograph, typographers
Manufactured in Japan by Toppan Printing Company

Library of Congress Cataloguing-in-Publication Data

Fine Arts Museums of San Francisco.
 The American canvas: paintings from the collection of the Fine Arts Museums of
San Francisco / by Marc Simpson, Sally Mills, and Jennifer Saville; Ann Karlstrom,
editor; foreword by Harry S. Parker III. — 1st ed.
 p. cm.
 Bibliography: p.
 Includes index.
 1. Painting, American—Catalogues. 2. Painting—California—San Francisco—
Catalogues. 3. Fine Arts Museums of San Francisco—Catalogues. I. Simpson, Marc.
II. Mills, Sally. III. Saville, Jennifer, 1955– IV. Title.
ND205.F45 1989
759.13'074'79461—dc20 LC 89-7629
 CIP

ISBN: 1-55595-025-6 (alk. paper)

23131

Contents

Colorplates

Acknowledgments

This publication was made possible by a grant from the Ralph J. Weiler Foundation, which provided the initial impetus and the means to carry out the project. As is the nature of such works, the book has been a collective effort from its beginning stages through the final editing, with the authors' efforts resting upon the work of many people and organizations. The Luce Fund for Scholarship in American Art has played a central role in supporting the research efforts of Sally Mills and Jennifer Saville, whose work on the catalogue of the entire collection forms the backbone of the present effort. Likewise, the National Endowment for the Arts has since 1983 provided the funds for a curatorial intern in the American Paintings Department—Shelley Mills, Elizabeth Boone, Koren Sawyer, and Derrick Cartwright successively have contributed mightily to our understanding of some of the works included in this selection. Mr. Cartwright has as well participated in many stages of verification, index making, and fact checking for the entire enterprise. Students from the University of California, Berkeley, and Stanford University have made significant additions to our research during their semesters or summers as interns, especially Susan Dennis, Linda Graham, Michelle Korjeff, Kirk Savage, Yolanda Starczak, Lesley Wright, and F. Lindsay Macbeth. Finally, all of us have relied upon the expertise and generosity of scholars, dealers, and collectors from across the country—a list too long to enumerate here, although specific references in the following essays begin to record the recipients of our gratitude.

The nearby presence of the West Coast regional headquarters of the Archives of American Art, with its ever-helpful staff (Paul Karlstrom, Jack Van Euw, and Victoria Ricciarelli), has greatly facilitated our research efforts.

The publication in its present form would not have been possible without the enthusiasm and patience of Paul Anbinder of Hudson Hills Press and his staff. We are particularly grateful to Virginia Wageman for the skill with which she edited and clarified the text. Within the Museums, Ann Karlstrom (Publications Manager), Karen Kevorkian (Editor), Mardi Leland (Photo Services Coordinator), and Joseph MacDonald and the late James Medley, Jr. (Photographers), have been central to the book. Directors Ian McKibbin White (under whom the project began) and Harry S. Parker III (under whom it ends) have allowed the allocation of staff time to the project and supported it in every way.

Greatest thanks, of course, are due to the donors of the American paintings and the supporters of the department who have been crucial in bringing the paintings to San Francisco and providing us with the means to research them. Finally, for the good grace with which she read the many versions of this text and the tact with which she offered suggestions, I would like to thank my wife, Fronia.

M.S.

Preface

The American paintings at The Fine Arts Museums of San Francisco form one of the best survey collections of American art in the country—a comprehensive overview of cultural ambition and accomplishment from 1670 through the mid-twentieth century. American art has played an important role in the exhibition and acquisition programs of both San Francisco city museums—the M. H. de Young Memorial Museum and the California Palace of the Legion of Honor—from the time of their foundings and notably since their merger in 1972 as The Fine Arts Museums of San Francisco. But it was in 1979 with the gift of Mr. and Mrs. John D. Rockefeller 3rd's outstanding private collection of American paintings and works on paper that the stature and importance of San Francisco's holdings came to national attention. The need to publish a guide to the highlights of this collection, enhanced by several notable acquisitions in recent years, has been pressing for the past decade.

I am pleased, therefore, that due to the help of the Ralph J. Weiler Foundation, the Luce Fund for Scholarship in American Art, and the generosity of the late Ednah Root, the book that many have desired has at last become a reality. So as to serve the broadest audience, the over one hundred colorplates in the book are each accompanied by a brief essay outlining the artist's career and summarizing the latest research on The Fine Arts Museums' painting. These essays are the work of Marc Simpson (The Ednah Root Curator of American Paintings), Sally Mills (Associate Curator, American Paintings), and Jennifer Saville (formerly Assistant Curator, Research, and now on the curatorial staff of the Honolulu Academy of Arts). Mr. Simpson, who was largely responsible for the selection of the works, has also provided a capsule history of the collection in his introductory essay.

I join with the authors in hoping that this book will prove useful and enjoyable, both as a way of helping our visitors learn about certain treasures of The Fine Arts Museums, and as a document to tempt amateurs, students, and scholars into exploring further the riches of this great collection.

Harry S. Parker III
Director of Museums

Introduction

As of March 1988, the American paintings collection of The Fine Arts Museums of San Francisco contained nearly one thousand works; this book focuses on approximately ten percent of them. In making this selection we have included those paintings that we consider most important, as well as those that will give a fair overview of the history of American painting as it is represented in the Museums, and (since every such selection is an exercise of personal taste) a number of works that simply have a particular appeal to the authors.

The collection presents a continuous spectrum of American painting from its earliest days through the first part of the twentieth century—from *The Mason Children* of 1670, attributed to the Freake-Gibbs Painter, through George Caleb Bingham's *Boatmen on the Missouri* of 1846, to Grant Wood's Regionalist masterwork, *Dinner for Threshers* of 1934. Considerable depth in the work of certain artists, notably Albert Bierstadt (fig. 1) and John Singer Sargent (fig. 2), provides a microcosmic view of an entire career from youth to old age. Elsewhere in the collection, some artists are represented by their single most important work—for example, William M. Harnett's *After the Hunt* (1885) and Thomas Anshutz's

The Ironworkers' Noontime (1880). In its breadth, depth, and in the quality of its individual works, the American paintings collection of The Fine Arts Museums of San Francisco forms a public treasure house of this country's artistic accomplishment, a record of the American mind and spirit.

In its present form, the collection integrates three separate parts—the American paintings from the M. H. de Young Memorial Museum, from the California Palace of the Legion of Honor, and from Mr. and Mrs. John D. Rockefeller 3rd. To appreciate how this collection grew, it is necessary to look briefly at the history and character of each of the constituent parts.

The M. H. de Young Memorial Museum traces its roots to the California Midwinter Exposition of 1894, itself an outgrowth of the 1893 World's Columbian Exposition in Chicago. Like many institutions that arose from the impetus of exhibitions and expositions at the turn of the century, the de Young had initially a wide-ranging collection that encompassed items of natural, military, and local history, as well as the fine arts. Numerous American paintings were acquired in those early years, including portraits

Figure 1. **Albert Bierstadt** (Solingen, Germany 1830–1902 New York, New York), *The Arch of Octavius (Roman Fish Market),* 1858. Oil on canvas, 28½ x 37½ in. Signed and dated lower right: *ABierstadt / 1858.* Gift of Mr. and Mrs. John D. Rockefeller 3rd, 1979.7.12

Figure 2. **John Singer Sargent** (Florence, Italy 1856–1925 London, England), *Study of Architecture, Florence,* ca. 1910. Oil on canvas, 28 x 35 in. Gift of The de Young Museum Society, purchased from funds donated by the Charles E. Merrill Trust, 66.14

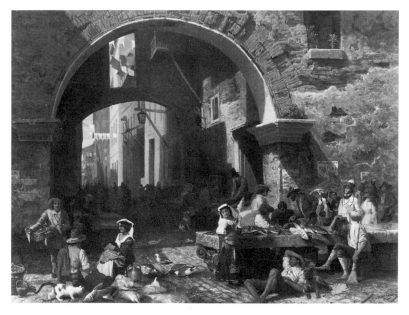

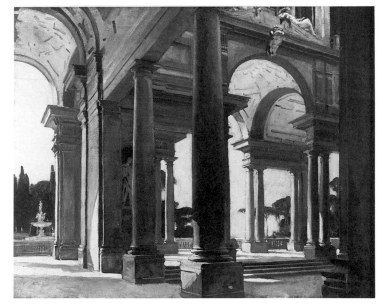

Figure 3. **Joseph Raphael** (San Francisco, California 1869–1950 San Francisco, California), *Child Sewing,* 1916. Oil on canvas, 24¾ x 27⅞ in. Signed and dated lower left: *JOS RAPHAEL / 16.* Gift of Albert M. Bender, 1926.2

tors of American folk art, began distributing portions of their large collection to museums across the country.[1] The de Young ultimately received eighteen works from the Garbisches, including portraits, religious works, and landscapes, such as the inspiriting *Composite Harbor Scene with Volcano* (ca. 1875), now attributed to Jurgan Frederick Huge. A year later, in 1969, Dr. T. Edward and Tullah Hanley of Bradford, Pennsylvania, donated to the de Young a large portion of their extensive art collection.[2] Including major works of art on paper as well as both European and American paintings, the Hanley collection was particularly strong in the areas of early-nineteenth-century portraiture—such as Gilbert Stuart's *Josiah Quincy* (1806)—and early-twentieth-century modernism—notably, Marsden Hartley's *A Bermuda Window in a Semi-tropic Character* (1917), once in Alfred Stieglitz's personal collection.

Figure 4. **Charles Sheeler** (Philadelphia, Pennsylvania 1883–1965 Dobbs Ferry, New York), *Still Life,* 1925. Oil on canvas, 24 x 20 in. Signed and dated lower right: *Sheeler—1925.* Gift of Max L. Rosenberg, 1931.34

of pioneer residents of California and, through the generosity of Miss Alice Skae, a significant group of contemporary California paintings, such as the superb, richly painted *The Blue Bay: Monterey* (ca. 1915) by Clark Hobart.

Paintings of exceptional quality and national importance came early to the collection. Among the first of these was John Vanderlyn's imposing *Caius Marius amid the Ruins of Carthage* (1807), donated by M. H. de Young in 1922. As the century progressed, the American paintings collection grew, particularly in the area of historic scenes of California, such as Alburtus Del Orient Browere's *Stockton* (1856) and William Hahn's anecdote-filled *Sacramento Railroad Station* (1874). Early-nineteenth-century works also grew in number; James Peale's *Still Life with Fruit* (ca. 1821) stands out as a notable example.

The decade of the 1960s was an era of great expansion for the American paintings collection at the de Young. A major opportunity to build in new directions occurred from 1966 on when, with the support of the Charles E. Merrill Trust, the de Young was able to purchase six important early-twentieth-century works, including *May Day, Central Park* (ca. 1905) by William Glackens, *Waldo Peirce* (1920) by George Bellows, and *O in Black with Scarf* (1910) by Robert Henri—paintings that now form the strong core of the collection of early-twentieth-century realism. Then, starting in 1968, Edgar William and Bernice Chrysler Garbisch, preeminent collec-

14

By 1970 the American paintings collection at the de Young Museum spanned the nineteenth and early twentieth centuries, with pockets of considerable depth in early portraiture, the Ashcan School, and California painting, along with significant examples of early-nineteenth-century history painting and still life.

As with the de Young, the California Palace of the Legion of Honor traces its origins to an international fair held in San Francisco— the 1915 Panama-Pacific International Exposition. Alma de Bretteville Spreckels conceived of the Legion of Honor in Lincoln Park, which opened to the public in 1924, as both a memorial to the California men who had died in World War I, and as a fine-arts museum centered upon her collection of "modern" art—sculpture by Auguste Rodin, Arthur Putnam, and Paul Troubetzskoy. Early patrons of American art followed her example. Albert M. Bender, for instance, who was a major donor to several area institutions, gave the Legion of Honor a splendid Diego Rivera of 1926 in 1926, along with works of Joseph Raphael (fig. 3) and other California Impressionists. Another patron, Max L. Rosenberg, contributed thirteen contemporary works by such artists as Max Weber, Charles Sheeler (fig. 4), and George C. Ault to the Legion in 1931.

Perhaps the major, even if indirect, contributor to the American collection of the Legion of Honor was a San Francisco–born woman who lived most of her life in Paris and did not herself

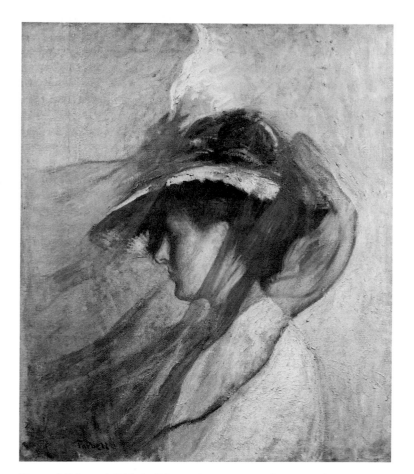

Figure 6. **Edmund C. Tarbell** (West Groton, Massachusetts 1862–1938 New Castle, New Hampshire), *The Blue Veil,* 1899. Oil on canvas, 29 x 24 in. Signed lower left: *Tarbell*. Mildred Anna Williams Collection, 1942.26

Figure 5. **Kay Sage** (Albany, New York 1898–1963 Woodbury, Connecticut), *Starlings, Caravan,* 1948. Oil on canvas, 32 x 39 in. Signed and dated lower left: *Kay Sage '48*. Mildred Anna Williams Collection, 1951.28

own American paintings. Collectors primarily of French art, Mildred Anna Williams and her husband, H. K. S. Williams, deeded their collection to the Legion of Honor in 1928 and gave individual works to the museum through the 1930s. In 1939 Mrs. Williams died suddenly, and, with war imminent, Mr. Williams brought the collection from Paris to San Francisco. His interest in the Legion of Honor's collection increased over the years, and with his support the museum began to purchase highly important paintings. Among the first of these to enter what was designated the Mildred Anna Williams Collection was Harnett's trompe l'oeil masterpiece *After the Hunt* in 1940, followed in 1943 by John Singleton Copley's *Joshua Henshaw* (ca. 1770) and Eastman Johnson's *The Pension Claim Agent* (1867). Mr. Williams ensured that the collection of the Legion of Honor would continue to grow after his death by establishing a generous endowment fund, the interest of which was to be used for thirty years for additions to the Mildred Anna

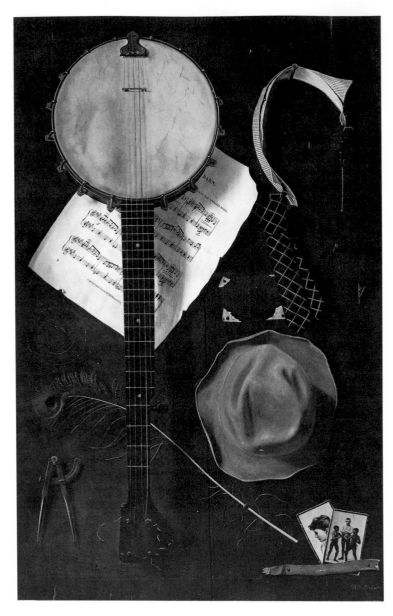

Figure 7. **William Keane** (active in Camden, New Jersey, late nineteenth century), *The Old Banjo,* ca. 1889. Oil on canvas, 39⅞ x 24⅞ in. Signed lower right: *Wm KEANE.* Museum purchase, Ehrman Fund, T. B. Walker Fund, and Huntington Trust, 1969.2

ized midwestern critics when it was exhibited in 1939, was purchased out of a traveling exhibition for the museum in 1940 by an anonymous donor. One of the most important purchases, given the course of the collection's later development, occurred in 1969 when *The Old Banjo* (ca. 1889; fig. 7), by the relatively unknown trompe l'oeil artist William Keane, entered the Legion of Honor's collection.

Thus, as of 1970, the American paintings collection of the Legion of Honor had a strong sampling of representational art from the 1920s and 1930s, a superb eighteenth-century portrait by one of America's finest painters, and a selection of important works from the nineteenth century, most notably landscapes and trompe l'oeil still lifes.

Although there was a substantial number of important American paintings in San Francisco by 1970, the breadth and richness of the city's holdings became evident only in 1971, when the American paintings from both the de Young and the Legion of Honor were gathered together in the landmark exhibition *Three Centuries of American Painting*, which served as a prelude to the official merging of the two institutions into The Fine Arts Museums of San Francisco in 1972. The two collections fit together like interlocking pieces of a jigsaw puzzle, with few redundancies and many enriching comparisons. Over much of the next decade, The Fine Arts Museums judiciously added to the American collection. In some instances the purchases led to strength, bringing together a collection of trompe l'oeil paintings (to complement the Harnett and the Keane) that now forms arguably the best collection of this tradition in the United States. Other purchases were clearly intended to add new dimensions to the collection, as was the case with Thomas Eakins's *The Courtship* (ca. 1878) and John Singer Sargent's *Dinner Table at Night* (1884). By 1977, when the first permanent galleries for American art were opened at the de Young, The Fine Arts Museums had a handsome survey available to its visitors and could count among its holdings some of the very finest American paintings.

In 1978 the entire character of the collection changed. In a letter of 16 January, John D. Rockefeller 3rd announced his intention to donate his superb American paintings collection to The Fine Arts Museums. The collection that Mr. and Mrs. Rockefeller had assembled, with the assistance of renowned scholar Edgar P. Richardson, was itself a comprehensive survey of American paintings of remarkably high quality. Although Mr. Rockefeller's family had a long and prestigious history of involvement with American art —including the restoration of Colonial Williamsburg and the establishment of the Abby Aldrich Rockefeller Folk Art Collection by his parents, and his mother's and wife's deep involvement in the affairs of the Museum of Modern Art in New York—he began to collect American art for himself only in the mid-1960s. The impe-

Williams Collection (figs. 5 and 6), after which the principal was to be expended in five years. Thus it was that Frederic Edwin Church's monumental *Rainy Season in the Tropics* (1866) came to San Francisco in 1970, twenty-six years after Williams's death in 1944.

Other American paintings from various sources were added to the Legion of Honor's collection over the years. Thomas Hart Benton's *Susanna and the Elders* (1938), a painting that scandal-

tus for the collection grew from his realization that his home, filled with French Impressionist paintings and the Oriental art that he had long collected, gave his international guests no trace of the art of his own country. To rectify this, he acquired two landscapes painted just before the Civil War and, during the course of the next twelve years, expanded that base to a comprehensive overview. Richardson wrote of the collection:

> Mr. Rockefeller has never, in my experience, acquired a work he has not himself enjoyed and found significant, often after long study. . . . [His collection] thus represents a thoughtful, personal view of our art by an observer of unusual experience and perspective. The collection interests me both for the works of art themselves and for its choices. It passes by works representing a purely esthetic impulse or mode, in favor of those expressing a response to human life and to nature. Included are realists and dreamers, artists of only an artisan's skills and those of great sophistication, famous names and unknown or forgotten figures. All speak from the heart.[3]

In 1978, therefore, when Mr. Rockefeller announced his intention to donate this collection to The Fine Arts Museums, he forecast the most magnificent gift in the history of the Museums. Following Mr. Rockefeller's unexpected death later that year, just over one hundred works came to the Museums (figs. 8 and 9). The Rockefeller gift established highpoints in nearly every area, including, among much else, the one seventeenth-century painting in the collection, a rich sampling of eighteenth-century portraiture, masterpieces of nineteenth-century genre painting (including works by Bingham and Anshutz), and two important works from the 1930s by Grant

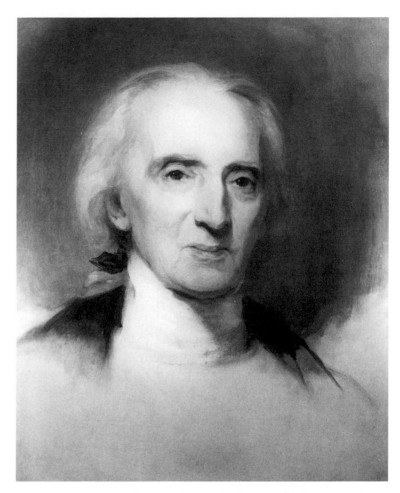

Figure 8. **Thomas Sully** (Horncastle, Lincolnshire, England 1783–1872 Philadelphia, Pennsylvania), *Charles Carroll of Carrollton,* 1826. Oil on canvas, 19⅛ x 15⅛ in. Gift of Mr. and Mrs. John D. Rockefeller 3rd, 1979.7.94

Figure 9. **Elihu Vedder** (New York, New York 1836–1923 Rome, Italy), *Death of Abel (The Dead Abel),* 1869. Oil on canvas, 12¼ x 45¾ in. Signed with monogram and dated lower left: *18 V 69.* Gift of Mr. and Mrs. John D. Rockefeller 3rd, 1979.7.103

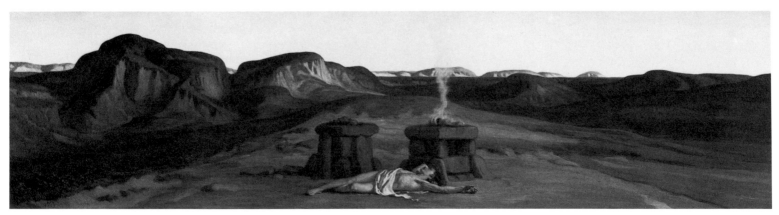

Wood and Charles Burchfield. In the area of The Fine Arts Museums' greatest strength, trompe l'oeil, the Rockefeller gift added two compelling works by an artist not previously strongly represented —John Frederick Peto's *Job Lot Cheap* (after 1900) and *The Cup We All Race 4* (ca. 1900). Thus the Rockefeller gift transformed The Fine Arts Museums' respectable collection into a comprehensive textbook of aesthetic and historic accomplishment.

Mr. and Mrs. Rockefeller's choice of San Francisco as a home for their collection has several roots. Because of the relative scarcity of important American historical works on the West Coast, as opposed to the bounty of works in the Northeast, the Rockefeller collection in San Francisco promised to make a meaningful difference in the cultural life of the area. Furthermore, as the gateway to the Orient (an area where the Rockefellers had long focused their interest), San Francisco seemed an appropriate site for an important collection of American painting. The Fine Arts Museums had earlier demonstrated a commitment to American art through several major purchases (Church's *Rainy Season in the Tropics*, most significantly), expanded galleries, and their organization of the Bicentennial tour of the Rockefeller collection. Likewise, the presence in the de Young building of the West Coast Regional Center of the Archives of American Art, a branch of the Smithsonian Institution, indicated the Museums' desire to foster scholarship in American art—not only in the Museums' projects but throughout the region. The Rockefellers were aware that, as the neighbor to several major universities with strong art-history programs, the Museums serve an educational as well as an aesthetic role in the community.

Since 1979 the collection has continued to grow, most notably with the continuing generosity of Mrs. John D. Rockefeller 3rd and the support of Peter McBean and Anna Bennett and Jessie Jonas, and by funds initiated by William E. Noble and Roscoe and Margaret Oakes, among others. Recently acquired works include portraits by artists as diverse as John Wesley Jarvis, Thomas Wilmer Dewing, and Mary Cassatt, a broad-ranging series of nineteenth-century landscape paintings by Albert Bierstadt, George Henry Durrie, and William Stanley Haseltine, along with the masterful *The Cello Player* (1924–26) by Edwin Dickinson. Each now plays a particularly important role in the galleries.

The story sketched above is but a summary, leaving out many important people and events that have contributed to the present shape of the American paintings collection. Perhaps the most notable of these was the late Ednah Root, an Honorary Trustee of the institution, who in 1978 decided to support the curatorial chair in American art at The Fine Arts Museums. Mrs. Root's continued generosity has had wide-ranging implications for the growth of the collection, since it was her support that began the American Paintings Department and has since funded its senior curatorial staff.[4] Her posthumous establishment in 1987 of the Ednah Root Foundation provides support for the department's activities well into the future.

The art of America is a distinct and beautiful body of work, as varied in its manners and styles as the inhabitants of the country itself. The collection commemorated in this volume admirably presents a handsome paradigm of that tradition. We hope that visitors to The Fine Arts Museums will find this book, the first major publication on the Museums' American paintings collection in over fifteen years, to be an enriching adjunct to their irreplaceable firsthand experience of the works themselves, and that those who have not yet visited The Fine Arts Museums of San Francisco will find herein sufficient temptation to make the journey.

Marc Simpson
The Ednah Root Curator of American Paintings

The American Canvas

Paintings from the Collection of
The Fine Arts Museums of San Francisco

Attributed to the Freake-Gibbs Painter
Active in Massachusetts 1670–74

Although seventeenth-century Boston was a major cultural center in the English-speaking world and there are reports of considerable artistic activity taking place in the city, fewer than thirty paintings sufficiently intact and with convincingly firm documentation survive to testify to that tradition. Of these, which are all portraits done in a simplified Anglo-Dutch style typical of Elizabethan and Jacobean portraiture of fifty to seventy years earlier, only four can be assigned to a known artist.[1] In the remaining paintings, at least five different hands or workshops can be distinguished on the basis of style. The largest and most brilliant group of these is composed of eight portraits of the Freake, Gibbs, and Mason families, all dating from 1670 to 1674. Until documentation linking these works to one or more known craftsmen is located, their artist is known as the Freake-Gibbs Painter.[2]

San Francisco's painting by this master, *The Mason Children: David, Joanna, and Abigail*, in addition to being the earliest American painting in the collection, is also the only known American painting from the seventeenth century to show more than two figures. *The Mason Children* shows three of the five children of Arthur and Joanna (Parker) Mason of Boston: David (1661–1724), Joanna (born 1664), and Abigail (baptized 1666).[3] Dressed as fashionable adults, the children have props that indicate gender and status—gloves and a silver-handled walking stick for the male heir of the family, and fan or flower and delicate coral beads for the two girls. While the artist has differentiated the face of one child from another, he has concentrated his greatest energy on portraying the intricate costumes, carefully detailing the slashed sleeves, billowing linen, and lace-trimmed square collar of David's somber suit and the tucks, gathers, laces, and ribbons of Joanna's and Abigail's pinafores and kerchiefs. The effort of recording these facts of the Mason family's wealth, displayed with an extravagance seemingly at odds with the Colony's strict sumptuary laws,[4] is paralleled by the artist's need to note the chronological facts of his commission. Inscriptions of gold dusted on yellow paint record the year of the painting—"Anno Dom 1670"—as well as the ages of each child—eight, six, and four. The inscriptions float on the surface of the canvas and deny the illusion of reality suggested by the fully modeled forms and vital personalities of the children, conveyed most successfully in the image of Joanna, the middle child who gazes from the picture.

The setting of the work is a spare, narrow room, its only decoration a swagged curtain that hangs over the heads of the two girls. A tiled floor suggests space and establishes that the artist was aware of the laws of one-point perspective, but the recession halts abruptly at the blank, brown wall. The edges of the canvas also bind the figures closely within its borders, leaving no space to imagine growth or movement. And so the Mason children, each individually charming, nonetheless appear unnaturally still, the attributes of their future adulthood already upon them.

M.S.

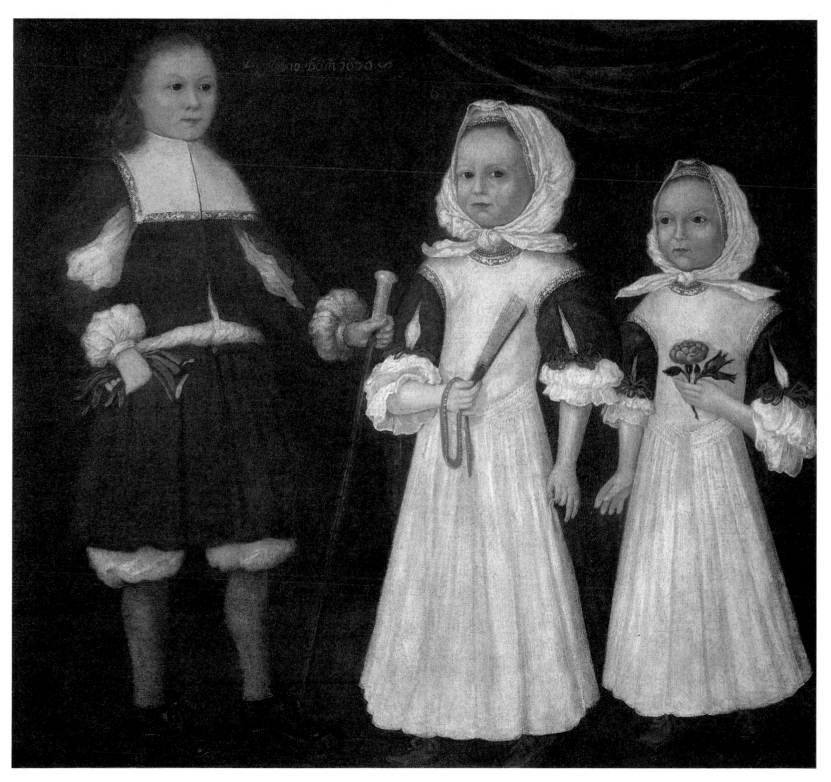

The Mason Children: David, Joanna, and Abigail, 1670
Oil on canvas, 39½ × 42¾ in. Inscribed and dated across top: *8 Anno Dom 1670 6 4*
Gift of Mr. and Mrs. John D. Rockefeller 3rd, 1979.7.3

The De Peyster Painter
Active in New York early eighteenth century

Painters working in the Hudson River Valley in the early eighteenth century produced a sizable and impressive body of work that includes portraits of wealthy Dutch patroon families and occasional religious pictures. Nearly all of these paintings are unsigned, and few documents remain from the period to suggest the identities of the artists. Yet stylistic distinctions can be made among the some two hundred portraits in existence today. In 1947 James Thomas Flexner first identified and praised the "De Peyster Manner," a simplified, linear, and elegant Baroque style evident in the portraits of five children of Abraham and Margareta (Van Cortlandt) De Peyster.[1] The De Peyster style can be seen in portraits of several New York families, all of which exhibit delicate draftsmanship in the hands and facial features, a schematic treatment of figures, drapery, and backgrounds, and compositions frequently borrowed from English mezzotint sources.

Although the artist has yet to be conclusively identified,[2] the De Peyster style is evident in the portrait of Maria Maytilda Winkler (later Mrs. Nicholas Gouverneur), especially in her delicate features, fine curling locks of hair, and the simplified lines and vivid red and blue of her costume. Although Maria was of Dutch origin—daughter of a merchant who settled in New Amsterdam after dealing in Sumatra, Indonesia—the model for her posture and attributes was English—specifically, the figure of Lady Mary Villiers in Sir Godfrey Kneller's (1646–1723) portrait of Lord William and Lady Mary Villiers, which was engraved in mezzotint by John Smith (1652[?]–1742) around 1715. The artist uses some invention in the turn of Maria's head and the appearance of the parklike background, but the remainder of the composition—the garland she holds and the lamb that nuzzles against her—are copied from the engraving. Such visual quotations were common practice among artists in the New World, who were deprived of both teachers and paintings from which to study.

Yet if some motifs are lifted wholesale from the English source, it is certain that the artist understood the iconography of such attributes as the garland and the lamb, traditional symbols of transient beauty and innocence. As in the portrait of her sister Jacomina (private collection), which was painted at nearly the same time, Maria sits in a calm, demure pose, loosely supporting her small animal and flowers. The De Peyster portraits of male children show the boys standing with large dogs or young deer—clear allusions to the hunt and the eventual dominion they would enjoy. As appropriate to the prevailing notions of feminine virtue, however, Maria sits, eyes averted, claiming not territory but beauty and innocence as her own.

S.M.

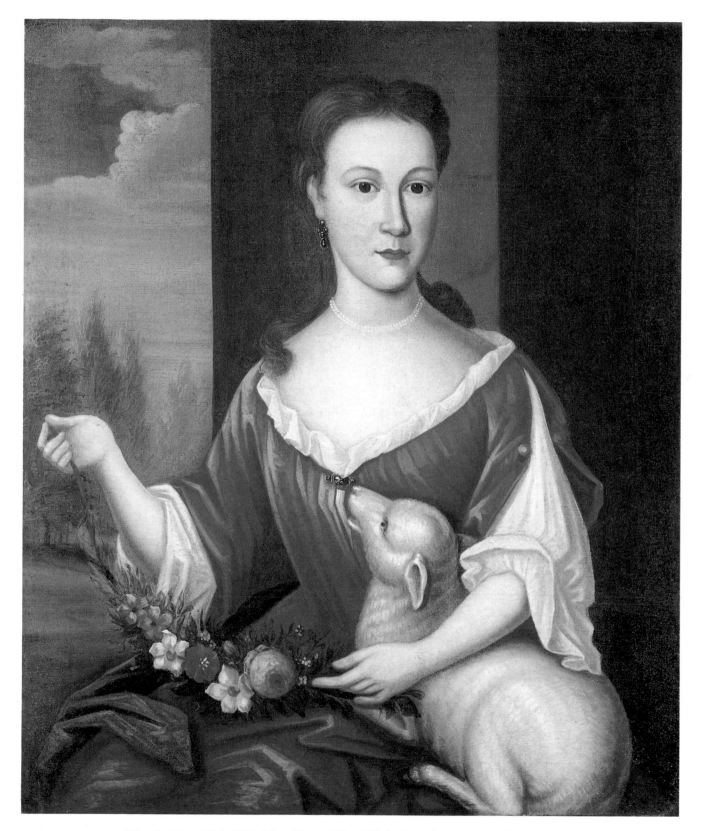

Maria Maytilda Winkler (later Mrs. Nicholas Gouverneur), ca. 1730
Oil on canvas, 30⅛ × 25⅛ in. Gift of Mr. and Mrs. John D. Rockefeller 3rd, 1979.7.34

John Smibert

Edinburgh, Scotland 1688–1751 Boston, Massachusetts

John Smibert, the first academically trained European painter to settle in the New World, brought an unprecedented level of artistic excellence to the American colonies. Born in Scotland, Smibert apprenticed to a house-painter before moving to London in 1709, where he worked as both a coach painter and copyist for art dealers. Smibert furthered his formal training by attending drawing school until, in the tradition of other eighteenth-century British painters, he traveled to Italy to study the Old Masters and the arts of antiquity. Returning to England, in 1728 Smibert joined the noted philosopher Dean George Berkeley, who was recruiting a faculty for his proposed college of arts and sciences in Bermuda. Smibert was to teach painting, drawing, and architecture, but Dean Berkeley's dream never materialized. Although the college was founded under British royal charter, Berkeley's group waited in vain in Newport, Rhode Island, for funds from Parliament. Berkeley eventually returned to England, but Smibert stayed in the colonies, moving in about 1729 to the larger cultural center of Boston. There he quickly became the favored portraitist of many prosperous colonials.

John Smibert's significant position in the development of Early American painting stems partly from the model that his own work provided for his contemporaries. However, in addition to rendering portraits, he ran an artist-supply shop and art gallery. His collection of oil copies and mezzotint engravings after the Old Masters, as well as his plaster casts of ancient statues, introduced native artists to the European heritage they yearned to study. For as long as a generation after his death, Smibert's gallery was central to the early artistic education of such painters as John Singleton Copley,* Charles Willson Peale,* and John Trumbull.*

Smibert painted the portrait of John Nelson (1654–1734) early in 1732—he recorded the work in February of that year, noting that he received forty guineas for it.[1] Also an immigrant to the New World,

Nelson had moved to Boston in 1680. A prominent merchant, fur trader, and statesman, he led the 1689 uprising against St. Edmund Andros, King James II's unpopular royal governor of all the English North American colonies, excluding Pennsylvania.

Smibert's representation of Nelson epitomizes the American interest in the European ideal of personal dignity and elegance, a tradition from which the colonists were separated by an ocean, but one with which they hoped to be identified. Nelson sits with an erect, confident carriage, gazing at the viewer, gripping two books. The muted palette contributes to the gravity of the scene. Were demeanor and mood insufficient to communicate Nelson's social stature, Smibert adorns the back wall with heraldry of the Nelson family.

Smibert tempered such portrait formality with a degree of naturalism also new to colonial art, shown here, for instance, in the sensitively rendered hands, prominent nose, and sagging facial features of this seventy-eight-year-old man. The easy movement of Nelson's arms and the slight rotation of his torso away from the picture plane add convincing animation. Due to the vitality of the characterization, it is easy to recognize the man described in "The Final Peace, Security, and Happiness of the Upright," the sermon delivered at Nelson's funeral in 1734:

With a very good understanding, improved by Education and Travel, the Spirit and Temper of an ancient and worthy Family appeared in him; Genteel, Enlarged, Liberal, contemning mean and sordid Actions. . . . He was unmoveably attach'd to what he tho't just and right, couragious in bearing Witness against and reproving Vice, a Despised of this World, a Lover of his Country, acceptable to his family. . . . Universally affable, courteous, and hospitable.[2]

J.S.

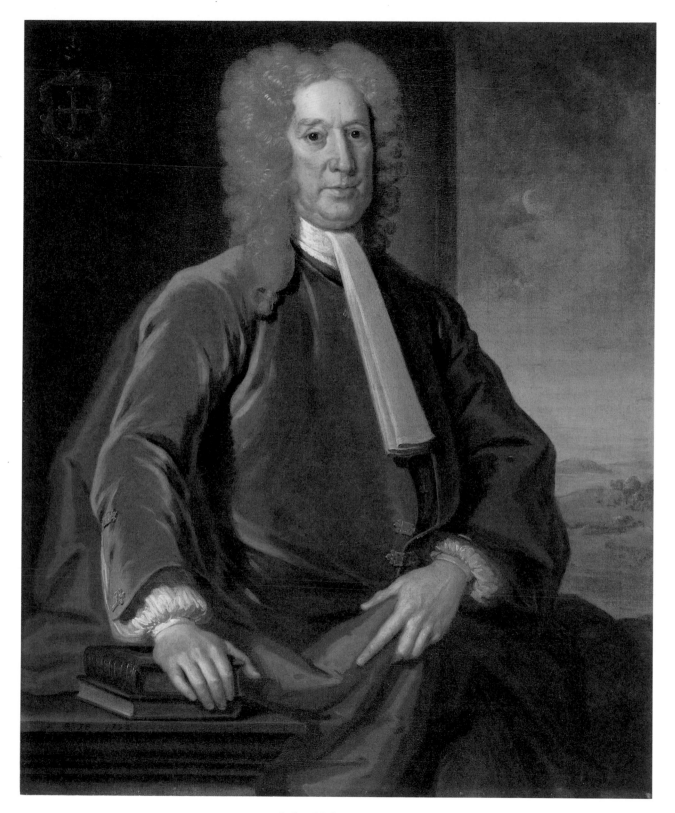

John Nelson, 1732
Oil on canvas, 44¼ × 36 in. Inscribed and dated lower left: *AEt78. 1732*
Gift of Mr. and Mrs. John D. Rockefeller 3rd, 1979.7.93

Robert Feke
Oyster Bay, New York ca. 1707–ca. 1752 (Barbados?)

Although Robert Feke was one of the most talented and distinctive of American-born painters of the eighteenth century, the circumstances of his life remain largely unknown. According to family tradition, he was born on Long Island in 1707 and perhaps spent a portion of his early maturity as a mariner. From 1741 to 1751 Feke worked as a portraitist primarily in Boston, Newport, and, in 1746, Philadelphia. The date of his death is uncertain; no documentation of Feke's activities has come to light for the years after 1751, except for a 1767 probate record that notes his demise an unspecified number of years earlier. Family history reports that Feke journeyed to the Caribbean in 1751 and never returned; the death of a Richard Feak recorded on Barbados in 1752 may refer to the painter. Amid this uncertainty of the biographical record, approximately sixty paintings remain to mark the artist's life and accomplishment. Of these, *Mrs. Charles Apthorp*, signed and dated 1748, stands as one of his handsomest creations.

Grizzell Eastwick was born in Jamaica on 16 August 1709. She went to Boston in 1716 and in 1726 married Charles Apthorp (1698–1758), an English-born merchant who was paymaster and commissary to the British troops quartered in Boston. Apthorp used his position to become "the greatest and most noted Merchant on this Continent," according to the obituary published in the *Newsletter* of King's Chapel, Boston, on 16 November 1758.[1] The couple had eighteen children, fifteen of whom survived their father. Mrs. Apthorp as well survived her husband by almost forty years, dying in her son's house in Quincy, Massachusetts, in 1796.[2]

In Feke's portrait, Mrs. Apthorp wears a gleaming satin overgown with large pearls hanging from her sleeves and bodice. The setting of the painting—a monumental stone column, gathered drapery, and a domesticated landscape visible through the portico to the left—as well as the sitter's pose derive from published mezzotint portraits of the English nobility.[3] Turning to print sources for elements of a composition was standard practice for most colonial artists, allowing them to benefit from the latest artistic developments of their European colleagues, while simultaneously granting to their sitters the most fashionable styles and accoutrements.

In this portrait, Feke has Mrs. Apthorp look up from John Milton's *Paradise Lost*. The page is open to the lines in book 9 where Eve has just told Adam that she has tasted the fruit of the tree of knowledge and has asked that he too eat of it. Speechless and pale, Adam thinks to himself:

> O fairest of Creation, last and best
> Of all God's Works, Creature in whom excell'd
> Whatever can to sight or thought be form'd,
> Holy, divine, good, amiable, or sweet!
> . . . with thee
> Certain my resolution is to Die;
> How can I live without thee, how forgo
> Thy sweet converse and Love so dearly join'd,
> To live again in these wild Woods forlorn?
> . . . no no, I feel
> The Link of Nature draw me: Flesh of Flesh,
> Bone of my Bone thou art, and from thy State
> Mine shall never be parted, bliss or woe.[4]

This apostrophe of woman is the human climax of Milton's epic—Adam will shortly follow Eve, eat of the forbidden fruit, and lose Eden for all humankind. But by citing this bold glorification of woman, Feke clearly means to associate Mrs. Apthorp with the qualities in Eve that Adam found so compelling.

Mrs. Charles Apthorp is one of Feke's most successful paintings. The sitter's direct gaze engages the interest of the viewer, while her poised and elegant figure convincingly occupies space. Cool blues and greens dominate the background, suggesting an Edenic setting awash with a full, even light. The sensual appeal of the work is further enriched by the artist's uncharacteristically specific reference to the passage from *Paradise Lost*, entwining an appropriately Puritan reflection on the perilous state of the human soul with one of English literature's strongest expressions of conjugal devotion.

M.S.

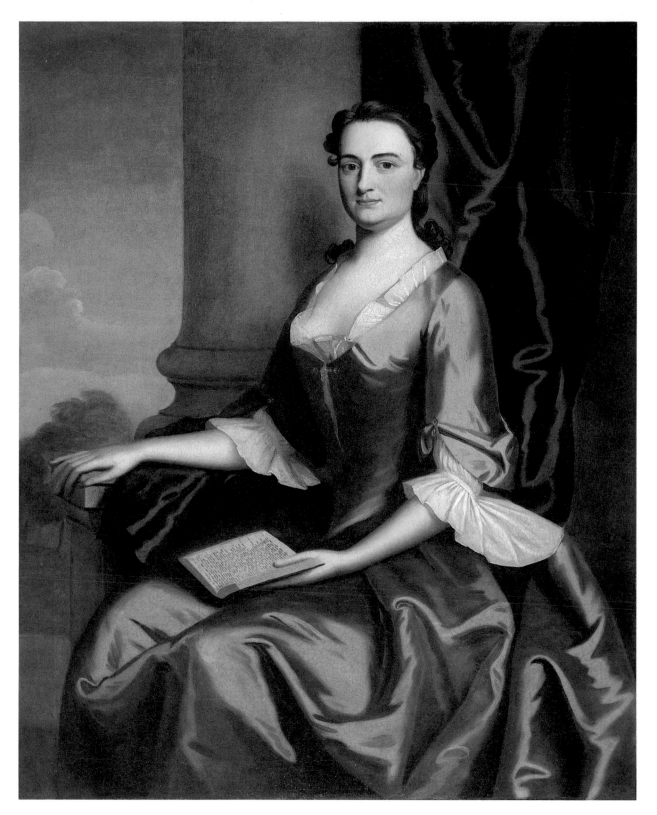

Mrs. Charles Apthorp (Grizzell Eastwick Apthorp), 1748
Oil on canvas, 49 × 39¼ in. Signed with initials, dated, and inscribed lower right: *RF Pinx^t / 1748*
Gift of Mr. and Mrs. John D. Rockefeller 3rd, 1979.7.42

Joseph Badger
Charlestown, Massachusetts 1708–1765 (Boston, Massachusetts?)

In the vacuum created by the deaths of John Smibert* and Robert Feke,* the painter Joseph Badger became the leading portraitist of mid-eighteenth-century Boston. As was true for many other self-taught artisans of the period, Badger began his career in trade as a glazier and painter of houses. Only as he reached his thirties did Badger add portraiture to his professional accomplishments. For some ten years during the 1740s and 1750s, when Boston did not have a major European talent, prosperous families relied on Badger to paint their portraits.

Joseph Badger's position as the leading portraitist in Boston, however, was brief, ending with the arrival of Joseph Blackburn (active in North America 1752–1763/64), a European-trained painter, and the ascendance of native-born John Singleton Copley,* thirty years Badger's junior. After Badger's death the artist's identity fell into obscurity until the early twentieth century, when his name was discovered in an eighteenth-century diary.[1] Unfortunately, since few of his paintings bear a signature or date, portraits such as that of Mrs. Nathaniel Brown have suffered from mis-identification. An old label attached to this canvas, for instance, bears an inscription ascribing it to "famous American . . . painter—Copley."

Anna Porter Brown (1718–1781), great-great-granddaughter of the colonial Massachusetts governor Simon Bradstreet, appears in three-quarter length in a landscape setting. Her appearance depends heavily on pictorial conventions that Badger adapted and repeated throughout his career. Placement of the figure high on the canvas, the single tree, and the open book with gilt-leather binding are features that Badger repeated with little variation in several of his portraits. The frontal pose itself, with hands casually at rest, derives from mezzotint engravings of British portraiture imported to the New World[2] and easily available at John Smibert's gallery, a few blocks from Badger's residence. Reliance upon such formulas and prototypes was the accepted norm for colonial portraitists, particularly for the untrained limners. Inexperienced with anatomy, perspective, and the rules of composition, Badger benefited from the example of academically educated artists, just as his sitters were pleased by their association with the latest style of European painting.

When judged against the traditional criteria of naturalism and skill, Badger's portraiture may not seem equal to the craftsmanship and polish of his predecessors Smibert and Feke. Words like "wooden," "clumsy," and "prim," often used to describe Badger's work, indeed may seem appropriate to suggest the stiff posture, boneless hands, and tight-lipped expression of Mrs. Nathaniel Brown. Such superficial interpretation, however, obscures the charm and sincerity of Badger's work. For example, Badger softens Mrs. Brown's rigidity by giving a pleasant rhythm to the swinging curves defined by her arms and skirt folds. Furthermore, grave as Mrs. Brown may appear, the seriousness of her straightforward gaze and solemn expression befits a well-placed young woman as she pauses in her reading. Badger's portrayal of this strong individual illustrates the best of American provincial painting.

J.S.

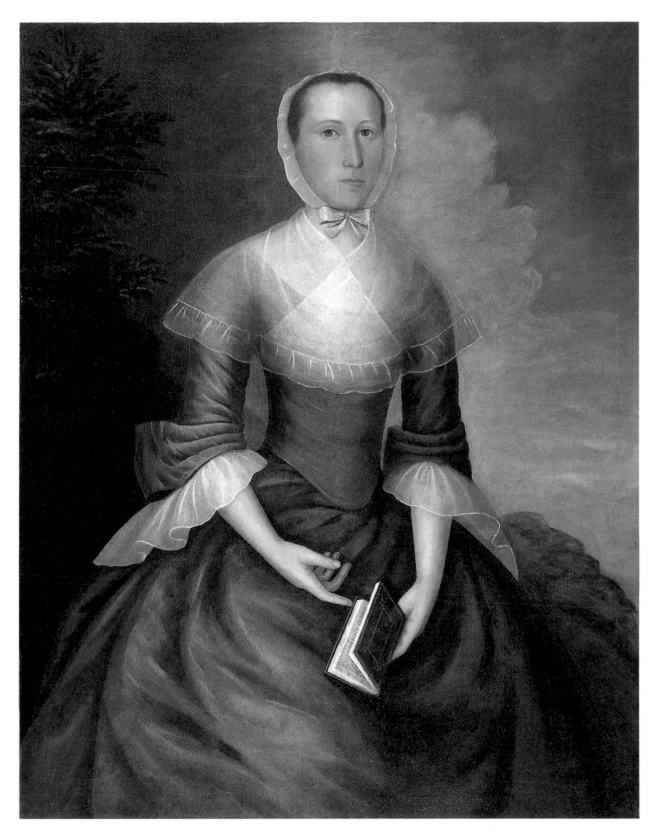

Mrs. Nathaniel Brown (Anna Porter Brown), ca. 1750

Oil on canvas, 49¼ × 38½ in. Gift of Mr. and Mrs. John D. Rockefeller 3rd, 1979.7.6

John Singleton Copley
Boston, Massachusetts 1738–1815 London, England

Indisputably the greatest American portraitist of the eighteenth century, John Singleton Copley was born to Irish immigrant parents. He was probably introduced to the artist's trade by his stepfather, Peter Pelham (1697–1751), a portrait painter and mezzotint engraver. By the age of fourteen or fifteen Copley had produced his own engravings as well as painted copies after allegorical prints owned by his stepfather. Copley's first portraits date from these years, around 1753. This early work is stiff but accomplished, revealing a clear knowledge of such local portraitists as Joseph Badger,* Robert Feke,* and John Greenwood (1727–1792), as well as a dependence on mezzotint print sources.[1] The arrival in Boston around 1755 of the English portraitist Joseph Blackburn (active in North America 1752–1763/64) provided both model and challenge to Copley, who quickly absorbed the older painter's rococo flair and skill in describing beautiful fabrics. By the age of twenty-five, Copley was on his way to becoming Boston's most celebrated portraitist. Balancing meticulous observation and superb craftsmanship, he was successful as no American artist before him in creating the illusion of a three-dimensional material reality on his canvas. Yet colonial Boston was insufficient to contain Copley's ambition and desire for self-improvement, as he wrote to a friend in England:

> Was it not for preserving the resembla[n]ce of particular persons, painting would not be known in the plac[e]. The people generally regard it no more than any other useful trade, as they sometimes term it, like that of a Carpenter tailor or shoemaker, not as one of the most noble Arts in the World. Which is not a little Mortifying to me.[2]

As early as 1765 Copley had submitted a picture to the Royal Academy in London. As did Benjamin West,* Sir Joshua Reynolds (1723–1792) praised the picture and encouraged Copley to study in Europe, assuring him that he could be "one of the first Painters in the World," provided he received the benefit of European instruction before his "Manner and Taste were corrupted or fixed by working in [his] little way at Boston."[3] Ambitious as well as eager to escape political tensions in Boston that would soon erupt in the Revolutionary War, Copley sailed for Europe in 1774. In 1775 he settled in London, where he continued to maintain his portrait practice and embarked on a series of historical and dramatic canvases that won him acclaim and financial success. He was elected to the Royal Academy in 1779. While he never achieved the preeminence he enjoyed in Boston, he continued to garner praise and commissions. He died in London, never returning to his native land.

Copley's portrait of Mary Turner (1743–1818), granddaughter of the Salem merchant who built the House of the Seven Gables, was painted in the year of her marriage to Daniel Sargent, a wealthy Gloucester shipowner. At least eleven members of the prominent Sargent family sat for Copley between 1758 and 1774. In this portrait of 1763, Copley's artistic maturity is as evident as the young sitter's beauty. Copley has set the figure in a shallow space, against the backdrop of a thinly painted brown wall. There is little in the portrait to distract attention from the sitter's lovely features or the opulent textures of her gown. Yet the illusion of tangible reality, created by the delicate, near-invisible brushstrokes that model the features and evoke the splendors of satin and lace, was achieved at no small cost. The artist Henry Sargent (1770–1845) later recalled that Copley had "painted a very beautiful head of my mother, who told me that she sat to him fifteen or sixteen times! Six hours at a time!!" And when Mrs. Sargent had the temerity to peek at her portrait when Copley had left the room for a few minutes, "to her astonishment, she found it all rubbed out."[4]

Present and tangible as she appears, Mrs. Sargent is far removed from her everyday world, set rather on the timeless stage of the emblematic universe that Copley had discovered in English prints. No one specific print lies behind this portrait, a fact that attests to the inventiveness of a young artist with limited models.[5] However, the curious gesture of lifting a scallop shell to catch the flow of water is certainly a quotation from John Faber's (1660–1721) mezzotint of 1691, after Sir Godfrey Kneller's (1646–1723) portrait of the Duchess of Grafton, one of the Hampton Court beauties.[6] Alluding to feminine virtue if not also to marriage, the shell is an attribute of Venus, goddess of love and beauty, while the fountain issuing mysteriously from the stone wall connotes the source of life, fertility, and purity. That Copley could imbue such artifice and theatricality with life and ease is testimony to his artistic skill.[7]

S.M.

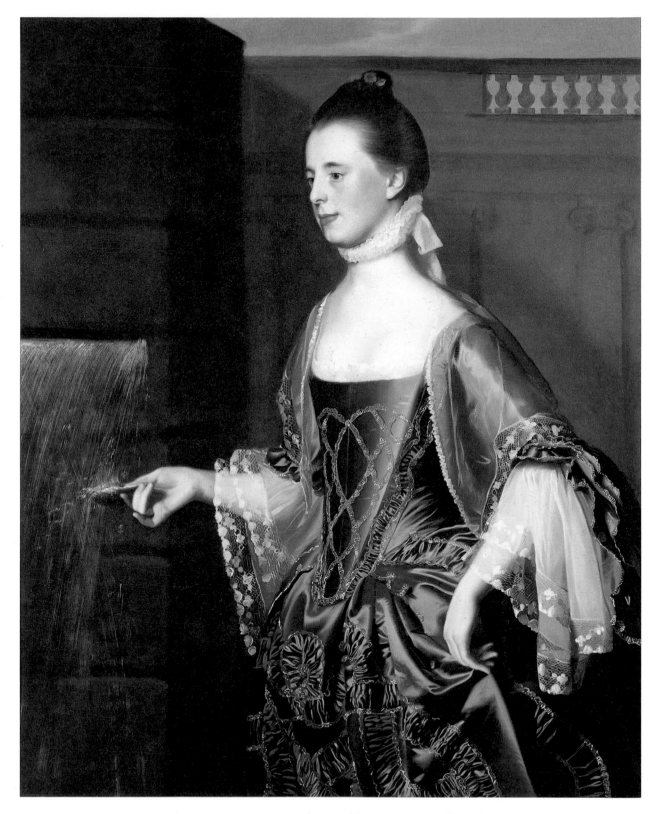

Mrs. Daniel Sargent (Mary Turner Sargent), 1763
Oil on canvas, 50 × 40 in. Signed and dated lower left: *John Singleton Copley / Pinx 1763.*
Gift of Mr. and Mrs. John D. Rockefeller 3rd, 1979.7.31

John Singleton Copley
Boston, Massachusetts 1738–1815 London, England

Although allied by marriage with one of Boston's wealthiest Tory families, John Singleton Copley attempted to remain politically neutral during the conflict between Britain and her colonies. While he continued to paint both Tories and Whigs during the early 1770s, the portraits from those troubled years before the American Revolution and the artist's move to London nonetheless display a new sobriety. Copley's portraits painted between 1769 and 1775, especially those of men, are often stark, even severe in their simplicity: ornamental details are all but eliminated, color schemes are restricted to deep red tones against dark brown backgrounds, and pictorial focus is provided by the intensity of the sitter's gaze and the material reality of clothing and accessories. Such dramatic sobriety is evident in Copley's portrait of Joshua Henshaw (1703–1777), a prominent Boston citizen and patriot.

Henshaw was born in Boston and entered the mercantile profession at an early age. Following his marriage in 1733 to Elizabeth Bill, daughter of a prosperous Boston merchant, Henshaw quickly rose to positions of prominence and influence. He was "repeatedly selected by his townsmen to participate in the discharge of duties requiring superior wisdom no less than unimpeachable integrity and undaunted resolution."[1] He served frequently as town magistrate, was appointed selectman in 1764, and served on various town committees with such individuals as John Hancock, Samuel Adams, and James Otis. While Henshaw never achieved the fame of his more fiery fellow patriots, he nonetheless used his position to advance colonial rights and to protest the impositions of British rule. The British occupation of Boston in 1774 forced Henshaw to flee his native city, and he moved with his family to Leicester, Massachusetts, where his brother and son-in-law lived. He later moved to Dedham, closer to Boston, remaining there until his death. A newspaper obituary noted that Henshaw was

a man of engaging aspect and deportment; of solid and unaffected piety; of untainted integrity and honor; of sincere and steady friendship; of great compassion for the distressed, and benevolent to all in private and domestic life.... He was one of those uniform patriots who early opposed the encroachments of the Administration, for which he was admirably distinguished by their frowns, and he died in the pleasing hope of the success of the American cause.[2]

Copley's portrait, which must have been painted before Henshaw fled Boston, successfully captures both the strength and the reserve of this genteel patriot. As if caught in an informal moment, having just removed the hat now held under his left arm and the glove in his left hand, Henshaw leans against cascading drapery. Although his gaze is somewhat averted, Henshaw strikes the viewer as an imposing figure, filling the picture space, his shoulders back but his body thrust forward. His furrowed forehead and firmly compressed lips underscore this determined stance. But the light is perhaps the most remarkable presence in this portrait, entering from the left and strongly illuminating Henshaw's hand and face, filling the background with soft radiance. The insistence of this light not only reveals the different textures of cloth, flesh, and hair but also molds Henshaw's form and features with precision and sensitivity.

Henshaw's portrait remained with a branch of the family until 1942, hanging for over a century in one house in Wayland, Massachusetts. The portrait retains its original frame, a masterful example of colonial craftsmanship, richly sculptural in its carving and spirited in its design. The cartouche atop this frame is a simplification of the Henshaw coat of arms.[3]

S.M.

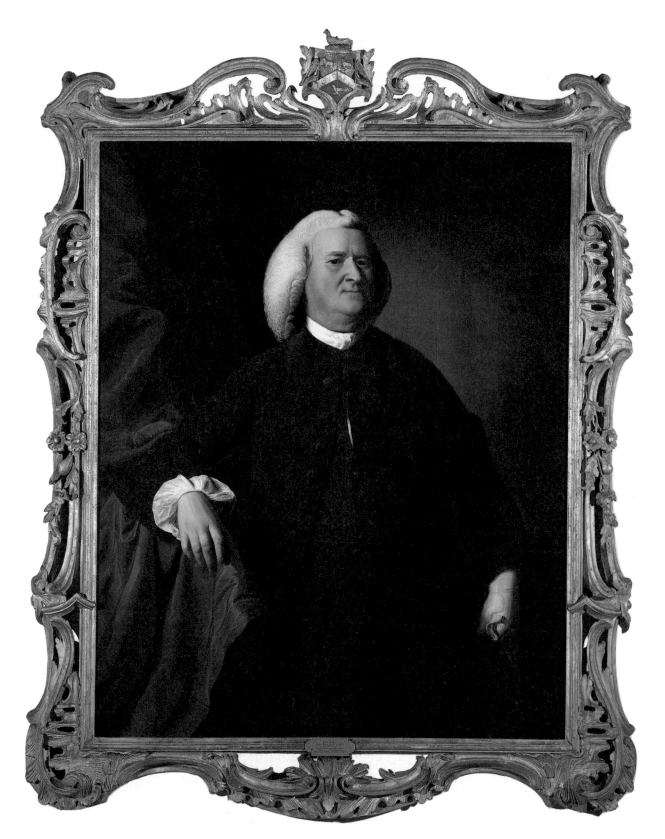

Joshua Henshaw, ca. 1770.
Oil on canvas, 50¼ × 40 in. Mildred Anna Williams Collection, 1943.4

John Singleton Copley
Boston, Massachusetts 1738–1815 London, England

John Singleton Copley's portrait of William and Leonard Vassall was the artist's first double portrait since his painting of Isaac Royall's two daughters (1758; Museum of Fine Arts, Boston). If this portrait indicates Copley's attempt to experiment with new postures and formats, perhaps it also reflects his consideration of advice offered him by Benjamin West.* Having admired Copley's *Boy with a Squirrel (Henry Pelham)* (1765; Museum of Fine Arts, Boston) in the Royal Academy's exhibition of 1766, West encouraged his countryman to send another picture to London and suggested a subject: "I advise you to Paint a Picture of a half figure or two in one Piec[e]."[1] Double portraits were then enjoying great popularity in Europe and presented a particular challenge to the aspiring artist.[2]

Copley's portrayal of father and son is animated by the painting's deep, rich colors and the extraordinary material presence of such details as the elder Vassall's shirt cuff and the dusting of wig powder about his shoulders. Despite the competence displayed, Copley nonetheless had difficulties with the double-portrait format. While the artist strove to present a natural and intimate moment of connection between the figures, there is some discontinuity, as if father and son had posed separately and were assembled later into one composition. While Leonard appeals to his father, perhaps for assistance with his book, the elder Vassall's direct outward gaze connects him much more strongly with the viewer than with his son.

The attempt to show a communion between father and son relates the portrait to a distinctly late-eighteenth-century sensibility and to the growing dominance of the Enlightenment. The educational theories of John Locke and other empiricists were gaining widespread influence by the end of the century. If, as Locke suggests, the child is born a "blank slate," and experience determines what is written on it, then instruction is essential for the development of a proper moral and intellectual standing. By attending to Leonard and his book, Vassall fulfilled a formal, societal role as well as a more intimate, paternal one.

The choice of a double portrait no doubt held personal significance for the sitters as well. After the birth of Vassall's first daughter in 1739, four sons died in infancy; his first son to live past the age of five was William, born in 1753. Leonard, born in 1764, was the fifth child and eldest son from Vassall's second marriage and no doubt a source of satisfaction to the aging man.

A Loyalist whose considerable wealth derived from family plantations in Jamaica, William Vassall (1715–1800) was born in the West Indies. His great-grandfather was one of the original patentees to Massachusetts land. Vassall's family returned to Boston sometime before 1723, and he graduated from Harvard College in 1733. John Adams referred to Vassall as "one of my old friends and clients, . . . a man of letters and virtues, without one vice that I ever knew or suspected, except garrulity."[3] Preferring the life of a gentleman, Vassall refused office when it was assigned to him, whether by the town or the king. Yet his professed neutrality went unrecognized by the revolutionary brigades. When in 1774 the Vassall family attempted to take refuge at their home in Rhode Island, they were "pelted by the Mob in Bristol, to the endangering of their Lives."[4] Lamenting "the unhappy disastrous War between two powers, to which I bore the greatest good will and for which I had the highest regard,"[5] Vassall sailed for London in 1775. He settled among a small colony of American expatriates that included Benedict Arnold. Despite several petitions, Vassall was not permitted to return to America after the war, nor was he successful with claims to recover the extensive property that he felt had been unjustly confiscated. His family portraits, however, had been placed in the custody of his friend Dr. Henry Lloyd, of Lloyd's Neck, Long Island.[6] The Copley portrait was shipped to London sometime after the Revolution, and Vassall installed it in his family estate at Oldbury Court. There it remained until it appeared at a London auction in 1972.

S.M.

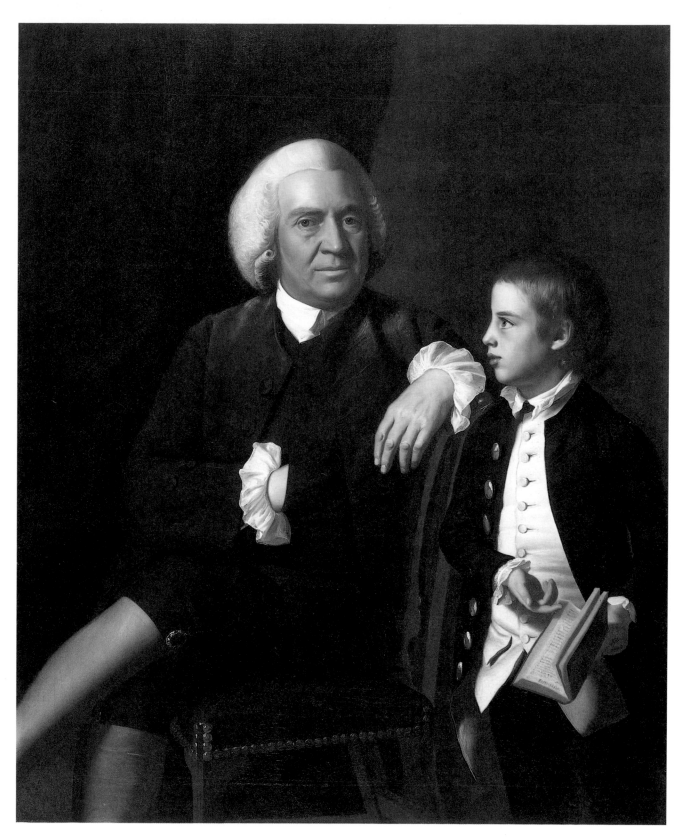

William Vassall and His Son Leonard, ca. 1770–72

Oil on canvas, 49⅞ × 40⅞ in. Gift of Mr. and Mrs. John D. Rockefeller 3rd, 1979.7.30

Benjamin West
Springfield, Pennsylvania 1738–1820 London, England

Born outside Philadelphia, Benjamin West was working as a professional portraitist there by the age of eighteen. Rather than portraits, the favored art form of American patrons, however, West aspired to paint historical and literary subjects, the most highly regarded form of art in the European academic hierarchy. With the financial assistance of a merchant acquaintance, West traveled to Italy in 1760; there he spent three years studying the art of antiquity as well as that of his contemporaries, and developed a familiarity with the stylistic conventions, philosophical framework, and iconography upon which he would later draw. In 1763 West settled in England, quickly earning a reputation for his historical pieces, becoming a founding member (and later second president) of the Royal Academy and history painter to George III. His studio was a center for aspiring American artists, to whom West offered training and encouragement throughout his life.

During his association with the king, which lasted more than a quarter century, West received many commissions for the refurbishment of Windsor Castle. One of these was the execution of nine studies for the paneled ceiling of a reception room at the Queen's Lodge.[1] *Genius Calling Forth the Fine Arts to Adorn Manufactures and Commerce* was the central scene of the commission.

As is appropriate for the theme of the work, West peopled his sketch with personifications of terrestrial and celestial sciences. On the left, a putto positions his calipers on a globe as if to measure a distance; below, a woman sits with a sextant, the mariner's means of calculating latitude and longitude, and additional putti examine what appears to be a compass. Above these figures, juxtaposed against the heavens, is the letter "H" from which hangs a disk—the astronomical symbol for the planet Uranus. The disk is the focus of the large telescope on the opposite side of the composition. Sir William Herschel, court astronomer to George III, had built a similar instrument through which in 1781 he discovered a planet he called *Georgium Sidus* (a name later changed to Uranus), in honor of his royal patron. The two moons West added to Uranus's sym-

bol may well refer to Oberon and Titania, the satellites Herschel discerned in 1787. Taken together, these groupings suggest the study of navigation, geography, and astronomy. At the center of the composition, Genius carries his torch of enlightenment. He gestures to classically robed figures carrying a palette and brushes, an Ionic column, a mallet and bas relief of George III, and recorder, summoning these personifications of painting, architecture, sculpture, and music to the aid of commerce and manufactures. Eight additional scenes, symbolically representing agriculture, manufactures, commerce, botany, chemistry, celestial science, terrestrial science, and the adornment of Britannia, were to surround *Genius Calling Forth the Fine Arts*.[2]

The late eighteenth century was for England a period of great commercial growth and global expansion. It saw as well the beginnings of the Industrial Revolution, and West believed the fine arts had an obligation to improve and promote British manufactured goods. He couched this modern concept, however, in traditional terms; the complex iconographic program and dependence on allegorical and classical allusions, even the compositional framework of the nine panels itself, look back to the ceiling design of Peter Paul Rubens (1577–1640) at London's Whitehall Palace and ultimately to sixteenth- and seventeenth-century Italian ceilings.

West himself never painted the ceiling in the Queen's Lodge. His sketches, however, were the basis of the design ultimately carried out on the ceiling in the popular new decorative technique of *marmortinto*—literally, tinted marble. The late-eighteenth-century practice of using stained marble dust, in combination with a fixative, to create decorative patterns for table centers was equally appreciated for ceiling and wall adornment.[3]

Unfortunately, the Queen's Lodge and ceiling no longer exist; with the reign of George IV and his redecorations of Windsor Castle, the structure was razed. *Genius Calling Forth the Fine Arts to Adorn Manufactures and Commerce*, however, stands as testament to one of West's few ceiling commissions, to his interest in Baroque art and important contemporary subjects, as well as to his devotion to George III, his royal patron.

J.S.

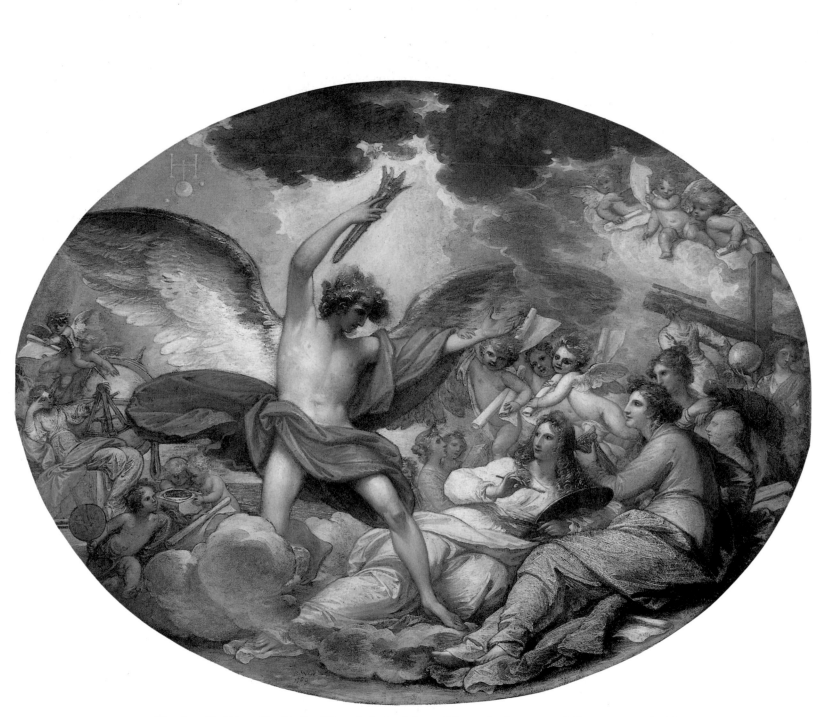

Genius Calling Forth the Fine Arts to Adorn Manufactures and Commerce, 1789
Oil on paper mounted on canvas, 19½ x 24½ in. (oval). Signed and dated lower left: *B. West / 1789*
Gift of Mr. and Mrs. John D. Rockefeller 3rd, 1979.7.104

Charles Willson Peale
Queen Anne's County, Maryland 1741–1827 Philadelphia, Pennsylvania

Charles Willson Peale was one of the most ambitious, versatile, and creative men of the early republic. Artist, naturalist, soldier, teacher, and founder of one of the country's earliest museums and its first society of professional artists, he was also the patriarch of an artistic dynasty that dominated Philadelphia through much of the nineteenth century. Apprenticed as a saddler, by 1763 he could advertise himself also as a clockmaker, silversmith, and sign painter. A group of Maryland patrons sent Peale to study art in London from 1767 to 1769. Although formally taught by his compatriot Benjamin West,* Peale's clearest lessons derived from the work of contemporary English portraitists, principally Sir Joshua Reynolds (1723–1792).

Upon his return to America, Peale established a profitable portrait practice in Maryland before moving in 1775 to Philadelphia. Serving as an officer during the Revolutionary War and familiar with its leaders, Peale later became the preeminent portraitist of the early capital. His interest in natural science came to dominate his time after 1782 and led to such activities as the exhumation of the first nearly complete mastodon skeletons in 1805.[1] Toward the end of his long life, he spent much time at his farm, Belfield, where he painted a number of intimate landscapes.

In the early 1770s, after his years in London, Peale found ready employment painting the portraits of Maryland's wealthy merchants and gentry. Among his clients was Mordecai Gist (1742/43–1792), a Baltimore merchant from a prominent family. A recent widower at the time of the portrait (he was eventually to marry three times), Gist wears a brown suit with gold filigree twined at the front and sleeve cuffs and a three-cornered hat pushed back at a jaunty angle. He is seated in an elegantly carved chair with a sea chart, brass dividers, and a volume of Euclid on the table before him. Through the window to the left is a particularly luminous seascape—a ship heading out to sea at dawn, which, while it certainly

refers to the source of his wealth, also seems to signal Gist's spirit and ambition again underway after the recent loss of his young wife.

Shortly after the portrait was painted, Gist found his greatest fame as an officer of the Revolutionary army. Devoted to the cause of liberty (he was later to name his two sons Independent and States), Gist eagerly sought an active role in the war. He wrote in a letter of 30 December 1775:

> Prompted by the regard I owe my country, I did, at the expense of my time and the hazard of my business, form a company of militia, early in December, 1774, a company composed of gentlemen, men of honor, family and fortune.... I have twice been appointed to the honor of being their commander....
>
> This consideration led me to an early and constant attention to military affairs; and allow me, sir, to assure you that I have neither spared time nor expense in the acquisition of that kind of knowledge. In private life I have ever been ambitious of being the useful citizen.[2]

It was not solely Gist's military accomplishments that compelled admiration. A young Quakeress was to write of him in 1777, "He is very pretty; a charming person; his eyes are exceptional; and he so rolls them about that mine always fall under them."[3]

Peale painted two known portraits of Gist, this one and an unusually casual and direct portrait that has descended in the sitter's family. The exact date of the San Francisco portrait is not known, although Peale records in his diary entry of 4 September 1788, "cleaned & Varnished the Portraits of Elizh. McCluer & Mr. Guest [sic], Which I painted upward 14 Yrs. past."[4]

M.S.

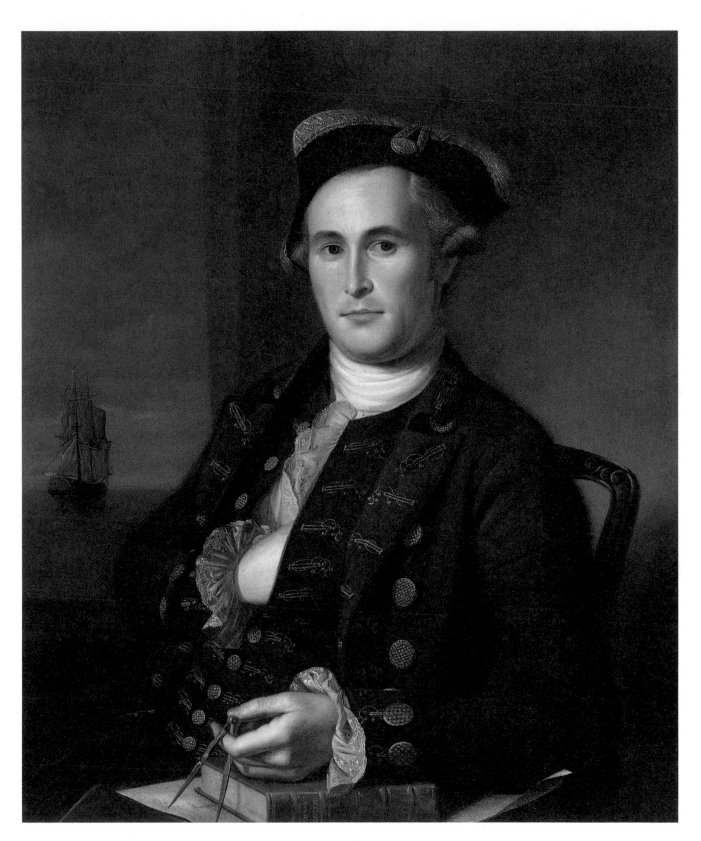

Mordecai Gist, ca. 1774

Oil on canvas, 30 x 25 in. Gift of Mr. and Mrs. John D. Rockefeller 3rd, 1979.7.79

Henry Benbridge
Philadelphia, Pennsylvania 1743–1812 (Norfolk, Virginia?)

Henry Benbridge was raised in a prosperous Philadelphia household where his stepfather, Thomas Gordon, a Scottish merchant, encouraged his interests in art. Charles Willson Peale* recalled in his autobiography that when Benbridge was about seventeen years old, he "showed his great industry in the use of his Pencil" by painting the walls, ceilings, and passages of a house belonging to his family: "The subjects were taken from prints and painted the size of life."[1] About the same time as this ambitious project, Benbridge also began to paint portraits. His efforts show the strong influence of John Wollaston (active ca. 1734–1767), an English portraitist active throughout the colonies, who had painted Thomas Gordon while working in Philadelphia in 1758.

Upon reaching the age of twenty-one, Benbridge came into an inheritance that enabled him to travel to Europe, and by 1765 he was living in Rome. He is said to have studied with the neoclassical artists Anton Raphael Mengs (1728–1779) and Pompeo Batoni (1708–1787); he certainly became acquainted with an active international community of artists, authors, and antiquarians. He moved to London late in 1769 and exhibited two works (both unlocated) in the spring exhibition at the Royal Academy, but soon thereafter he decided to return to Philadelphia. He married Hetty Sage (dates unknown), a miniature painter who had studied briefly with Charles Willson Peale, and in 1773 they moved to Charleston, South Carolina. Benbridge's career flourished in South Carolina. Though successful, he was an uneven painter, remembered by a contemporary as "a promising young man, [who] did not realize much."[2] Probably due to failing health, Benbridge painted very little after 1790. Around 1800 he moved to Norfolk, Virginia, and spent his remaining years in the home of his son.

The work that launched Benbridge's career was the monumental portrait of Corsican patriot Pascal Paoli (1725–1807). Paoli, successful leader of the 1755 Corsican revolt against Genoa, governed the island under enlightened rule until 1768, when Genoa ceded the island to France. The French army defeated the Corsicans in 1769, and Paoli escaped to England. Meanwhile, the cause of Corsican independence was taken up by cultivated Europeans, none more so than Scottish biographer and journalist James Boswell. Boswell had visited Corsica in 1765 at the end of his grand tour of Italy. He sought out Paoli and developed a long-standing and enthusiastic admiration. Upon returning to England, Boswell trumpeted the Corsican general as a model of virtue, heroism, and magnanimous statesmanship, beginning with his 1768 *An Account of Corsica . . . and Memoirs of Pascal Paoli*. In his journal, Boswell recalled a conversation in which Paoli replied to his question "in one line of Virgil. . . . This, uttered with the fine open Italian pronunciation and the graceful dignity of his manner, was very noble. I wished to

have a statue of him taken at that moment."[3] Instead, at the height of renewed crisis in Corsica, he commissioned from England a painted portrait of Paoli.[4] How he found and selected Henry Benbridge is not known; but by June 1768, Sir John Dick, the English consul at Leghorn, was assuring Boswell that he had "carefully forwarded your letters to Mr. Bambridge [*sic*]."[5]

Benbridge's portrait was heralded upon its arrival in London in May 1769:

> There is just arrived in London a portrait of the illustrious Chief Paoli, painted for Mr. Boswell of Auchinleck. Mr. Boswell sent for this purpose to Corsica last Summer Mr. Bambridge [*sic*], a young American Artist, who had finished his studies in Italy, and amidst all the fatigues and dangers of war, his Excellency was pleased to sit, to indulge the earnest desire of his ever zealous friend. . . . The Painter has taken great pains, and has finished the face in a very masterly manner.[6]

The portrait went on view at the Free Society of Artists, displayed near a collection box for contributions to the Corsican refugees. The exhibition drew crowds, including the royal family, and the portrait was almost immediately published as a mezzotint engraving. Yet the mezzotint at least met some disapproval, as Boswell learned from a friend in Dublin:

> People here like the Countenance very well but say the Painter has shewn no Taste in the Attitude or the Air of the Figure. I have met with some artists here that know Benbridge, they tell me he has a talent for taking an exact Resemblance, but has no other Excellence.[7]

Benbridge no doubt painted what he saw, and he was surely aware of the scrutiny with which his portrait would be received in the London community. Accordingly, his efforts were cast in the international grand-manner style of Batoni and Sir Joshua Reynolds (1723–1792). The general's imposing form is structured within a standard pose, one leg flexed to provide a relaxed *contrapposto* stance, one arm akimbo, the other outstretched and holding a baton.[8] The rocky landscape and distant shoreline suggest the rough terrain of Corsica. Benbridge's palette is rich but somber in its greens and golds; the softened contours and extensive use of glazes suggest the manner of Reynolds as well as the more immediate inspiration of Batoni.

After its exhibition in London, the Paoli portrait was transported to Auchinleck, the Boswell family home in Ayrshire, Scotland, where it remained until 1974.

S.M.

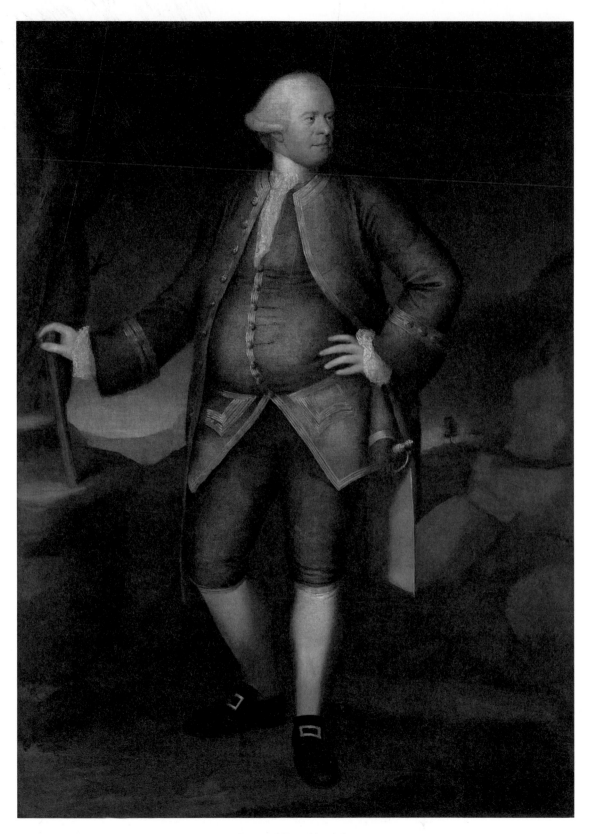

Pascal Paoli, 1768
Oil on canvas, 81⅝ × 58¼ in. Gift of Mr. and Mrs. John D. Rockefeller 3rd, 1979.7.8

James Peale
Queen Anne's County, Maryland 1749–1831 Philadelphia, Pennsylvania

James Peale was apprenticed as a saddler, carpenter, and cabinetmaker before he studied art while making frames for the paintings of his eldest brother, Charles Willson Peale.* After serving as officers with the Continental army, the two brothers entered into a portrait-painting partnership that divided their energies with characteristic pragmatism. Charles Willson Peale described the arrangement in a letter of 22 October 1786:

> James is well and I hope going into a hurry of business. I have left of[f] painting in miniature, lowered my price in the large portraits in order to fill up that spare time which would have been spent in the other branch, and James paints miniatures at 3 guineas each.[1]

While James Peale also painted portraits, landscapes, and paintings of contemporary history over the course of his long career, the artist found his greatest success late in life when, in his seventies and suffering from poor health and failing eyesight, he began a series of still-life paintings showing abundant piles of fruits and, less frequently, vegetables.

Peale, along with his nephew Raphaelle (1774–1825), was one of the first Americans to practice pure still-life painting.[2] Although still-life elements were standard in numerous eighteenth- and early-nineteenth-century portraits, the basic format of the Peales' late works was derived from seventeenth-century Dutch examples of edibles and vessels on a shallow ledge. Beneath an even, diffuse light cast from the left, Peale has given *Still Life with Fruit*, depicted at life size, a carefully wrought illusion of reality. A white porcelain fretwork bowl holds ripe peaches and green grapes, while pears, apples, three varieties of grapes, and, to the far right, yet another peach spread across the breadth of the painting in restrained profusion. The artist's concern with distinguishing textures evokes a tactile as well as a visual sense of this rich bounty. One of three closely related paintings,[3] *Still Life with Fruit* is a particularly elegant example of Peale's earliest still-life work.

More than any other subject, still-life painting afforded the early-nineteenth-century artist thorough control of his work. Independent of likeness of either face or locale, the painter could select, arrange, and portray his subject with virtually no concern but to please his eye and to hone his technique. It is this passivity of subject that allows the painting to reflect in its choice of objects and its formal order the values common to the artist's time. Thus Peale's depiction of imported porcelain and bounteous fruits provides an optimistic paean to American trade and agriculture. Simultaneously, the gentle play of curves that echoes across the picture and the concentration on elegant surfaces imbue the image with balance, clarity, and synthetic unity.[4]

M.S.

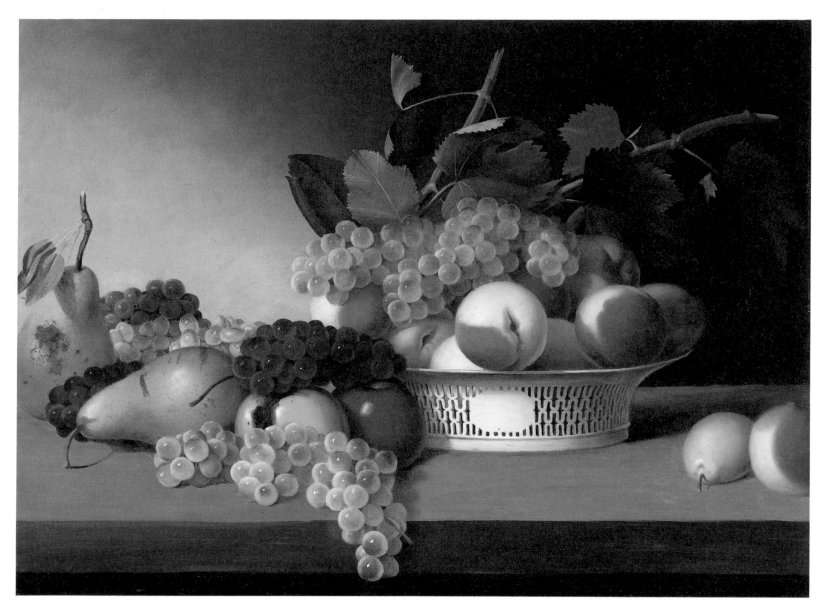

Still Life with Fruit, ca. 1821
Oil on panel, 18¼ × 25¾ in. Museum purchase, 46.11

Gilbert Stuart
North Kingston, Rhode Island 1755–1828 Boston, Massachusetts

We consider the late Gilbert Stuart to have been the "*Father of American portraiture*," supereminently endowed with genius as a painter, and particularly gifted with the power of hand which so admirably counterfeited life upon the canvas, one whose pencil was as the wand of a magician, matchless and beautiful.

Gilbert Stuart's fame was such that he was thus lauded in the newspapers on his death.[1] Even today, a century and a half later, the portraits painted by this son of a Rhode Island snuff miller remain among the most vivid and best-known documents of his era.

Stuart received his first lessons in art from Cosmo Alexander (ca. 1724–ca. 1772), a Scottish portrait painter who, in 1771, took the young man to South Carolina and elsewhere in the colonies as his assistant. Together the two men went to Scotland. Upon the sudden death of his mentor, Stuart made his way back to the colonies as a sailor. In 1775 Stuart sailed for England. Two years later, unable to support himself with his painting, Stuart entered the studio of his compatriot Benjamin West,* becoming one of his many assistants.

During his five years with West, the history painter for George III, Stuart mastered the craft of painting by working on many of West's large history paintings and state portraits. By the 1780s Stuart was himself receiving commissions from fashionable London patrons. Living well beyond his means, in 1787 Stuart escaped his creditors by moving to Ireland. In 1792 he returned to America for good. He was immediately popular as a portraitist and traveled between New York, Philadelphia, and Washington, D.C., the changing capital cities of the new republic. He painted portraits of presidents, statesmen, and well-established families before settling in Boston. Thus, Stuart completed his career as what might be called the court painter to the youthful nation.[2]

Josiah Quincy (1772–1864) descended from a family of Massachusetts merchants, councilors, and judges. He graduated from Phillips Academy, Andover, and from Harvard College. After serving as a U.S. congressman, Massachusetts state senator and representative, and judge of Boston's municipal court, he was elected mayor of Boston from 1823 to 1828. During that time Quincy became known for his important reforms in the area of public health: he ordered the streets of Boston to be thoroughly cleaned, forbade burials in crowded city areas, and had installed a municipal water-supply system. Furthermore, he had a large market facility constructed across from Faneuil Hall; Quincy Market still stands today as a monument to his mayoralty. Also a writer, historian, and abolitionist, Quincy ended his long public career as president of Harvard University from 1829 through 1845. According to one of Quincy's friends, he was

an upright magistrate, an eloquent senator, a fearless champion of the Right, a man of the world, a man of letters and a sage, with a noble presence from youth onwards,—what better type could those of us who are proud of America, and who believe in America, possibly imagine?[3]

In this portrait, Quincy sits comfortably, looking up from his reading, self-confident, pleasantly smiling at the viewer. Quincy was well familiar with Stuart and his techniques: the artist ultimately painted likenesses of Quincy's wife (1806; John Howard Joynt Collection, Washington, D.C., pendant to the San Francisco panel); his father (1825; location unknown); and a second portrait of the famous Bostonian himself (1824; Museum of Fine Arts, Boston). Given this firsthand experience with Stuart and the pleasingly approachable demeanor that Stuart evokes in his painting of Quincy, the sitter's description of the artist's working method is believable:

It was his habit to throw his subject off his guard, and then by his wonderful powers of conversation he would call up different emotions in the face he was studying. He chose the best, or that which he thought most characteristic, and with the skill of genius used it to animate the picture.[4]

Unlike earlier American portraitists who carefully blended their brushstrokes to create a smooth and highly finished surface, Stuart adopted the tactile, broken application of paint recently made fashionable in England by Thomas Gainsborough (1727–1788) and Henry Raeburn (1756–1823). Stuart's shimmering handling of the paint, his focus on Quincy's face without any distracting props or background, and the restricted colors of this work—deep olive, black, and reddish tones—define and construct the portrait's visual richness. Through his careful orchestration of color, texture, and pose, Stuart has, in the words of his fellow artist Washington Allston,* "seemed to dive into the thoughts of men, for they were made to live and speak on the surface."[5]

J.S.

Josiah Quincy, 1806
Oil on panel, 30¼ × 24½ in. Memorial gift from Dr. T. Edward and Tullah Hanley, Bradford, Pennsylvania, 69.30.195

Gilbert Stuart
North Kingston, Rhode Island 1755–1828 Boston, Massachusetts

To the near exclusion of other types of painting, in the early nineteenth century Americans commissioned portraits of themselves and their families. Not only recording likeness, these portraits also indicated respect for an individual and his achievements. Commissions for these works came from all levels of society and went to artists of diverse skill and ambition. For the most powerful and the most fashionable, the artist of choice was Gilbert Stuart.

Among the many prominent people from Massachusetts who sat for Stuart were William Gray, one of the first New England merchants to trade with Russia, India, and China and a lieutenant governor of Massachusetts; his wife; and their eldest son, William Rufus Gray (1783–1831).[1] A graduate of Harvard College and the Boston agent for his merchant father, the younger William Gray added Rufus to his name by an act of legislature in 1802, a decision traditionally said to be a whimsical reference to the color of his hair.

In Stuart's portrait of him, William Rufus Gray sits at his slant-top desk holding a letter, gazing out and engaging the attention of the viewer; his glance, gesture, and carriage animate the portrait image. The nineteenth-century American art critic Henry Tuckerman may have best described such visual vitality:

There is a living, fresh reality about [Stuart's portraits] which captivates or impresses the spectator with an almost magnetic attraction and human individuality. We seem to know the person represented, and to feel an actual presence and character, as if somewhat of the will and experience, the sympathies and traits of the original, had been vitally communicated to pigment and outline.[2]

To a student in 1817, Stuart offered other explanations for the naturalism and energy of his portraits: "Load your brush, but keep your tints as separate as you can. No blending; it is destructive to clear and beautiful effect."[3] Stuart later enlarged this thought by explaining to a patron, "Good flesh coloring [partakes] of all colors, not mixed, so as to be combined in one tint, but shining through each other, like the blood through the natural skin."[4] In his portrait of William Rufus Gray, Stuart builds forms with deft strokes of different colored pigment, enlivening the surface of the painting and suggesting the translucence of flesh, the different textures of fabrics, even the palpability of the atmosphere. Stuart has created an appealing portrait of a young merchant at the threshold of his business career.

J.S.

William Rufus Gray, ca. 1807
Oil on canvas mounted on hardboard, 33¼ × 27 in. Gift of Osgood Hooker, 1964.114

John Trumbull
Lebanon, Connecticut 1756–1843 New York, New York

Best known for his depictions of the seminal events of the founding of America, John Trumbull was the first college-trained professional painter in America. Against the wishes of his father, a distinguished governor of Connecticut, he studied to become an artist. At the beginning of his career, during an enforced tenure at Harvard, Trumbull rented the old Boston studio of John Smibert,* complete with the master's collection of engraved copies and sculptures, and became familiar with the portraits of John Singleton Copley.* After serving as aide-de-camp to General Washington during the Revolutionary War, Trumbull crossed the Atlantic to study in London with Benjamin West.* A few months later, in retaliation for the American execution of John André, British negotiator with the treasonous Benedict Arnold, the British arrested Trumbull as a spy and released him on the sole condition that he leave England. Only after more amicable relations were established between the two nations in 1784 was Trumbull able to return to London, resume his studies with West, and begin a series of large historical subjects.

Trumbull spent the bulk of his remaining years in New York City, painting portraits, completing numerous battle scenes and other subjects drawn from the early years of the new nation, and acting as irascible president of the American Academy of Fine Arts. Perhaps Trumbull's greatest moment came in 1817 when, by act of Congress, he received the commission to execute four elaborate historical subjects to ornament the rotunda dome of the U.S. Capitol in Washington, D.C. Finally, in 1831, Trumbull accepted a pension from Yale University in exchange for his collection of paintings. The gallery in which these works appeared was one of the first public art museums in the United States.

In 1777 Trumbull first became acquainted with Philip Church's father, then known under his nom de guerre as John Carter, who audited and settled Trumbull's military accounts. The two met again in 1784 in London, when Carter resumed the friendship under the name of John Barker Church. After his years as a revolutionary, Church had returned to England; as a wealthy merchant and member of Parliament, he helped finance Trumbull's studies and English career. In 1784 Trumbull painted for his benefactor a "small whole length of Philip Church" and a "copy of the above—smaller" (the San Francisco painting, which was sent to Church's maternal grandparents, the Schuyler family of New York).[1] Trumbull posed the boy with military toys—a drum, gun, and feathered hat—attributes of childhood and masculinity.[2]

The two portraits of Philip Church mark a milestone in the development of Trumbull's style. Executing these works during his early years in London, Trumbull used a brushstroke markedly more fluid than was typical of his earlier American pieces. According to tradition, Sir Joshua Reynolds (1723–1792), the leading British portraitist of the time, upon seeing another Trumbull likeness had exclaimed "in a quick sharp tone, 'that coat is bad, sir, very bad; it is not cloth—it is tin, bent tin.'"[3] Not one to ignore criticism from such an important source, Trumbull took to heart Reynolds's comments about the hardness of his technique[4] and adopted the freer and softer stroke that is readily apparent in Church's clothing, hair, and flesh.

Philip Church (1778–1861) received his education at Eton before moving to the United States. He served with his uncle Alexander Hamilton in suppressing the Whiskey Rebellion—the Pennsylvanian farmers' revolt against a 1791 excise tax on liquor—and came to the favorable attention of George Washington. Washington later wrote to Philip Church's grandparents:

> Your grandson has all the exterior of a fine young man and from what I have heard of his intellect and principles will do justice to and reward the precepts he has received from yourself, his parents and Uncle Hamilton. So far then as my attentions to him will go, consistent with my duties, he may assuredly count upon.[5]

When Church later married, Washington gave the bride away.[6]

J.S.

Philip Church, 1784
Oil on canvas, 18⅛ × 14 in. Gift of Mr. and Mrs. John D. Rockefeller 3rd, 1979.7.97

Joseph Wright
Bordentown, New Jersey 1756–1793 Philadelphia, Pennsylvania

After attending school from 1768 to 1771 in Philadelphia, where he showed little if any inclination toward a career in art, Joseph Wright traveled to London in 1773, following his colorful and somewhat eccentric mother who had moved there the previous year. A successful modeler of wax likenesses, Patience Lovell Wright (1725–1786) found in London both an audience for her waxworks and notoriety for her outspoken support of the American colonies.[1] Mrs. Wright knew most of the American community in London at the time, so her son may have visited the studio of Benjamin West* for advice. He was admitted to the Royal Academy's school in 1775, becoming its first American student.

In 1781 Wright traveled to Paris, where he secured a coveted commission to paint the portrait of his mother's friend Benjamin Franklin. Mrs. Wright discouraged her son's plans to pursue further study in Italy, urging him to paint not the Old Masters of Europe but rather the new heroes of America.[2] Bearing letters of introduction from Franklin, Wright returned to Philadelphia in 1783 and joined such artists as Charles Willson Peale* and John Trumbull* in the competition for portrait commissions—and the chance of capturing the best likeness—of George Washington. Apparently following the nation's newly formed government, Wright moved to New York in 1786 and returned to Philadelphia in 1790. Wright is said to have given instruction in modeling to William Rush (1756–1833), America's first sculptor of note; he also began engraving dies for the striking of medals and coins. What might have been a promising career and a secure post as the official engraver to the newly established United States Mint came to an abrupt and untimely end in 1793 when Wright fell victim to one of Philadelphia's worst epidemics of yellow fever.

Soon after his return to Philadelphia in 1783, Wright painted the portrait of John Coats Browne (1774–1832), to whom he was distantly related.[3] Son of Mary Coats and Peter Browne, a Philadelphia ironmonger who renounced his Quaker upbringing to bear arms in the American Revolution, Browne graduated from the University of Pennsylvania in 1793. He joined his father's blacksmith shop and specialized in furnishing ironwork for ships. In 1800 he married Hannah Lloyd, whose own membership in the Society of Friends was renounced upon her "marrying out" of the Quakers. Eventually Browne was appointed the first president of the Kensington Bank and held many additional civic posts of prestige and honor.[4]

Wright painted Browne when the sitter was about ten, still a student at Philadelphia's Episcopal Academy. Accompanied only by a column and an enormous silk drapery, Browne stands nearly life-sized, posed with his feet set at a right angle, his left arm akimbo, his right hand holding a plumed hat. Wright chose a specific model for this posture: Thomas Gainsborough's (1727–1788) portrait of another ironmonger's son, Jonathan Buttall, better known as *Blue Boy* (1770; Henry E. Huntington Library and Art Gallery, San Marino, California).[5] Although Wright mimics Gainsborough's composition, he does not place Browne within a verdant landscape or under tempestuous skies. Nor does Wright invoke the English artist's flickering brushwork and adventurous colorism. In keeping with the more contained, man-made setting, the mood is subdued, serious, and reflective of Wright's recent visit to Paris and exposure to the neoclassicism of French artists, including Jacques-Louis David (1748–1825).

By invoking Gainsborough and updating the style, Wright bestowed upon his American sitter all the sophistication and grandeur of contemporary continental portraiture. Despite the grand-manner setting, there remains something simple and unaffected in Wright's portrait. Browne strikes a commanding pose, but his form hardly has the bulk to command the picture space. His soft, almost wistful gaze dispels some of the impact of his forward-thrust hip. Even the color scheme, though bold for Wright in the way it pits a rusty orange against blue and red, is softened by the thin application of paint, the central placement of the pastel blue, and the expanse of muted background tones. One senses that Wright, however conscious of his grand European quotation, was no less aware of the reality present before him—an American boy, ten years of age.

S.M.

John Coats Browne, ca. 1784
Oil on canvas, 61¾ × 43¼ in. Gift of Mr. and Mrs. John D. Rockefeller 3rd, 1979.7.107

James Earl

Paxton, Massachusetts 1761–1796 Charleston, South Carolina

For nearly a century and a half, James Earl's winning and genial works were frequently attributed to his elder and better-known brother, Ralph (1751–1801).[1] Aside from the facts of his birth and death, little is known of his biography even now. He seems to have traveled to England in 1784, just before the Loyalist Ralph returned to the United States, and may have studied there under Benjamin West.*[2] In 1787 he began to show portraits at the Royal Academy, where he was to exhibit annually until his death, and in 1789, two years later, he enrolled at the Royal Academy school.

Earl returned to America in 1794. Although his only documented stay was one of nearly two years in Charleston, South Carolina, the identities of his sitters indicate that he was earlier active throughout New England. Reportedly on the eve of his scheduled departure to rejoin his family in London, Earl died during one of the yellow-fever epidemics that swept through Charleston. The fullest biographical and critical record of Earl in the eighteenth century was the obituary published two days later in the *South Carolina State Gazette and Timothy and Mason's Advertiser* of 20 August 1796:

> Died, on Thursday, the 18th instant, Mr. JAMES EARL, Portrait Painter, of Paxton, Massachusetts. This gentleman has resided for nearly two years in this city, in which time he has exhibited so many specimens of his art as to enable us to speak with decision of his talents. To an uncommon facility in hitting of the likeness, may be added a peculiarity in his execution of drapery, and, which ever has been esteemed in his art the NE PLUS ULTRA, of giving life to the eye, and expression of every feature.

He was a Royal Academician in London, where he resided ten years and where his wife and children are; and his name appeared equally prominent with the other American geniuses of the present time, Copeley, West, Trumbull, Savage.

As a man, he must be regreted as possessing a suavity of disposition, benevolence, and good humor. As a husband, a father, we attempt not to reach his merits![3]

Earl's portrait of Elizabeth Rodman Rogers (1760–1848) testifies to his ability to give "life to the eye" and "expression [to] every feature." Daughter of a prominent Newport family and wife of a distinguished Providence attorney, Mrs. Rogers leans casually forward, her chin resting on her hand, and wears a pleasant, engaging expression. The upholstered lolling chair, velvet background drapery, and detailed paneling evoke a rich and substantial setting for the sitter, emphasizing by contrast her informal costume and pose. Earl uses this contrast to create a vivid, apparently spontaneous moment of reality, in which Mrs. Rogers glances up from her book, finger still holding her place, as if a friend or family member had just entered her chamber. The fashionable effect of intimacy is extremely close to the practice of the British artists Sir Joshua Reynolds (1723–1792) and Allan Ramsay (1713–1784).

Earl's handling of paint in this portrait is particularly fluent. Mrs. Rogers's cap, kerchief, and sash are effectively summarized with thick, continuous strokes of creamy paint, while the strands of her lightly grizzled hair contrast with the lustrous material of her gown. *Mrs. John Rogers*, a painting in which formal and illusionistic qualities give equal pleasure, prompts severe regret at the early death of the artist.

M.S.

Mrs. John Rogers (Elizabeth Rodman Rogers), ca. 1795
Oil on canvas, 34⅞ × 28⅞ in. Gift of Mr. and Mrs. John D. Rockefeller 3rd, 1979.7.38

Robert Salmon
Whitehaven, Cumberland, England 1775–1848/51 (place unknown)

Writing in 1867 of Robert Salmon, the biographer and art critic Henry Tuckerman reported: "This painter's name was once quite familiar to the Bostonians.... He was one of the earliest marine painters of reputation in Massachusetts."[1] Salmon was active as a marine painter throughout England and Scotland from 1800 through 1828, principally in Liverpool and Greenock, Scotland. During a fourteen-year stay in Boston, from 1828 through 1842, Salmon established himself as the foremost marine artist in America and laid down the traditions that would govern the field for the next century. Aside from two paintings of Italian scenes, signed and dated 1845, no documents have been located that relate to Salmon's life and work after his 1842 return to Europe; the date and place of his death are likewise unknown.

British Merchantman in the River Mersey off Liverpool, although a relatively early work, exhibits all the qualities of great marine painting that established the reputation of the British artist during his years in America—clear delineation of naval architecture, a vivid decorative sensibility for both design and color, and the ability to suggest convincing effects of light and atmosphere. Laboring with a miniaturist's technique on the large canvas, Salmon has captured each line and figure aboard the principal ship and has accurately transcribed Liverpool's skyline. But as with the equally specific works of the great seventeenth-century Dutch and Italian marine painters or those of his admired compatriot J. M. W. Turner (1775–1851),[2] Salmon has here subsumed this close detail within an atmospheric whole. He accomplishes this both by the generally gray-toned palette, suggestive of the icy chill of an ocean port on an overcast day, and by his consistently smooth brushwork. The larger patterns of light and shade that break across the waters of the harbor, as clear sunshine bursts through the clouds at the right, also mitigate the effect of what Tuckerman called the artist's greatest defect, "the treatment of the water ... as a succession of short, choppy waves."

It was again Tuckerman who described the artist as "a very eccentric man, [who] lived for years in a little hut on one of the wharves in Boston, studying the subjects he most loved."[3] While Salmon's chosen studio and living quarters were indeed not in town but over a boatbuilder's shop on the Marine Railway Wharf at the foot of Commercial Street, he appears nonetheless to have been a social, methodical, and down-to-earth individual. One element of his method was the use of a daybook that he began in 1806, upon his arrival in Liverpool, and that he continued through 1840 when he held, as the *Boston Daily Advertiser* of 11 July announced, "the last sale he will have of small paintings, his physician having forbidden him to paint any small work."[4] In this daybook Salmon recorded nearly one thousand works, for many of them giving title, dimensions, buyer, price, and the amount of time each took to paint. Unfortunately, the only known transcription of this list, in the collection of the Boston Public Library, includes a mere summary for the years 1806 to 1828, and the painting *British Merchantman in the River Mersey off Liverpool* cannot be distinguished in it.

M.S.

British Merchantman in the River Mersey off Liverpool, 1809

Oil on canvas, 27⅞ × 50⅜ in. Signed with initials and dated lower right: *R. S 1809.* Gift of Mr. and Mrs. John D. Rockefeller 3rd, 1979.7.89

John Vanderlyn
Kingston, New York 1775–1852 Kingston, New York

John Vanderlyn was the grandson of the colonial American limner Pieter Vanderlyn (ca. 1687–1778). Showing a precocious talent for drawing, Vanderlyn apprenticed with an art dealer and studied at the Columbian Academy of Painting in New York, becoming a protégé of Aaron Burr.[1] Perhaps through Burr's intervention, in 1796 Vanderlyn worked briefly in Philadelphia with Gilbert Stuart.* Later that same year Burr sent Vanderlyn to study in Europe. Unlike most American art students of his era, Vanderlyn went to Paris rather than London for his training.

Studying for five years under François-André Vincent (1746–1816), Vanderlyn followed the example of Jacques-Louis David (1748–1825) and other neoclassical artists in painting morally instructive subjects frequently based on classical themes, honing a highly finished, smooth-surfaced technique. After a two-year sojourn in the United States (1801–3), Vanderlyn returned to Europe where he concentrated on the creation of ambitious history paintings. Among these, his most notable work was *Caius Marius amid the Ruins of Carthage*, painted in 1807 when he was living in Rome.[2] It was an immediate success: "It affords me infinite pleasure & Satisfaction that I can tell you that my picture meet [*sic*] with great approbation and applause in *Rome*,—indeed it exceeded my expectation to me for the many sacrifices I have made."[3]

The painting was to bring Vanderlyn even greater satisfaction. In 1808 he moved to Paris and entered the canvas at the annual Salon. Of the over twelve hundred works on exhibition, Vanderlyn's received a Gold Medal and specific praise from Napoleon Bonaparte. According to tradition, the French leader wished to purchase the masterpiece for the Louvre.[4]

Vanderlyn derived his depiction of Marius from Plutarch's *Parallel Lives*, a series of biographical essays on great Greeks and Romans. A military leader who was elected Roman consul six times, Marius fell from power during the political turbulence of the second century B.C. Defying his banishment, he fled to the North African coast, where he hoped to gather troops. On his arrival at the Libyan city of Carthage, however, an official instructed him that the Governor Sextilius "forbids thee . . . to set foot in Africa; and if you disobey him, he says that he will uphold the decrees of the senate and treat you as a public enemy." Marius responded, "Tell him that you have seen Caius Marius sitting as a fugitive among the ruins of Carthage."[5]

Vanderlyn shows the brooding Marius alone, barefoot, holding his sheathed sword while his helmet lies on the fallen stones beside him. The seated pose, one leg extended, is a free variation on the antique *Ludovisi Mars* (Museo Nazionale, Rome). To evoke the fallen glories of Carthage in the painting's background, Vanderlyn conflates the Claudian aqueduct and other ruins from the Roman Campagna with a temple facade, perhaps adapted from the Temple of Poseidon at Paestum. While Marius's massive body, painted at well over life size, twists to confront the viewer, and dark clouds billow in the distance, the scene is preternaturally still—as if the intensity of Marius's thoughts has imposed a quiet on the world around him. As Vanderlyn wrote: "I thought the man and the position combined, was capable of showing in two great instances the instability of human grandeur—a city in ruins and a fallen general. I endeavoured to express in the countenance of Marius the bitterness of disappointed ambitions mixed with the meditation of revenge."[6]

In 1815 Vanderlyn returned to the United States, bringing with him *Caius Marius amid the Ruins of Carthage* and other historical canvases, seeking to foster history painting in the republic. Although he exhibited his works extensively from New York to Havana, Vanderlyn was unable to generate further commissions for history paintings or even to find purchasers for the already finished works. Only in 1837, with the commission for the *Landing of Columbus* (Capitol Rotunda, Washington, D.C.), did he find the partial fruition of his great ambition.

Vanderlyn sold *Caius Marius amid the Ruins of Carthage* in 1834 to his friend Leonard Kip of New York. The painting has been in California collections since the mid-1850s when it came West with the household goods of Kip's son, Canon William Ingraham Kip, later the first bishop of the Protestant Episcopal Church in California.

<div align="right">M.S. / J.S.</div>

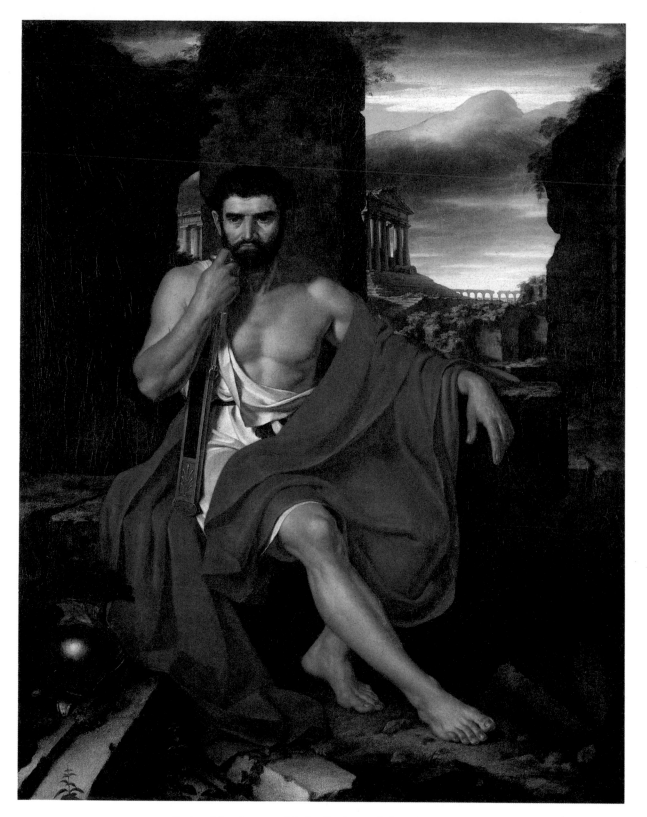

Caius Marius amid the Ruins of Carthage, 1807
Oil on canvas, 87 × 68½ in. Signed, dated, and inscribed lower right: *J. Vanderlyn, / Roma / 1807*
Gift of M. H. de Young, 49835

Washington Allston

Georgetown County, South Carolina 1779–1843 Cambridge, Massachusetts

Painter, poet, novelist, and art theorist, Washington Allston introduced the heightened emotions of romanticism to the fine arts of America, inspiring an artistic tradition that continued through the nineteenth century. Allston began his career in London in 1801, soon after graduating from Harvard College as class poet. He spent two years at the Royal Academy and studied painting as a pupil of Benjamin West.* He settled in 1804 in Rome, where he impressed the artistic community with his pastoral landscapes and earned the appellation the "American Titian," a reference to his mastery of glazing techniques reminiscent of those developed by the sixteenth-century Venetian artist. During a second sojourn in England from 1811 to 1818, he executed several dramatic canvases. British artists as well as the general public recognized Allston as a major force in the highly regarded field of history painting; on his final departure for the United States, they honored him by electing him an associate of the Royal Academy.

A member of the Carolina aristocracy, good friend to the writers Washington Irving and Samuel Taylor Coleridge, a respected poet, international cosmopolite, and member of the leading British artists' society, Allston arrived in Boston in 1818 at the pinnacle of his career to wide acclaim. C. C. Felton, president of Harvard College, summed up the young nation's appreciation by stating that Americans felt "no small pride in Mr. Allston's genius and fame. It is part and parcel, and no small part, of our national reputation."[1] Allston spent the remaining years of his life in Boston, on the one hand, cursed by his inability to complete his final masterpiece, *Belshazzar's Feast* (begun 1817; Detroit Institute of Arts), and on the other, rendering scenes of gentle reverie and quiet sentiment. The year he died Allston received perhaps his greatest accolade: the 1843 edition of *The Poets and Poetry of America* was dedicated to him, "the

eldest of the living poets of America, and the most illustrious of her painters."[2]

During his second stay in England, Allston fell seriously ill. On the advice of his London physician, Allston went to Bristol in 1813, hoping the change in air would cure him. Treated there by Dr. John King (1766–1846), the American painter recovered from his illness. The following year, while visiting Bristol a second time and making arrangements there for a one-man exhibition (among the first for a living American painter), Allston executed the portrait of Dr. King and presented the work to him.[3]

Dr. King was a highly respected Swiss-born surgeon who lived in Clifton, a suburb of Bristol. Allston commemorates his friend not as a great surgeon, however, but as an artist. Instead of a scalpel and medical treatise, Dr. King grips a watercolor brush in one hand and touches with the other what must be sketchbooks. Prior to his medical practice in Bristol, Dr. King had studied engraving and worked as a professional artist in London; even after his change in career, Dr. King maintained strong ties with the Bristol artistic community as an amateur painter, art critic, and art patron. It is known that he possessed in his collection a second work by his noted patient.[4] The implements in Dr. King's hands, then, become appropriate attributes of his avocation, if not of his vocation.

Allston presents Dr. King in three-quarter length, sitting quietly, looking into a bright light. Holding the symbols of his hobby only idly, with his face averted, Dr. King is caught in a moment of focused introspection. The viewer, not privy to the object of King's thoughts yet compelled by the dramatic intensity of his gaze, is carried into the psychological energy of the scene. Believing that truth to feeling and man's inner life was of utmost importance, Allston deemed *Dr. John King* one of his two best portraits.[5]

J.S.

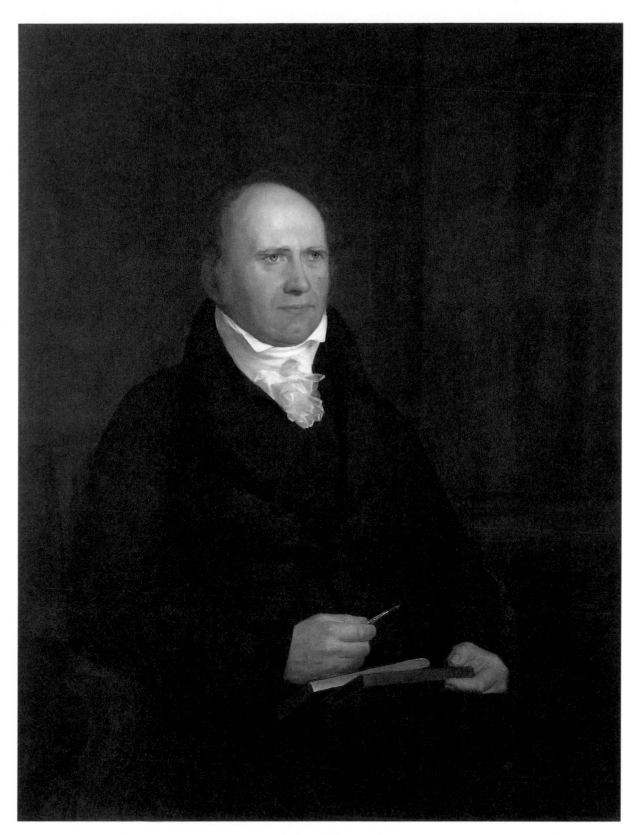

Dr. John King, 1814
Oil on canvas, 44½ × 34 in. Gift of Mr. and Mrs. John D. Rockefeller 3rd, 1979.7.2

Thomas Birch
Warwickshire, England 1779–1851 Philadelphia, Pennsylvania

Today, as in his own time, Thomas Birch is remembered primarily as a painter of marine subjects and seascapes. His fellow artist John Neagle (1796–1865) proclaimed that Birch's "forte was the roaring 'briny deep.'"[1] However, Birch also made a significant contribution to the development of landscape painting in America.

His father, William Birch (1755–1834), a successful engraver and miniature painter in England, brought his family to America in 1794 and settled northeast of Philadelphia. Father and son collaborated on a series of engraved views of Philadelphia, published as a set in 1800. In the same year, the younger Birch set up his own practice in Philadelphia, taking profile likenesses and painting portraits. His interest in painting landscapes is said to date from a trip to the Cape of Delaware in 1807;[2] around this same year, Birch began to paint "estate portraits"—more or less topographical views of country manors and their grounds.[3] The War of 1812 provided a boost to Birch's career, while confirming his talents as a marine painter. His scenes of battle between British and American ships, full of accurate detail and patriotic fervor, became tremendously popular, and Birch painted many replicas of his most successful views. After the 1820s he focused more on general scenes along the coasts and around the harbors of Philadelphia and New York. At the same time he essayed a number of winter landscapes and romantic scenes of shipwrecks and tempests inspired by the French painter Claude-Joseph Vernet (1714–1789). Although Birch painted a number of scenes depicting foreign ports and shores, no European trip by Birch has been recorded,[4] and it is likely that such works were adapted from paintings or engravings by other artists. Birch was active in the artistic community of Philadelphia, serving as both a founder and later the keeper of the Pennsylvania Academy of the Fine Arts. The National Academy of Design in New York elected him an honorary member, and he was held in high esteem by collectors, critics, and fellow artists.

The Narrows, New York Bay is among the earliest of Birch's landscape views, foreshadowing his later specialty of marine painting but demonstrating as well his talent for portraying wooded banks and animal life. A triangular wedge of land establishes the foreground, opening onto an expanse of water that in turn gives way to a cloud-filled sky. A writhing tree stands out as solid form against the richly atmospheric sky, providing a strong vertical accent echoed by the masts of the ship to the right. The precision of Birch's draftsmanship, as well as the careful brushwork and minuteness of detail, reflect the artist's training as an engraver and the topographical approach that he would have learned while apprenticed to his father. However, the compositional format as well as the choice of elements that enliven this coastal view reflects seventeenth-century Dutch traditions. The strong contrasts of light and dark, the close tonal relationships between sky and water, the heroic tree and contented cows recall the work of such Dutch masters as Salomon van Ruysdael (ca. 1600–1670) and Aelbert Cuyp (1620–1691). Birch would have been familiar with such painters, for his father owned a small art collection that contained at least one work by Ruysdael.[5] Still, the smooth, rich brushstrokes, the freshness of color, and the breadth of atmosphere indicate at least a foundation of direct observation.

The title of *The Narrows, New York Bay* is traditional, appearing with the painting when it entered the art market after having stayed in a Philadelphia family for over a century.[6]

S.M.

The Narrows, New York Bay, 1812

Oil on panel, 20 × 26¾ in. Signed and dated lower right: *T. Birch 1812.* Gift of Mr. and Mrs. John D. Rockefeller 3rd, 1979.7.17

John Wesley Jarvis
South Shields, England 1780–1840 New York, New York

John Wesley Jarvis has the reputation of being one of the most flamboyant, witty, and dissolute of American nineteenth-century artists, the direct opposite in temperament to his maternal uncle, John Wesley, the founder of Methodism, who raised the boy to the age of five.[1] In 1785 the future artist joined his family in America, settling eventually in Philadelphia, where in 1796 he was apprenticed to the self-taught portrait painter, engraver, and gallery director Edward Savage (1761–1817). Together in 1800 Savage and Jarvis moved to New York, where the younger man finished his term of indenture and rapidly established himself as an engraver, portraitist, and miniature painter. In 1808, with the return to Europe of his chief competitor, John Trumbull,* Jarvis became portraitist to New York's leading citizens.

During the next decade Jarvis received most of New York's important commissions, including one depicting heroes of the War of 1812, six full-length portraits that hang in City Hall, the most notable of them *Commodore Oliver Hazard Perry at the Battle of Lake Erie* (1816). He maintained an elegant studio that served both as a work space and an exhibition hall for his own and others' works. From 1814 he also had a studio in Government House, an elegant Palladian mansion erected for but never lived in by George Washington, which at the time served as the home of the Customs Office, the New-York Historical Society, and the American Academy of the Arts.[2] The artist took on apprentices[3] and maintained his trade both in New York and on travels throughout the South, charging prices that rivaled those of Gilbert Stuart* and his European contemporaries.[4]

In the 1820s Jarvis's career began to decline, in part because of a severe nationwide economic depression, but also because of his roisterous life. Accounts by fellow artists describe him alternately as an eccentric dandy with magnolia blossoms and a baby alligator in his waistcoat pocket, and as a devastated, alcoholic wreck dribbling tobacco juice.[5] Jarvis suffered a stroke in 1834 that caused his speech to be slurred, depriving him of his famed storytelling abilities; more crucially, it paralyzed or severely restricted the use of his painting arm, effectively ending his career.

In 1809 Philip Hone (1780–1851) had for a decade been a partner, along with his elder brother, John, in the family auction house, one of New York's more profitable firms.[6] Hone prospered to the extent that he could retire in 1821 and, after a tour of Europe, take a leading role in the civic and social life of New York City. In 1825 he was elected mayor, thus having the honor to greet Lafayette during the Revolutionary War hero's return tour of the nation and to represent the city in the festivities surrounding the opening of the Erie Canal. A major character in Whig politics and an ardent supporter of New York's theatrical and literary worlds, Hone is best known today from his twenty-eight-volume diary, covering the years 1828 to 1851.[7]

In this portrait Hone sits casually, one arm twisted over the back of his chair. A finger marks his place as he looks up from a small book, giving the work an air of spontaneity and immediacy in spite of its solid, pyramidal composition. The careful modeling and rich colors of the figure, set off by a swag of red drapery, contrast with the muted greens and browns of the background, suggestive of a wooded pasture visible through an open window. The artist has conjured a vivid likeness of Hone, truthfully rendered without artifice; "I will give the color of nature," Jarvis said.[8] In his own day, however, his paintings were criticized as being too lifelike, "remarkable for the strong individuality of his favourite heads—bold, natural composition, manner, and attitude. Yet, as *pictures* there is too little merit."[9] Today it is precisely this type of straightforward, unpretentious work that is most appreciated. As the Jarvis scholar Harold Edward Dickson wrote, "Strongly objective portraits of 1809 are among the best that Jarvis painted."[10]

M.S.

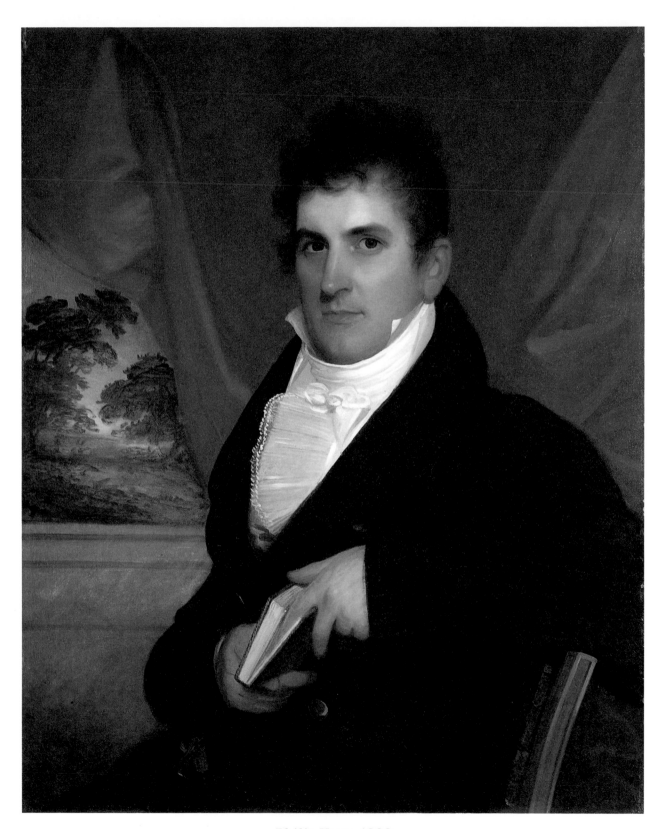

Philip Hone, 1809
Oil on panel, 34⅜ × 27 in. Signed and dated lower left: *JARVIS / JULY 1809*
Gift of Mr. and Mrs. John D. Rockefeller 3rd, 1986.84

Thomas Doughty
Philadelphia, Pennsylvania 1793–1856 New York, New York

One of the first American artists to devote himself entirely to landscape painting, Thomas Doughty was recognized even in his own day as a pioneer. Son of a ship carpenter, Doughty began his professional career in Philadelphia as a leather currier but left that trade to pursue painting, a move that his friends assured him was "a rash and uncertain step!"[1] Despite minimal instruction and few opportunities to practice, Doughty listed himself in the 1816 city directory as a "painter" and exhibited a landscape at the Pennsylvania Academy of the Fine Arts; four years later he changed his listing to "Landscape painter."[2] His declaration of focus signals a general shift in landscape painting in the 1820s, from topographical views of particular places to more generalized, suggestive images of natural beauty and native scenery. Doughty quickly achieved renown for his evocative, poetic views. In 1828 he moved to Boston, apparently seeking a more lucrative market for his art; but he was back in Philadelphia by 1830 to begin work on *The Cabinet of Natural History and American Rural Sports*, a monthly magazine featuring hand-colored lithographs after Doughty's works. When the *Cabinet* ceased publication in 1832, Doughty returned to Boston and made numerous sketching trips along the New England coast and into the White Mountains of New Hampshire and the Catskills of New York. At the height of his career, Doughty made his first trip abroad, spending the years from 1837 to 1839 in London; he continued to travel both in Europe and throughout New York State until the end of his life.

In Doughty's later years his health and artistic powers began to fail and criticism of his work increased. Yet his achievements remained present in the public and critical eye. Writing in 1869, the critic John Neal said:

> Twenty-five or thirty years ago, the landscapes of Doughty were the very best of the age . . . with beautiful skies, foliage dripping with sunshine, or golden river-mist. Such water as you seldom see anywhere on canvas, and atmosphere you could breathe. His range was narrow, but within that range he had no rival; . . . the beautiful, instead of the sublime, he dealt with, even to the last. . . . I knew him well, and must say I never knew a worthier man, or a truer artist.[3]

Doughty's view of landscape was a reflective one; avoiding the wild and tempestuous side of nature, he chose more often to portray her moods of lyrical calm, as evidenced in his *View on the St. Croix River*. His vividly painted glimpse of that river, which flows as the border between Maine and New Brunswick, seems based in observation. Yet, the composition, in its simple contrasts of light and dark, land and water, foreground and distance, conforms to standard late-eighteenth- and early-nineteeth-century notions of the picturesque.[4] In the foreground, dark foliage at either edge of the canvas joins the bend of the shoreline to funnel the viewer's attention toward the green-gold vista beyond. As the bank gives way to water, so does shade give way to sunlight, to the smooth surface of water and the cloud-filled sky above. Brushed with lively contrasts of pink, yellow, and gray, the clouds form a sweeping arc that complements the curve of the shoreline below. Over the water and background falls a mellow light, and the mood is still. As a critic in 1833 noted, Doughty "infuses into his pictures all that is quiet and lovely, romantic and beautiful in Nature."[5]

On the rocky promontory to the left stands a tiny figure, recognizable as a city dweller by the sketchy indications of hat, cane, and coattails. Such figures appear frequently in both British and American landscape painting of the early nineteenth century, often as a measure of the smallness of man against the vastness of nature. The urban traveler also represented that educated segment of Anglo-American society who—unlike the rough woodsman or savage Indian—was trained to appreciate nature, both for its inherent beauties and for the poetic, religious, or moral associations it might afford. The American traveler, however, unlike his British counterpart, was critically aware of the progress of civilization in his country that had so recently tamed the wilderness and made possible his genteel travel.[6] Thus Doughty's figure reflects upon both the landscape and the ships that glide within it. Human activity is subordinate to the order of nature in this landscape, but appreciation of that order depended on the very progress that threatened it.

S.M.

View on the St. Croix River near Robbinston, 1835.
Oil on canvas, 18 × 24 in. Signed and dated lower center left: *T. DOUGHTY / 1835.* Gift of Julius H. Weitzner, 54824

George Catlin

Wilkes-Barre, Pennsylvania 1796–1872 Jersey City, New Jersey

In 1826 George Catlin committed himself to recording the fast-disappearing customs and appearance of Native Americans. He described his self-appointed mission in his 1841 *Letters and Notes on the Manners, Customs, and Condition of the North American Indians*: "The history and customs of such a people, preserved by pictorial illustrations, are themes worthy of the lifetime of one man, and nothing short of the loss of my life, shall prevent me from visiting their country, and of becoming their historian."[1] Thus Catlin became the first major American artist to travel the western plains.

From 1830 to 1836 Catlin made numerous journeys through the American woodlands, Great Plains, and Great Lakes regions amassing a collection of notes, artifacts, sketches, and paintings that documented the landscape as well as the people and their native customs. On his return to New York in 1837, the artist opened a traveling "Indian Gallery," hoping his display of objects and paintings would educate the public about the courage, dignity, and purity of "Nature's proudest, noblest men."[2] Although the exhibition was well received along the East Coast, when admission receipts dropped Catlin took his gallery to Europe. In London and Paris he became an instant celebrity. After a series of setbacks and financial reversals, however, in 1852 the artist sold the Indian Gallery.[3] During the next twenty years, he re-created his original Indian Gallery by painting from sketches and memory; this second series of pictures became known as Catlin's Cartoon Collection. The twelve hundred paintings and sketches of his Cartoon Collection were displayed in 1871 at the newly formed Smithsonian Institution in Washington, D.C. Not only did Catlin finally have public space to hang his pictures, but he also had use of a room where he lived and continued to paint.[4] *Fire in a Missouri Meadow*, a reworking of an earlier painting, dates from this final stage of the artist's career.

In addition to recording the appearance and life of the Native Americans, Catlin recorded his deep appreciation of the beauty of the land. References to the mighty forests, oceans of waving grass, and spectacular topography of North America recur throughout his writings. Even natural disasters, such as prairie fires, are described at length in the artist's *Letters and Notes on the Manners, Customs, and Condition of the North American Indians*:

> There is yet another character of burning prairies . . . the war, or hell of fires! where the grass is seven or eight feet high . . . and the flames are driven forward by the hurricanes, which often sweep over the vast prairies of this denuded country. . . . The fire in these, before such a wind, travels at an immense and frightful rate, and often destroys, on their fleetest horses, parties of Indians, who are so unlucky as to be overtaken by it.[5]

Although untrained as an artist, Catlin in *Fire in a Missouri Meadow* intuitively evokes the terror of man and animal narrowly escaping destruction; flames leap skyward in the distance and heavy drifts of dark smoke blow threateningly overhead. Catlin reinforces the dynamism of the scene with vigorously applied, swirling strokes of pigment and the assertive rhythm of repeated forms—man, beast, flames, and clouds. Furthermore, Catlin enlivens his typically objective approach with a sense of exaggerated drama. This is readily apparent in the anthropomorphic expressions of the panicking horses, the unnaturally large size of the flames, and the sharply acute angle of the rapidly drifting clouds of smoke. It is in paintings such as this that Catlin temporarily puts aside the scientific rationalism of his Indian Gallery and responds instead to the romantic love of the sublime.[6]

J.S.

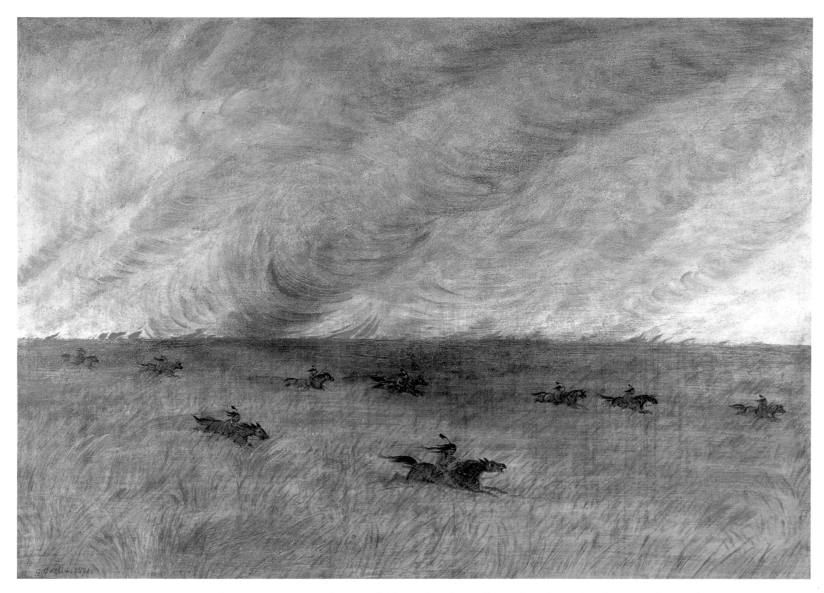

Fire in a Missouri Meadow and a Party of Sioux Indians Escaping from It, Upper Missouri, 1871

Oil on paper mounted on board, 18 × 24¼ in. Signed and dated lower left: *G. Catlin. 1871.*

Gift of Mr. and Mrs. John D. Rockefeller 3rd, 1979.7.24

John Quidor
Tappan, New York 1801–1881 Jersey City, New Jersey

John Quidor combined a keen wit, an accomplished technique, and a genuine originality to fashion some of the best literary genre scenes of the American nineteenth century. Throughout his nearly fifty-year career, he illustrated the bizarre or harrowing moments described in the writings of his fellow New Yorkers Washington Irving and James Fenimore Cooper. Sadly, he was profoundly out of step with his times and, saddled with dogged and persistent bad luck, never found popular favor.

Apprenticed as a portrait painter in 1818 to the fashionable John Wesley Jarvis,* Quidor successfully sued Jarvis in 1821 for "breach of covenant," claiming that the master neglected him and failed to instruct him in "the mystery of a portrait painter."[1] And although he listed himself as a portraitist in New York City directories until 1836, no portraits by Quidor are known. While supporting himself largely as a sign and banner painter, Quidor sought to win recognition for his genre paintings—renting rooms at the National Academy of Design in 1847 and showing in various New York exhibitions, even during the years from the mid-1830s to 1851 when he lived as a land speculator and painter in Illinois. Reportedly beset by problems of alcoholism, Quidor retired to his daughter's home in Jersey City in 1869 and was inactive during his final years.

While a tendency to narrative exaggeration and caricature is fairly consistent in Quidor's work, a stylistic change occurred in the 1850s. Moving away from his trademark dark paintings with patches of bright, almost enamel-like color, Quidor began working with scarcely any color other than thin glazes of golden browns. *Tom Walker's Flight* is one of the most elegant and well preserved of these later compositions. Quidor has chosen to paint the climactic moment of "The Devil and Tom Walker" from Washington Irving's *Tales of a Traveller* (1824). The story tells of the miser and usurer Tom Walker, who bands with the devil to find the treasure of Captain Kidd and uses that fortune to become immensely rich as a moneylender.[2] On the point of foreclosing on a mortgage, Tom swears an oath at his protesting victim:

Tom lost his patience and his piety. "The devil take me," said he, "if I have made a farthing!"

Just then there were three loud knocks at the street-door. He stepped out to see who was there. A black man was holding a black horse, which neighed and stamped with impatience.

"Tom, you're come for," said the black fellow, gruffly. Tom shrank back, but too late. . . . The black man whisked him like a child into the saddle, gave the horse the lash, and away he galloped, with Tom on his back, in the midst of the thunder-storm. The clerks stuck their pens behind their ears, and stared after him from the windows. Away went Tom Walker, dashing down the streets; his white cap bobbing up and down; his morning-gown fluttering in the wind, and his steed striking fire out of the pavement at every bound. When the clerks turned to look for the black man, he had disappeared.[3]

Tom, of course, never returned.

Quidor stands outside the mainstream of nineteenth-century American art. Yet *Tom Walker's Flight* does have direct precedents. Tom's bulging eyes and wildly indecorous pose, the fleeing dog, the steep perspective, and the generally nervous outlines reveal Quidor's knowledge of works by the British caricaturists George Cruikshank (1792–1878), James Gillray (1757–1815), and Thomas Rowlandson (1756–1827). The painting's warm tonality, likewise, recalls seventeenth-century Dutch paintings, an appropriate reference to New York's patroon past. And yet dependent on none of these, nor even on the narrative he illustrates, Quidor synthesizes these diverse elements within his own sensitive visualizations of a text. Although commentators have recently noted that Quidor exaggerates his texts, amplifying their elements of burlesque,[4] in a work such as *Tom Walker's Flight*, Quidor's spare elegance of color and form combines with his bizarre imagery to create a close visual equivalent of Washington Irving's own droll, ironic voice.

M.S.

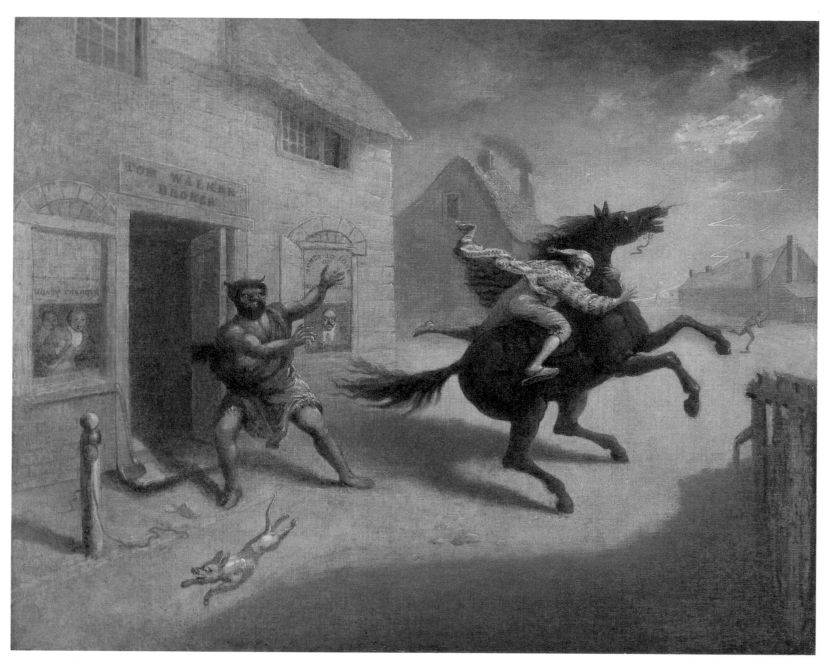

Tom Walker's Flight, ca. 1856
Oil on canvas, 25 × 34 in. Gift of Mr. and Mrs. John D. Rockefeller 3rd, 1979.7.84

William Matthew Prior
Bath, Maine 1806–1873 Boston, Massachusetts

Outnumbering such academic counterparts as Gilbert Stuart* and John Wesley Jarvis,* several painters known today as folk artists worked to satisfy the early nineteenth century's voracious demand for portraits. Among the most successful, prolific, and versatile of these artists was William Matthew Prior. Little is known of his artistic training, but an inscription on the back of a canvas from 1824 suggests that he received consideration, if not actual instruction, from Charles Codman (1800–1842), a portrait, landscape, and sign painter in Portland, Maine.[1] By 1824 Prior was painting portraits and by 1827 advertising his skills at "fancy, sign, and ornamental painting."[2]

Prior's early works indicate that he aspired to academic standards of modeling and composition. In 1831 Prior exhibited a portrait at the Boston Athenaeum and named his first son Gilbert Stuart Prior, after the artist he most admired. But that same year he advertised in the *Maine Inquirer* that "persons wishing for a flat picture can have a likeness without shade or shadows at one quarter price."[3] Prior's subsequent portraits all seem to be executed in the more or less "flat" style now associated with folk painting. But this advertisement and a label announcing "PORTRAITS / Painted in this Style! / Done in about an hour's sitting. / Price $2,92, including Frame, Glass, &c."[4] testify that Prior's style was not based on any lack of skill or talent but rather on his accommodations to client preferences—in this case, for a recognizable likeness, produced quickly and at minimal expense.[5]

In 1828 Prior married Rosamund Hamblin, whose father and brothers ran a house, sign, and ornamental painting business. From 1834 to 1837 Prior shared residences in Portland with his Hamblin in-laws; by 1841 Prior's family and three brothers-in-law had moved to Boston.[6] Prior occasionally traveled in search of commissions but maintained a studio at 36 Trenton Street that he called his "Painting Garret," where he received

sitters, prepared his canvases and pigments, and constructed his own frames.[7] In his later years Prior ventured outside his portrait practice with a number of landscapes and "fancy pieces," including several reverse paintings on glass depicting famous Americans such as George Washington. An ardent follower of the Adventist preacher William Miller, Prior published two lengthy books concerning his spiritualist beliefs in the 1860s. These beliefs also allowed Prior to paint posthumous portraits "by spirit effect," claiming he could follow his subject into the afterworld.[8]

No signature or inscription appears on the portrait of Isaac Josiah and William Mulford Hand of Lynn, Massachusetts, but research has confirmed many affinities between this portrait and Prior's known works. The common geographical sphere of sitters and artist strengthens the likelihood of this attribution. Typical of Prior are the long, buttery strokes of paint; the puffy, cigarlike fingers; the sprightly bows on the shoes; and the decorative linear accents provided by kite string and curtain fringe. Prior painted several double portraits of children, and these efforts are often more ambitious and accomplished than his standard "flat" likenesses. Here the artist has linked the two boys through costume and caused them to lean toward one another; at the same time he has taken care to distinguish his sitters. A curtain placed behind the head of Isaac and the rectangle drawn behind the figure of William serve to separate and silhouette the individual faces. William (born 1842), with the corners of both his mouth and eyes upturned, wears an impish expression that his older, perhaps more serious brother Isaac (born 1840) does not share. Yet the colorful toy drum and the lively kite that flies out of the window lend a playful mood to the portrait. If the painting style of this portrait is simple, its construction and composition are not, and the work rewards its viewer as an object of considerable aesthetic interest as well as decorative appeal.

S.M.

Isaac Josiah and William Mulford Hand, ca. 1845
Oil on canvas mounted on board, 29¾ × 25½ in. Gift of Roger Sturtevant, 54116

Attributed to Jurgan Frederick Huge
Hamburg, Germany 1809–1878 Bridgeport, Connecticut

Jurgan Frederick Huge is known primarily for his marine and seascape watercolors—large works that are among the most exciting in the folk tradition. Few facts of his life are known beyond family tradition and what can be gleaned from public documents in Bridgeport, Connecticut, where he lived most of his life. Although it is not known when Huge immigrated to America, by 1830 he was married to the daughter of a prominent Bridgeport family. He was reportedly a sea captain at one time. Huge's earliest known works are steamboat portraits (one watercolor and one lithograph) dated 1838, both displaying a proficiency that testifies to earlier artistic activity. The first notice of Huge in the Bridgeport city directories, however, appeared in 1862, where he was listed as "J. F. Huge, grocer; house near Crossley Mills."[1]

For the 1869–70 directory, Huge amended his profession to include his creative work—"Grocer and artist, North Avenue near Woolen Mills"—and thereafter until his death painting became an ever more important element in his public persona: "Landscape and marine artist, groceries, &c." (in 1871–72), and later, "Teacher in drawing and painting, landscape and marine artist."[2]

Composite Harbor Scene with Volcano and the closely related *Composite Harbor Scene with Castle* (ca. 1875; National Gallery of Art, Washington, D.C.), two of Huge's three known oil paintings, are vibrant catalogues of the architecture and modes of transportation available to a New England village in the third quarter of the nineteenth century.[3] In *Composite Harbor Scene with Volcano*, for example, Federal-era buildings dominate the town, although Gothic and Elizabethan Revival mansions sit up in the hills at its outskirts. The busy harbor contains a wide variety of shipping vessels, while trains and carriages move across the land. This bright and clear-colored work could almost depict a New England village on a Sunday afternoon. Some of its charmingly detailed citizens, well dressed and decorous, survey the cascades, ride in their carriages, or attend church; others enjoy their leisure by sporting in the harbor. Two factors deny the reality of the scene, however, and reveal that the artist looked inward rather than at a real scene when composing the picture. Throughout the village, although each spoke of a moving carriage wheel is carefully detailed, neither shops, ships, nor the train station bear any identifying prose. Only one building carries the generic label of "Woollen Factory" over its doorway. And, of course, there is the volcano in the background—possibly an echo of Huge's third known oil painting, *A Fanciful View of the Bay of Naples* (ca. 1875; private collection),[4] but decidedly out of place as accompaniment to a New England village.

The style of the painting is simple and direct. Huge creates his scene with clear, high-toned colors, the objects being first drawn and then colored in with relatively unmodulated hues. Almost as if he were using watercolor, he sometimes scratches away the paint to reveal the ground, thus establishing his sharp white lines, and occasionally uses the untouched ground to describe white objects. Huge establishes some of his finest detail work by drawing pencil lines into the dried paint rather than attempting to paint them. He uses linear and aerial perspective, foreshortening, and other conventions of illusion, but without rigor. Horses, ships, and people are most often portrayed in silhouette, their placement conforming more to the demands of characteristic shape than the chance arrangements of perceived reality. What is known or dreamed rather than what is observed dictates Huge's decisions of shape, color, and position.

The art historian Jean Lipman offered a definition of folk art and the criterion for judging its quality in her first book on the subject:

> The style of the typical American Primitive is at every point based upon an essentially nonoptical vision. It is a style depending upon what the artist knew rather than upon what he saw.... The degree of excellence in one of these primitive paintings depends upon the clarity, energy, and coherence of the artist's mental picture ... and upon the artist's instinctive sense of color and design when transposing his mental pictures on to a painted surface rather than upon a technical facility for reconstructing in paint his observations of nature. Abstract design is the heart and soul of the American Primitive.[5]

By this standard, *Composite Harbor Scene with Volcano* helps to establish Huge among the very best American folk painters of the nineteenth century.

M.S.

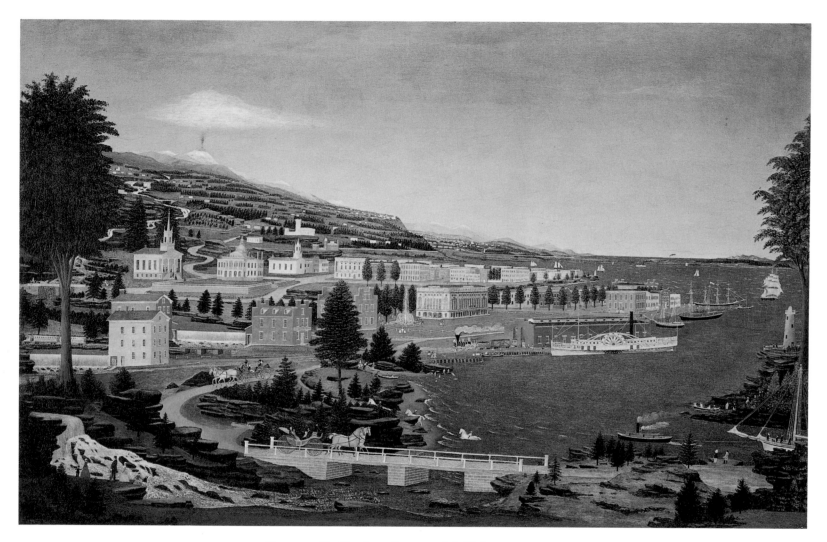

Composite Harbor Scene with Volcano, ca. 1875
Oil on canvas, 25½ × 40⅛ in. Gift of Edgar William and Bernice Chrysler Garbisch, 69.32.1

William Page
Albany, New York 1811–1885 Tottenville, New York

William Page, known in his own time as the "American Titian," painted portraits and history paintings using a luminous technique derived from constant experimentation and his study of Venetian Old Masters. In 1826, on the grudging advice of John Trumbull,* who "generally discouraged young men from becoming artists, . . . [yet] thought young Page might be permitted to starve genteelly,"[1] Page turned from his law studies and enrolled at the National Academy of Design under Samuel F. B. Morse (1791–1872). In 1828 he began to train for the Presbyterian ministry, but that enterprise lasted less than two years. Returning first to Albany and then going back to New York as a portraitist, Page settled in Boston in 1844. After two years in New York from 1847 to 1849, Page lived in Italy until 1860, one of the Anglo-American community that included James Russell Lowell, William Wetmore Story (1819–1895), Hiram Powers (1805–1873), and Robert and Elizabeth Barrett Browning.[2] There, in 1850, Page was introduced to the teachings of the eighteenth-century Swedish theologian Emanuel Swedenborg, whose mystical philosophy and beliefs in the spirit world and in séances were to permeate the artist's life and work for his remaining years. President of the National Academy of Design from 1871 through 1873, yet beset with financial difficulties that plagued most of his career, Page found keen admiration and steady neglect curiously entwined throughout his lifetime. His career was aptly summarized by the contemporary critic Henry Tuckerman as one that

> seems to unite the conservative instincts of an old-world artist with the bold experimental ambition of our Young Republic. . . . No American and few modern artists of any nation, have reached a higher point than Page in his felicitous works; few have gained such distinction, and few have found both fame and fortune more precarious.[3]

Page's work continues to be one of the unjustly overlooked and understudied oeuvres in American art history.[4]

Cupid and Psyche depicts an embracing couple sheltered within a forest, their rounded figures pressed to the right foreground of the small canvas. A soft light falls on the edges of the couple's forms; a luminous landscape opens to the left. Whether because of the nudity of its figures or the fact that the couple was based on an ancient marble statue housed in the Capitoline Museum in Rome (thus making the canvas in a sense a copy), the work created considerable controversy in 1843 when it was rejected by the National Academy of Design for its annual exhibition.[5] This was a highly unusual action, as Page's status as an academician should have prevented the rejection. The National Academy's decision prompted a flurry of newspaper criticism. A particularly ironic passage appeared in *Brother Jonathan* when the Boston Athenaeum finally exhibited the painting to the public in September 1843: "There too, is the 'Cupid and Psyche' of Page, which so shocked the delicacy of your citizens, when exhibited in New York. The people of Boston are either less refined or less squeamish, for it does not seem to have given any offense here."[6]

In fact, the intensity of the image and the compelling power of the landscape captured in this miniature realm combine to make *Cupid and Psyche* a distinctly erotic and unsettling work.[7] By presenting the figures shown only to the waist, positioning them so that a relative modesty is preserved, and placing them within the sheltering darkness of the forest, Page emphasizes the intimate, private mood of the painting. This makes the viewer's closeness to the figures an abrupt (albeit unnoticed) intrusion.

M.S.

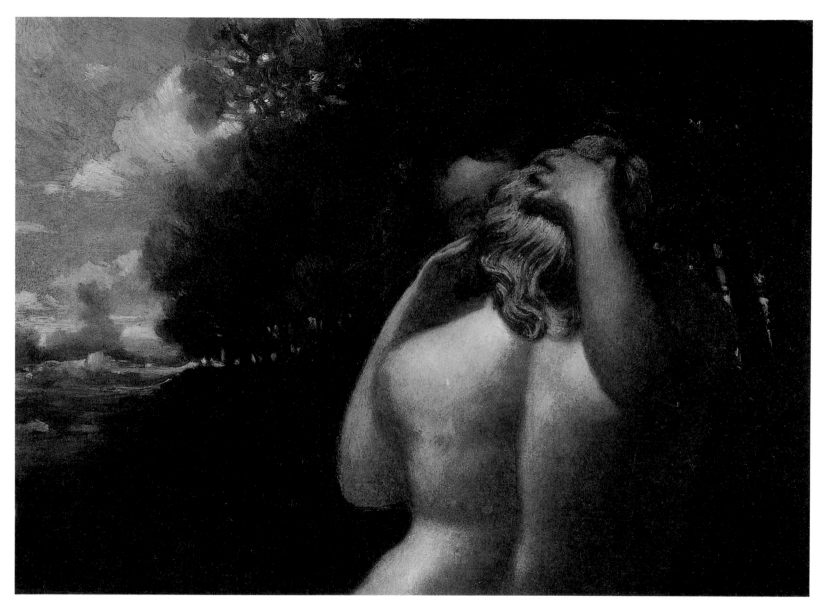

Cupid and Psyche, 1843
Oil on canvas, 10⅞ × 14¾ in. Gift of Mr. and Mrs. John D. Rockefeller 3rd, 1979.7.77

George Caleb Bingham

Augusta County, Virginia 1811–1879 Kansas City, Missouri

George Caleb Bingham was one of the first artists from America's far-western frontier to establish a prominent position in the American art world. In 1835 the first public notice of him proclaimed, "ere long, the country shall see with delight, and hear with pleasure, the productions and the praises—to borrow a title of Rubens—of a Western 'meteor of the arts.'"[1] The "Western meteor" was in fact born in Virginia, although in 1819 the Bingham family moved to Franklin, Missouri, a recently founded community on the banks of the Missouri River. In 1823 Bingham was apprenticed to a cabinetmaker in nearby Boonville; later he considered a career in law. The sight of an itinerant portraitist's work, however, is said to have inspired Bingham to choose painting as a profession. By 1833 the self-taught artist had portrait commissions, and two years later he was active in Saint Louis, "painting without intermission."[2] In 1838 Bingham traveled to Philadelphia and perhaps New York for approximately three months, where he "obtained a little knowledge of color by looking at pictures which before he had no opportunity of studying,"[3] and where he may have had the chance to see genre works by William Sidney Mount (1807–1868). From 1840 through 1844 Bingham painted portraits in Washington, D.C. Back in Missouri in 1845, Bingham began concentrating on genre scenes of river life and the political process. By submitting these paintings for exhibition, sale, distribution by lottery,[4] and, in 1847, engraving by the New York–based American Art-Union, he found for himself a responsive national audience. The art critic Henry Tuckerman, writing in 1867, attributed to Bingham's "exotic" frontier images the power of generating a market for Western scenes, although it is clear that Tuckerman did not respect Bingham's monumental simplicity of form and innovations of color:

> Such representations also of border life and history as Bingham made popular, though boasting no special grasp or refinement in execution, fostered a taste for primitive scenes and subjects which accounts for the interest once excited in cities and still prevalent at the West in such pictures as "The Jolly Flat-Boatman."[5]

In 1848 Bingham successfully entered the political arena as a Missouri state legislator. Combining his political and artistic careers for nearly the next decade, he traveled extensively throughout the country until 1856. In that year he went briefly to Paris and then to Düsseldorf in order to oversee the production of engravings after some of his political scenes. While in Germany he worked primarily on large historical portraits of George Washington and Thomas Jefferson (both destroyed). From his return to the United States in 1859 until his death, Bingham's political

career took increasingly large portions of his time, and portraiture dominated his artistic output.

Boatmen on the Missouri is one of Bingham's earliest and simplest celebrations of, as Walt Whitman would write:

> The beauty of all adventurous and daring persons,
> The beauty of wood-boys and wood-men with their clear
> untrimmed faces,
> The beauty of independence, departure, actions that rely on
> themselves.[6]

Bingham's decision to paint life on the river was an apt one. As the vital arteries of commerce and communication, the rivers of the midcontinent provided the backdrop to much of Bingham's own life. By painting scenes of raftsmen and fur traders, he was in large part responding to the world about him. In *Boatmen on the Missouri*, the three woodsmen drift down the river on their raft, from which they sell split logs and kindling to the large paddle-wheel steamers that ply the river; the boat moving upstream in the distance suggests a recent customer. Two of the men, with clear faces and massive arms, rest and stare out of the picture; the third busies himself at the stern of the craft. The river is quiet and, except for deceptively elegant snags in the distance, smooth surfaced. At the back, playing upon the landscape and gently defining the ranges of distant hills and trees, a diffuse light unifies the muted colors of the scene into a luminous whole.

Bingham augments the early morning stillness of the landscape by quietly securing the central group firmly to three edges of the canvas. Anchored at the bottom by its dark-colored reflection, the raft is pinned into place, perpendicular to the picture plane, by the two oars that extend beyond the sides of the canvas. The artist has arranged the men in a taut, triangular arrangement that manifests an almost Renaissance appreciation of geometry and stability. The hard light that falls on the figures, distinct from that falling on the background, casts strong shadows and models their statuesque forms in simple and broad gestures. Bingham's use of rich, strong colors to portray this group, such as the glowing red that warms the flesh shadows, further distinguishes the figures from the setting. The contrast in the quality of light and the range of colors between foreground and background brings the figures forward, increasing their visual impact while removing them (in their rough but spotless clothes) yet farther from the realm of activity. As with his fellow Missourian Mark Twain, Bingham's depictions move beyond the reportorial to the mythic.[7]

M.S.

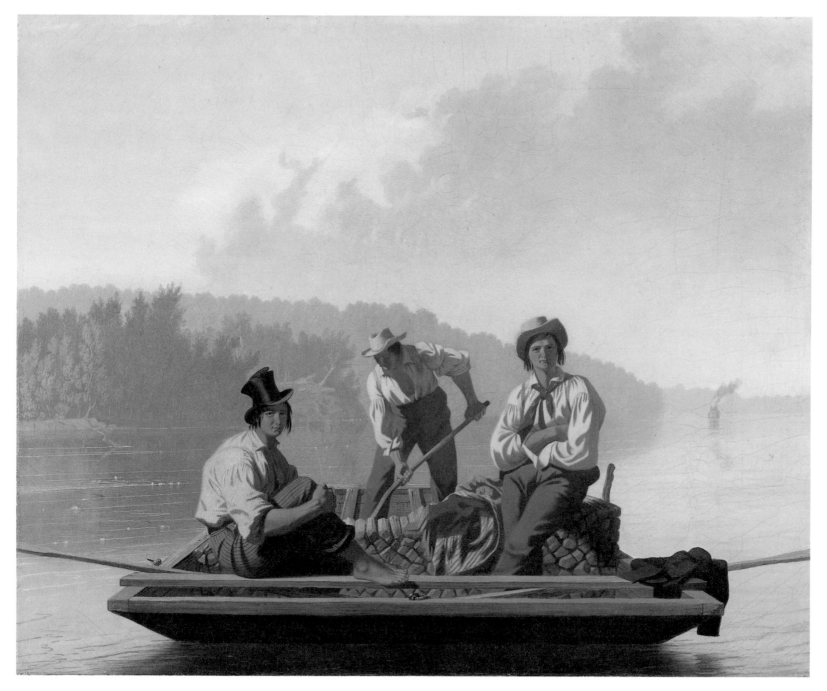

Boatmen on the Missouri, 1846

Oil on canvas, 25 × 30 in. Gift of Mr. and Mrs. John D. Rockefeller 3rd, 1979.7.15

George Caleb Bingham
Augusta County, Virginia 1811–1879 Kansas City, Missouri

George Caleb Bingham had two careers, as an artist and as a politician, though he tried to deny the latter at various points throughout his life. While he was in Washington in the early 1840s, for example, he wrote:

> Though I have a painting room in the Capitol, I know less of the proceedings of Congress than if I were in Missouri. . . . I have not felt sufficient interest in what was passing to attend the debates in either house this winter. . . . I am a painter and desire to be nothing else.[1]

Shortly thereafter, amid the fray of a contested 1846 election for the Missouri state legislature in which he eventually lost the seat, Bingham reiterated: "As soon as I get through with this affair, and its consequences, I intend to strip off my clothes and bury them, scour my body all over with sand and water, put on a clean suit and keep out of the mire of politics *forever*."[2] But in fact Bingham was deeply involved with Missouri politics throughout his maturity. Painting political banners and making speeches in 1840, he won a seat in the state legislature in 1848 (triumphing over his opponent of 1846); he was later appointed state treasurer from 1862 to 1865 and adjutant-general of Missouri in 1875.

Given Bingham's lifelong involvement in politics[3] and the colorful character of political gatherings in the early years of Jacksonian democracy, it is natural that he would turn his painter's eye toward the events surrounding the election process. He was popularly successful with a series of large, outdoor crowd scenes that date from 1851 to at least 1857, each a boisterous catalogue of types, behaviors, and emotions. Bingham also turned on occasion to more modest, concentrated political paintings. One of the most successful of these, and one of his earliest works of any size on the theme, was *Country Politician*, done in 1849.

An interior scene with four figures, the painting attracted critical attention while it was still in Bingham's Saint Louis studio:

> Yesterday we had the pleasure of examining three paintings by G. C. Bingham, Esq., who is better known by the sobriquet above given—albeit he is not unknown as a statesman and politician. In his peculiar line of Western characters he has added three gems to the productions of his pencil. One is a scene in a bar-room, in which the group is most perfect and lifelike. The jolly old landlord, smoking his pipe; a politician, most earnestly discussing to a very indifferent listening farmer, the Wilmot Proviso; whilst a boy, with his coat-tail turned up to the stove, is reading a show-bill.[4]

Bingham's elegant composition and predominantly golden brown color scheme may ultimately derive from seventeenth-century Dutch precedents, but his most immediate source is William Sidney Mount's (1807–1868) *The Long Story* (1837; Corcoran Gallery of Art, Washington, D.C.). He might have seen Mount's work in New York in 1838 when it was the star of the National Academy of Design's annual exhibition; he would certainly have known it through reproduction.[5] As happened throughout his career, Bingham used a close variant of the figural group in *Country Politician* in the later *Canvassing for a Vote* (1857; Nelson-Atkins Museum of Art, Kansas City, Missouri).[6]

In spite of its spareness, the world depicted in *Country Politician* is a full and complex one. As the Saint Louis critic reported in 1849, the topic of conversation in this barroom is the Wilmot Proviso, which sought to prohibit slavery in southwestern territories annexed as a result of the Mexican War. Bingham must have informed the critic of this topic, for it is nowhere evident in the composition. The playbill on the wall at the left clearly advertises the Mabie Brothers Circus, a Wisconsin-based troupe that toured Missouri for nine seasons between 1843 and 1859.[7] With only four figures (a microcosm of laborer, farmer, merchant, and statesman), Bingham presents a spectrum of engagement that ranges from concern for the most serious issues of the day to the search for idle enjoyment.

M.S.

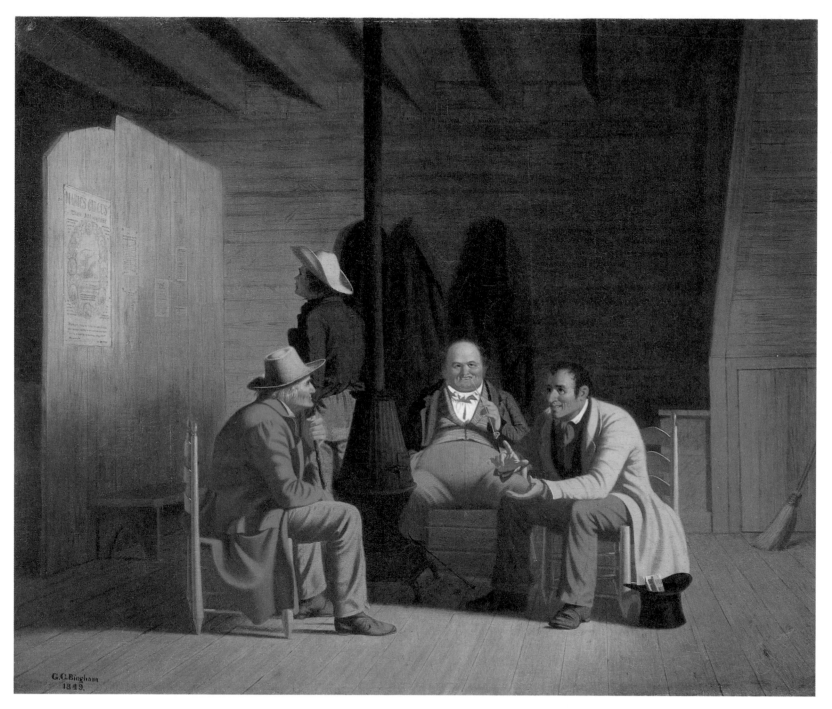

Country Politician, 1849

Oil on canvas, 20 × 24 in. Signed and dated lower left: *G. C. Bingham / 1849*. Gift of Mr. and Mrs. John D. Rockefeller 3rd, 1979.7.16

Alburtus Del Orient Browere
Tarrytown, New York 1814–1887 Catskill, New York

Eldest son of the sculptor John Henry Isaac Browere (1792–1834), as a boy Alburtus Del Orient Browere[1] assisted his father in a monumental project to create a sculptural portrait gallery of prominent Americans. He later began to paint, exhibiting at the National Academy of Design in 1831. Browere's earliest works are genre and narrative scenes, many of them derived from the tales of his Tarrytown neighbor Washington Irving. In 1841 Browere received the National Academy's premium award for a historical canvas, *Canonicus and the Governor of Plymouth* (location unknown). That same year he moved to Catskill, New York, home of Thomas Cole (1801–1848) and mecca to America's growing number of landscape painters. Browere too began to paint landscapes and village scenes in the 1840s, but family accounts indicate that he faced financial hardships, in part brought on by his father's unpaid debts. Browere turned to sign and carriage painting when necessary, a trade that saw him through his later years as well, and the influence of which can be seen in the broad strokes, strong colors, and somewhat naïve simplicity of his style.

In 1852 Browere joined the Gold Rush. He spent four years in California, observing and painting the mountain ranges, mining camps, and boomtowns of the new state. He made a second trip to California from 1858 to 1861 before returning once again to Catskill, where he spent the remainder of his life. Browere appears in a few of his California paintings, sporting a red mining shirt and accompanied by his pet mule. If he prospected for gold, apparently he found none; but the inspirations he found in the everyday life and unsettled landscapes of early California have become some of the earliest and most treasured painted records of that era.

When gold was discovered in 1848, the city of Stockton was still a tiny settlement known as Tuleburg. But its location at the headwaters of the San Joaquin River made it a natural outfitting center and distribution point for the southern mining regions. Practically overnight the small town was transformed, as journalist Bayard Taylor wrote in the spring of 1849: "There in the heart of California, where the last winter stood a solitary ranche [*sic*] in the midst of tule marshes, I found a canvas town of a thousand inhabitants and a port with twenty-five vessels at anchor!"[2] The "canvas town" quickly sprouted wooden structures, but after Stockton was ravaged by successive fires, sturdier buildings of brick were erected. (A brickyard is conspicuous at the center right of Browere's painting.)

Browere shows Stockton as it must have appeared to many a visitor approaching from the coast, looking east toward the head of the Stockton Channel and the center of town, the Sierra Nevada range in the far distance.[3] A wide path cuts through finely detailed vegetation at the right; with the channel of water to the left, it leads the eye back into space. Yet this recession is effectively halted by the narrow band of townscape that neatly divides the canvas in half, separating the bright blue sky from the darker earth and water below. In the foreground, fishermen, working in water so still that it mirrors the buildings on its shore, strain to pull in their nets.[4] At the right, an egret takes wing. A sunken ship's hull lies at the left of the channel; no sign of Stockton's bustling steamer traffic appears. Browere presents an idyllic, picturesque vision of the young city, focusing on those other resources—breathtaking expanses of sky, abundance of fish and wildlife, and a colorful, stable townscape— that might await the visitor hoping to find gold.

S.M.

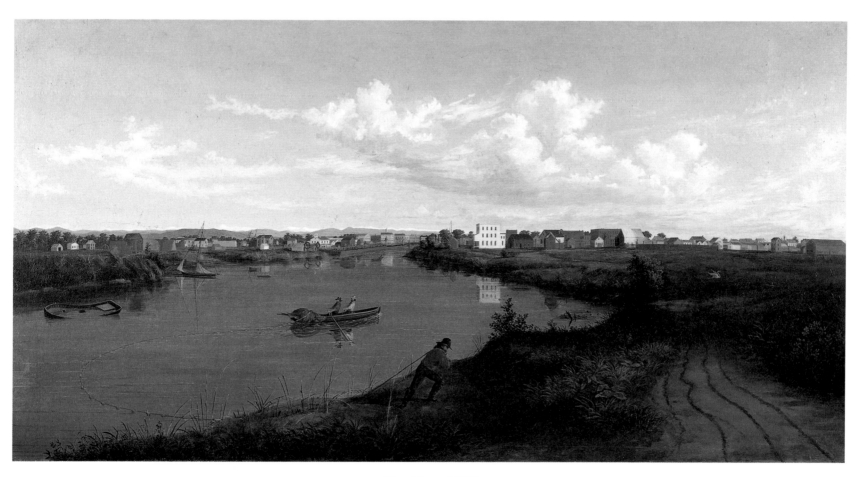

Stockton, 1856

Oil on canvas, 36⅞ × 69⅞ in. Signed and dated lower center: *A. D. O. Browere / 1856*. Museum purchase, 39.3

Jerome Thompson
Middleboro, Massachusetts 1814–1886 Glen Gardner, New Jersey

Henry Tuckerman gave Jerome Thompson only a nod of recognition, noting in one line in his 1867 *Book of the Artists* that the artist was "chiefly known by his rustic scenes, half landscape and half rural labors or sport."[1] But a writer ten years earlier had proclaimed:

> No living artist, more than the subject of this sketch, catches the lights and shades of American life and humor.... With the true hand of the master, and a taste skilled by much study, he adds that intangible faculty of seizing the most picturesque view of things, and succeeds in producing pictures which literally *talk* with reminiscences and life.[2]

Thompson's father, Cephas Thompson (1775–1856), a portraitist of some repute, encouraged the artistic talents of his eldest son, Cephas Giovanni (1809–1888), while ignoring those of Jerome, who was consigned to the business of the family farm. Yet the boy persisted, and with the profits earned from sign and ornamental painting he soon left home with his sister. After working briefly in Barnstable, Massachusetts, the pair moved to New York in 1835. By 1844 Thompson had changed his listing in the New York City directory from "portrait painter" to "artist" and by 1848 offered a genre painting to the American Art-Union. Elected an associate of the National Academy of Design in 1851, Thompson spent the following two years in London, where, according to a contemporary account, he studied the art of Claude Lorrain (1600–1682), J. M. W. Turner (1775–1851), and William Hogarth (1697–1764).[3] After 1850 Thompson focused almost exclusively on genre subjects, scenes of rural labors and rustic pleasures that became both his strength and staple. These works were widely praised, engraved for magazines, and distributed as chromolithographs. However, as Thompson's work grew in popularity, so did it increase in nostalgia and sentiment: his later pictures included many "pencil ballads," illustrations of popular verses such as "The Old Oaken Bucket" and "Home, Sweet Home." In 1861 Thompson traveled west with his family, eventually buying a farm in Minnesota, but he maintained a studio address in New York and continued to paint until the end of his life.

During the 1850s Thompson returned again and again to subjects that combined his interest in both landscape and figures. He showed little inclination toward painting pure landscape. But unlike the genre painters William Sidney Mount (1807–1868) and George Caleb Bingham,* Thompson cast his subjects in natural settings so powerful that he confused some critics, who complained that his work was "neither landscape with figures nor figure composition with landscape; [n]or is it both."[4] But it is precisely this combination that enabled Thompson to portray an optimistic (if idealized) harmony between natural splendor and human activity. This balance between nature and civilization found perfect expression in the themes of harvests and picnics.[5]

In *Recreation*, Thompson describes a quiet, almost reverent, gathering near Mount Mansfield in Vermont. The landscape is decidedly not that of a wilderness; here nature is comfortable and accommodating, an oasis of repose. A group of people of similar age, most likely related by friendship, not family ties, relaxes at the base of a tree, ignoring the picnic fare spread before them. Their attention is variously drawn to the musician, to the landscape, to their own thoughts, or in the case of one couple who wanders off by the water, perhaps to the possibility of romance. Thompson has included a wealth of anecdotal and descriptive detail, from the wine jug that cools in a stream to the delicate rendition of grasses and flowers, but he unifies the picture with a silvery light that casts a crystalline glow over the scene. In praising this painting, one contemporary critic wrote:

> There is something exquisite in its hazy, dreamy distance, and the graceful lines of the far-off mountains.... It is a difficult thing in compositions like the "Recreation," to place figures in the foreground, without giving them undue prominence, and thus affecting, somewhat, the harmony of the picture. It is precisely in this point that Mr. Thompson excels. The grouping is tasteful.... One standing figure is beautiful.... Mr. Thompson works almost alone in the peculiar field he has chosen. He is no imitator, but a hard-working, painstaking, conscientious artist, in love with his art, and doing all he can to exalt it.[6]

S.M.

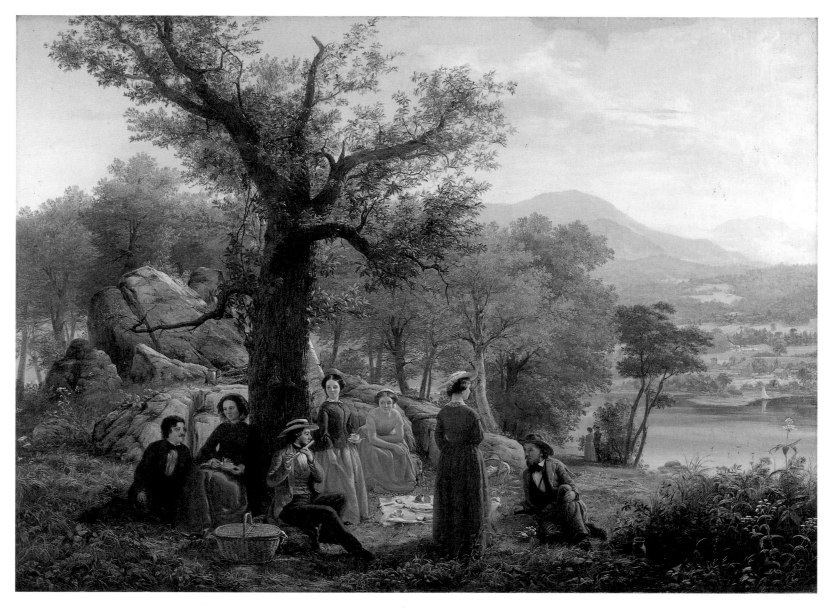

Recreation, 1857
Oil on canvas, 40½ × 56 in. Museum purchase, 47.13

John Frederick Kensett
Cheshire, Connecticut 1816–1872 New York, New York

John Frederick Kensett began his artistic career as a professional engraver in New Haven, New York, and Albany; in 1838 he had a painting accepted for exhibition by the National Academy of Design. In 1840, wishing to further his education in art, Kensett, like so many before him, traveled to Europe. For the following seven years, supported by money earned from engraving, Kensett took classes, visited museums, and sketched and painted throughout England and the Continent. In late 1847, preceded by a reputation established by landscapes sent to both the American Art-Union and the National Academy of Design, he returned to New York. For the remainder of his life Kensett depicted the favorite haunts of the Hudson River School landscapists—the Catskills, Adirondacks, White Mountains, and eastern coastal areas—and visited the West in 1870. Also like them, he sketched and painted directly from nature, taking his studies back to a New York studio where he turned them into more finished works of art. His paintings sold well.

Kensett was a strong advocate of the advancement of art in America. Not only an academician and many-time committeeman at the National Academy, he also served on numerous national and local councils and was a founding member of the Metropolitan Museum of Art.[1] The respect in which Kensett was held by his contemporaries is clearly expressed by the art critic Henry Tuckerman:

> Of all our artists, he has the most thoroughly amiable disposition, is wholly superior to envy, and pursues his vocation in such a spirit of love and kindliness, that a critic must be made of very hard material who can find it in his heart to say a severe, inconsiderate, or careless word about John F. Kensett.[2]

In the mid-1850s Kensett turned his attention from inner woodland subjects—the initial focus of his work—to the coastal areas of Rhode Island, particularly those of Newport; *Sunrise among the Rocks of Paradise* is an example of this change. Kensett was one of the first major landscapists to visit this seaside area, which had become more easily accessible by rail and road and, in a period of increased leisure time and recreation, was a newly favorite resort area.[3] In general, Kensett, as well as the other visiting landscapists, depicted the rocky cliffs of Newport where land, sea, and sky meet in a stark three-way confrontation. *Sunrise among the Rocks of Paradise*, however, represents the wet area of Paradise Rocks that lies behind the coastal promontory known as Hanging Rock;[4] a trip to this spot in nearby Middletown was a popular afternoon excursion from Newport.

With great fidelity to nature, Kensett has recorded the mire of grass, mud, and water and the weather-beaten ridges of rock that separate this marsh from the unseen ocean beyond. The blades of grass, drift of clouds, and multicolored lichens demonstrate Kensett's keen eye for detail, light, and texture. The artist also brought to his work his gentle personality. Not one for the visual grandeur and breadth of Albert Bierstadt* and Frederic Edwin Church,* Kensett sought, as Tuckerman said, "the simplest material [and] he has by his skill and feeling as a painter, taught us the beauty and poetry of subjects that have been called meagre and devoid of interest."[5]

J.S.

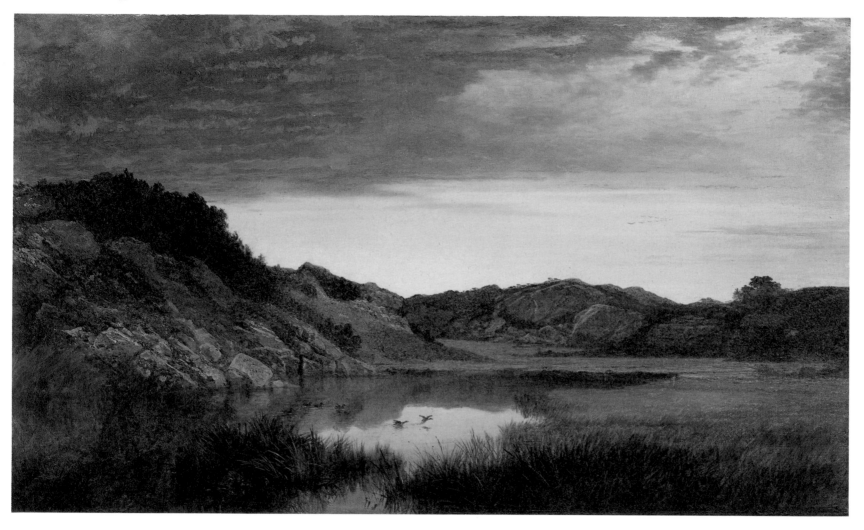

Sunrise among the Rocks of Paradise, Newport, 1859

Oil on canvas, 18⅛ × 30 in. Signed with initials and dated lower left: *JF K. 59.* Gift of Mr. and Mrs. John D. Rockefeller 3rd, 1979.7.69

William Rickarby Miller
Staindrop, County Durham, England 1818–1893 West Chester, New York

William Rickarby Miller trained primarily as a watercolorist, perhaps with his father, Joseph Miller, an art-shop proprietor, before immigrating to America in the winter of 1844–45.[1] First settling in Buffalo, New York,[2] he seems to have met with some difficulty in establishing himself. However, by 1848 he had settled in New York City and had received commissions for several watercolors from the American Art-Union. "Many things in America I like exceedingly, its climate is so superior to home, its chances of doing better, etc.," he wrote home to England.[3] Supplementing his independent work, Miller illustrated books and periodicals throughout the 1850s and 1860s.

After 1867 Miller spent much of his time traveling and sketching, in 1873 beginning work on a publishing project, "1,000 Gems of American Landscape," which failed to develop. From 1875 Miller became increasingly estranged from his family, due (it is said) to his temperamental nature and penchant for continual work.[4] Miller's memoirs (New-York Historical Society), however, are filled with poetry and plays and, along with his prose vignettes and stories, reveal, as one critic has noted, "a simplicity of soul, a genial humor, and an inherent love of nature and of music that are genuinely attractive."[5] Miller died while on a sketching trip in West Chester, New York.

Still-life painting in the mid-nineteenth century was generally held in low esteem as the province of amateurs; the artists' biographer Henry Tuckerman noted only one specialist, George Hall (1825–1913), in his massive 1867 *Book of the Artists*.[6] Yet a significant number of landscape artists turned to the subject at least once at midcentury, including Jasper Francis Cropsey,* Sanford Robinson Gifford,* John Frederick Kensett,* and Worthington Whittredge.* As with these better-known painters, landscapes predominate in Miller's oeuvre. But a dozen or so still-life paintings by him are now known, among them comparatively rare depictions of pineapples dating from the 1880s.[7] During the early 1860s, in fact, Miller evidently concentrated on still-life subjects; five of the six works he showed at the National Academy of Design in 1863 and 1864 were fruit pieces. It cannot be determined if *Still Life—Study of Apples* was one of these exhibited works, perhaps under the simple title of *Fruit* in 1863 or the more imaginative *Fruit—The Brothers* in the next year. But its Ruskinian finesse and polish reveal that Miller devoted considerable attention to the work—it stands as one of his most successful.

Still Life—Study of Apples shows four varieties of apples on a crisp white tablecloth. With snapped stem, torn leaf, and brown mottling, all have the weight and feel of specific objects seen with intense scrutiny. Miller, working at life scale, has carefully described each of the four apples with thin glazes of color, recording their eccentricities of form and texture, taking full advantage of the heightened vibrancy projected by the juxtaposition of the complementary colors of red and green.

The subject of the painting is four apples. Even if we note that the appeal of the work includes an imagined ability to feel, smell, and perhaps even taste these fruits, as well as to see them, the work seems a straightforward one. Many scholars have suggested, however, that an extremely simple still-life subject often masks more complex issues, including the complex play among reality, illusion, perception, and artifice. As the art historian Meyer Schapiro has noted:

> Still-life engages the painter (and also the observer who can surmount the habit of casual perception) in a steady looking that discloses new and elusive aspects of the stable object. At first commonplace in appearance, it may become in the course of that contemplation a mystery, a source of metaphysical wonder.[8]

Still Life—Study of Apples, through the dignity and sincerity of Miller's careful transcription of these natural objects, appears to partake in this noble mystery of objectivity.

M.S.

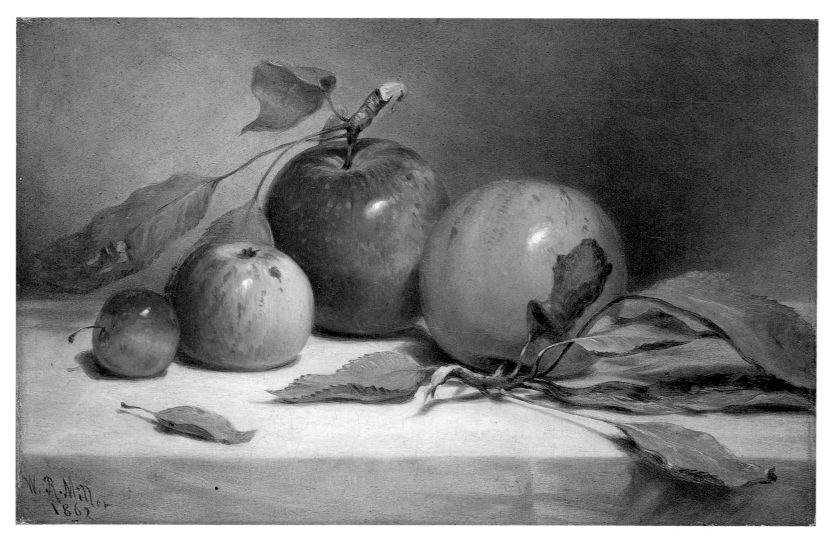

Still Life—Study of Apples, 1862

Oil on canvas, 8 × 12½ in. Signed and dated lower left: *W. R. Miller / 1862.* Bequest of Whitney Warren, Jr., in memory of Mrs. Adolph Spreckels, 1988.10.1

Charles Christian Nahl
Kassel, Germany 1818–1878 San Francisco, California

Born into an artistic family, Charles Christian Nahl was an accomplished watercolorist by the age of twelve. Studies at the Kassel Academy during the mid-1830s laid the foundation of his neoclassical style. Nahl contributed to exhibitions in Berlin in 1838 and Dresden in 1842 before moving with his family to Paris in 1846. There he discovered the vivid colors of the Flemish artist Peter Paul Rubens (1572–1640) and had the opportunity to work with the French historical painter Horace Vernet (1789–1863).[1] The Nahls moved again in 1849, leaving Europe and settling in Brooklyn, but soon the family was lured to the West by the promise of gold. Arriving in California in 1851, they briefly and unsuccessfully worked a claim outside Marysville before abandoning the miner's life and moving to Sacramento. There Nahl set up a studio with August Wenderoth (1819–1884) and began producing lithographs, wood engravings, and newspaper illustrations. When fire destroyed Nahl's home and studio, the family moved to San Francisco, where Nahl executed portraits as well as illustrations and designs for certificates.

An accomplished and prolific draftsman, during the 1860s and 1870s Nahl was rarely at a loss for work. Showing no interest in landscape painting, he preferred complex allegorical or historical compositions. For such works he won the patronage of Judge E. B. Crocker, who commissioned from him a number of subject pictures, the most famous being *Sunday Morning in the Mines* (1872; Crocker Art Museum, Sacramento) and the most infamous being the 1870–71 series of three paintings *The Rape of the Sabines* (The Fine Arts Museums of San Francisco).[2] Unlike his colleagues Thomas Hill,* Albert Bierstadt,* and William Hahn,* Nahl did not send his works to East Coast exhibitions after his move to California. Although he exhibited regularly at the Mechanics' Institute in San Francisco, he did not join the various artists' associations or social clubs that were organized in the early 1870s. His pioneering role in California art, however, was recognized and respected from an early date, and his obituary in the *San Francisco Chronicle* noted that he was "distinguished alike for his attainments and his efforts to create a field of art when California was more of a wilderness than a cultivated and thriving state."[3]

Portraiture played a central role in Nahl's career, providing a steady stream of commissions that ensured his artistic as well as financial survival during the 1850s. As orders increased, Nahl's studio assumed the air of a production shop: Nahl's half-brother, Arthur, who joined his studio on the departure of Wenderoth, wrote to a relative in 1858, "We are working like a factory; Carl [Charles] paints the heads and I paint the garments."[4] The Nahl Brothers studio provided photographic as well as painted portraits; sometimes the line between the two was indistinct.[5] Many of Nahl's portraits appear to be based to a greater or lesser degree on photographs; still, when at his best, Nahl's talent as a still-life painter and his skill at rendering textures and fabrics readily overcame the inherent stiffness of the photographic medium.

Among the most ambitious of Nahl's portraits, and one that embodies both the strengths and limitations of his European-based academic style, is his 1867 *Sacramento Indian with Dogs*. Despite the hard, brilliant color and certain contrived effects, such as the shadows around the lower edges of the composition that suggest stage lighting, Nahl achieves a successful integration of a posed studio likeness with a composed landscape background. The crisply defined, exquisitely finished details of foliage and animal life in the foreground gently give way to a softened, atmospheric landscape suggesting the Sacramento River valley. Little is known of the sitter, called "Wahla" and described as chief of the Yuba (or Yubu) tribe of the Southern Maidu Indians.[6] By 1867 Wahla was attached to the household of Milton S. Latham, California's governor in 1860 and a United States senator from 1860 to 1863. Wahla was perhaps Latham's protégé, but more likely a trusted and valued personal servant.[7] Dressed as a white man, the Indian is still consigned to the natural domain of landscape and animals, his domestication echoed by the spotted coach dogs who proudly display Latham's name on their silver collars. Wahla's stiffness may not be entirely the result of his original sitting in the Nahl studio; it may reflect his curious position between two worlds.

S.M.

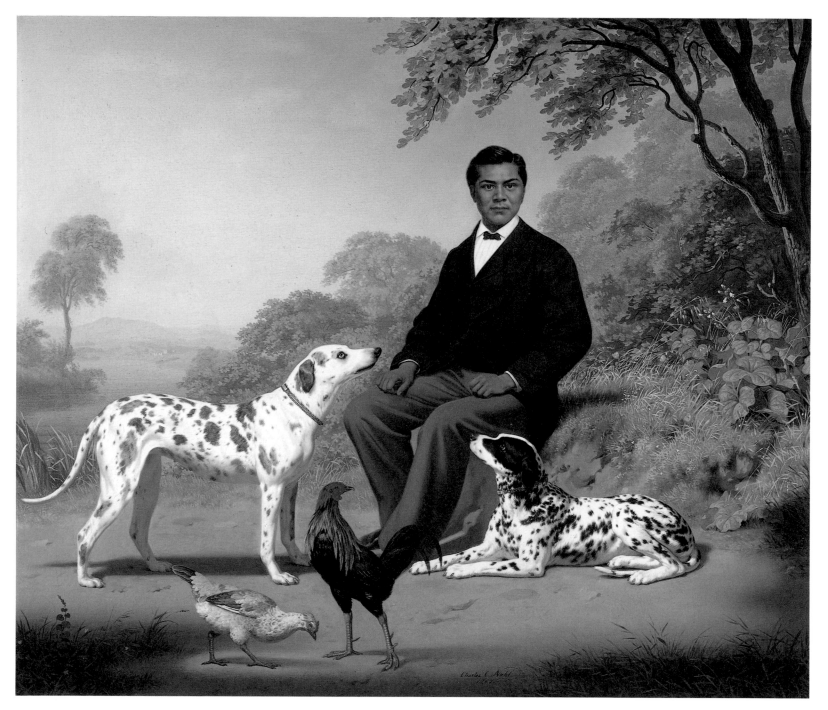

Sacramento Indian with Dogs, 1867

Oil on canvas, 42 × 49¼ in. Signed and dated lower center: *Charles C. Nahl. / 1867.* Gift of Mrs. Milton S. Latham, 41988

Martin Johnson Heade
Lumberville, Pennsylvania 1819–1904 Saint Augustine, Florida

An artist who, even in a peripatetic age, had seen more of the world than most,[1] Martin Johnson Heade grew up in rural Pennsylvania and received training in art from Thomas Hicks (1823–1890) and his cousin, the folk painter Edward Hicks (1780–1849). Heade spent a large part of his long career on the move. During the 1840s and 1850s alone, he made two lengthy sojourns in Europe and had various stays in New York; Trenton, New Jersey; Philadelphia; Saint Louis; Chicago; and Providence, Rhode Island. He finally established his studio in New York in 1859. Although Heade's earliest paintings are primarily portraits with a few genre and allegorical works, the artist shifted his attention during the following two decades to the subjects for which he is best known today—still lifes and landscapes.

Despite an active life, Heade was not an artist who played a leading role in the contemporary art scene. A good friend of a ranking academician, Frederic Edwin Church,* Heade did not become a member of the National Academy of Design nor did he join popular clubs. An ardent conservationist, he was a frequent contributor to the magazine *Forest and Stream* (precursor to *Field and Stream*) under the pseudonym Dedymus. Fascinated with nature, Heade found inspiration in his continuing travels to South America, Central America, Jamaica, California, and the coastal areas of Rhode Island and Massachusetts.

In 1885, after having spent four years in Washington, D.C., Heade moved for the last time and settled in Saint Augustine, Florida. There, at the close of his prolific career, he concentrated on depicting the nearby marshlands and indigenous Cherokee rose and magnolia. Although one of nineteenth-century America's more versatile painters, Heade was never honored during his own life and died in Saint Augustine all but forgotten by the art world.[2]

Most of Heade's portraits date from the early, itinerant years of his career. The San Francisco portrait can be identified as a posthumous likeness of Allen Clapp (1768–1851),[3] superintendent of the Pennsylvania Hospital in Philadelphia from 1840 to 1849. A family history records that Clapp "was noted for his fine presence and courtly manners, and was considered the gentleman of the family, *par excellence*."[4] An obituary further noted that "the deceased was a worthy member of the Society of Friends and highly esteemed by all who had any intercourse with him as a most amiable, benevolent and kind hearted man."[5]

J.S.

Allen Clapp, 1854
Oil on canvas, 29 × 24½ in. Signed and dated lower right: *M. J. Heade / 1854*
Gift of Mr. and Mrs. John D. Rockefeller 3rd, 1979.7.50

Martin Johnson Heade
Lumberville, Pennsylvania 1819–1904 Saint Augustine, Florida

On his three trips to South America and Jamaica, Martin Johnson Heade found inspiration for subjects that today number among his most highly admired—orchids and hummingbirds. In 1863, on his first sojourn in Brazil, Heade observed and painted various species of native humming-birds, hoping to publish his work in a fully illustrated volume to be entitled "The Gems of Brazil." Although he completed several represen-tations of the iridescent birds in their tropical habitat, Heade's plan for a quarto chromolithographic album was never fulfilled.[1] It was not until 1871, on his return from Jamaica with sketches of orchids, that Heade combined depictions of hummingbirds and flowers. *Orchid and Hummingbird* exemplifies this subject, which he was to explore for the remainder of his career.[2]

In the foreground of a lushly vegetated, vaporous mountain landscape, Heade presents a Heliodore's Wood Star hummingbird, perched on the waxy leaf of a blooming cattleya orchid.[3] With almost a taxonomist's eye for shape, detail, and color, Heade depicts the distinctive foliage and plumage of flower and bird alike. His keen observations of the orchid's frilled petals, the color variegation of its pods, and even the lustrous projecting gorget of the hummingbird make possible the identification of these species. Not mere biological illustration, however, the image's saturated tints, heavy atmosphere, and dense plant life also suggest the fecundity of the rain-forest environment and create a visual richness.

Both hummingbirds and orchids were organisms that commanded growing followings among nineteenth-century botanists and scientists.[4] While each was the subject of careful examination, the appeal of the flowers during the 1830s and 1840s led to what has been called an orchid mania.[5] Large and lavishly illustrated botanical treatises on the plant ap-peared at the same time that its flower became the consuming interest of many amateur horticulturalists. Yet, current as the subject was within the scientific community, orchids did not appear in the popular literature or flower books of the time,[6] nor did Heade's canvases receive much critical attention. Recently scholars have suggested that knowledge of the Greek root for the flower's name—*orchis*, meaning "testicle"—caused unease within conservative Victorian circles, as did the flower's well-known use during antiquity as an aphrodisiac.[7] Other objections to the orchid may have been prompted by the vaginal shape of the blossom and phallic form of its seed-bearing pods. Furthermore, both orchid and humming-bird thrived in the lush environment and steamy atmosphere of the tropics. Although by joining landscape and still-life elements Heade intro-duced a new subject to American art, the sexual associations as well as the qualities of visual richness that have made these paintings so admired today may also have made them unmentionable to his contemporaries. Unnoticed during his own life, paintings such as *Orchid and Hummingbird* reveal the private concerns of this rather nonconforming painter.

J.S.

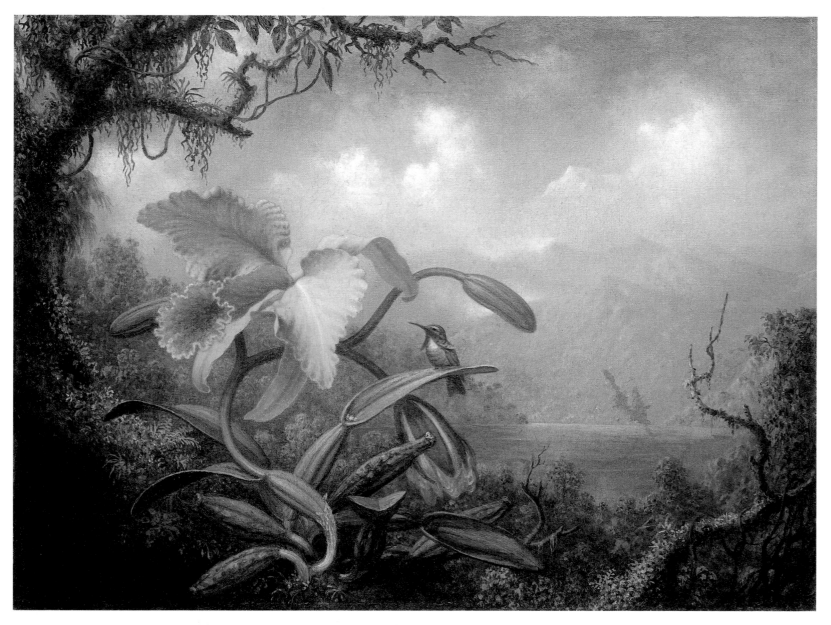

Orchid and Hummingbird, ca. 1885

Oil on canvas, 15⅛ × 20¼ in. Signed lower right: *[M.] Heade.* Gift of Mr. and Mrs. John D. Rockefeller 3rd, 1979.7.49

George Henry Durrie

Hartford, Connecticut 1820–1863 New Haven, Connecticut

Although he studied with the portraitist Nathaniel Jocelyn (1796–1881) and began his own career as an itinerant portrait painter, George Henry Durrie gained his greatest fame as a painter of New England winter scenes. One of the foremost practitioners of this specialized genre in the nineteenth century, Durrie's visions of all seasons frequently incorporate landscape elements from the area surrounding New Haven, Connecticut, where he lived most of his adult life. Populating the foreground of these scenes is an apparently interchangeable vocabulary of genre and architectural elements that recurs in paintings throughout his mature career. In spite of the beauty of his works, Durrie's contemporary reputation was primarily local. From 1861 to 1867, however, the New York lithographers Currier and Ives published reproductions after ten of his compositions, several purchased from the artist's estate expressly for the purpose. This popular dissemination through the lithographic medium established Durrie's idyllic vision of rural America in the nation's collective memory.

Winter in the Country is an effective image of old-time New England, combining the bracing snap of a clear winter's day with closely observed genre activities. The inn yard bustles with life: comfortable patrons congregate and depart; horses are tended in the barn; a mixed team of horse and oxen pulls the wood sled through the snow. Overarching all is a luminous, cloud-filled sky, delicately touched with pink and gold to echo the dominant colors of the architecture below. The painting is among the most detailed of the artist's works, with each twig and clapboard defined and every icicle on eave or sill a carefully twisted strand of turquoise and white paint. Durrie's use of a restricted, mute palette—composed primarily of pale yellow, dusty red, and an icy blue-green, along with white,

black, and brown—unifies these diverse elements into a convincing, atmospheric whole. Such concern with finish in *Winter in the Country* is a display of virtuosity unusual in Durrie's career. It might be explained by noting that in 1857, the year of the work, the artist used a portion of his patrimony to establish himself in New York City; it seems likely that the care lavished on the painting reflects his expectation of a more discriminating audience. Unfortunately, the experiment was unsuccessful and after only a year he returned to New Haven. Even so, *Winter in the Country* did find admirers. In 1859 the New York artist John Henry Whitney (1840–1891) made a direct copy of it.[1] Soon thereafter the collector Theodore Irwin of Oswego, New York, purchased the painting; it remained in his family until it entered The Fine Arts Museums' collection in 1985.[2]

The years of Durrie's greatest activity, those just prior to the Civil War, coincided with the increasing industrialization of the North and the decline there of an agrarian way of life. Many artists and patrons responded to this socioeconomic change with images of increasing innocence and simplicity—genre paintings of children, for example, or tidy and shining scenes of the frontier.[3] Durrie's modest, comfortable vision is one version of this popular mythmaking about rural life and its rituals. Rather than attempting to record the often harsh realities of mid-nineteenth-century America, his images of country life are consciously pastoral—ordered, well-tended, and idealized in the fashion of a fond memory. As early as 1860 a commentator noted the nostalgia inherent in these works: "The frozen pond and boys skating, with woods and mountains in the distance. It is a capital sketch, and makes one sing—'Oh, would I were a boy again!'"[4]

M.S.

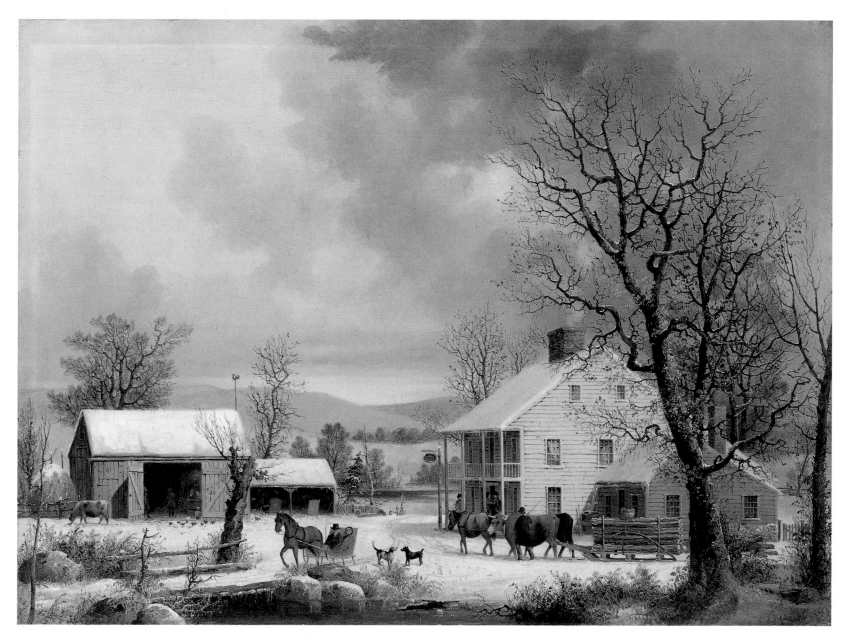

Winter in the Country, 1857

Oil on canvas, 18 × 24 in. Signed and dated lower left: *G. H. DURRIE / 1857*. Museum purchase, Roscoe and Margaret Oakes Income Fund, 1985.47

Worthington Whittredge
Springfield, Ohio 1820–1910 Summit, New Jersey

Born in a log cabin on what was then the western frontier, Worthington Whittredge left his family's farm at seventeen in order to learn house and sign painting in Cincinnati. A peripatetic early career that included taking daguerreotypes in Indianapolis and painting portraits in Charleston, West Virginia, culminated in 1843 with his resolve to become a landscape painter. In 1846 Whittredge submitted a landscape to the National Academy of Design in New York, where it was accepted and warmly praised by the academy's president, Asher B. Durand (1796–1886). Proud of the recognition accorded the young artist, in 1849 a group of Cincinnati patrons, through commissions and direct support, sent Whittredge to study in Europe. There he settled in Düsseldorf, working closely with Emanuel Leutze (1816–1868), Andreas Achenbach (1815–1910), Albert Bierstadt,* and William Stanley Haseltine.* In 1854 Whittredge sojourned in Italy. Only in 1859, after ten years abroad, did he return to the United States.

Whittredge soon came to play a major role in the art life of New York City—he was elected an academician of the National Academy of Design in 1861 and served as its president from 1874 until 1877. Yet after his years in Europe, Whittredge felt himself to be at a creative impasse. He later wrote in his *Autobiography:*

> Frankly, I doubt the desirability of long foreign study.... It was impossible for me to shut out from my eyes the works of the great landscape painters which I had so recently seen in Europe, while I knew well enough that if I was to succeed I must produce something new and which might claim to be inspired by my home surroundings.[1]

During sketching trips in the Catskills and throughout New England, Whittredge searched for inspiration for a new and distinctly American school of landscape painting. He finally found this subject matter in 1866, when he made the first of three journeys to the American West. The experience was crucial for the artist. Almost forty works in oil resulted from this and his two subsequent trips—one with Sanford Robinson Gifford* and John Frederick Kensett* in 1870 and another by himself in 1871. Through the decade of the 1870s, Whittredge continued to paint critically acclaimed paintings based on his western sketches.

Whittredge's approach to western scenery was considerably different from that of such colleagues as Albert Bierstadt* and Thomas Moran.* Rather than concentrating on the vertical in the landscape—towering mountains, sheer rock cliffs, cavernous canyons—Whittredge was deeply impressed with the open expanse of the plains—the horizontal element of the view. He wrote: "I had never seen the plains or anything like them. They impressed me deeply. I cared more for them than for the mountains . . . [and] could hardly fail to be impressed with [their] vastness and silence and the appearance everywhere of an innocent, primitive existence."[2] And the artist described his sense of wonder at the openness of the western landscape: "Nothing could be more like an Arcadian landscape than was here presented to our view. . . the earth covered with soft grass waving in the wind, with innumerable flowers often covering acres with a single color as if they had been planted there."[3]

In *On the Cache la Poudre River, Colorado* Whittredge uses a stand of aged cottonwood trees to frame and limit the view of the plains—a scene about fifty miles north-northeast of Denver, with the towering Rockies melting into the air in the distance. Although the painting is inscribed on the back with the date 1868, scholars now feel that the work was in fact done on the third of Whittredge's western trips, in 1871.[4]

The physical evidence of the work—pinholes on the edges of the canvas, the free handling of the paint, and its light palette—indicates that *On the Cache la Poudre River* was begun and largely finished in one sitting in the out-of-doors, wet paint touched into wet paint. Since Whittredge was a self-proclaimed Hudson River School painter,[5] his strategy in dealing with the immensities of the West is especially interesting. Here, focusing on the trees and extending their limbs to the top edge of the canvas, Whittredge encloses the panorama, creating, as the art historian E. P. Richardson has noted, "his own quiet poetry of light, his distinctive note of silence and repose."[6]

M.S.

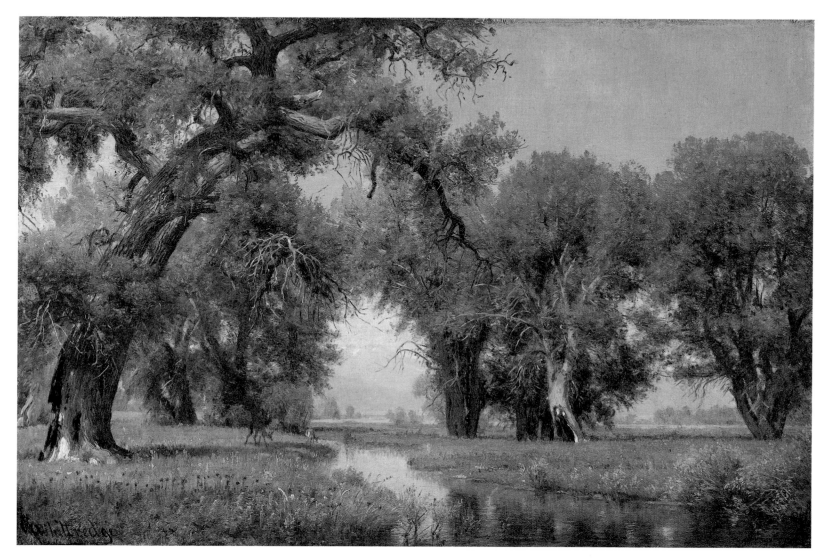

On the Cache la Poudre River, Colorado, 1871

Oil on canvas, 15⅛ × 22¾ in. Signed lower left: *WWhittredge.* Museum purchase, Roscoe and Margaret Oakes Income Fund, 1986.39

George Fuller

Deerfield, Massachusetts 1822–1884 Brookline, Massachusetts

Although his fame dwindled in the century following his death, George Fuller was a visionary who late in his career became one of the most highly acclaimed American figurative painters. The son of a farmer, Fuller left his family to study drawing and painting in Albany, Boston, and New York. He entered the National Academy of Design as an associate in 1852 and worked with minor success as an itinerant portraitist in New England and the South. Having discovered in Alabama "many fine subjects for study in the Negroes, . . . women ploughing, [and] . . . men chopping & burning,"[1] Fuller began to shift his painting interests toward genre and figurative subjects. In 1860 he sojourned in Europe for six months, studying the Old Masters and the work of such French painters as Jean-François Millet (1814–1875) and Edouard Frère (1819–1886). That same year, owing to the death of his father in 1859, Fuller returned to Massachusetts to assume responsibility for the family farm in Deerfield. For the next sixteen years he devoted himself to the land and to his family, continuing to paint landscapes and figures for his own pleasure. In 1875 the Fuller farm faced bankruptcy due to a depression and fall in agricultural prices, and the next year Fuller sent several new works to Boston. Their exhibition generated both sales and critical approval. For the short remainder of his career, Fuller exhibited in Boston and New York his evocative scenes of Puritan or peasant women and gypsy girls in atmospheric rural settings. Critics praised the poetic and idealistic sensibilities evident in these paintings; one of them, writing shortly before Fuller's death, summed up the artist's appeal: "His imagination is not of a powerful kind. His poetry is seductive, not compelling; idyllic, not passionate; marks him a dreamer, not a seer. But it is true poetry, and proper to himself alone."[2]

Among the works acknowledged as Fuller's best is *Girl and Calf*,[3] painted in the last year of the artist's life. A young woman stands barefoot in a barren field at twilight. Clad in a fanciful garment, with gold hoops in her ears and coins suspended from her necklace, her hair loosening and gently blowing in the breeze, she idly holds a switch in one hand and the lead of her calf in the other. As if unconcerned with her present task, the girl lifts her eyes and gazes wistfully beyond the viewer, psychologically transported into another, perhaps more elevated, world. Alone with her thoughts and the empty landscape, this sturdy yet poetically rendered young woman recalls the peasants ennobled by French painters such as Millet and Jules Breton (1827-1906).[4] But it is not her labor, but rather her yearning, soulful gaze and attitude that so elevate this rural woman.

Abandoning the sharp detail and smooth finish of his early works, Fuller developed during the late part of his career a rather unorthodox method of painting reminiscent not only of Barbizon mists, but also of the rich glazes of seventeenth-century Venetian painters and the crusty pigments of late Rembrandt (1606–1669). With successive layers of liquid and scumbled tinted glazes, and areas, such as the bodice of the peasant's dress, punctuated by the end of a brush, *Girl and Calf* exemplifies Fuller's heavily worked images of nebulous forms and mysterious mood. The muted harmony of brown, rust, and golden tones, as well as the shadowy atmosphere that envelops the scene, contributes to the air of otherworldliness and introspection. Such softened forms, restricted color schemes, and general unity of tone and brushwork are typical of several later nineteenth-century American artists such as George Inness (1825–1894), Ralph Albert Blakelock,* and Albert Pinkham Ryder,* who sought an idealized, even spiritual expression in their art. Rather than a literal description of a narrative or landscape, these artists worked toward an art of suggestion and poetic mood.[5] Fuller described this intent to a reporter while he was still at work on *Girl and Calf*:

> What shall I make of it? I don't know yet. The subject is all there, of course, but what is the subject in a picture? Nothing. It is the *treatment* that makes or mars. . . . "A Girl and a Calf"—what is that? We have all seen such figures a thousand times, and taken no interest. It is my business to bring out something the casual eye does not perceive—to accentuate, to interpret.[6]

Fuller's representations of peasant girls and Puritan subjects often carry strong overtones of purity and sentimentality and have been interpreted frequently as nostalgic yearnings for a way of life quickly disappearing from New England.[7] But Fuller's depictions of black farm workers, half-castes, and gypsies[8] are tinged with an ambiguous exoticism, suggesting the artist's sympathy with the dispossessed. The identity of the young woman in Fuller's *Girl and Calf* remains unknown, as does the significance of her unusual costume and jewelry. Yet the very ambiguity of the girl's race, livelihood, and expression serves Fuller well, allowing layers of poetic associations to accrue to the image just as the artist himself layered successive glazes and tints to his canvas.

S.M. / J.S.

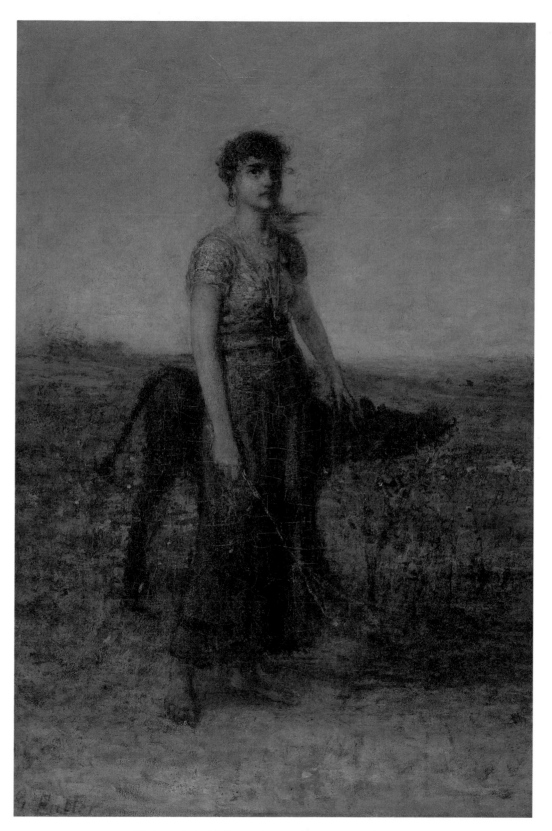

Girl and Calf (Led through Meadows), 1883
Oil on canvas, 53½ × 35¾ in. Signed lower left: *G Fuller*. Mildred Anna Williams Collection, 1942.20

Thomas Waterman Wood
Montpelier, Vermont 1823–1903 New York, New York

As one of numerous American artists well known during the nineteenth century for their depiction of genre subjects, Thomas Waterman Wood is remembered today especially for his representations of black people and rural laborers. Wood was essentially self-taught as an artist, except for a brief period of study in the Boston studio of the portraitist Chester Harding (1792–1866). He spent several years working as a painter in the slave states of Maryland, Tennessee, and Kentucky. Although he began his career as a portraitist, Wood turned increasingly to genre scenes during the years prior to the Civil War and received high critical commendation for many of the works drawn from his experiences in the South. In 1866 Wood established a studio in New York, later helping to organize the New York Etching Club and acting as president of the American Watercolor Society. That Wood completed his artistic career as president of the National Academy of Design from 1891 to 1899 testifies to his high professional standing.[1]

Moses, The Baltimore News Vendor dates from 1858, the last of three years that Wood spent in Baltimore. A work that marks his shift from portraiture to genre painting, it portrays Moses Small (d. 1861), a free black who was particularly famous in antebellum Baltimore.[2] According to an article published in *Lippincott's Magazine* on the "monuments" of Maryland's capital, Moses delivered to "the doors of citizens of credit and renown the damp and limber tidings of the day, as they came fresh from the rattling presses of the *Gazette*, *American* and *Patriot*—journals of orthodox and standard respectability."[3] In praise of the newspaper carrier's gentlemanliness and decorum, the author states that Moses "ennobled a humble sphere with the dignity of his self-respect, refined vulgar offices by the delicacy of his doing them, and imparted to the homeliest business the charm of his own fidelity, cheerfulness and patience."[4]

In Wood's painting, Moses rests a stack of *Baltimore Patriot*s on his left arm (additional issues appear folded in his deep coat pocket), tips his old white hat, "that badge of grateful courtesy,"[5] and cogenially greets his next customer—the viewer. Giving Moses a natural pose and open expression, Wood has sympathetically personified the cordiality for which Moses was so beloved.

Wood's personal papers document the early history of *The Baltimore News Vendor*. A datebook entry for 6 January 1858 records a twenty-five-cent payment to Moses, presumably a modeling fee.[6] Wood's ledger for 20 April of the same year then records the sale of the painting, together with three other works depicting free blacks, to the wealthy Baltimore merchant John C. Brune.[7] Brune's payment was not received until 2 July, and when Wood sent *The Baltimore News Vendor* to the 1858 spring exhibition at the National Academy of Design—his first showing at the institution over which he would eventually preside—a misunderstanding arose that allowed Robert L. Stuart, a New York sugar refiner and art collector, to purchase the work. Only after an expensive legal suit was Brune able to reclaim his property.[8] Before turning over the painting, however, Stuart commissioned James Henry Cafferty (1819–1869) to make a replica after the original (1860; New York Public Library on permanent loan to the New-York Historical Society).[9]

Moses, The Baltimore News Vendor exemplifies the increasing presence of black people in nineteenth-century American painting. The issue of blacks and their place in American society stood at the heart of a growing national controversy; in 1858 free blacks in Maryland—a slave state that supported the Union cause—were the focus of attention from both sides. The attendant stereotypes necessarily influenced artistic portrayals of these people. Thus Moses's compliant, cordial attitude and the anecdotal quality of Wood's image may suggest the sentimentalization of black people common at the time, as well as the qualities most palatable to white audiences. Yet the artist also penetrated beyond these conventions —the naturalism and sympathy with which Wood depicted the hardworking news vendor ultimately reflect his respect for the man's dignity and humanity.

J.S. / S.M.

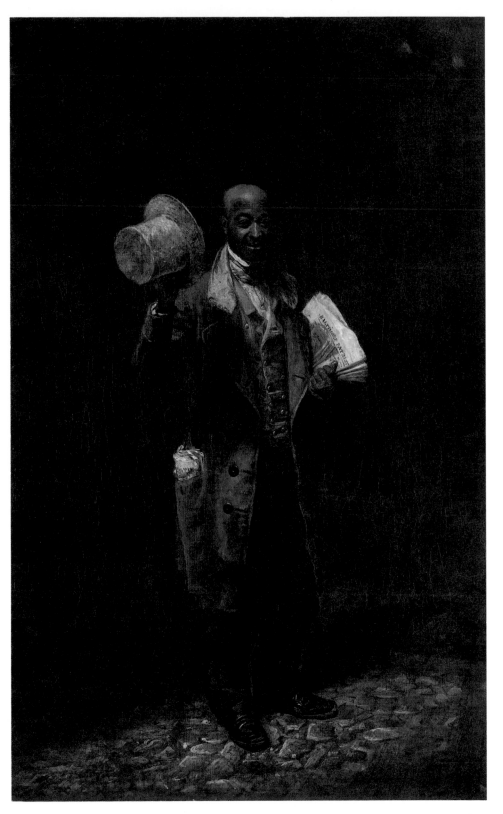

Moses, The Baltimore News Vendor, 1858
Oil on canvas, 24⅛ × 15 in. Signed and dated lower right: *T. W. WOOD. / 1858.*
Mildred Anna Williams Collection, 1944.7

Jasper Francis Cropsey
Rossville, New York 1823–1900 Hastings-on-Hudson, New York

Mr. Cropsey is one of the few among our landscape painters who go directly to nature for their materials. For one so young in his art, his attainments are extraordinary.... He carefully analyses all the truths, which of course include the beauties of nature, and garners up what he thus laboriously acquired for use hereafter.[1]

With such praise the popular press of the mid-nineteenth century recognized the artistic achievements of the twenty-three-year-old Jasper Francis Cropsey as a landscapist. It was during this period of developing interest in American nature that Cropsey left his architectural practice, his initial professional pursuit, and in 1843 took up a career in painting. Although largely untrained in his art, Cropsey adhered to the doctrines laid out by Thomas Cole (1801–1848) and Asher B. Durand (1796–1886). He based his scenes of the natural world, presented in finished studio works such as *View of Greenwood Lake, New Jersey*, on the careful scrutiny and constant sketching of the outdoors. His success was such that at the age of twenty-one he was elected to the National Academy of Design. To broaden his artistic background, Cropsey spent two years making his grand tour of Europe in 1847 and 1848. He resumed his work in New York, teaching, traveling, sketching, and specializing in pastoral scenes of autumn. A second sojourn in England from 1856 to 1863 proved successful when the British, impressed by the colorful spectacle of American autumnal foliage in Cropsey's scenes, eagerly purchased his works. Finally, settling permanently in the New York area, Cropsey not only continued to paint fall landscapes but also devoted time to watercolors and his earlier architectural interests. At the close of the century, however, Cropsey's vision of American man and nature coexisting in universal harmony no longer satisfied the critical art community. With the other members of the Hudson River School, he slipped from public favor.

Of the various sites Cropsey sketched, the place to which he returned most frequently was Greenwood Lake.[2] Located some twenty-three miles west of the Hudson River, the lake was first visited by Cropsey in 1843; he later wrote, "I lived at the Greenwood Lake during the summer for a number of years and found a strong attachment to the place. It has been the origin of many of my pictures. It is a beautiful sheet of water."[3]

Cropsey was not alone in his affection for the spot. According to travel guides of the period, Greenwood Lake was on a par with Cape May, Atlantic City, and Long Branch as a popular resort[4] and was

a very agreeable jaunt from the metropolis [of New York], whether for the pure air of the hills, the pleasant aspect of nature, or for the sports of the angle and the gun.... It is a beautiful water of seven miles in extent, and all about it, in every direction, are lesser but scarcely less charming, lakes and lakelets, some of which, as you ride or ramble over the country, delight your surprised eyes, where least dreamed of.[5]

View of Greenwood Lake dates from early in Cropsey's career and is one of his first representations of this favored site. Closely related to a pen-and-ink sketch drawn from nature (1843; Cleveland Museum of Art), this work may also be related to the painting of the same subject, now unlocated, that Cropsey showed at the National Academy in 1844 and for which he was elected an associate.[6]

This spacious view overlooks the valley from the north end of the lake. Crisply detailed in the foreground, atmospheric in the distance, carefully framed by the leaning pines at the right, and designed around the receding diagonal of the lake, Cropsey's painting depicts the pastoral harmony of man and nature in mutual accord. Within the foreground wilderness of jagged rocks and blasted trees, a man and his dog pass through the broken sunlight. The valley floor, dotted with houses, lies beyond the ridge on which they walk, and the lake itself is nestled between the receding lines of mountains, creating a panoramic vista of tremendous depth. At this time of growing national prosperity, Cropsey's countrymen perceived both the majesty and primeval nature of their landscape as a symbol of their nation's untapped promise and the agrarian harmony with the land as a record of that promise fulfilled. Juxtaposing untouched forests with tamed farmland, where neither man nor nature dominates, Cropsey celebrates in *View of Greenwood Lake* the idyllic dream of peace, plenty, and optimism so strongly held by Americans at mid-century.

J.S.

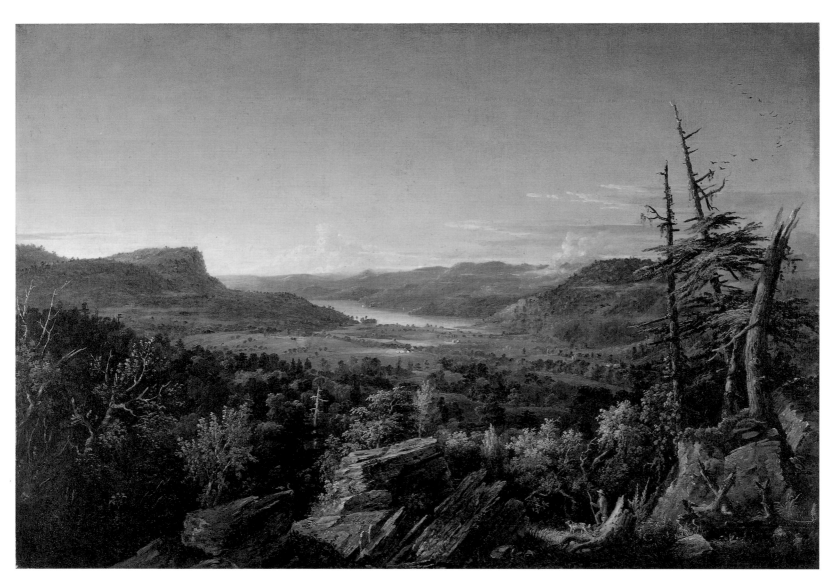

View of Greenwood Lake, New Jersey, 1845

Oil on canvas, 30¾ × 40¾ in. Signed and dated lower right: *J. F. Cropsey / 1845*. Gift of Gustav Epstein, 45.24

Sanford Robinson Gifford
Greenfield, New York 1823–1880 New York, New York

Nineteenth-century eulogists of Sanford Robinson Gifford referred frequently to his thorough originality, keen intelligence, and the near perfection of his character, citing his as one of the principal landscape talents of the age. Son of a wealthy factory owner, Gifford attended Brown University for two years before deciding in 1845 to study full time in New York City under the portraitist John Rubens Smith (1775–1849). A summer sketching tour near his family's home in Hudson, New York, however, diverted his attention to landscape painting. He wrote in retrospect:

> During the summer of 1846 I made several pedestrian tours among the Catskill Mts. and the Berkshire hills, and made a good many sketches from nature. These studies, together with the great admiration I felt for the works of [Thomas] Cole developed a strong interest in Landscape Art, and I opened my eyes to a keener perception and more intelligent enjoyment of Nature. Having once enjoyed the absolute freedom of the Landscape painter's life, I was unable to return to portrait painting. From this time my direction in art was determined.[1]

His work found a broad and enthusiastic audience almost immediately. One painting was the prize of the American Art-Union lottery in 1847, and others were exhibited at the National Academy of Design in the same year and nearly annually thereafter. In 1850 he was elected an associate of that institution and a full academician in 1854.

A widely traveled man, with European sojourns in 1855–57 and 1868–69 and trips across the American West in 1870 and 1874, Gifford painted locales stretching from Istanbul to Mount Rainier. His contemporary Worthington Whittredge* described Gifford's working method while on this seemingly insatiable search for nature:

> He would frequently stop in his tracks to make slight sketches in pencil in a small book which he always carried in his pocket and then pass on, always suspicious that if he stopped too long to look in one direction the most beautiful thing of all might pass him by at his back.[2]

No matter the terrain, however, Gifford noted that his primary purpose was to "reproduce the impressions made by the harmonies of nature," asserting later that, "the really important matter is not the natural object itself, but the veil or medium through which we see it."[3] Although the majority of his works are based on observable sites, their real subjects are the responses of the artist's serene and poetic sensibility to the atmosphere and mood of a scene. In many instances, the finished painting of a spot would postdate Gifford's visit by years, being based on his sketches, studies, and memories. This is surely the case with the artist's *Windsor Castle* of 1860.

Gifford first went to Windsor, England, on 9 July 1855 as an early stop on his first grand tour of Europe. His journal of the trip—actually a document that served double duty as journal and as a series of informative letters home—records that on that first evening

> I made a sketch of the castle from "Datchett Mead" in the home park. "Datchett Mead" you remember was the place where the merry wives of Windsor got Falstaff a ducking. It was quite light while I was sketching, viz, 9 o'c. Twilight does not entirely fade till 10, or later.

With lines from Shakespeare rising to his consciousness, the artist stayed in Windsor for the next several days. He wrote of 11 July:

> In the evening we had a fine sunset, and I enjoyed a walk up the Thames. . . . There was a fine "effect" on the castle just before sunset. It crowns a bluff, and at this time its regal towers and battlements were relieved in the warm sunlight against the sullen gray of the clouds behind them: high over them arched a brilliant rainbow.[4]

Two themes apparently occupied the artist while he was at Windsor—the crenellated, multiturreted castle and crepuscular light effects. It is not surprising, then, that when he returned to the United States in September 1857, these two elements recurred in the works he based on his sketches.[5]

In *Windsor Castle* Gifford devotes the top third of the canvas to a spectacularly colored sky that shades from a deep blue at the top to a brilliant yellow at the roof line of the castle. Across the middle of the canvas the masses of the castle are lost in shadow; only the accurately depicted silhouette of the north front identifies the fortress atop its bluff. Off to the left a bank of pink-orange clouds meets and continues the line of the land. In the foreground the dark and quiet Thames reflects the distant shoreline, while figures walk along the nearer shore in the dawning light. The vision is consciously pastoral, with little visible trace of the modern industries that in fact flanked the royal preserve.[6] This is the stately and glorious Windsor of England's storied past, but presented, as the contemporary critic Henry Tuckerman was to characterize all of Gifford's work, as "an harmonious effect and impression . . . minister[ing] to our most gentle and gracious sympathies, to our most tranquil and congenial observation."[7]

M.S.

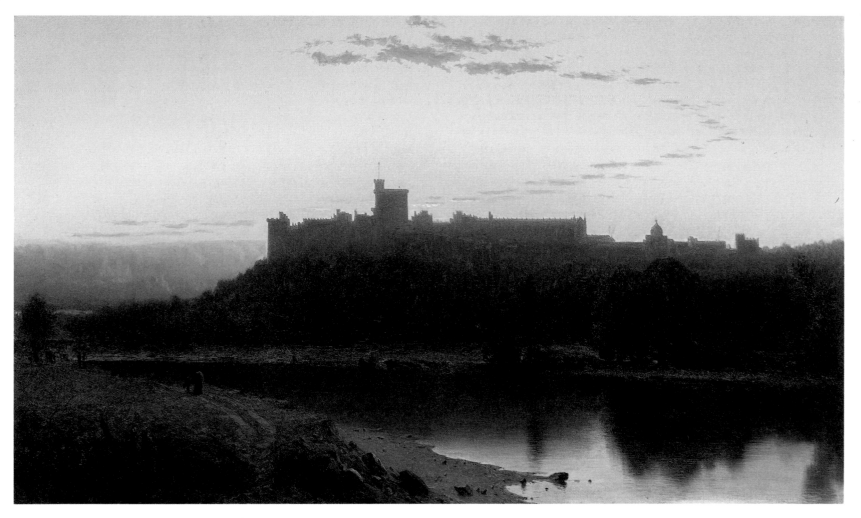

Windsor Castle, 1860
Oil on canvas, 18⅛ × 30¼ in. Signed and dated lower left: *S. R. Gifford 1860.* Gift of Mr. and Mrs. John D. Rockefeller 3rd, 1979.7.44

Sanford Robinson Gifford
Greenfield, New York 1823–1880 New York, New York

At the outbreak of the Civil War, Sanford Robinson Gifford was one of the few major painters of the era to seek an active role in the Union army. Mustered into the Seventh Regiment of the New York State National Guard on 30 April 1861, Gifford saw three tours of duty.[1] In between times of service, however, he continued his usual routine of extended sketching trips into the countryside, often visiting the Catskill Mountains and the Berkshire Hills, and converting his sketches into exhibition paintings. One such trip took place in early September 1862, when the artist spent about three weeks traveling with Launt Thompson (1833–1894) and Worthington Whittredge* along the Housatonic River in western Connecticut and Massachusetts.[2] For Gifford only two paintings are known to have resulted from the trip—the larger of which is *A View from the Berkshire Hills*.[3]

Late in his life Gifford spoke to a writer for the *New York Evening Post*, who reported: "Landscape painting, he said, was air painting; and the object of the landscape painter was to reproduce the impression made upon him by beautiful natural scenery—and he emphasized the word 'beautiful.'"[4] "Air painting" is an apt description of *A View from the Berkshire Hills* and demonstrates the unity and consistency of Gifford's career across thirty years. *A View from the Berkshire Hills* is an autumnal landscape in which a hunter shares the foreground with a light-struck body of water. A range of hills in purples and browns defines the middle ground, while above, a light gray sky with the afternoon sun gleaming at its center fills half the canvas. But it is the thick and heavy atmosphere that the artist has best captured, the almost palpable haze that softens the forms of the middle ground and makes the glare of the sun bearable.

Gifford has laid the paint onto the canvas in thin, almost transparent strokes that allow the pebbled texture of the ground layer to show through. It is of work such as this that John Ferguson Weir (1841–1926) wrote when eulogizing the artist: "His finest impressions were those derived from the landscape when the air is charged with an effulgence of irruptive and glowing light, and he dared follow the dictates of his intuitions in placing on the canvas the equivalent of these impressions."[5]

M.S.

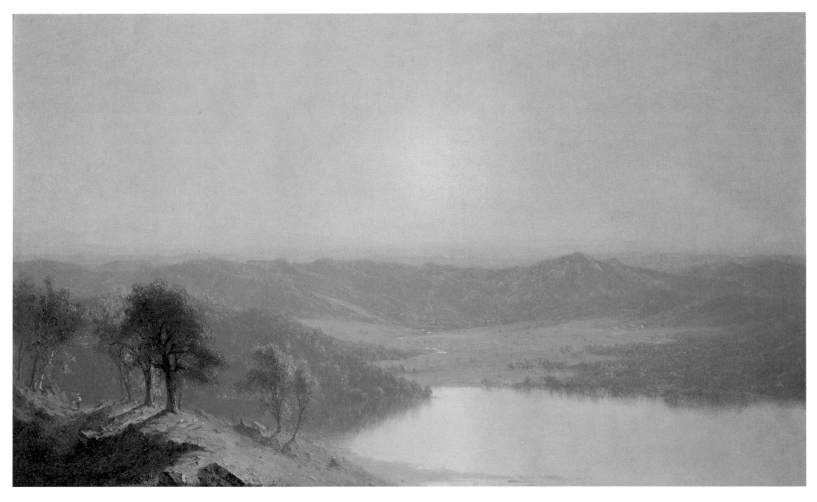

A View from the Berkshire Hills, near Pittsfield, Massachusetts, 1863

Oil on canvas, 22⅛ × 36⅛ in. Gift of Mr. and Mrs. Will Richeson, Jr., 78.74

William Bradford
Fairhaven, Massachusetts 1823–1892 New York, New York

Fascinated with ships and the sea, William Bradford was the primary American landscapist of the nineteenth century to specialize in scenes of the Arctic. He grew up near the prosperous whaling port of New Bedford at a time when the United States stood second only to Great Britain in shipping. After several years as a merchant in business with his father, Bradford turned to painting in the 1850s, working briefly with the Dutch-born painter Albert Van Beest (1820–1860). Beginning with portraits of ships, Bradford depicted coastal and harbor scenes of New Bedford and its surroundings. In 1861, the year that Frederic Edwin Church* exhibited his enthusiastically received *Icebergs* (1861; Dallas Museum of Fine Arts), a monumental canvas inspired by the artist's travels in the Arctic, Bradford himself headed north on the first of several expeditions to the polar region. Almost annually through the decade of the 1860s Bradford spent the summer months in the far north taking photographs and making sketches. Bradford's book, *The Arctic Regions*, appeared in 1873; his descriptions and one hundred twenty-five hand-tipped photographs received instant recognition.[1] Bradford's photographs, together with his sketches of icebergs, Eskimos, western explorers, and topography, also inspired the Arctic scenes the artist painted during the later part of his career. Exhibiting these canvases in New York, Boston, and London, Bradford gained recognition and received commissions from important patrons, including Queen Victoria and many peers of the British realm.[2]

The Coast of Labrador was apparently one of the artist's entries to the Artists' Fund Society's exhibition of 1864. One critic noted: "It is full of feeling. A time-stricken and dismantled wreck lies ashore upon a desolate coast. The pale sun cannot enliven the grey and sombre tints. It is all in good keeping; an impressive subject, carefully and creditably handled."[3] Henry Tuckerman, in his role as critic for the *New York Evening Post*, wrote: "Bradford shows one of the results of his recent northern trip in a picture of 'The Coast of Labrador,' with high rocky shores. A dismantled hull lies beached upon the sands, and the effect of the sunlight flung upon the water is unusually brilliant."[4]

In the San Francisco painting, the mood of the landscape is one of unearthly calm. Sound and movement seem to have ceased except for the gentle lapping of the waves, and the only living things are the sea gulls perched quietly on the shore. The sun, low in the sky, illuminates the underside of clouds; light reflects off the water and glances off each pebble of the rocky shore and each irregularity of the steep and barren headlands. The resultant stark contrast of bright illumination and deep shadow, combined with the painting's unworldly color and absolute stillness, underlines the desolate harshness of the land.

The mid-nineteenth century was a period of significant and well-publicized Arctic explorations. Americans, aware of the worldwide stature of their country's mercantile trade and drawn by the exotic appeal of a hostile environment, were eager to learn about the northern polar reaches. The unexplained disappearance of Britain's Sir John Franklin in 1845 during his search for the Northwest Passage caused an international sensation and sparked the departure of numerous British and American search expeditions. These, in turn, led to the publication of enormously popular illustrated accounts.[5] Bradford's representations of the far north and his artistic popularity reflect this fascination with the Arctic. *The Coast of Labrador*, however, not only illustrates a contemporary passion for a distant land but also suggests another side of the excitement surrounding the many daring polar explorations. The weathered vessel with its cruciform mast, abandoned in this frigid world, reminds the viewer of man's hubris. Bold and confident as man may be, existence is but temporary, subject always to nature's whim.[6]

J.S.

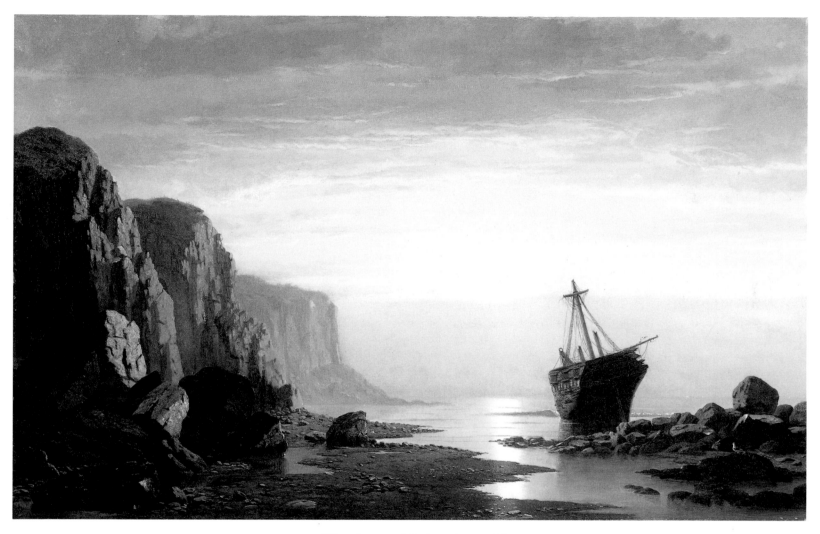

The Coast of Labrador, 1864
Oil on canvas, 28 × 44 in. Gift of Mr. and Mrs. Duane B. Garrett, 1982.121

Eastman Johnson
Lovell, Maine 1824–1906 New York, New York

After a brief stint in 1840 at the shop of Boston lithographer John Bufford, Eastman Johnson began his professional career making charcoal drawings of notables in his native Maine and, by 1844, in Washington, D.C., where he maintained a studio in the west wing of the Capitol. In 1849 he went abroad for study, spending nearly two years in Düsseldorf and, crucially, over three years in the Hague. There he immersed himself in both the subject matter and manner of seventeenth-century Dutch paintings. In the summer of 1855 he studied for several months in Paris with Thomas Couture (1815–1879) until news of his mother's death prompted his return to the United States. He spent the next several years in Washington, D.C.; Ohio; and Wisconsin, where he painted a series of Indian scenes. In 1858 he settled in New York, playing an active role in the city's cultural life as well as in the National Academy of Design, where he was elected an associate in 1859 and a full academician in 1860. In 1870 Johnson first traveled to Nantucket, where the customs and people of the island provided the subject for some of his most significant work, including his masterpiece *The Cranberry Harvest* (1880; Timken Art Gallery, San Diego, Calif.). Increasingly from 1880 Johnson spent more of his time painting the social, financial, and political leaders of the nation.

Although Johnson began and ended his long career as a successful portraitist, during his middle years (about 1859 to the mid-1880s) he found greater fame as a genre painter. Most often his works in this tradition evoked nostalgia for disappearing country rituals or celebrated the innocence of childhood. But in the mid-1860s Johnson, who traveled several times to the front with Union troops, re-created traumatic scenes of the Civil War featuring runaway slaves, heroic drummer boys, or wounded soldiers recuperating in field hospitals.[1] Among these Civil War paintings, perhaps the starkest is *The Pension Claim Agent*. Worked in a style relating to such contemporary European artists as Edouard Frère (1819–1886), the painting re-creates a scene common in the years immediately following the Civil War. As part of the procedure to validate disability claims, a government official traveled to the homes of wounded veterans in order to verify that pensions were necessary and deserved. The art critic Henry Tuckerman described the picture as

one of the numerous incidents in real life, resulting from national war. The scene is laid in the cottage of a soldier, who has been disabled by the loss of a leg. The agent has seated himself at the table, thrown his hat upon the bed, and deposited his valise filled with papers pertaining to his business, upon the floor. He sits with pen in hand listening to the soldier, who stands upon his crutch, telling the story of his battles. Two old persons sit upon one side, perhaps the father and mother of this youthful veteran; and the housewife is busy at a cupboard, while a little girl sits peeling apples, and at the same time listening to the story.[2]

Through the window a chill, bleak winter farmyard is visible.

The painting elicited singularly favorable response when it was first exhibited:

> In this year's picture, there is a directness and simplicity of aim, and a manly energy, that are quite worthy of very high admiration and unreserved praise. It is a picture of some importance; we are the richer for having it. . . . [No painting] that we have, is nearer to complete rightness than this picture of Mr. Johnson's.[3]

To a degree this acclaim was due to the subject matter, with its stark record of sacrifices made for the Union cause. The image of a young hero facing a curtailed and impoverished future necessarily prompted sentimental and emotional responses from its viewers. Further, as in a Victorian novel, Johnson's effective portrayal of setting and character involved his audience with the painting as a text to be read for revelations concerning the social, economic, and familial relationships of its characters.

The painting has strengths beyond its emotional and narrative elements. A superb technician, Johnson conjured the scene with a minimum of detail—capturing gesture and form by a sure line and extremely thin layers of color washed over the penumbrous brown that initially covered the canvas. Even the darkest shadows warmly glow as the winter light touches the edges of the kitchen's humble furnishings.

M.S.

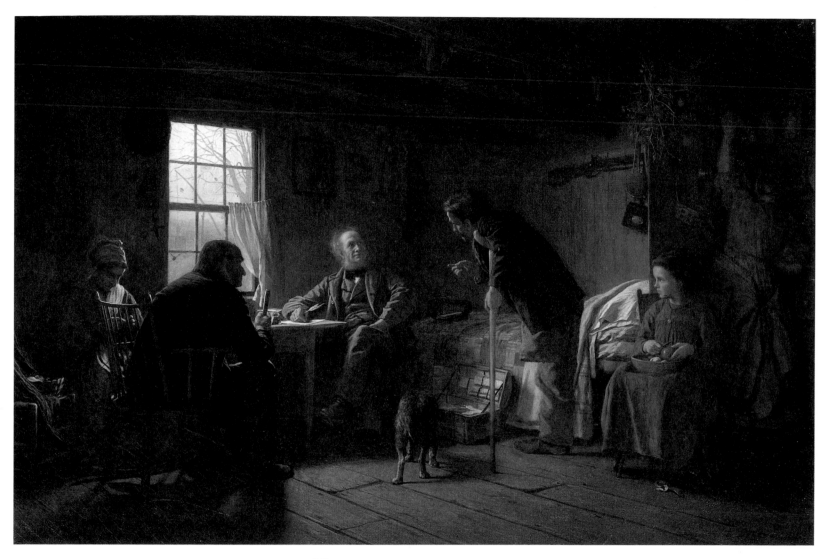

The Pension Claim Agent, 1867
Oil on canvas, 25¼ × 37⅜ in. Signed and dated lower right: *E. Johnson. / 1867.* Mildred Anna Williams Collection, 1943.6

Eastman Johnson
Lovell, Maine 1824–1906 New York, New York

Although recognized today as a leading nineteenth-century genre painter, Eastman Johnson was also a popular portraitist. Entering his profession as an itinerant artist creating crayon likenesses, Johnson completed his career as the sensitive recorder of American presidents, successful industrialists, and wealthy financiers such as James Brown (1791–1877). Born in England, Brown was the New York representative of his family's international banking firm, Brown Bros. & Co. (still operating in the United States and England as Alex. Brown & Sons Incorporated). A prominent and prosperous businessman, Brown was also a founder of Presbyterian Hospital, vice-president of the Society for the Prevention of Cruelty to Animals, and a trustee of Union College. The New York community held him in such respect that on his death the city's mayor ordered flags on public buildings flown at half-mast.[1]

Johnson's 1869 portrait of *The Brown Family* shows James Brown with his second wife, Eliza Marie Coe Brown (1803–1890), and their grandson, William Adams Brown (1865–1943). Linking the generations, though physically absent, is John Crosby Brown (1838–1909), fourth son of James and father of William, who commissioned the work.[2] John Brown sent a second, reduced version of Johnson's portrait (1869; National Gallery of Art, Washington, D.C.) to a nephew in London, with a letter that provides insight into both works:

> My Dear James
> You will soon receive . . . a box from New York containing as a Xmas gift to yourself and your good wife from your grandparents, a picture the history of which is curious, as it owes its existence to a combination of misunderstandings which I will tell you about when we meet. To make a long story short I will simply say in this present note, that it is Eastman Johnson's handiwork, and considered as a specimen of his workmanship very good. It is in reality a copy of a portion of the picture he painted for me . . . and is really a very good likeness of your grandfather, with a poor one of your grandmother.
>
> . . . Your grandfather felt that you, as the bearer of his name, in connection with that of his old country home, every vestige of which will in a few years entirely pass away, would not object to have a likeness of himself in his old age, the last one probably for which he will ever sit. At any rate, it will answer its purpose if it serves as a reminder at these Xmas seasons, that the grandchildren and their children across the sea, are always remembered by the old people in New York.[3]

What the "misunderstandings" were is not known. But in suggesting to his nephew the significance of a family portrait, Brown alludes to the motivations behind his original commission of a work from Eastman Johnson.

Rather than arranging his three sitters in a formal grouping, Johnson portrayed them within the comfort of James Brown's parlor at 21 University Place. Mrs. Brown quietly knits, watching as her husband interrupts his newspaper reading to gaze down at their grandchild. The young boy gently grips his grandfather's arm, as if eager to ask some question or share some exciting news. Through such natural rendering of glance, pose, and gesture, Johnson suggests the affection and quiet harmony of the intimate family circle, then wraps it in the warm and cozy glow of lamp- and firelight. Home and hearth reign supreme.

This portrait, however, expresses more than domestic accord. As one critic noted when Johnson exhibited the work at the National Academy of Design in 1869, *The Brown Family* is a portrait of "mirrors, curtains, carpet, mantle-piece, and upholstery."[4] The parlor in which the Browns are seated had been transformed in 1846—by the French cabinetmaker and interior designer Léon Marcotte—from the Grecian style into a highly fashionable French Renaissance Revival interior. With carefully blended brushstrokes, meticulous attention to specifics, and consideration of local color, Johnson recorded the room's elegant furnishings and elaborate architectural decorations. His detailing extends to the pattern of the carpet, the diverse moldings adorning the ceiling, and the cutout designs applied to the walls and doorframe.[5] Because the elder Browns moved in 1869 to a new home on Park Avenue (in which they reassembled portions of the Marcotte parlor), it seems likely that John Brown commissioned this work to preserve a memory of the tasteful interior of his childhood home as well as likenesses of his aging parents and growing son.

Conversation pieces—informal group portraits of people socializing in their own parlors, libraries, or other rooms—played an important role in American portraiture, particularly in the years following the Civil War. Rich, self-made American businessmen and professionals desired images that would record their hard-earned wealth and stature in society, while simultaneously acknowledging the strength and sanctity of their family bonds.[6] Eastman Johnson combined his skills in portraiture and genre to become a leading proponent of such conversation pieces.[7] In turning to Johnson for a family portrait in his father's Marcotte parlor, John Crosby Brown was rewarded by the artist's sensitivity not only to domestic harmony, but to his family's material prosperity as well.

J.S. / S.M.

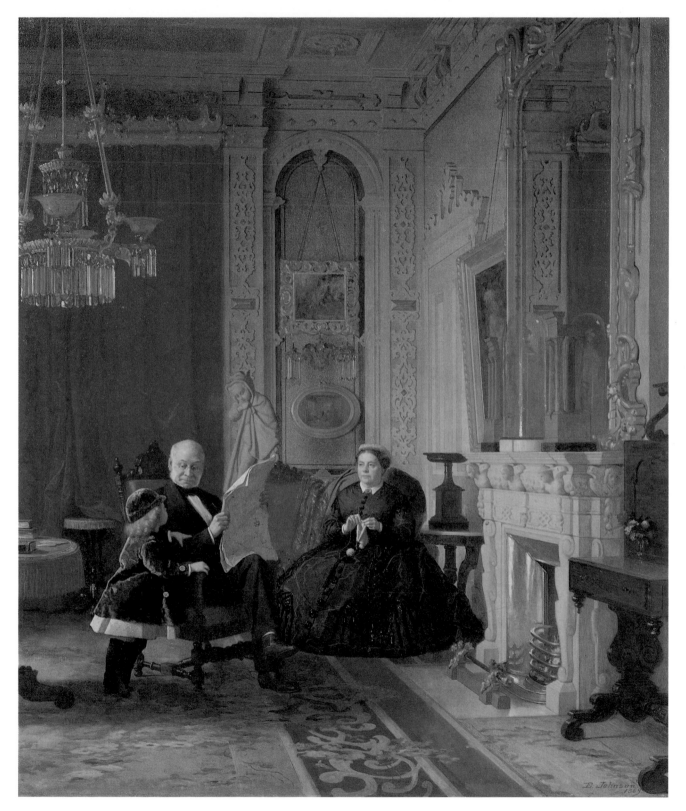

The Brown Family, 1869
Oil on canvas, 38½ × 32½ in. Signed and dated lower right: *E. Johnson. / 1869.*
Gift of Mr. and Mrs. John D. Rockefeller 3rd, 1979.7.67

Frederic Edwin Church
Hartford, Connecticut 1826–1900 New York, New York

More than any other American painter of the nineteenth century, Frederic Edwin Church popularized panoramic landscapes of epic proportions and cosmic meaning. Church observed the wilderness of the New World with the eye of a naturalist, interpreted it with the vision of a prophet, and rendered it with the hand of an artist. The son of a wealthy Hartford, Connecticut, businessman, Church began his career by becoming the only pupil of Thomas Cole (1801–1848). From his training with Cole, Church learned to sketch directly from nature, completing more finished works of art in the studio. By 1850 Church had settled in New York, achieving the rank of full academician at the National Academy of Design and firmly establishing himself socially and professionally. Over the course of his career Church not only traveled extensively but also exhibited his art nationally and internationally to great critical acclaim. Well known for his pictorial fidelity, Church augmented his vision by his study of the natural sciences, as the numerous volumes in his library and exhaustive sketches testify.[1]

In *Rainy Season in the Tropics*, one of the last in his series of large-scale tropical vistas, Church created a spectacular panorama that represents in composite form the Andes of Ecuador and rain forests of Jamaica.[2] Inspired by the German scientist-explorer Alexander von Humboldt's publications and his descriptions of South America, Church traveled twice in the 1850s to that relatively unknown continent; he was the first American to respond to the suggestion that artists paint the natural history of the region. Several years later, in 1865, Church headed south again, this time staying for almost five months in Jamaica. In each case Church extensively sketched the flora, geology, and atmospheric effects of the different locales. On his return in 1866, he seems to have conflated his Jamaican observations with a large South American canvas begun in 1864, resulting in *Rainy Season in the Tropics*.[3] A year after it was completed, Henry Tuckerman described the canvas in his *Book of the Artists*:

Athwart a mountain-bounded valley and gorge, floats one of those frequent showers which so often drench the traveller and freshen

vegetation in those regions, while a bit of clear, deep blue sky smiles from the fleecy clouds that overlay the firmament, and the sunshine, beaming across the vapory vail, forms thereon a rainbow, which seems to clasp the whole with a prismatic bridge. . . . The aerial perspective is exquisitely true—the floating vapor, the blue sky, the radiant iris—the brooding mists on the distant mountains, the rich vegetation of the foreground, and green, rugged declivity and mule-path—water, air, cloud, hill, and vale—all wear the tearful glory of "The Rainy Season in the Tropics."[4]

More than an image of skilled technique and convincing naturalism, *Rainy Season in the Tropics* bears, like so many of Church's landscapes, additional levels of meaning. During the nineteenth century Americans viewed nature as the most profound manifestation of the divine. Artists frequently made landscapes the vehicle for expressing nationalistic or moralistic sentiments, with the rainbow a commonly recognized symbol of God's blessing.[5] Here, as its double arc unites the scene, it sanctifies the rejuvenation of a new world cleansed by a tropical shower. *Rainy Season in the Tropics* is a paean to the theme of hope and regeneration.[6]

Although well received on its exhibition at the Paris Exposition Universelle of 1867, the critics were not so kind to *Rainy Season in the Tropics* when mentioning it in reviews of the 1900 Church memorial exhibition in New York. One writer commented upon the painting's atmospheric effects, which Tuckerman had so applauded in 1867, saying, "It is a very easy trick to surround a mountain with enveloping steam from a tea-kettle."[7] More than with most American artists, the dramatic drop that occurred in Church's reputation—even by the time of his death—demonstrates the vacillations so common in art-historical criticism. Today, however, *Rainy Season in the Tropics* takes its place as a work that demonstrates the qualities integral to the best of American landscapes at mid-century, providing an epic vista of grandiose conception and profound optimism.

J.S.

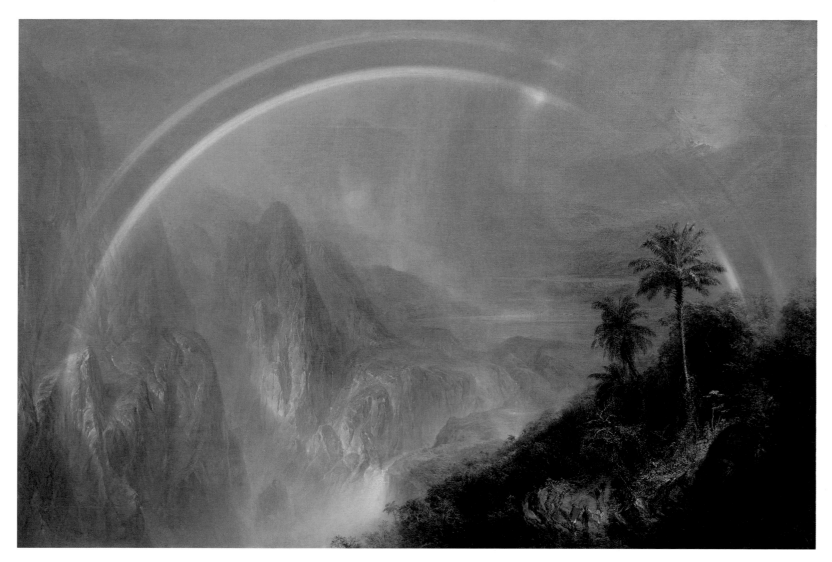

Rainy Season in the Tropics, 1866

Oil on canvas, 56¼ × 84¼ in. Signed and dated lower left: *F. E. CHURCH / 1866*; signed and dated lower right: *F. E. CHURCH 1866*
Mildred Anna Williams Collection, 1970.9

Thomas Hill
Birmingham, England 1829–1908 Raymond, California

Son of a British tailor, Thomas Hill came to the United States with his family when he was fifteen. After serving an apprenticeship to a coach painter, he joined a Boston firm of interior decorators. In 1853 he moved to Philadelphia and studied at the Pennsylvania Academy of the Fine Arts. While painting portraits and still lifes, Hill continued to earn his living by decorating furniture. In 1861, threatened by tuberculosis and hoping for better career opportunities, Hill sought the milder climate of California and settled in San Francisco. A visit to the Yosemite Valley in 1862 marked the turning point of his career. In 1866, the same year his *View of the Yosemite Valley* (1865; New-York Historical Society) was shown at the National Academy of Design in New York, Hill traveled to Paris for further study. On his return in 1867, he spent three years in Boston, where his grand-scale panorama *The Yo-Semite Valley* (1868; location unknown) was hailed as "the whole of what Bierstadt gave us half."[1] Returning to California in 1870 and rising to prominence in San Francisco's booming art community, Hill readily won fame and patronage. Following a tremendously successful decade, Hill's later years were marred by poor health and strained relations with both family and patrons. His output continued to be prolific, however, and he traveled to Alaska in 1887, commissioned by naturalist John Muir to paint the Muir Glacier. In 1896 Hill suffered the first of a series of paralyzing strokes; he spent the last years of his life in his home near Yosemite Valley.

If Hill achieved his greatest renown for grand and spectacular views of mountain scenery, he was no less a master of the small sketch and intimate study, works that one contemporary described as "such gems as only the most accomplished artist with great feeling and honesty of method can execute."[2] These smaller paintings reveal most clearly Hill's remarkable facility with brush and palette knife, as described by Hill's friend and sketching companion Benjamin Champney (1817–1907):

> Thomas Hill has all the facility of Bierstadt, and can make more pictures in a given time than any man I ever met. In one afternoon of three hours in the White Mountain forests I have seen him produce a study, 12 x 20 in size, full of details and brilliant light. There is his greatest strength, and his White Mountain wood studies have not been excelled.[3]

Fishing Party in the Mountains is one of these engaging "White Mountain wood studies," portraying a festive outing whose purpose is recreation, not sport. The scene must have been familiar to the artist from his own numerous sketching trips and outing parties, often made with fellow artists and their families.[4] Hill casts the scene in the pink-brown hues he favored. Against this tonality stand the sharp accents of dark green in the distant foliage, bright green in the largest punt, a crisp blue stripe of a lady's sash, or the white of the foreground flowers. The paint is laid on thickly, in broad strokes that suggest rather than describe details. The confidence with which Hill handles brush and paint is everywhere evident; his ease of execution matches the relaxed informality of the outdoor gathering.

S.M.

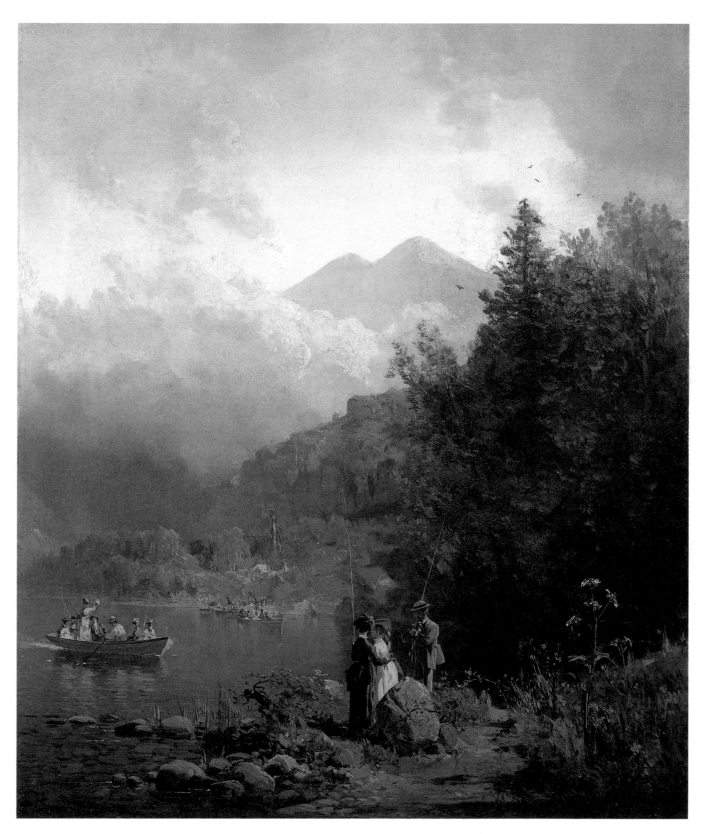

Fishing Party in the Mountains, ca. 1872
Oil on canvas, 24⅛ × 20¼ in. Signed lower right: *T. Hill.* Museum purchase, 46.1

William Hahn

Ebersbach, Germany 1829–1887 Dresden, Germany

At the age of fifteen, William Hahn began studies at the Royal Academy of Art in Dresden under the portraitist and historical painter Julius Hübner (1806–1882) and the figure and animal painter Ludwig Richter (1803–1884). Hahn won both gold and silver medals for works shown at the Dresden Gallery in 1851. While remaining active in Dresden, he moved in 1854 to Düsseldorf, where he opened a studio and joined Malkasten, the artists' club founded by the American painter Emanuel Leutze (1816–1868). In the 1860s Hahn painted genre subjects and pastoral scenes, sending several of his works to exhibitions in Vienna, Berlin, Boston, New York, and San Francisco.[1]

In 1869 Hahn met the California artist William Keith (1839–1911) in Düsseldorf and two years later left Germany to join Keith in the United States. The two artists shared a studio in Boston in spring 1872, and by August of that year they had moved to San Francisco. Hahn quickly became part of that city's growing art community, joining artists' associations and social clubs, taking sketching trips, and exhibiting his work extensively. Following the collapse of the silver market, Hahn moved to New York in 1878 to seek new opportunities.[2] Many of his later small genre works show the influence of John George Brown's* popular depictions of children. Hahn returned to California late in 1879, where he painted some of his most ambitious and successful large-scale works, such as *Logging (Saratoga Gap)* (1880; First National Bank of San Jose, Calif.) and *The Return from the Bear Hunt* (1882; Oakland Museum, Oakland, Calif.). Hahn married in 1882 and traveled to London; in 1885 the Hahns moved to Dresden. Hahn intended to return to San Francisco but became ill and died in Germany at the age of fifty-eight.

Hahn's first arrival in California coincided with a boom in both the production and patronage of art in San Francisco.[3] Wealth from railroads and silver mines poured into the city. Artists originally drawn to the West by the promise of spectacular landscapes now discovered a community of newly made millionaires hungry for the comforts and diversions of culture. Hahn arrived on this scene already established as a figure and genre painter; his only rival was Charles Christian Nahl,* whose hard neoclassical draftsmanship, romanticized historical themes, and strident color contrasted sharply with Hahn's approach. Hahn announced his quieter, more naturalistic style and his concern for contemporary subject matter with the exhibition of *Market Scene, Sansome Street, San Francisco* (1872; Crocker Art Museum, Sacramento, Calif.), and approval was sounded with the purchase of the painting by Judge Edwin Bryant Crocker (brother of Charles Crocker, one of the "Big Four" railroad magnates). Following the success of this large-scale, contemporary genre scene, Hahn embarked on a sequel, a scene of the Central Pacific Railroad depot in Sacramento, which is now in The Fine Arts Museums' collection.

Sacramento's first passenger station, constructed in 1867 to accommodate growing rail traffic, replaced a small ticket office built by Collis Huntington in 1864. Upon the driving of the Golden Spike in 1869, this station became the western terminus of the first transcontinental railroad, a major thoroughfare for immigrants and vacationers alike.[4] While Hahn's painting of the depot inevitably sets the new technology of the iron horse against the older mode of horse-drawn carriage, the artist's main concern is for the station's role as a catalyst and crossroads of human activity.

In a composite of several closely observed and carefully arranged vignettes, Hahn unfolds the typical drama—both high and low—provoked by the arrival of the morning train from the east. Anchoring the composition at the center stand two bay horses,[5] held in check by their driver who looks down on the well-dressed family entering his carriage. To his left, a humorous scene evolves from the consternation of two porters carrying a trunk whose bottom has fallen out, exposing its owner's delicate finery. Behind them to the left towers the great triangular structure of the station; the engine itself, attended by a mechanic, still steams. At the right in the distance, street life scurries by—carriages, businessmen, Chinese laborers, and young boys.

Despite the various characters and abundant anecdote, a calm pervades what might otherwise be described as a bustling arena. Restricted to the bottom half of the composition, human activity assumes a relatively modest scale and is tamed by a succession of vertical lines—the pillars of the station, the legs of the horses, the flag and tall chimney above, and the wooden porches and verandahs at the right. The light is mellow and the colors warm, subdued. Hahn's control of these several elements was praised by contemporary critics. One of them, calling *Sacramento Railroad Station* "the most ambitious and certainly the most successful picture" in the Ninth Industrial Exhibition at the San Francisco Mechanics' Institute in 1874, remarked that "the light is well arranged and distributed, and the auxiliary objects and groups, though carefully finished, are skillfully kept from undue prominence. The entire work is perfectly natural, without any straining after effect. Everything and everybody seems in the right place."[6]

S.M.

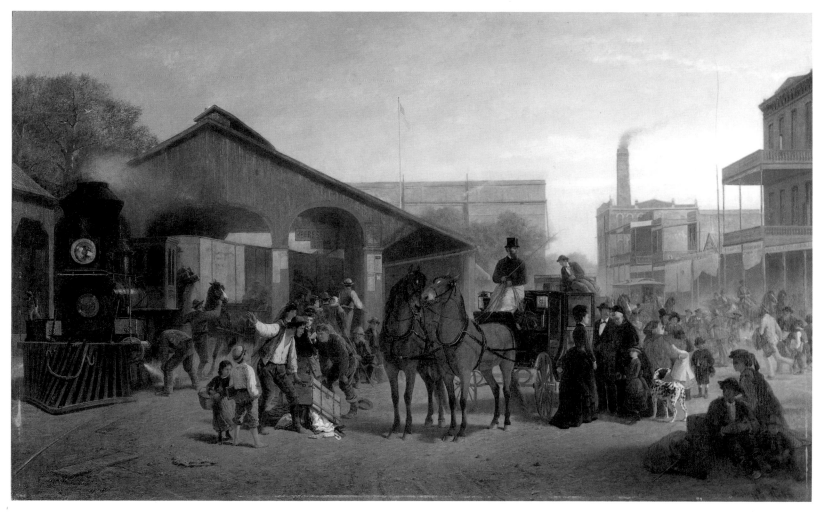

Sacramento Railroad Station, 1874

Oil on canvas mounted on board, 53¾ × 87¾ in. Signed lower right (over a second signature): ***Wm. Hahn.*** Gift of the M. H. de Young Endowment Fund, 54936

Albert Bierstadt
Solingen, Germany 1830–1902 New York, New York

Born near Düsseldorf, Germany, Albert Bierstadt moved at the age of two with his family to the United States. Growing up in New Bedford, Massachusetts, he apparently developed an interest in art without formal training, advertising himself as early as 1850 as a teacher of "monochromatic painting." Like many of his contemporaries, Bierstadt was attracted to Europe for formal study and in 1853 returned to Düsseldorf, home of an art school known for its instruction in landscape, genre, and historical subjects. Although never actually enrolled at the Düsseldorf Academy, Bierstadt spent two years working on his own in the studio of Worthington Whittredge.* There, during the winters, he primarily painted landscapes based on sketches he made on summer walking tours through the German countryside. Before returning to New Bedford in 1857, Bierstadt spent a year in Italy with Whittredge and Sanford Robinson Gifford,* painting scenic views and images of Italian life. Back in America Bierstadt briefly resumed teaching while painting and exhibiting works of European subjects, such as *The Arch of Octavius (Roman Fish Market)* (1858; see illustration, p. 13).

It was not long before Bierstadt made the first of three journeys to the American West. Whereas in 1858 he traveled only as far as Wyoming, he spent the last two trips (1863 and 1871–73) in and around the San Francisco Bay area.[1] Those last visits provided inspiration for three landscapes at The Fine Arts Museums: *Farallon Islands* (1872); *View of Donner Lake, California* (see pp. 122–23); and *California Spring* (see pp. 124–25).

The 1860s and early 1870s were the years of Bierstadt's greatest success. He received international recognition as the preeminent artist of the American West, with his large-scale and finely detailed records of the grandeur and beauty of that newly explored region commanding high prices from collectors. As did other American landscapists such as Gifford, Frederic Edwin Church,* and William Bradford,* Bierstadt traveled extensively within the United States and beyond. However, American taste soon changed, and Bierstadt's grandiloquent landscapes fell into disfavor. Although at one time his major landscapes were assured of acceptance at any exhibition, in 1889 the American jury selecting the paintings to represent the United States at that year's Paris Exposition rejected the epically conceived *Last of the Buffalo* (ca. 1889; Corcoran Gallery of Art,

Washington, D.C.; a study, ca. 1888, is in The Fine Arts Museums of San Francisco). Declaring bankruptcy in 1895, Bierstadt died a few years later all but forgotten by the American art community, victim of its changing interests.[2]

Sunlight and Shadow, painted in 1862, is based on a sketch of the entrance to the Löwenburg Chapel at Castle Wilhelmshöhe in Kassel (*Sunshine and Shadow*, 1855; Newark Museum, Newark, N.J.),[3] which Bierstadt had executed on one of his German walking tours. Whittredge records in his autobiography the genesis of the painting:

> He remained away [sketching] without a word to us until late autumn when he returned loaded down with innumerable studies... [including] one very remarkable study of sunlight on the steps of an old church which some years afterwards was turned into a picture that gave him more fame than anything he had ever painted.[4]

In the year following its completion Bierstadt exhibited the finished work at the National Academy of Design, where it became his first critical success. One critic wrote highly of it as

> a very skilful [*sic*] bit of effect produced by the sun glinting through foliage upon a balustrade and the porch of a church. Alternate flecks of high light and soft shade have been often heretofore made the chief points in a subject; but they have seldom been more carefully distributed, more tenderly laid in, more nicely adjusted to gain the end. You may study this canvas again and again under the light of different hours, yet will you always find in it a certain union of qualities that stamps it with success.[5]

Sunlight and Shadow, however, is more than just a study of light; it is an image of the present and the past, where time has weathered the fabric of man's handiwork and where, with its muted color harmonies and quiet mood, Bierstadt has created a moving meditation on man—his work, humanity, and mortality.

J.S.

Sunlight and Shadow, 1862

Oil on canvas, 41½ × 35½ in. Signed and dated lower right: *ABierstadt. / 1862*. Gift of Mr. and Mrs. John D. Rockefeller 3rd, 1979.7.10

Albert Bierstadt
Solingen, Germany 1830–1902 New York, New York

Albert Bierstadt began his third and longest western journey in summer 1871. The *San Francisco Daily Evening Bulletin* reported the arrival of the artist (with his wife and sister-in-law) on 21 July:

> ARTISTIC ARRIVAL.—Albert Bierstadt, the renowned landscape painter, arrived in this city last night, and is stopping at the Grand Hotel. He contemplates an extended professional trip on this Coast, during which he will make studies of some of the finest scenery for future use.[1]

Over the next two years, although he made lengthy sketching trips throughout California and at least one visit to New York, Bierstadt based his activities in San Francisco.[2]

One of the principal works of Bierstadt's stay in California was a commission from Collis P. Huntington, *Donner Lake from the Summit* (1873; New-York Historical Society). Bierstadt appears to have begun the work for Huntington, one of the "Big Four" magnates of the Central Pacific Railroad, soon after his arrival. As early as 5 March 1872, the San Francisco papers reported that Bierstadt "has made many careful studies for an important picture for C. P. Huntington of the Central Pacific Railroad,"[3] implying that he had made the journey to Truckee and the overlook on Donner Lake the previous autumn, before the heavy snowfalls of the winter. He traveled to the region at least twice more during the autumn of 1872.

In early January 1873 Bierstadt put *Donner Lake from the Summit* on public view at the San Francisco Art Association. It was a huge success, inspiring large crowds, dedicatory poetry, and lavish praise:

> It is a sublime painting of a sublime landscape, and has the truthfulness and minuteness of detail, that just completion of perspective, that fine arrangement of light and shade, and that exquisite delicacy of coloring, which only the true genius can fix in oil—a real, vivid landscape—on canvas.[4]

One writer for *California Art Gallery* attributed record-breaking attendance at the association to the presence of Bierstadt's work, while another critic in the same paper wrote simply:

> Many a time have I stood upon the summit and watched the glories of the matchless scene that lies along the Donner Lake over to the Truckee hills; I have walked too from the Lake to the heights . . . and I am familiar with the view that Bierstadt has given in this picture. I am happy to offer my testimony as to the fidelity of his reproduction of one of the most charming and grand landscapes in the State, and I thank the artist for the hour of pleasure he has afforded me by one of the most striking paintings I ever saw, and which is to be, I judge, his *magnum opsus* [*sic*].[5]

View of Donner Lake, California is among the most finished and beautiful studies of the central portion of *Donner Lake from the Summit*. Both study and final painting show the rough terrain near Truckee, featuring the highest pass in the Sierra Nevadas traveled by the Central Pacific line. Huntington reportedly chose the site to be painted "because right here were overcome the greatest physical difficulties in the construction of the road, while the immediate vicinity was the scene of the most pathetic tragedy in the experience of our pioneer immigration."[6] The latter reference, of course, was to the doomed Donner party that in 1846 was fatally trapped in the winter snows on the shore of Donner Lake. The rail line and its miles of snowsheds, small but crucial elements in the paintings, provide a sharp and proud reminder of how quickly man came to tame nature's power in the intervening twenty-five years.

Because of its narrower scope, *View of Donner Lake, California* brings the record of this progress into sharper focus than the larger painting—abetted by a large cross in the central section found in this earlier version. It is a fully finished and composed work, featuring a mist-enshrouded sunrise over Donner Lake, with the trestles, tunnels, and snowsheds of the railway to the right balanced by a hardy conifer on the left.[7] Its mute, close-toned palette of golds, browns, and grays imparts a mystical atmosphere to the scene, echoing German Romantic landscapes of an earlier generation. The compelling glow of the rising sun and the precipitous drop of the foreground combine to urge the viewer toward an exhilarating projection into space. The artist's handling of paint in the foreground, with loose patches of streaked pigment minimally outlined to suggest rocky outcroppings, reinforces the suggestion of quick movement out into the void.

Family tradition records that *View of Donner Lake, California* was purchased from the artist by Dr. August F. Jonas, chief medical officer for the Union-Pacific Railroad. The painting descended in Dr. Jonas's family until 1984.

M.S.

View of Donner Lake, California, 1871 or 1872

Oil on paper mounted on canvas, 29¼ × 21⅞ in. Signed lower left: *ABierstadt*

Gift of Anna Bennett and Jessie Jonas in memory of August F. Jonas, Jr., 1984.54

Albert Bierstadt
Solingen, Germany 1830–1902 New York, New York

Albert Bierstadt ended his third and final journey west in 1873, leaving California in October and returning to his wife's hometown of Waterville, New York. There his father-in-law built the artist a studio adjacent to the family home, where Bierstadt quickly resumed his professional routines—painting new works, completing unfinished ones, securing commissions, attempting to sell canvases or place them in public institutions.[1] He was well stocked with pictorial ideas, as a visitor to his studio reported in 1874:

> [Bierstadt] showed me a large number of his original sketches. These sketches, let me observe, are mostly in oil . . . and were made in the open air at all seasons of the year, not excepting winter. They are classified, for the most part, according to the country or district where they were made, and are arranged in separate portfolios kept in closets or trunks, so that any sketch which may be wanted for a particular purpose can be found without a moment's delay. The California sketches were most numerous.[2]

By early 1875 Bierstadt was back in New York City, preparing work for the annual spring exhibition of the National Academy of Design. Eventually four California works would represent the artist in that important show, which was to mark the fiftieth anniversary of the founding of the academy. A critic making customary studio rounds before the exhibition noted that

> Mr. Albert Bierstadt, of the landscape-painters, is at work on one of the largest pictures, probably, which will appear in the exhibition, a view of "The Sacramento Valley in Early Spring." The valley, at the point selected for the picture, is broad, and, with its scattered groves and isolated trees, resembles a grand old park. . . . [The] great strength of the work lies in its broad and masterly perspec-tive, and in the passing shower which is drifting over the right foreground.[3]

Upon the close of the New York show, Bierstadt sent *California Spring* to Chicago for exhibition;[4] the next year he sent it to Philadelphia for the Centennial Exposition, where it was one of four Bierstadt works on view.

Despite the prominent exposure Bierstadt's canvas received at such major exhibitions, it did not meet universal approval. The same critic who had admired *California Spring* on Bierstadt's easel found in the completed work "a crudeness of color and want of unity in its composition"; John F. Weir dismissed Bierstadt's contributions to the Centennial as "a lapse into sensationalism and meretricious effects."[5] Yet *California Spring* is in fact much less sensational than the artist's exhibition works of the 1860s. Shunning the steep mountain ranges or enormous redwood trees that earlier had won him acclaim, Bierstadt chose a view of the flat Sacramento Valley as it might be seen from the low-lying foothills of the Sierra Nevadas. His perspective is one of breadth, not height, and his drama meteorological rather than geologic or botanical. Despite its imposing vastness, and the atmospheric splendor of its billowing clouds and dramatic light, the image is pastoral, reassuring. Grazing cattle and fertile land present a picture of peace and comfort, echoed in the tiny farmhouse to the left beyond the riverbank. Away in the right distance stands the dome of the State Capitol in Sacramento, completed only in 1869.

While the meticulous description of the foreground detail, coupled with the composition's tremendous breadth, reflects the artist's Düsseldorf training and standard formats, Bierstadt's conception of the landscape itself seems to reflect Dutch as well as German traditions. The view is taken from hills that could not exist in this location,[6] just as the seventeenth-century Dutch artists invented high vantage points from which to survey their flat homeland. The splendid clouds are one of Bierstadt's trademarks, yet like the clouds of Jacob van Ruisdael (1628/29–1682), they command the sky as critical design elements, even as they emphasize the expanse of the land below them. Finally, the composition itself recalls one of Rembrandt's (1606–1669) most famous etchings, *The Three Trees* (1643).[7] Like Rembrandt, Bierstadt structured a diagonal view into the landscape through a descending line of trees; the dark clouds of a passing storm to the left break to reveal the vista, patched with light and shade. This magnificent view bespeaks the gentler splendors of this western land.

S.M.

California Spring, 1875

Oil on canvas, 54¼ × 84¼ in. Signed lower right: *ABierstadt.* Presented to the City and County of San Francisco by Gordon Blanding, 1941.6

Albert Bierstadt
Solingen, Germany 1830–1902 New York, New York

Returning from California in 1873, Albert Bierstadt faced dramatic changes in both the critical and economic climate of New York and found himself struggling to maintain the income and prestige that came to him so easily in the 1860s. His magnificent operatic panoramas of western scenery were finding lukewarm, if not hostile, reception among a public now weary of Düsseldorf technique and grandiose compositions. The very size of his canvases, as well as his now-familiar repertoire of western subjects, repelled those critics now favoring a more intimate, Barbizon-inspired view of the landscape. One of these critics complained, "To tell the truth, we have had plenty of the Yosemite and the Big Trees, and we don't want any more."[1] In addition, several of Bierstadt's most prominent patrons in America and England had suffered financial setbacks and bankruptcies.

But if the late 1870s mark the beginnings of a decline in Bierstadt's career, these years were not without their successes. Bierstadt enjoyed a certain artistic rejuvenation by the end of the decade, thanks largely to his experience in the Bahamas.[2] In 1877 Bierstadt made the first of what would become many visits to the town of Nassau. Bierstadt's wife, Rosalie, had been diagnosed with consumption; tropical air was recommended as the best cure for the disease, and more than one writer proclaimed, "If there is any place where people with weak lungs can go and be benefitted by the climate, I believe that place to be Nassau."[3] Mrs. Bierstadt took up residence at the fashionable Royal Victoria Hotel, where she and her husband could easily resume familiar social routines. Soon her "*salon*, hung round with her husband's sketches," became "the scene of many pleasant afternoon and evening gatherings."[4] Mrs. Bierstadt returned to Nassau for several months nearly every winter from 1877 until her death in 1893. Bierstadt accompanied his wife on most of these winter visits but did not stay as long as she did, returning to his New York studio and continuing the active schedule of work, travel, and social engagements that ensured his patronage and livelihood.

While Mrs. Bierstadt sheltered her health under the tropical sun, Bierstadt found new subject matter and inspiration for his art. As did Winslow Homer* and Marsden Hartley* who visited the Caribbean after him, Bierstadt filled his portfolio with sketches of the bright colors and tropical vegetation, so unlike any landscape he had previously encountered in his extensive travels. Testimony to a new vision are paintings such as *Nassau Harbor*, a vibrant, rapidly executed oil sketch on paper, brimming with color and detail. Bierstadt probably painted much of this work on the spot, laying on the brilliant turquoise and emerald hues of the ocean with long strokes, daubing in the sandy browns of the foreground with quick touches, deftly adding the short strokes that describe the dark figures of natives or the white sails of a ship. The larger ships and their upright masts are more crisply defined, and near the center an American flag flies prominently. The hot summery atmosphere is suggested by a hazy blue sky and scudding clouds. The most captivating presence overall is that of light, brilliantly evoked by the small boat overturned at the right foreground, its one side hot white, the other sculpted by shadows. It was in sketches such as this that Bierstadt recaptured the attention of the art world in the mid-twentieth century,[5] earning the respect of such art historians as E. P. Richardson, who praised his "marvelous freshness of eye" and chose to remember the artist as "a remarkable observer of air, light, and the feeling of a place."[6]

S.M.

Nassau Harbor, after 1877

Oil on paper mounted on board, 14¾ × 20 in. Signed lower right: *ABierstadt*. Mildred Anna Williams Collection, 1961.22

John George Brown
Durham, England 1831–1913 New York, New York

John George Brown began studies at a government school of design while still apprenticed to a glass cutter in Newcastle-on-Tyne. He later attended night classes at the Royal Scottish Academy while working at the Holyrood Glass Works in Edinburgh. He painted a few portraits upon moving to London in 1853, but soon set sail for the United States. He found work in a Brooklyn glass factory under an employer who encouraged him to continue art studies, and within two years had set up his own painting studio. In 1860 Brown moved to New York, taking a studio in the renowned Tenth Street Building where he remained over fifty years. Elected to the National Academy of Design in 1861, he became its vice-president in 1899 as well as the chairman of its school committee.

Brown quickly established a niche in New York's art community. By 1867 the artists' biographer Henry Tuckerman confidently classified the "young artist" as a specialist in "*genre* subjects of a more humble, and especially those of a juvenile and sportive kind."[1] This description would characterize Brown for the remainder of his career. In 1882 the critic George Sheldon accurately predicted that "for some time to come" the subjects of "boot-blacks, farmers' chubby-cheeked little daughters, old men playing violins, and young ladies promenading by the sea [would] monopolize his attention."[2] Brown achieved his greatest fame (and considerable wealth) from anecdotal, sentimental depictions of city street urchins—the well-scrubbed, smiling shoeshine boys and newspaper vendors who earned him the epithet "Boot-Black Raphael" and became the artist's trademark after 1880.[3] But shortly before his death, Brown confessed to a newspaper reporter, "When J. G. Brown is no more . . . those who come after me will be rummaging about this studio and they will discover scores of canvases which will show, I hope, that I was not a painter of one idea."[4]

Among those works in Brown's studio was an 1865 study[5] for *On the Hudson*, the painting that perhaps more than any other proves the range of Brown's talents and vision. Pure landscape appears rarely in Brown's art and mostly after 1900, although the outdoor settings of his rural genre paintings from the 1860s and 1870s reveal his keen sensitivity to nature, fresh observation, and delight in the patterns created by strong sunlight and bold shadows. These qualities find full expression in *On the Hudson*.

In both size and scale it marks a departure from Brown's earliest works, where tight description and intimate focus reveal his contacts and sympathy with the American Pre-Raphaelites.[6] In fact, with this landscape work Brown seems to ally himself with the older tradition and more expansive idiom of the Hudson River School.

The warm, rich tones of autumn dominate Brown's view; a tripartite composition lends equal weight to sky, land, and water. Through the mellow haze of an afternoon sun, passing clouds cast their shadows on cliffs and river. Nearly upstaged by this pageant, river traffic and dockside settlements bustle with activity. The water is painted with broad, yet precise strokes of color; autumn foliage appears in soft, spongy daubs. The steamboats, however, are described with sharp clarity. Drawn to the white ship at the center, the viewer's eye follows a sparkling wake as the steamboat heads for Burdett's Landing and the town of Fort Lee, New Jersey, nestled at the foot of the Palisades.

To observers of the 1860s, these striking cliffs on the west bank of the Hudson River, which extend nearly twenty-four miles and rise in height from two hundred to five hundred feet, easily lent themselves to flights of romantic fancy and pseudoscientific musing:

> If any scenery in the United States clothes itself with the mour[n]ful interest that attaches to old-world ruins, it is surely the Palisades of the Hudson. These perpendicular, buttressed walls, rising originally straight from the river's edge, were built, one might think, by some primeval race. . . . The columnar structures of volcanic rock are the outlying defences of the primeval forces, whose . . . dominion orig[i]nally covered the whole surface of the earth. But a new power has entered, stealthily at first, low down on the mountain sides, but it soon closes in deadly embrace with the rocky heights —the power of organic life—and the battle still wages.[7]

Brown suggests a third protagonist in this drama. While his 1867 painting glorifies the natural splendor of the Fort Lee region, it also records a human presence that enjoyed, utilized, and eventually overwhelmed that landscape.[8]

S.M.

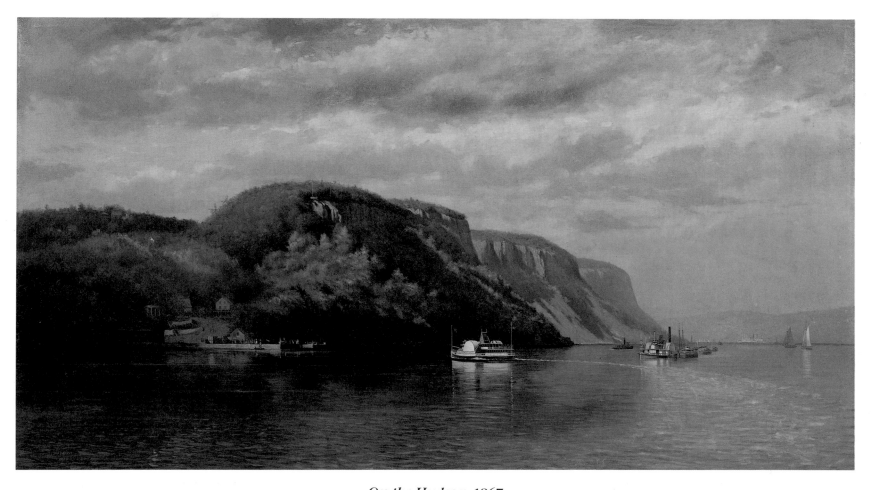

On the Hudson, 1867

Oil on canvas, 39 × 72 in. Signed, dated, and inscribed lower left: *J. G. Brown / N. Y. 1867*. Gift of Mr. and Mrs. John D. Rockefeller 3rd, 1979.7.19

James McNeill Whistler
Lowell, Massachusetts 1834–1903 London, England

After a boyhood that included schooling in the Russian Imperial Academy of Fine Arts in Saint Petersburg and then an unsuccessful period as a cadet at West Point, James McNeill Whistler began his professional career in November 1854 as a draftsman for the United States Coast and Geodetic Survey. Whistler resigned from the post after less than three months, however, and in September 1855 left the United States, never to return. In Paris he studied initially with Marc-Gabriel-Charles Gleyre (1806–1874). Whistler gained his first considerable notoriety in 1863 when his early masterwork *The White Girl* (National Gallery of Art, Washington, D.C.), with its facture and boldness revealing the young man's affinity for the realism of Gustave Courbet (1819–1877), was prominently exhibited at the Salon des Refusés. An articulate and flamboyant figure, Whistler moved in bohemian society in both Paris and London, including among his friends Edouard Manet (1832–1883), Henri Fantin-Latour (1836–1904), Dante Gabriel Rossetti (1828–1882), and Algernon Swinburne. In common with many progressive artists of the 1860s, Whistler collected Oriental porcelain and artifacts, and their aesthetic came increasingly to influence his work in both subject and design. Active and innovative as a painter, printmaker, draftsman, and interior decorator, Whistler was as well a master of self-advertising. His exquisite gallery installations, his well-publicized legal battles, and the several collections of witty writings and observations that he collected and published combined to make him one of the best-known artists of his day.

The Gold Scab: Eruption in Frilthy Lucre is one of Whistler's most striking and atypical works. Known for his delicate color harmonies and elegant sense of design, Whistler here draws upon another of his well-known qualities, a cutting wit. The painting is a caricature of Frederick R. Leyland (1831–1892), a British shipping magnate and one of Whistler's first important patrons. Among many projects for Leyland's family, Whistler in 1876 had transformed the dining room of their London townhouse into *Harmony in Blue and Gold: The Peacock Room* (Freer Gallery of Art, Smithsonian Institution, Washington, D.C.), creating one of the most splendid and original interiors of the nineteenth century. However, strong disagreements about the project—its extent, costs, and the publicity surrounding it—ruptured the relationship between artist and patron.[1]

Three years later, after financial reverses that included the outcome of a disastrous libel suit against the English art critic John Ruskin[2] and overexpenditure on a handsome house and studio on Tite Street in London's Chelsea district, Whistler was forced to file for bankruptcy. His chief creditor was Leyland. To greet his ex-patron when he and the other creditors appeared to inventory Whistler's house and studio, the artist prepared this and two other mocking portraits (now lost). *The Gold Scab* depicts Leyland as a cruel and hideous peacock encrusted with golden scales, sitting upon Whistler's "White House" as if it were an obscene egg. Using the same colors as the disputed *Peacock Room*, the artist caricatures Leyland's wealth, skill at the piano, and habit of wearing frilled shirts (hence, "frilthy" lucre). Whistler confirms his malicious intent by having his signature—the abstract butterfly at the top center of the canvas—bear a long, sweeping tail with its barbed end poised behind Leyland's neck, ready to strike.

Whistler designed and decorated the frame that is now on the painting. It was initially intended to surround *The Three Girls* (1868; location unknown), an unfinished commission from Leyland. The frame, dating to about 1873, is decorated with flowers and petals and includes the artist's butterfly signature and the opening measures of Franz Schubert's *Moments Musicaux*, op. 94, no. 3.[3]

M.S.

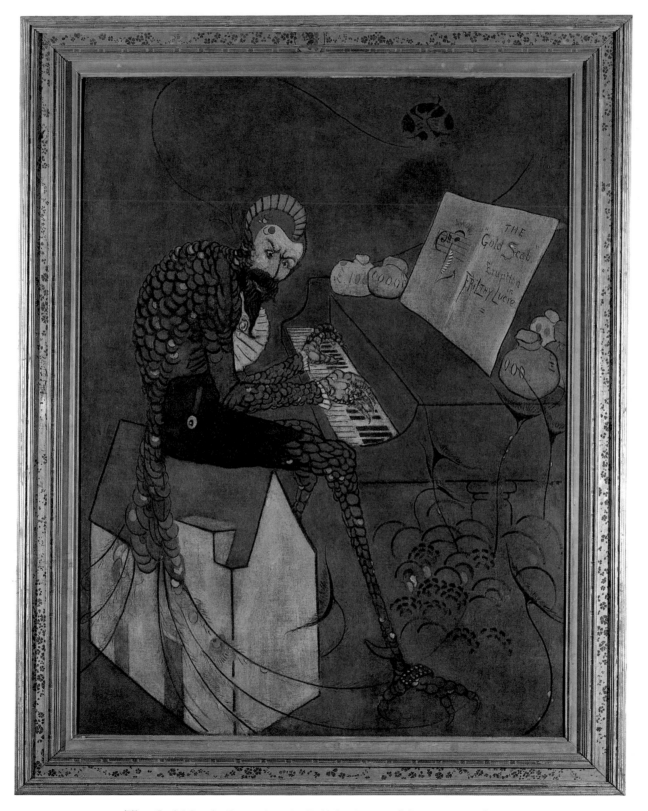

The Gold Scab: Eruption in Frilthy Lucre (The Creditor), 1879
Oil on canvas, 73½ × 55 in. Signed with butterfly monogram top right
Gift of Mrs. Alma de Bretteville Spreckels through the Patrons of Art and Music, 1977.11

William Stanley Haseltine
Philadelphia, Pennsylvania 1835–1900 Rome, Italy

Son of a wealthy merchant, William Stanley Haseltine first studied painting in 1850 with the German-born Paul Weber (1823–1916), while simultaneously enrolled at the University of Pennsylvania. After two years Haseltine transferred to Harvard College, graduating in 1854. In 1855, determined upon an artist's profession, he accompanied Weber to Düsseldorf, there becoming close friends with his compatriots Albert Bierstadt,* Emanuel Leutze (1816–1868), and Worthington Whittredge.* For the next several years, in various combinations, the four Americans painted together throughout Germany, Switzerland, and Italy. Haseltine returned from Italy to the United States in June 1858. Established by the winter in the Tenth Street Studio Building in New York (where Bierstadt, Leutze, and Whittredge were all soon to have studios), Haseltine began to play an active role in the art world of the city. He exhibited at the Century and Salmagundi clubs and at the National Academy of Design, where he was elected an associate in 1860 and an academician in 1861.

After the death of his first wife and his remarriage, Haseltine and his family moved to Europe in 1866. They traveled throughout France and Italy over the next several years, finally settling in the Villa Altieri in Rome in 1874. With the exception of extended tours in both Europe and America, Haseltine lived there for the rest of his life.

European subjects dominate Haseltine's oeuvre. Only from 1861 to 1865 are the majority of his large exhibition works of American scenes. During these years of the Civil War (from which he was exempted from service for a chronic eye ailment), Haseltine journeyed repeatedly to the rocky Atlantic coastline of New England to sketch the simple scenes of sea and shore that form the basis of his strongest work. *Indian Rock, Narragansett, Rhode Island* is one of these comparatively rare North American masterworks.

The painting is an image of poised and elegant power. Waves rise from the blue sea, turn green as they stretch toward the sky, then crash upon the orange rocks. In the distance white-sailed yachts race before the wind. The painting's horizontal emphasis and cool, hard light lend a calm timelessness to the scene parallel to that in works by Fitz Hugh Lane (1804–1865) and Martin Johnson Heade.* It is such painting that prompted the contemporary critic Henry Tuckerman to note Haseltine's "remarkable accuracy" and the "emphatic beauty" of "these noble rock portraits set in the deep blue crystalline of the sea."[1]

Haseltine worked over the surface of the canvas with minute brushstrokes, changing tone and color almost imperceptibly in his attempt to remove all trace of personality from the work.[2] Yet he prevents this highly detailed rendering of local and reflected color from taking on an enamel-like hardness by texturing the ground layer of the painting. Evenly stippled like the skin of an orange, the texture of the gesso ground diffuses the light as it falls upon the thin layer of paint, laying an atmospheric veil across the scene. Haseltine is thus able to work in his most detailed and objective manner[3] while creating a scene filled with the sensation of sea-blown breezes.

Haseltine's synthesis of realist verisimilitude and romantic atmosphere prompted Tuckerman to specific and quite pertinent praise of the artist's works:

> The waves that roll in upon his Rhode Island crags look like old and cheery friends to the fond haunters of those shores in summer. The very sky looks like the one beneath which we have watched and wandered; while there is a history to the imagination in every brown angle-projecting slab, worn, broken, ocean-mined and sun-painted ledge of the brown and picturesquely-heaped rocks, at whose feet the clear, green waters plash: they speak to the eye of science of a volcanic birth and the antiquity of man.[4]

Paintings such as Haseltine's, with their careful "rock portraits," must indeed have prompted many of his contemporaries to consider the origins of man and the geologic origins of the world. Yet the painting's strength, and certainly the source of the viewer's emotional response, depend upon the truth that Herman Melville so succinctly realized: "As everyone knows, meditation and water are wedded forever."[5] Man is fascinated with boundaries, and few are more dramatic than that depicted by Haseltine's *Indian Rock, Narragansett, Rhode Island*—a place where land, sea, and sky are joined. We are drawn to these junctions of elemental opposites, as we are moved by those things—graceful yachts, swooping gulls, or flying foam—that transcend expectations and sail, white and pure, seemingly unencumbered by materiality.

M.S.

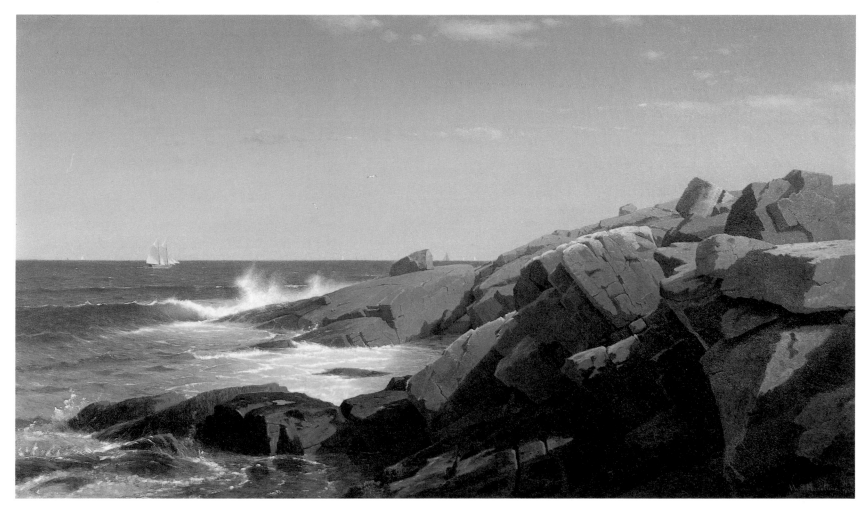

Indian Rock, Narragansett, Rhode Island, 1863

Oil on canvas, 22 × 38¼ in. Signed, dated, and inscribed lower right: *W. S. Haseltine N.Y / 1863*. Museum purchase, Roscoe and Margaret Oakes Income Fund, 1985.28

William Stanley Haseltine

Philadelphia, Pennsylvania 1835–1900 Rome, Italy

With the exception of travels throughout Europe and North America seeking subjects for his picturesque views, the last thirty years of William Stanley Haseltine's life were spent in Italy. Although he was based in Rome, one of his favorite sites was in Sicily, where from the well-preserved Roman ruins at Taormina he could look out to the smoldering, volcanic Mount Etna. The artist sought to return to this site "whenever possible."[1] This spectacular view, reputed to be "one of the most beautiful in Italy,"[2] is the subject of *Ruins of the Roman Theatre*.

In the foreground of the picture, cacti and aloe plants growing amid the ruins are wrapped in a deep shadow, turning them a rich malachite green. Across the middle of the canvas, strong morning light washes the remains of the theater's stage and back wall, making the orange brickwork gleam. Through the triple arches of the wall are glimpses of the jagged Sicilian shoreline where it meets the brilliant blue of the Mediterranean. Away in the distance, purple and green hills lead toward Mount Etna's cone and steaming plume, all ranged beneath a blue sky dusted with scudding clouds.

Haseltine is absolutely convincing in capturing the transient effects of light and air. Shadows cast by the clouds on mountain and plain seem to move before the eye. Brilliant, hot colors fade and distant spaces become hazy as palpable air intercedes between object and viewer. Haseltine's ability to evoke this atmospheric complexity holds in balance both the majesty of Etna and the romanticism of the ruins. Although it seems clear from Haseltine's choice of viewpoint that he consciously sought to establish thematic dichotomies in the picture—the pairings of nature/civilization and ancient/modern seem the most central[3]—still it is the unity of the luminous atmosphere that compels our admiration.

Italy served American artists as a tangible symbol of the glory and fall of great civilizations, the diametric opposite of America's youth and potential. Taormina, with its intermingled records of Greek, Carthaginian, Roman, and medieval civilizations, had a particularly rich and storied past for the American traveler to absorb. Thomas Cole (1801–1848) was perhaps the first American artist of note to praise the spot during his travels of 1842: "What a magnificent site! Etna with its eternal snows towering in the heavens—ranges of nearer mountains—the deep romantic valley—the bay of Naxos— ∗ ∗ I have never seen anything like it. The views from Taormina certainly excel anything I have ever seen."[4] Of Sicily as a whole he wrote:

> There is a sad pleasure in wandering among the ruins of these cities and palaces. We look at the arches and columns in decay, and feel the perishable nature of human art: at the same glance, we take in the blue sea rolling its billows to the shore with the freshness, strength and beauty of the days, when the proud Caesars gazed upon it.[5]

When Cole and artists of his generation sought to record this thrilling melancholy in paint, they most frequently included human figures to act out the various emotions.[6] With Haseltine, however, the human figure is no longer a necessary clue to the tone of the work. The barren landscape and mute stones are sufficient to convey meaning[7] as a sustained meditation on the theme of antiquity and the landscape of Italy, a subject evocative of awe, nostalgia, and (with the latent power of Etna contained in the distance) sublimity.

M.S.

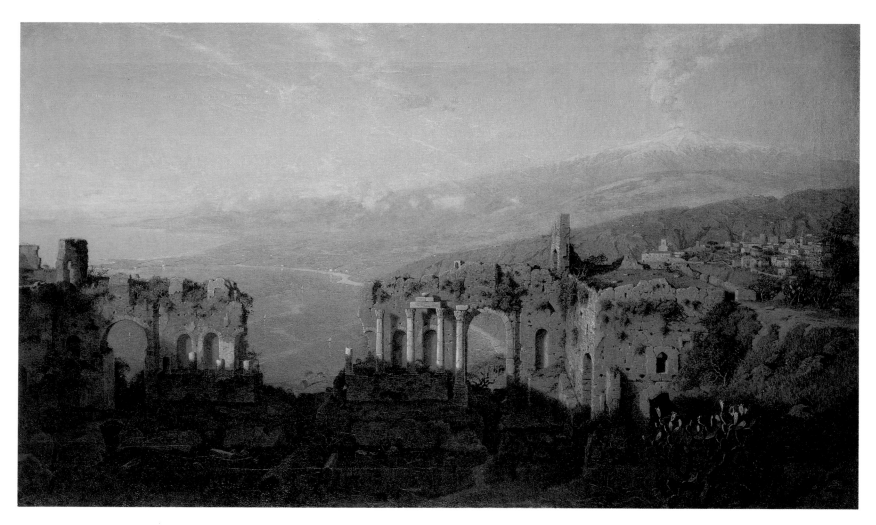

Ruins of the Roman Theatre at Taormina, Sicily, 1889

Oil on canvas, 33 × 56 in. Signed, dated, and inscribed lower left: *W. S. Haseltine. / Rome 1889.* Gift of Peter McBean, 1986.41

Winslow Homer
Boston, Massachusetts 1836–1910 Prout's Neck, Maine

Winslow Homer began his artistic training at the relatively late age of nineteen when he was apprenticed to the Boston lithographer J. H. Bufford. He began selling illustrations to newspapers in 1857, and by 1859 he was employed part time by the foremost paper in the country, *Harper's Weekly.* It was for *Harper's* that Homer made the first of several sketching trips to Civil War battlegrounds, where he made straightforward sketches that later formed the basis for both illustrations and his first oil paintings. Although he was largely self-taught, Homer's oil paintings were critically and commercially successful from the first. In 1864 he was elected an associate of the National Academy of Design, and an academician in the following year. Henry James's equivocating sentiment of a decade later summarizes the standard view that praised Homer's art somewhat in spite of itself:

> He is almost barbarously simple, and, to our eye, he is horribly ugly; but there is nevertheless something one likes about him.... He has chosen the least pictorial features of the least pictorial range of scenery and civilization; he has resolutely treated them as if they *were* pictorial, as if they were every inch as good as Capri or Tangier; and, to reward his audacity, he has incontestably succeeded.[1]

A trip to Paris in 1866, perhaps prompted by the fact that two works (*Prisoners from the Front* [1866; Metropolitan Museum of Art, New York] and *The Bright Side*) were included in the American section of the Paris Exposition Universelle, brought him into contact with both Oriental and modern French art, especially the work of Edouard Manet (1832–1883). He returned to his New York studio with a lighter palette and a generally more decorative approach to genre subjects, predominantly children and vacationing adults, that would occupy the next decade. Summers spent in upstate New York and various resort towns along the Atlantic coast provided material for these idyllic scenes in oil and, increasingly after 1873, watercolor.

In 1881 Homer again traveled abroad, this time to England where he stayed for a year and a half, largely in the fishing village of Cullercoats on the North Sea. Here, fascinated with the sea and the people who lived by it, Homer first invested his works with the somber heroism and seriousness that were eventually to dominate his art. On his return to America, Homer settled into a solitary and, with time, reclusive existence in Prout's Neck, Maine, where his art turned increasingly to the elemental subject of surf and rock, a monumental series broken only by the many vivid watercolors that document his sporting trips and vacations throughout the later decades of his life.

The Bright Side is one of Homer's earliest works and brought the artist, in spite of its small scale, considerable fame. It shows a Union army campsite—supply wagons and mules dominate the middle ground and distance—with a group of muleteers in the foreground lounging in the sunshine. Four men, caught in poses of great naturalness, bask in the sun on "the bright side" of their tent, while a fifth pokes his head through the tent flap and directly confronts the viewer. Homer's attention to dress and gesture, and his skill at rendering his observations, prompted one contemporary critic to claim the painting as "a right sterling piece of work...the best thing he has painted," and Homer as "the best chronicler of the war."[2] In the earliest published biography of the artist, an article by T. B. Aldrich in an 1866 issue of *Our Young Folks,* a reduced wood engraving after *The Bright Side* was the sole reproduction.[3]

The painting, like many of Homer's Civil War works, portrays life in the camps rather than conflict on the battlefield. Its straightforward style seems congruent to the ordinariness of the observation, although its punning title, alluding to the men's noncombatant position in the Union army no less than to their place in the sun, lends a wry edge to the image.[4] As a British critic noted, reviewing *The Bright Side* and *Prisoners from the Front* while they were on exhibition at the Exposition Universelle, "These works are real; the artist paints what he has seen and known."[5]

M.S.

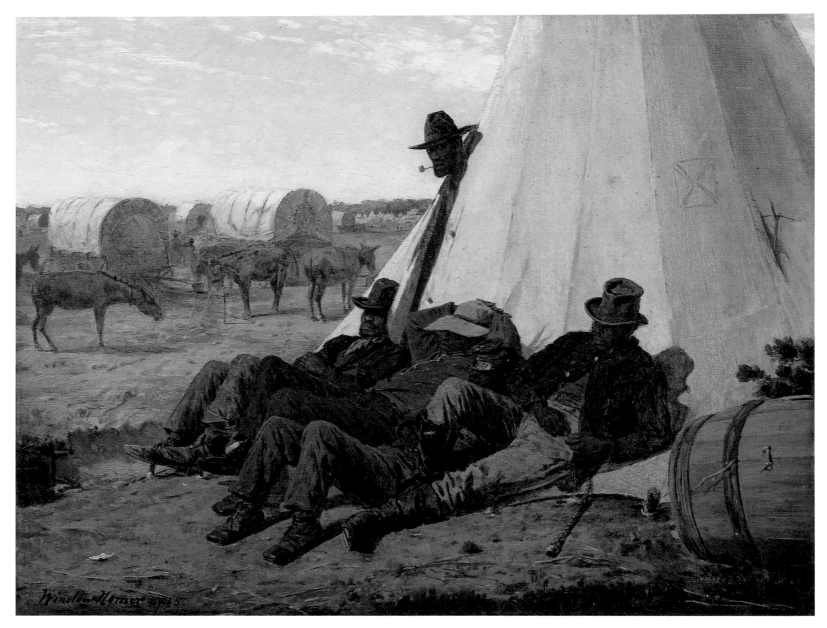

The Bright Side, 1865

Oil on canvas, 13¼ × 17½ in. Signed, dated, and inscribed lower left: *Winslow Homer NY—65*. Gift of Mr. and Mrs. John D. Rockefeller 3rd, 1979.7.56

Elihu Vedder
New York, New York 1836–1923 Rome, Italy

I have intended to hold the mirror up to nature, only in this case nature is the little world of my imagination in which I wander sometimes and I have tried to give my impression on first meeting these strange beings in my wandering there.... If the scene appears extraordinary, all I can say is that it would be stranger if it were not.[1]

With these words the nineteenth-century visionary artist Elihu Vedder characterized the imaginative works for which he is best known today. Vedder turned his experience of the natural world inward and created images disturbing in their concurrent foundation in fantasy and reality. Born in New York City, Vedder entered the Sherburne, New York, studio of the genre and history painter Tompkins H. Matteson (1813–1884) around 1853 for his initial artistic training. He traveled to Europe in 1856 for further study in Paris and Italy and returned to New York in 1861 to begin in earnest his professional career as painter, muralist, illustrator, sculptor, silversmith, and tile maker. After setting up his studio, Vedder made his living by contributing illustrations to *Vanity Fair* but established his reputation with haunting works, often of mythological or literary subjects, which were popular in literary and artistic circles. His paintings were so distinctively enigmatic and disturbing in subject and effect that, when reviewing his paintings, critics eschewed standard descriptive terminology in favor of the newly coined "Vedderesque."[2] In 1866 Vedder returned to Rome, making that city his permanent residence despite frequent trips to the United States to fulfill his many commissions. Along with William Stanley Haseltine,* Vedder was among the last in the great wave of expatriate artists to settle in Italy in the mid-nineteenth century, finding inspiration in her rich historical and cultural past.[3]

The Sphinx of the Seashore not only reflects Vedder's preoccupation with the legendary characters of classical antiquity, but also presents a subject that he treated as early as 1863 and to which he returned numerous times. In this, one of his last representations of the sphinx, dating to 1879 although copyrighted twenty years later, the creature rests a paw possessively on a human skull.[4] Beneath the eerily glowing sky and alone on the beach marked by the ruins of a town and aqueduct, she lies among the bleached remnants of those who could not properly answer her riddle of life and existence. The broken chains and battered ship timbers in the foreground seem to be offerings to the one who has caused such ruin. Graphically depicting the detritus of the sphinx's ruthlessness, rendering the overcast sky and desolate landscape in haunting and unnatural color, and animating the mythical with the real, Vedder positions the viewer directly opposite the sphinx's predatory stare, suggesting that he too may wash up on this seashore.

The Sphinx of the Seashore is related to a drawing Vedder used in his major illustration project—Omar Khayyám's *Rubáiyát*. That drawing, called by Vedder *The Inevitable Fate*,[5] accompanied verses of the twelfth-century Persian mathematician-astronomer's poems on the mysteries of life and death:

> 55
> Would you that spangle of Existence spend
> About The Secret—quick about it Friend!
> A Hair perhaps divides the False and True—
> And upon what, prithee, does Life depend?
>
>
>
> 58
> A moment guess'd—then back behind the Fold
> Immerst of Darkness round the Dramma roll'd
> Which for the pastime of Eternity,
> He does Himself contrive, enact, behold.[6]

Vedder considered the question of human existence in his own writings. On the sphinx of the seashore he wrote:

> The Philosopher [Omar Khayyám] had evidently pondered on the fact of the disappearance of so many forms of life and the certainty that in time even man himself with all his inventions must disappear from the face of the earth. What wonder that he calls the brief moment of existence between two eternities a spangle or that the artist should represent this idea under the form of the all devouring Sphinx.[7]

J.S.

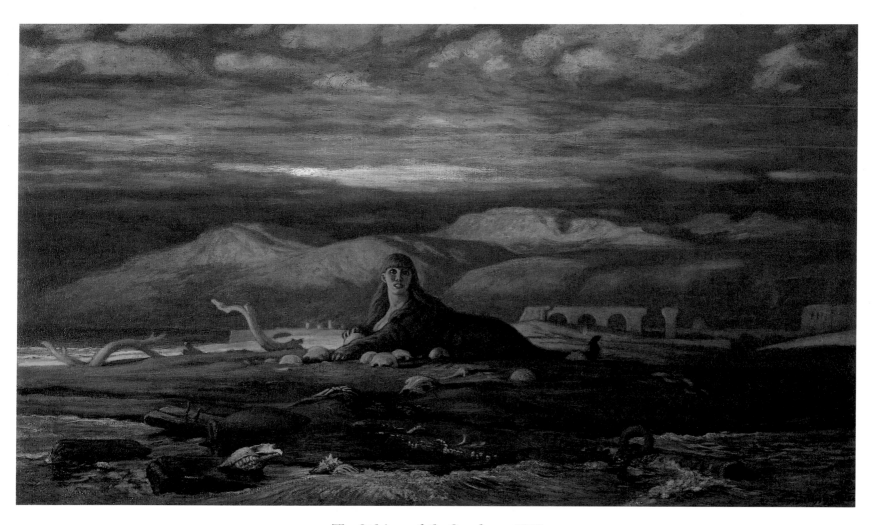

The Sphinx of the Seashore, 1879
Oil on canvas, 16 × 28 in. Signed with monogram and inscribed lower right: *Roma / Copyright 1899 by E. Vedder*
Gift of Mr. and Mrs. John D. Rockefeller 3rd, 1979.7.102

Thomas Moran
Bolton, Lancashire, England 1837–1926 Santa Barbara, California

In a period when Americans were eager to learn about the wonders of the American West, Thomas Moran recorded in paint many of the most spectacular sites, including Yellowstone and the Grand Canyon. Moran moved with his family to Philadelphia in 1844; there he apprenticed several years with an engraving firm before establishing his studio in 1856. During the following decade Moran made two trips to Europe, exhibited his work at the Pennsylvania Academy of the Fine Arts, taught painting, and earned his living illustrating books and magazines. The turning point of his career came in 1870 when, working only from manuscript descriptions and crude sketches made by an amateur, he illustrated an article on Yellowstone for *Scribner's Monthly*.[1] Fascinated with that region of geysers, hot-water springs, and other natural phenomena, Moran eagerly accompanied the expedition of 1872 responsible for its survey. The watercolors, illustrations, and oil paintings that resulted from that first journey not only received great popular acclaim, but were also instrumental in convincing the United States Congress to establish Yellowstone in that same year as the first national park. For the remainder of his lengthy career, Moran made regular sketching trips to those still remote areas of natural beauty such as Yosemite, Lake Tahoe, and the Green River of Wyoming. These sites provided the inspiration for much of his mature work. The place and subject to which Moran returned most frequently, however, was the Grand Canyon.[2] Awed by its size and moved by its beauty, Moran wrote in 1902 that "its tremendous architecture fills one with wonder and admiration, and its color, forms and atmosphere are so ravishingly beautiful that, however well traveled one may be, a new world is opened to him when he gazes into the Grand Canyon of Arizona."[3]

Grand Canyon with Rainbow, dating from late in his career, represents Moran's wish to capture the scale and grandeur of the desert gorge. Moran places the spectator at the very rim of the canyon, confronted with a view framed by weathered trees and a high rock face. Space drops vertiginously downward and opens onto a vista of strangely eroded formations, brightly colored by their varied mineral content. Moran depicts the moment after a storm has passed, when the clouds break and mists evaporate; the sun's radiance casts a changing pattern of light and shade across the panorama of irregular canyon shapes and creates a rainbow— one of the most ephemeral and precious of natural phenomena. The painting offers an image of color, dizzying space, and dramatic atmospheric effects. As Moran wrote when discussing the Grand Canyon, it is "the terrible and sublime feelings that are stirred within [the viewer], as he feels himself in the jaws of the monstrous chasms."[4]

With his representations of the American West, Moran also hoped to inspire a distinctly American art form. The late-nineteenth-century preoccupation of the American art community with European training and styles was of serious concern to the painter, who believed that the future of American art depended on artists being truthful to their country.[5] The beauty of the Grand Canyon was Moran's primary evidence as he urged his colleagues to focus on their native land:

> My chief desire is to call the attention of American landscape painters to the unlimited field for the exercise of their talents to be found in this enchanting Southwestern country; a country flooded with color and picturesqueness, offering everything to inspire the artist, and stimulate him to the production of works of lasting interest and value.[6]

In *Grand Canyon with Rainbow* Moran not only exalts the grandeur of the landmark; with the rainbow, the commonly understood nineteenth-century symbol of blessing, he expresses his faith in the promise of America and indeed creates a landscape of "lasting interest and value."

J.S.

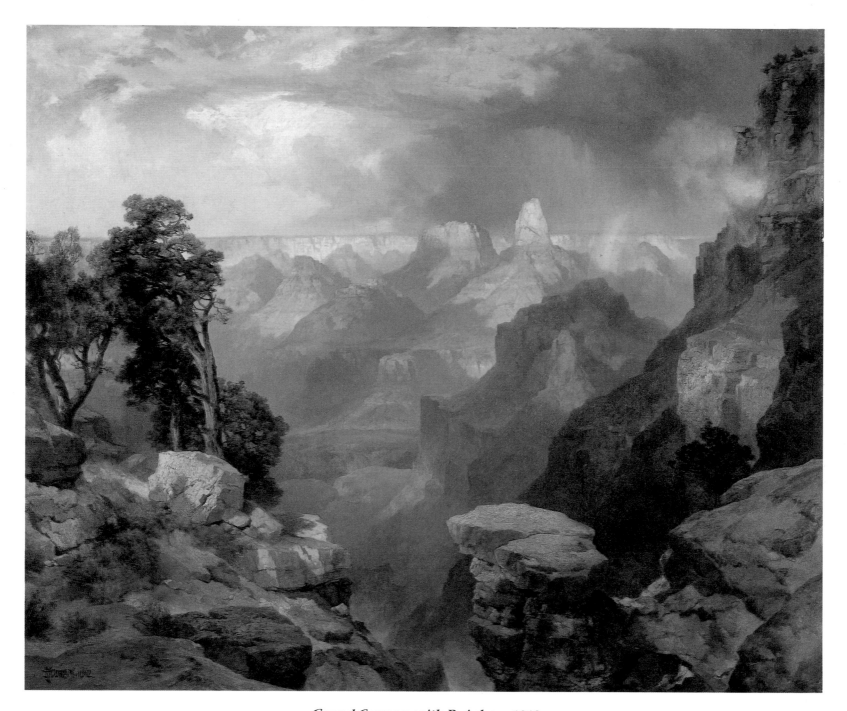

Grand Canyon with Rainbow, 1912
Oil on canvas, 25 × 30 in. Signed and dated lower left: *TMoran. 1912*. [initials in monogram]
Gift of Mr. and Mrs. Robert Gill through the Patrons of Art and Music, 1981.89

Thomas Hovenden
Dunmanway, County Cork, Ireland 1840–1895 Plymouth Meeting, Pennsylvania

At the age of twenty-three Thomas Hovenden immigrated to the United States, earning his living in New York making frames and coloring photographs by day while studying by night at the National Academy of Design. In 1874 Hovenden traveled to Paris where he matriculated at the Ecole des Beaux-Arts as a painter of historical genre scenes. In the late 1870s he settled in the American artists' colony at Pont-Aven, Brittany. There he painted the scenes of Breton peasant life that won him critical approval at the annual French Salons. Returning to America in 1880, Hovenden spent a year in New York before settling in Plymouth Meeting, Pennsylvania. Six years later he became an instructor at the Pennsylvania Academy of the Fine Arts and counted Robert Henri* among his many pupils. Having been elected to the National Academy in 1881, Hovenden maintained ties in New York by exhibiting regularly at the academy's annual shows. He reached the pinnacle of his career at the 1893 World's Columbian Exposition in Chicago, with the exhibition of his *Breaking Home Ties* (1890; Philadelphia Museum of Art). Hovenden died tragically two years later while attempting to rescue a child from under the wheels of a moving train.

Like many of his contemporaries, Hovenden executed genre scenes of home and family life. Unlike most of them, however, Hovenden also specialized in representations of the American black. Associated by marriage to a family of ardent abolitionist sympathizers and painting in a studio previously used as a center for the Underground Railroad, Hovenden focused much of his work on the newly freed people.[1] One such painting is *Taking His Ease*, which depicts an aging black man at home surrounded by his well-worn and simple possessions. He leans back comfortably in his chair and draws contentedly on his pipe. With chin lowered and eyes half-closed, the man gazes with shrewdness and quiet consideration, engaging the spectator in a silent dialogue. By means of this sympathetic, unaffected rendering of pose and gesture, Hovenden neither sentimentalizes nor caricatures his sitter. Despite the humbleness of the scene, he suggests the humanity and dignity of the subject.

Though simple in theme, Hovenden's image is both visually rich and strikingly immediate. The darkened interior is defined as light enters from the window and reflects off the forms of man and furniture. Slowly the spectator's eye discerns the dim shapes in the background. The loosely brushed colors of green, beige, and brown not only suggest naturalistic objects, they also assume in their freedom a life, beauty, and coloristic harmony of their own. In this tactile yet evocative description of everyday life, light, shadow, texture, and tone prevail. Thus Hovenden takes the unassuming subject of a solitary man smoking his pipe and infuses it with a rich and compelling sense of visual—and ultimately human—presence.

J.S.

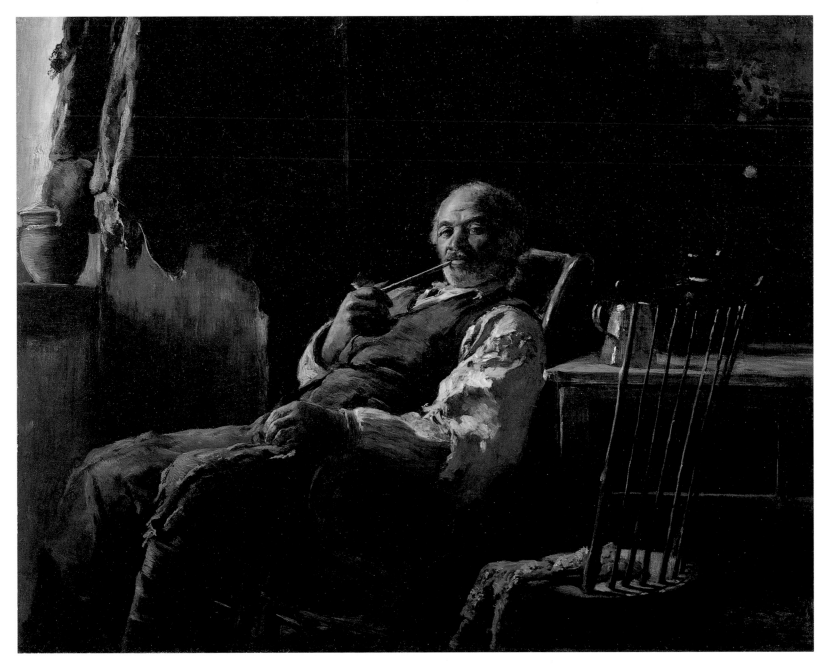

Taking His Ease, 1885

Oil on canvas, 16 × 20 in. Signed at right (on table crosspiece): *THovenden* [initials in monogram]. Gift of Mr. and Mrs. John D. Rockefeller 3rd, 1979.7.59

Thomas Eakins

Philadelphia, Pennsylvania 1844–1916 Philadelphia, Pennsylvania

After graduating from the academically rigorous Central High School in Philadelphia, in 1862 Thomas Eakins enrolled in classes at the Pennsylvania Academy of the Fine Arts. Completing course work in 1866, he briefly followed his father's profession as a writing master before traveling to Paris to study at the Ecole des Beaux-Arts. For the next two and one-half years he studied in the atelier of Jean-Léon Gérôme (1824–1904), whose meticulous draftsmanship and careful composition were central to Eakins's development.[1] With family and friends, Eakins traveled during these years through much of Europe. His longest sojourn was from November 1869 through June 1870 in Spain, where the luminous works of Velázquez (1599–1660) at the Prado in Madrid made a particularly strong impression on him.

Upon his return to Philadelphia in the summer of 1870, Eakins set up a studio in the family home and, supported financially by his father, began to paint a series of genre and sporting scenes. To further his interest in anatomy he attended courses at Jefferson Medical College in 1873. During the mid-1870s Eakins's career flourished. He began to exhibit his work widely, at the same time painting the portraits of eminent men, including President Rutherford Hayes, Dr. Samuel D. Gross, Archbishop James F. Wood, and General George Cadwalader. In 1879, after three years of instructing in various volunteer capacities at the Pennsylvania Academy, he received an appointment there as professor of drawing and painting. Photography began to interest him increasingly from the early 1880s, and he undertook his first independent sculpture commissions in 1882.

The forward momentum of this successful career came to a halt in February 1886 when, due to criticism over his use of the naked model in his teaching, Eakins was forced to resign the directorship of the Pennsylvania Academy school. Personally, professionally, and socially, this enforced break was disastrous, and it cast him into a year-long depression during which he did little painting. For the decade following, although he lectured sporadically in New York, Washington, and Philadelphia (not at the Pennsylvania Academy) and attempted (with varying degrees of success) to exhibit his works, his public career as a painter was largely thwarted. Only after 1895, with his resignation from most of his teaching duties and his concentration on probing and insightful portraits of his friends (the bulk of them uncommissioned), did he receive prizes and recognition commensurate with his accomplishments.

Eakins's earliest interior scenes record his family and friends engaged in simple domestic activities. In 1876, however, he began to work on a history painting—*William Rush Carving His Allegorical Model of the Schuylkill River* (1877; Philadelphia Museum of Art)—in which he sought to re-create events that had occurred seventy years earlier. This was the first of a small group of paintings, watercolors, and sculptures, infused with a nostalgia for that earlier time, that he would undertake over roughly the next seven years.[2]

One recurrent image in these retrospective works, of which *The Courtship* is among the most ambitious, was of a woman spinning.[3] Eakins had been attracted to spinning as a subject as early as 1870 while still in Spain, where he wrote that one of the foreground figures in Velázquez's *Las Hilanderas* (1644–48; Prado, Madrid) was "the most beautiful piece of painting that I have seen in my life."[4] The impetus for his choosing the subject in 1876 might well have been an exhibit at the Philadelphia Centennial. William Dean Howells described the New England Log House from Massachusetts in which

> at the corner of the deep and wide fire-place sat Priscilla spinning—or some young lady in a quaint, old-fashioned dress, who served the same purpose. I thought nothing could be better than this, till a lovely old Quakeress, who had stood by, peering critically at the work through her glasses, asked the fair spinster to let her take the wheel. She sat down beside it, caught some strands of tow from the spindle, and with her long-unwonted fingers tried to splice the broken thread.... That was altogether the prettiest thing I saw at the Centennial.[5]

The female model in *The Courtship* was Anna W. (Nannie) Williams, a young teacher who posed for the nude figure in *William Rush* and whose profile was the model for Liberty for U.S. coinage through the 1920s.[6] Eakins lavished great care upon the realistic modeling of her down-turned face, full arm, and modest white gown. Beside her sits a young man, patient, watchful, his hat crumpled in his lap. His figure is summarily formed with swift strokes to conjure his natural, relaxed pose. His face is hidden by shadow, but his elegant black and tan boots, set off by a dark green jacket and cream-colored trousers, glisten in the golden light. He has come to call upon the girl and he waits, with the casualness of intimacy, while she yet concentrates on her work.[7]

Although a study for The Fine Arts Museums' painting indicates that Eakins had planned a more developed background for *The Courtship*, he ultimately left the setting unresolved.[8] Perhaps he felt that he was skimming too close to poetic painting and wanted the roughness of the finish to temper the implied narrative.[9] Perhaps real life intruded as well: in April 1879 Eakins's own courtship ended with the death of Katherine Crowell, his fiancée of five years.

M.S.

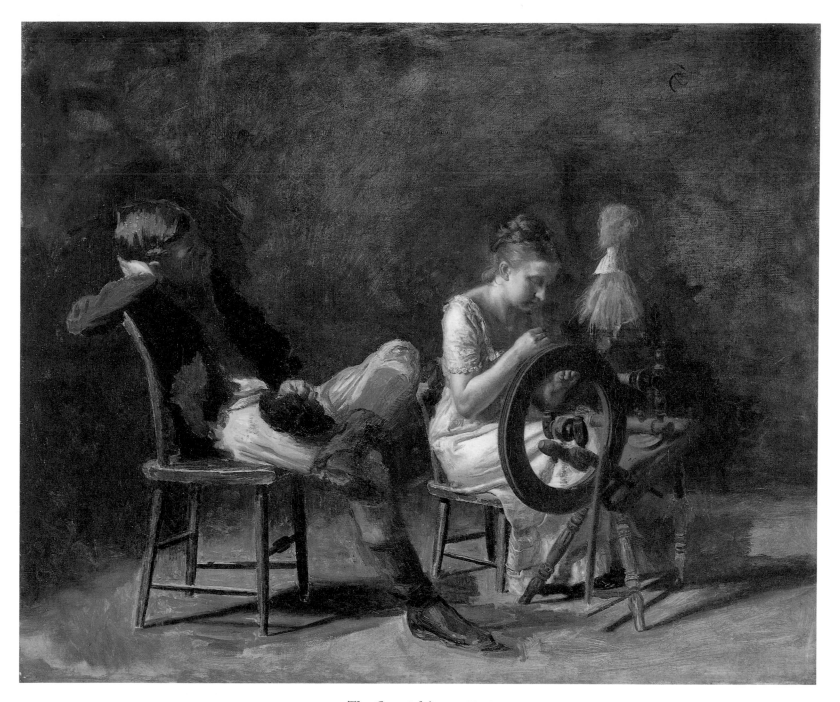

The Courtship, ca. 1878
Oil on canvas, 20 × 24 in. Signed center right (on base of spinning wheel): *[EA]KINS*
Museum purchase by exchange: Gift of Mrs. Herbert Fleishhacker, M. H. de Young, John McLaughlin, J. S. Morgan and Sons, and Miss Keith Wakeman, 72.7

Thomas Eakins
Philadelphia, Pennsylvania 1844–1916 Philadelphia, Pennsylvania

From the mid-1880s until about 1910, with few exceptions Thomas Eakins concentrated his picture making on portraits. These many works of insightful and forceful beauty, "among the strongest artistic creations of nineteenth-century America,"[1] were largely uncommissioned. Barely ten percent of the two hundred forty-six portraits known to have been painted over the course of his career are documented as commissions.[2] Instead Eakins would frequently ask to paint those friends and acquaintances who attracted or interested him. Once the sittings were over (and they were often a long and exhausting series), he would offer the finished works to the sitters or their families. In many instances the paintings were not accepted or, less frequently, were subsequently destroyed or "lost." As Eakins himself bemoaned in 1894 when considering his career, "My honors are misunderstanding, persecution, & neglect, enhanced because unsought."[3]

We do not know whether Frank Jay St. John (d. 1900), commissioned his portrait, but the work did descend in the sitter's family for at least two generations. The painting, a miniaturized full-length format unusual in Eakins's oeuvre,[4] shows St. John seated in near profile. He wears a heavy black overcoat and holds his hat in his hand. These elements, along with his crossed legs and alert gaze, combine to suggest impatience and barely repressed energy. His golden hair and full mustache are striking, as are his pale eyes and pince-nez. At his throat is a brilliant scarlet tie. Eakins has described the figure fully, using thin, short strokes to model the form and suggest the varying textures of flesh, cloth, and leather.

At the same time as Eakins worked on this painting, Samuel Murray (1869–1940), Eakins's sculptor protégé, made a portrait bust of St. John. The sittings took place in the Philadelphia studio the two artists shared at 1330 Chestnut Street, as documented by two photographs showing them at work with St. John posing in the cluttered space, its wooden floor markedly bare.[5] Eakins apparently created the carpet and setting from his mind's eye. He was, however, scrupulous in his choice of props to include in St. John's portrait. Eakins firmly believed in portraying the sitter at work, or at least surrounded with the tools of his occupation; this practice is evident throughout his career in his many portrayals of scientists, clerics, doctors, teachers, and musicians. St. John, a Philadelphia coal merchant, followed a profession that did not directly open itself to this treatment.[6] But in the background at the left of the canvas Eakins has included the evidence of his sitter's pragmatic and intellectual accomplishments. Leaning against the map on the wall are two portions of a ship's grate bar—the grill upon which coal burns to operate steam boilers. In March 1894 St. John had received a patent for improvements to grate bars that, he reported, "not only... enable a clean and bright fire to be maintained, but entail less labor on the stoker than with any bars which my experience has brought to my notice." The result of what St. John described as "a most extensive use and thorough practical test," the improved grate bar was his attempt to advance the profession.[7] Eakins, alert to the quiet accomplishments of modern life, celebrates in this painting both the man and his deed.

M.S.

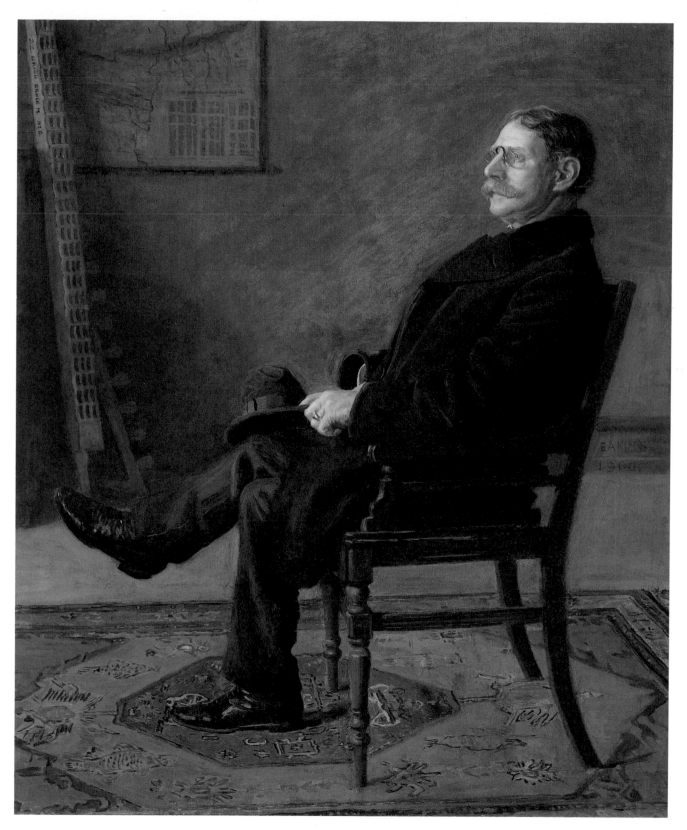

Frank Jay St. John, 1900

Oil on canvas, 24⅛ × 20 in. Signed and dated center right: *EAKINS / 1900.* Gift of Mr. and Mrs. John D. Rockefeller 3rd, 1979.7.37

Mary Cassatt
Allegheny City, Pennsylvania 1844–1926 Mesnil-Théribus, France

After spending four years of her childhood abroad, Mary Cassatt began her artistic training at the Pennsylvania Academy of the Fine Arts, Philadelphia, in 1861. Upon completion of her course work at the academy in 1865, she went again to Europe, where she studied (apparently with no lasting effect) with Charles Chaplin (1825–1891) and Jean-Léon Gérôme (1824–1904), among others. She was in Rome by the summer of 1870, when the outbreak of the Franco-Prussian War prompted her return to the United States. Subject to dreadful bouts of seasickness, she nevertheless crossed to Europe the following year, studying in Parma and traveling widely. In 1877 her parents and sister joined her in Paris, and France became her permanent home.[1]

In April 1877 Edgar Degas (1834–1917) visited Cassatt's studio[2] and invited her to participate in the Independent (or Impressionist) exhibitions. She eventually exhibited in the fourth, fifth, sixth, and eighth group shows, the only American included with the group.[3] In 1912 she remembered Degas's invitation: "I accepted with joy. At last I would be able to work with absolute independence and without concerning myself with the potential decision of a jury! I had already recognized who were my true masters. I admired Manet, Courbet, and Degas. I hated conventional art. I began to live."[4]

Beyond the Impressionist techniques in her own radical work, Cassatt championed the "new painting" of her French colleagues among her American friends and patrons. Her influence was central to the formation of several major collections of modern works, notably that of Horace and Louisine Havemeyer, whose collection provides the core of Impressionist works at New York's Metropolitan Museum of Art.[5] Cassatt was persuasive not only by her example but also by her verbal skills. Mrs. Havemeyer later reported: "Our evenings were devoted to art talks, for Miss Cassatt was the most brilliant talker I ever listened to. I have been told by strangers that they timed their dinner hour just to get some of the crumbs as she chatted with my sister and my husband."[6]

Active as a painter and pastellist, Cassatt also made innovative prints, including a series of drypoints with colored aquatint inspired by her admiration of Japanese woodcuts, and one mural (now lost) for the Women's Building of the Chicago World's Columbian Exposition in 1893. Gradually Cassatt's subject matter turned from the social practices of the upper bourgeoisie (the opera, afternoon tea, reading the newspaper) to intimate scenes of mothers and children. Failing eyesight curtailed her activities after 1910. In 1914 she stopped painting.

Cassatt's mother, Katherine Kelso Johnston, the subject of this portrait, was born in Pittsburgh in 1816. Cassatt recalled her as

an American daughter of Americans. Her family, which was Scottish, immigrated to America in about 1700.... However, my mother received a French education.... [As a girl she had learned] to speak the purest French, and she continued throughout her life to correspond in French with those of her friends who spoke that language. She was a cultivated person and extremely literary.[7]

Johnston married Robert Simpson Cassatt, a wealthy banker, in 1835. Together they had five children who survived infancy, of whom the artist was the fourth. Socially prominent in Pittsburgh and Philadelphia, Mrs. Cassatt was by all reports a broadly traveled and well-read woman. Mrs. Havemeyer wrote of her:

Anyone who had the privilege of knowing Mary Cassatt's mother would know at once that it was from her and her alone that [Mary] inherited her ability. In my day, she was not young [but] she was still powerfully intelligent, executive, and masterful and yet with that sense of duty and tender sympathy that she had transmitted to her daughter.[8]

Katherine Cassatt died in her daughter's château at Mesnil-Théribus in October 1895.

Mrs. Robert S. Cassatt is the last of Cassatt's known depictions of her mother.[9] The sitter's carefully modeled head and hands, worked in parallel hatchings of mauve and pink, are fully realized. By contrast, the brooch at her neck and portions of her shawl are bare canvas, untouched by the artist. Following the examples of Degas and Edouard Manet (1832–1883), Cassatt uses broad areas of black to accentuate the two-dimensionality of the canvas. She surrounds the strong and solid pyramidal figure with wild slashes of color that suggest the elegant background—the Louis XV chair, gold-framed mirror, and floral bouquet.

Writing of this portrait in 1913, Achille Segard was critical of its placid remove, noting that although "it expresses the calm, lulling sweetness and rather ordered spirit in the organization of her life ... [Cassatt] has not sought to reveal hidden sentiments, the byways of the heart." But he concluded his comments by writing that the portrait was "well painted, it is a handsome painting."[10] The foremost modern scholar of Cassatt's work, Adelyn Breeskin, cited it simply as "certainly one of her strongest and finest works."[11]

M.S.

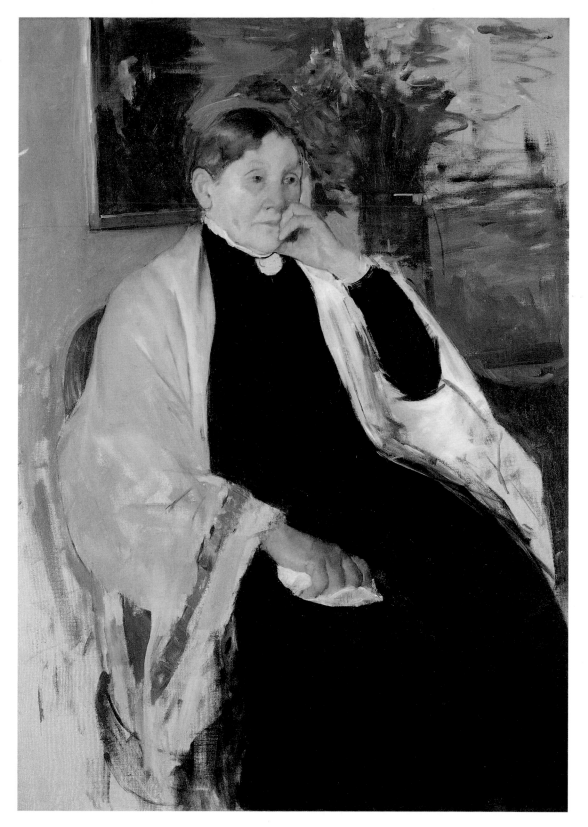

Mrs. Robert S. Cassatt, the Artist's Mother (Katherine Kelso Johnston Cassatt), ca. 1889
Oil on canvas, 38 × 27 in. Museum purchase, William H. Noble Bequest Fund, 1979.35

Ralph Albert Blakelock
New York, New York 1847–1919 Elizabethtown, New York

After two years of college in his native New York City, Ralph Albert Blakelock took up painting in the 1860s. The formative experience of his career was a lengthy trip to the western United States, begun in 1869, during which he executed drawings and oils of the land and Native American population. Upon his return to New York around 1872, Blakelock developed a style and subject that were to characterize much of his mature work— representations of Indians and their domestic activities in the American plains and forests, at the quiet light-filled moments of dawn, sunset, and moonrise. Perhaps because these images derived more from Blakelock's memory and imagination than the reality preferred by the public, or perhaps due to the unfashionably rough and textured qualities of his finished canvases, Blakelock received little critical approval and was plagued by severe financial problems during his career. In 1891 the artist suffered a mental collapse allegedly brought on by poverty; afterward Blakelock suffered from psychological problems and spent most of his remaining years in a mental hospital. Ironically, at this point in his life when he was past his period of productivity, attitudes changed and the critical art community recognized the artist: paintings no longer owned by him commanded high prices, the National Academy of Design elected him to membership in 1913, and major publications about him appeared.[1]

To create the dense atmospheric qualities of his mature works, Blakelock developed an unconventional painting method. He primed his canvas or panel with a white ground laid on in an irregular fashion—thicker in some areas, thinner in others—and roughly textured it with palette knife or brush. When the priming had dried, Blakelock built up the image with multiple layers of pigment that have no relation to the patterning in the ground.[2] It is said that Blakelock then used pumice to rub the surface, revealing the underlying areas of color. As one critic wrote in 1919, "occasionally an authentic little canvas burning with autumnal color will seem hardly more than a panel over which molten jewels have been poured in an indirect flood."[3] He might as well have been commenting upon *Indian Encampment on the James River*, a work that remains today in singularly fine condition.

Blakelock's paintings of Native Americans, such as *Indian Encampment on the James River, North Dakota*, do not answer the ethnographic questions addressed by George Catlin* and other painters. Instead, Blakelock places the viewer at a physical distance from the small Indian settlement and establishes a temporal separation by enveloping the twilight serenity with a sense of reverie. Caught between night and day, the light takes on the colors of the setting sun in a rich harmony of gold and brown tonalities. As the river in the distance reflects the last vestiges of light with unnatural brilliance, the trees stand silhouetted against the sky, their foliage reduced to a lacelike effect. The figures go about their domestic tasks in harmony with nature. Indistinct and haunting, representative of neither specific place nor people, *Indian Encampment on the James River* expresses Blakelock's vision of bucolic simplicity.

J.S.

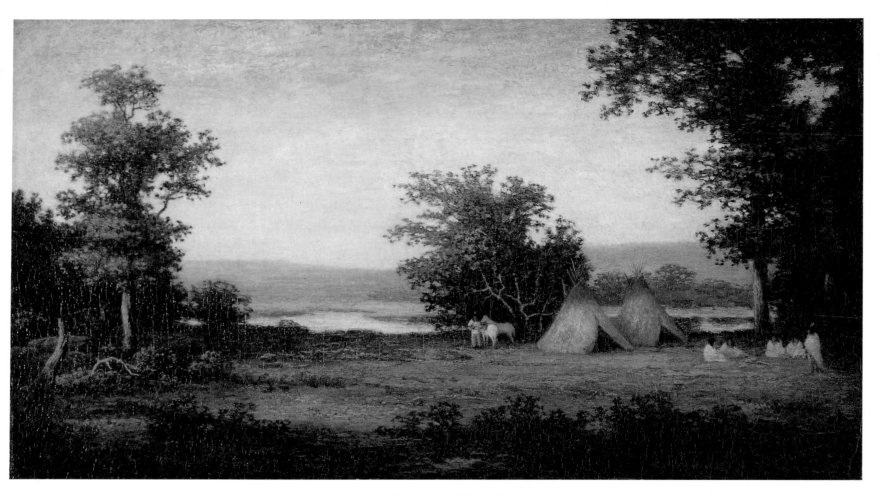

Indian Encampment on the James River, North Dakota, after 1872
Oil on panel, 15¾ × 28½ in. Signed lower right: ***Ralph Albert Blakelock*** [in inscribed arrowhead]
Gift of Mr. and Mrs. Robert Gill through the Patrons of Art and Music, 1980.17

Albert Pinkham Ryder
New Bedford, Massachusetts 1847–1917 Elmhurst, New York

Educated only through grammar school because of an eye weakness reportedly caused by a faulty vaccination, and largely self-taught in the craft of painting, Albert Pinkham Ryder was America's great mystical artist of the nineteenth century.[1] Throughout his youth he lived opposite the home of Albert Bierstadt's* family in the busy whaling port of New Bedford. In about 1870, with his mother and father, he moved to New York City. There, when he failed to gain admission to the School of the National Academy of Design, he studied with William Edgar Marshall (1837–1906). Later he was admitted to drawing classes at the academy, which he attended for four years.

Late in his life Ryder described the epiphany that started him upon his characteristically small and thickly worked paintings:

It stood out like a painted canvas—the deep blue of a midday sky—a solitary tree, brilliant with the green of early summer, a foundation of brown earth and gnarled roots. There was no detail to vex the eye. . . . I threw my brushes aside; they were too small for the work in hand. I squeezed out big chunks of pure, moist color and taking my palette knife, I laid on blue, green, white and brown in great sweeping strokes. As I worked I saw that it was good and clean and strong. . . . Exultantly I painted until the sun sank below the horizon, then I raced around the fields like a colt let loose, and literally bellowed for joy.[2]

Ryder did not date many paintings, and a comprehensive overview of his life and oeuvre has yet to be completed.[3] It seems, however, that his work of the 1870s emphasized rural scenes bathed in a heavy golden atmosphere. In the 1880s and 1890s literary subjects and nocturnal marines of startling strength and abstraction dominated his work. At this same time Ryder grew increasingly reclusive, devoting himself to his painting and ignoring the practical matters of daily living. To an almost unbelievable extent he lived by his words: "An artist needs but a roof, a crust of bread and his easel, and all the rest God gives him in abundance. He must live to paint and not paint to live."[4] Yet as he ceased to exhibit works at the National Academy or the Society of American Artists, of which he had been a founding member in 1877, his works drew more critical attention and became highly prized by collectors.[5]

After 1900 Ryder stopped conceiving projects and worked primarily on paintings already begun (and in some instances sold) long before. A circle of close and protective friends formed around him. Artists as diverse as J. Alden Weir (1852–1919) and Marsden Hartley* sought his companionship and admired, through purchase or imitation, his thickly encrusted visions. Ten of his works were included in the ground-breaking Armory Show of 1913.

Changing and amending, always searching for some ineffable crystallization of his idea, Ryder wrote of his long painting campaigns:

Have you ever seen an inch worm crawl up a leaf or a twig, and then clinging to the very end, revolve in the air, feeling for something to reach something? That's like me. I am trying to find something out there beyond the place on which I have a footing.[6]

Unfortunately, the unorthodox techniques that he used, with layers laid upon layers of still-wet paint, varnish, and turpentine, have led to significant condition problems that mar many of his most famous works.

In *The Lone Scout*, an uncharacteristically bright and clear-colored work, a bearded horseman (perhaps a self-portrait) in white burnoose with elaborate trappings rides slowly toward the viewer. Holding an elegant rifle in his right hand, the rider gazes calmly ahead. Brilliant blue sky and desert sand surround him and his horse; only their shadows give definition to the ground.

Like many American artists of his period, Ryder traveled to Europe several times. On his first trip in 1877 he stayed about a month in London; on his third and fourth trips, in 1887 and 1896, he again stayed only in London. Only during the second trip of 1882, made with his dealer Daniel Cottier, did Ryder travel to the Continent and as far afield as Tangier. *The Lone Scout*, along with *By the Tomb of the Prophet* (probably after 1882; Delaware Art Museum, Wilmington) and *Oriental Camp* (probably after 1882; Mead Art Museum, Amherst College, Amherst, Mass.), perhaps relates to this trip in North Africa.[7] These three works stand out in Ryder's oeuvre as peculiarly exotic, yet without specific literary sources.

Numerous other American artists traveled to North Africa at the end of the nineteenth century and drew upon their experiences in their art, from the travel reportage of Louis Comfort Tiffany (1848–1933) and John Singer Sargent* to the visions of Elihu Vedder.*[8] Nevertheless, Ryder's love for and apparently deep knowledge of literature should not be discounted as an alternate source of inspiration for *The Lone Scout*. Standing before his *Oriental Camp*, Ryder is said to have recited Longfellow's lines that the cares of day "Shall fold their tents, like the Arabs, / And as silently steal away."[9]

M.S.

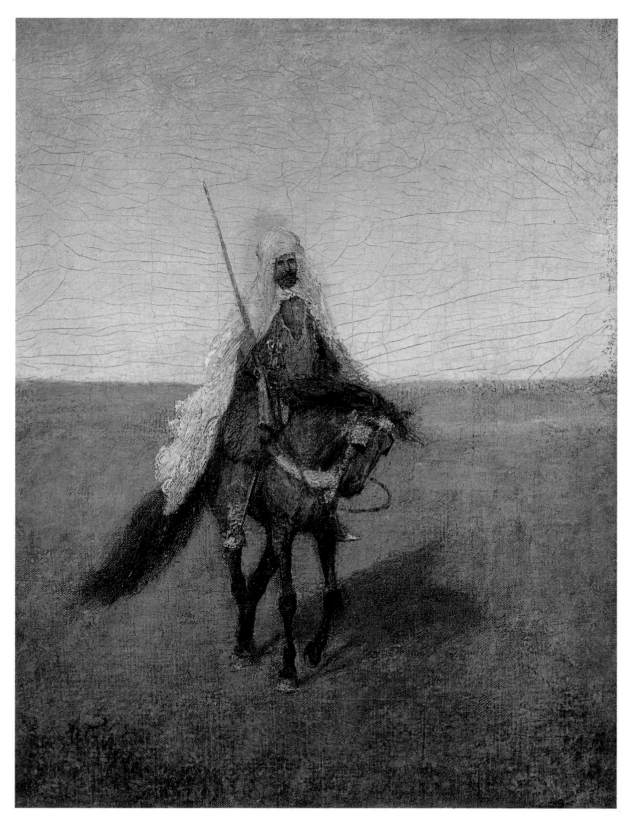

The Lone Scout, ca. 1885
Oil on canvas, 12 × 9¼ in. Signed lower left: *A. P. Ryder.* Gift of Mr. and Mrs. John D. Rockefeller 3rd, 1979.7.88

William M. Harnett

Clonakilty, County Cork, Ireland 1848–1892 New York, New York

William M. Harnett was brought to Philadelphia in 1849 and, beginning at age seventeen, trained there as a metal engraver. He enrolled in night classes at the Pennsylvania Academy of the Fine Arts in 1867 and, following his move to New York in 1869, at the National Academy of Design and the Cooper Union. Throughout the period of his schooling Harnett worked for jewelry firms by day and attended classes at night. In 1875 he exhibited and sold a still life (*Fruit*, priced at seventy-five dollars) at the National Academy of Design, where he was to exhibit regularly through the mid-1880s. In 1876 the artist returned to Philadelphia, opened a studio, and resumed study at the Pennsylvania Academy. In 1880 Harnett journeyed to Europe, spending four years in Munich. In late 1884 or early 1885 he traveled to Paris and London, and by April 1886 was again in New York. He remained there, with the exception of another trip to Germany in the summer of 1889, until his death in 1892.

In one of his few autobiographical statements, an interview of 1889 or 1890 with a reporter from the *New York News*, Harnett recalled the circumstances surrounding the creation of his masterpiece, The Fine Arts Museums' *After the Hunt*:

> In 1884, I determined to test the merits of my work. I decided to discover whether the line of work I had been pursuing [trompe l'oeil, or "fool-the-eye" painting] had or had not artistic merit. Some of the Munich professors and students had criticised me severely, and I wanted to refer the question of my ability as a painter to a higher court. Accordingly I went to Paris and spent three months painting one picture.
>
> I put into it the best work I was capable of. I called it *"After the Hunt."*[1]

The painting done in Paris was actually the fourth and final version of *After the Hunt*.[2] Each variant of the theme shows a weatherbeaten door with elaborate hinges and keyhole plates, upon which hang dead game and antique instruments of the hunt—guns, powderhorns, swords, and horn. The San Francisco version is the most elaborate of the four. The basic format of game and the hunter's equipment hung upon a door is familiar from European precedents, including seventeenth-century French paintings and, most particularly, the photographs of Adolphe Braun (1811–1877), which the artist apparently knew.[3]

Harnett submitted *After the Hunt* to the Paris Salon of 1885, where it attracted a modest amount of critical attention.[4] True fame did not surround the painting, however, until Harnett's return to America in April 1886. Theodore Stewart, who owned two saloons in lower Manhattan, tested the wit and sobriety of his customers by surrounding them with trompe l'oeil paintings. The glory of his establishment at 8 Warren Street was *After the Hunt*:

> The possession of this masterpiece alone should stamp its home as the "Mecca" of art worshippers for many leagues around. . . .
>
> Hundreds of prominent citizens—artists, journalists, judges, lawyers, men about town and actors—visit this wonderful work of art daily, and wildly wager and express opinions as to its being an optical illusion or a real painting.[5]

The ability to fool the eye was an attention-getting device that, amid the masculine settings of club and saloon, earned Harnett fame and commissions. But this same verisimilitude was used by his critics to dismiss the artist's trompe l'oeil paintings as mere craft, calling for skill of hand but no artistic spirit. One unknown critic, although admiring, spoke to the heart of the matter: "The artist shows the highest skill in the representation of textures. The wood *is* wood, the iron is iron, the brass is brass, the leather is leather. . . . We see not the artist nor his method of working. The things themselves only are seen."[6]

And yet it is more than just Harnett's uncanny ability to render the fall of light on diverse surfaces that gives *After the Hunt* its compelling power. Harnett himself spoke of his pride and effort in establishing the abstract strength and the tonal unity of his arrangements:

> To find a subject that paints well is not an easy task. . . .
>
> Let me illustrate what I mean by referring to my Salon painting, *"After the Hunt."* Take for instance the handle of the old sword that is suspended from the door. The ivory has a particularly mellow tint. Had I chosen an ivory handle of a different tint the tone of the picture would have been ruined.
>
> In painting from still life I do not closely imitate nature. Many points I leave out and many I add. Some models are only suggestions.[7]

The painting's verisimilitude, taken in conjunction with Harnett's assertion that he does "not closely imitate nature," suggests the complexity of this seemingly straightforward object and locates the painting's power not solely in the artist's skill of hand but in the complexities of choice and intention.

M.S.

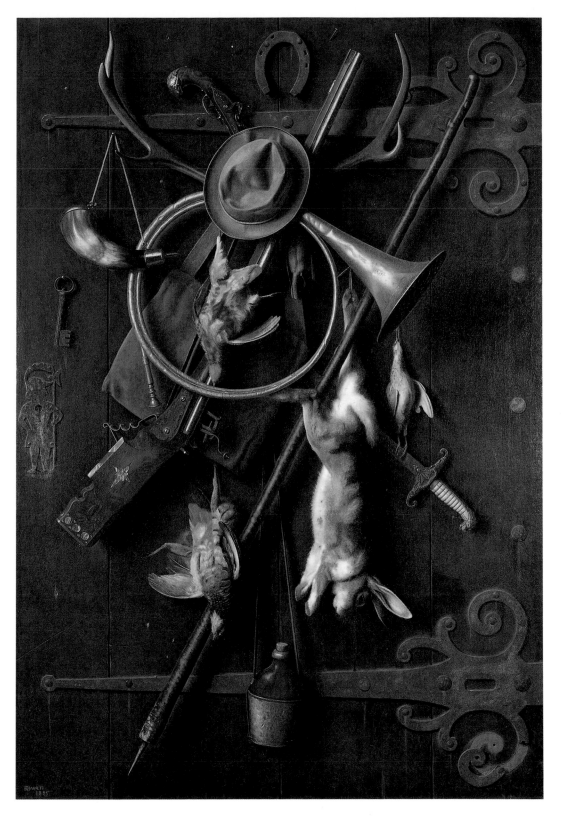

After the Hunt, 1885
Oil on canvas, 71½ × 48½ in. Signed and dated lower left: *WMHARNETT / 1885*. [initials in monogram]
Mildred Anna Williams Collection, 1940.93

Alexander Pope
Dorchester, Massachusetts 1849–1924 Hingham, Massachusetts

Product of an age that elected Teddy Roosevelt president in 1901, Alexander Pope was among the many artists of the later nineteenth century, such as Albert Bierstadt* and Winslow Homer,* who enjoyed the active life of a sports-loving outdoorsman along with the more contemplative pursuit of painting. Although he may have studied briefly with the Boston painter and sculptor William Rimmer (1816–1879), Pope claimed to be self-taught. He described his "first attempts in the line of art" as "wood carvings of game painted to imitate the real birds,"[1] which he made while working in his father's lumber business in the 1870s. Two of these carvings were reputedly sold to the Czar of Russia, Alexander III. Nevertheless, Pope gave up sculpting in the 1880s, feeling uncomfortable with the medium and concerned that "at best he could not attain eminence" in that branch of art.[2] After providing illustrations for two portfolios of lithographs, *Upland Game Birds and Water Fowl of the United States* (1878) and *Celebrated Dogs of America* (1882), Pope turned to oil painting in 1883. He maintained a specialty in animal portraits but often ventured into more ambitious historic or sentimental themes. Among these was a monumental canvas entitled *Calling out the Hounds* (1886; location unknown), painted in collaboration with Emil Carlsen (1853–1932). The painting received high commendations and earned Pope the first of many comparisons with the English painter Sir Edwin Landseer (1802–1873).

The illusionist still-life paintings that Pope called his "characteristic pieces"—characteristic in the way they successfully captured the distinctive qualities of visual phenomena, not in the sense that they characterized Pope's career—are the least numerous of his works, but to present-day critics they represent his most significant achievements.[3] His first trompe l'oeil paintings are dated 1887. While these works seem to grow naturally out of the artist's interest in carving lifelike wooden birds, his forays into the genre were probably sparked by the success of William M. Harnett's* *After the Hunt* (see pp. 54–55). By the strength of his formal constructions—his convincing illusions structured within rigid, often symmetrical compositions—Pope distinguished himself from the host of other artists eager to rival Harnett's masterful illusion of hunting trophies and implements assembled against a flat wooden door.

Pope called *The Trumpeter Swan* his "best-known work."[4] Unlike Harnett's *After the Hunt* or even Pope's own trophy paintings, which describe a profusion of objects and a variety of textures, *The Trumpeter Swan* presents the stark image of a single white bird, haunting in its solitude, hanging by its trussed feet against a green wooden door.[5] The soft fullness of plumage, so deftly yet delicately rendered, stands out in strong relief against the plain background. The wings are spread flat, no doubt to present the form in its shallowest relief, but also in a way that invites allusion to crucifixion or sacrifice. Perhaps the painting was meant to signal caution or reproach. Pope was an active sportsman but also an ardent advocate of wildlife conservation, and the painting hung for many years in the Boston office of the Massachusetts Society for the Prevention of Cruelty to Animals. Yet when the work first appeared in public, its illusion alone compelled the most attention. One critic, after praising the "beauty of outline and the delicacy of the white plumage," concluded that "at close range the average spectator would cheat himself into believing that a real bird hung before him."[6] Another Boston critic advised that if "a person wishes to be startled out of his ordinary complacency and to almost believe the days of sorcery have returned, he has but to visit Alexander Pope's studio in this city and to look at a recent painting titled 'The Wild Swan.'"[7]

S.M.

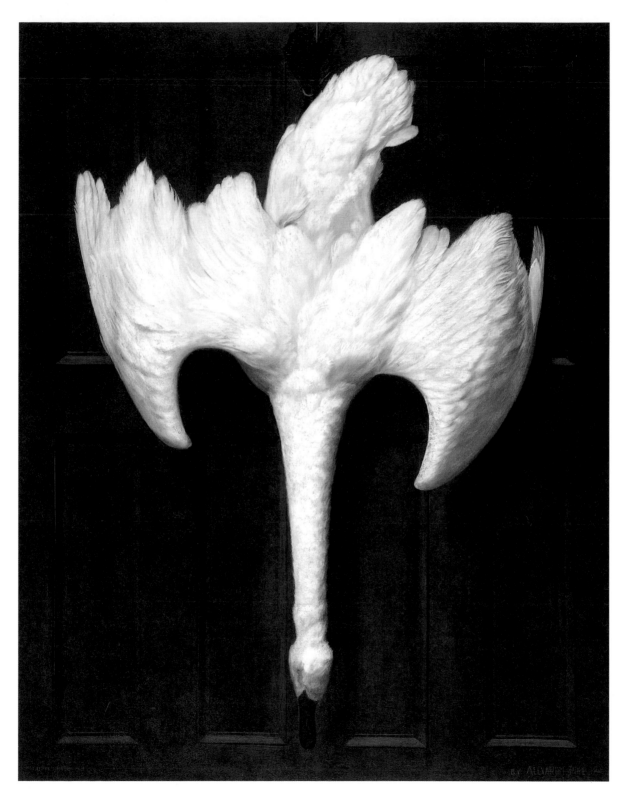

The Trumpeter Swan, 1900
Oil on canvas, 57 × 44½ in.
Signed and dated lower right: *BY. ALEXANDER POPE 1900*; inscribed lower left: *COPYRIGHTED 1901*
Museum purchase through gifts from members of the Boards of Trustees, The de Young Museum Society and the
Patrons of Art and Music, friends of the Museums, and by exchange, Sir Joseph Duveen, 72.28

William Merritt Chase
Williamsburg, Indiana 1849–1916 New York, New York

A dynamic painter, popular teacher, charismatic figure in New York society, and leader of the city's art community, William Merritt Chase had received his first formal training in Indianapolis. After moving to New York in 1869, studying at the National Academy of Design, and then briefly working in Saint Louis, Chase traveled to Munich in 1872 under the sponsorship of patrons from Missouri. The artist enrolled at the Munich Academy, where in five years he so mastered the vigorous brushwork and bold colors associated with the school that he was offered a professorship. Declining the position, Chase spent nine months in Venice and then returned to New York in 1878. During the 1880s Chase established a routine that characterized much of his remaining career: winters were spent painting, teaching, and dominating the artistic and social scene of New York, while summers were spent with family and students, visiting seaside resorts or touring Europe. Highly respected by his peers, Chase was elected academician of the National Academy in 1890 and served as president of the Society of American Artists from 1885 to 1895; he also devoted extraordinary time and energy to a teaching career of widespread influence. He instructed pupils at the Art Students League in New York (a school affiliated with the Society of American Artists) and the Pennsylvania Academy of the Fine Arts in Philadelphia, as well as in Chicago and Carmel, California. He also taught summer classes abroad; at a second studio in Shinnecock, New York; and at the Chase School in New York, which he founded. Known for his generosity and enthusiasm as a teacher, Chase numbered Irving R. Wiles,* Charles Sheeler (1883–1965), and Georgia O'Keeffe (1887–1986) among his many students.

For over sixteen years, much of Chase's teaching, painting, and socializing took place in his New York studio at 51 West Tenth Street, a structure popularly known as the Tenth Street Studio Building. Designed by the American architect Richard Morris Hunt and completed in 1857,[1] not only was it a facility designed specifically to fit the needs of painters, but it also became the center of New York studio life. On his return from Europe in 1878, Chase took a small studio there but soon moved into the large gallery originally intended to serve as a communal exhibition space. He hoped this would become the finest studio in New York, and so furnished it sumptuously, filled it with his extensive collection of objets d'art, and hosted elaborate receptions and monthly musicales there. Numerous newspaper accounts described the studio in detail, his colleagues freely commented upon it, and the public was intensely fascinated with it. As one visitor noted, however, it was Chase's art collection that was most remarkable:

The artist brought home with him a great variety of curios and interesting objects which he picked up abroad.... Faded tapestries that might tell strange stories, quaint decorated stools, damaskeened blades and grotesque flint-locks, are picturesquely arranged around the studio with a studied carelessness.... It is altogether a nook rich in attractions that carries the fancy back to ... the romance of bygone ages.[2]

Chase maintained and reveled in this environment until 1895, when an apparent reexamination of purpose caused the artist to give up the studio and auction off its contents.[3] As one newspaper critic lamented:

How this able artist could bring himself to part with this delightful houseful of beautiful things is no matter of the public's concern, yet the thought will not down, for the dispersal of these interesting trophies of travel, of research, and good taste seems positively pitiful when the studio itself is recalled, and one remembers how each separate piece seemed to be a part and parcel of a harmonious and picturesque whole.[4]

One in a series of related works, *A Corner of My Studio* represents a view into this most famous working place of American artists. The finely carved Renaissance chest, German tall case clock, Spanish velvet hangings, and Turkish coffee urn of bronze—all collected during Chase's trips abroad—hint at the studio's extraordinary lavishness. With his fully saturated colors, dashing brushwork, and technical virtuosity in suggesting diverse objects and textures, Chase captures the sensory richness of his studio interior.

For Chase, his collection was not merely a repository of props awaiting selection for figural subjects and still lifes, nor was his gallery designed to appeal to prospective clients simply through its ornateness and "taste." Yet the two taken together, embodied in Chase's studio, symbolized the man, his art, and his aesthetic beliefs. Chase found inspiration in the beauty of art objects and their reflection of the spirit of creative genius. By filling his workplace with such fine examples of man's artistic being, Chase produced a self-contained environment conducive to further creative expression. The studio was his *sanctum sanctorum*, celebratory of art, its past and its present.[5] Thus, *A Corner of My Studio* not only suggests the process of art through Chase's technical verve, but also literally reveals, with the woman working at an easel, a moment of artistic inspiration.

J.S.

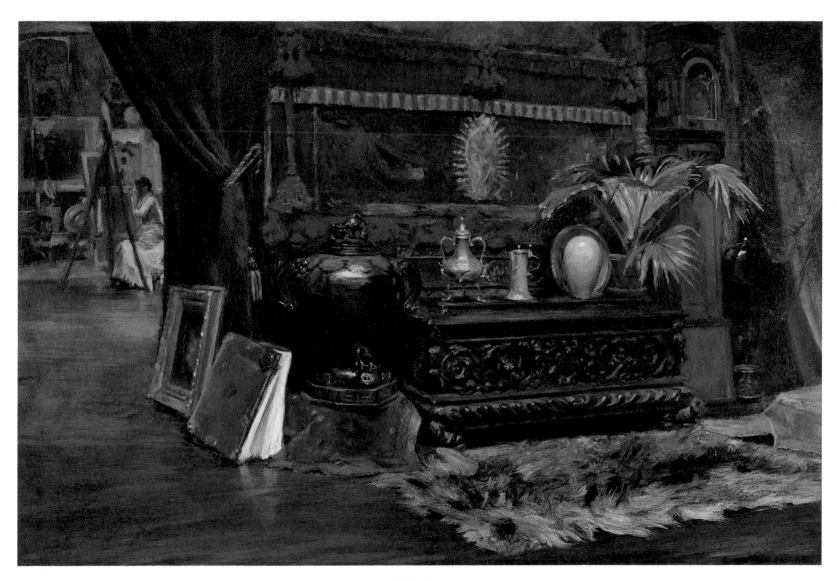

A Corner of My Studio, ca. 1885
Oil on canvas, 24⅜ × 36¼ in. Signed lower right: *Wm M Chase.* Gift of Mr. and Mrs. John D. Rockefeller 3rd, 1979.7.29

Thomas Anshutz

Newport, Kentucky 1851–1912 Fort Washington, Pennsylvania

Lauded as one of the major art instructors of the era, his lessons forming a bridge between the careful construction and anatomical precision of Thomas Eakins* and the more emotive works of the Eight, Thomas Anshutz had begun his own artistic education in 1871 when he enrolled in the School of the National Academy of Design in New York. After four years there, he joined his family in Philadelphia and in 1876 enrolled as a student of Eakins in the Pennsylvania Academy of the Fine Arts. Anshutz worked closely with Eakins at the academy, serving as his assistant demonstrator in the anatomy classes of 1878 and 1879, and in 1881, upon completion of his course work, becoming chief demonstrator and assistant professor of painting and drawing. In 1884 Anshutz worked with Eakins and Eadweard Muybridge (1830–1904) on their experiments with motion photography at the University of Pennsylvania.

By 1886, however, relations between Anshutz and Eakins had soured. Anshutz was one of several who brought what they considered Eakins's improprieties to the attention of the academy board of directors, their actions ultimately prompting the older artist's resignation from the Pennsylvania Academy.[1] Anshutz then assumed the responsibilities of the painting class. Thereafter he devoted himself to his teaching. With the exception of a year abroad in 1892–93 (a combined honeymoon and study year—his first in Europe), Anshutz taught regularly at the academy until his death, having become director of the school in 1909. Among his students were many of the major figures of early-twentieth-century American art—Robert Henri,* William Glackens,* George Luks,* and John Sloan (1871–1951)—as well as more modern artists, including Charles Sheeler (1883–1965) and Charles Demuth (1883–1935).

The majority of Anshutz's oeuvre is composed of two types of work: large, dark oil portraits and figure pieces that show his academy training; and oils, watercolors, and pastels of the out-of-doors that, especially after 1893, feature a light palette and summary handling. These latter works often document Anshutz's use of photography as an adjunct to his compositions. One work stands apart from the rest of his career, however, by its daring and accomplishment: *The Ironworkers' Noontime*. Inspired by a trip to Wheeling, West Virginia, the painting shows the yard of a busy factory with the workers milling about on their noontime break. With its deep, rich coloring, the anatomical precision and variety of the figures, and the psychological objectivity that the artist imposes on the scene, the painting is a model of the "scientific realism" that Eakins taught at the academy.

In many ways this painting should be considered Anshutz's masterpiece, not just in the sense of its being his finest work, but in the original sense of the word—the extravagantly competent object made to demonstrate the end of an apprenticeship and the advent of maturity. A long series of figural and perspectival studies testifies to the seriousness and intensity of Anshutz's effort.[2] But the work's success is not solely due to diligence. Conceptually, coloristically, and structurally, the painting is an inspired achievement. The dark factory buildings and dust-caked wheel ruts establish a convincingly deep space. Countering this recession, the pale workers—representing all the ages of man from mischievous childhood through full maturity—form a vigorous frieze across the canvas, their aspects enlivened where the sunlight picks out the deep red of their shirts. The men are individuals, their attitudes running the gamut from cool appraisal to distracted exhaustion. The contrast between this varied humanity and the stark gloom of the surroundings rivets attention and gives the work a monumentality that transcends its small size.

Anshutz was not the first American artist to depict the industrial scene, but his image remains one of the most moving and powerful of such works.[3] Thomas B. Clarke, the most important patron of American art of the time, acquired the painting soon after it was finished and exhibited it with his collection in New York in December 1883. Favorably reviewed, the painting was featured as a full-page reproduction in *Harper's Weekly* as "a representative American art work."[4] Strangely, however, the artist never again approached a comparable subject or tried to build on this success.[5]

M.S.

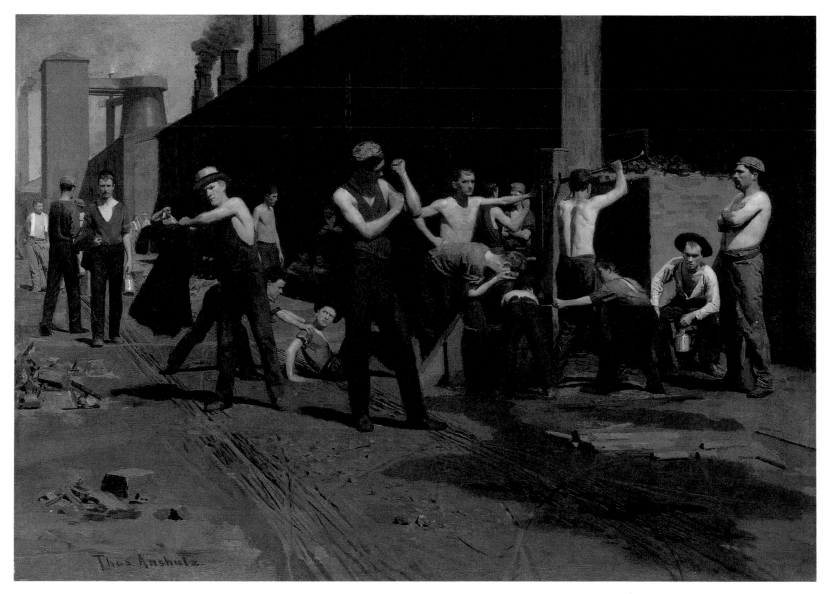

The Ironworkers' Noontime, 1880

Oil on canvas, 17⅛ × 24 in. Signed lower left: *Thos. Anshutz.* Gift of Mr. and Mrs. John D. Rockefeller 3rd, 1979.7.4

Thomas Wilmer Dewing
Boston, Massachusetts 1851–1938 New York, New York

The records of Thomas Wilmer Dewing's early training in Boston are imprecise, although it appears that he apprenticed as a lithographer, practiced taxidermy, and participated in the informal life class run by pupils at the Lowell Institute.[1] From 1876 to 1878 he studied in Paris at the Académie Julian under Gustave Boulanger (1824–1888) and Jules-Joseph Lefebvre (1836–1911). On his return to Boston in 1878, he began teaching in the new School of the Museum of Fine Arts. In late 1880 he settled in New York. From 1885 to 1905 he was a central member of the artists' colony at Cornish, New Hampshire, along with Augustus Saint-Gaudens (1848–1907), Abbott Thayer (1849–1921), Charles Platt (1861–1933), and other leaders of the American Renaissance movement. After 1890 Dewing worked (sometimes in collaboration with his wife, Maria Oakey Dewing [1845–1928], and with Stanford White [1853–1906]) on folding screens[2] and ensembles of related paintings. In 1898 Dewing became one of the founding members of the Ten, a group of artists (including Childe Hassam* and Willard L. Metcalf*) dedicated to organizing small, nonjuried exhibitions of their Tonalist/Impressionist works. Dewing was an exquisite draftsman in both pastel and silverpoint, and works in these media dominated the later decades of his career.

Dewing's art epitomized many of his era's aesthetic ambitions: idealism, elegance, poetic sensibility, and a fin de siècle wistfulness. He is best known for his atmospheric paintings of elegant women set in pastoral landscapes or refined interiors—"beautiful ladies," as one writer characterized them,

> mostly mature women of thirty ... possess[ing] large fortunes and no inclination for any professional work. They all seem to live in a Pre-Raphaelite atmosphere, in mysterious gardens, on wide, lonesome lawns, or in spacious, empty interiors. ... They all have a dream-like tendency, and, though absolutely modern, are something quite different from what we generally understand by modern women.[3]

Elizabeth Platt Jencks differs from these standard works, although it, too, portrays a beautiful woman. In this case, however, the sitter is a specific individual rather than an idealized model. Dewing painted Elizabeth Platt Jencks (1867–1953), sister of the artist and architect Charles Platt, in the summer of 1895, while in residence near Cornish, New Hampshire.[4] He had begun the work by 14 August 1895, for he wrote then to his patron Charles Lang Freer, "I am painting the portrait of Platt's sister."[5] By 22 September the painting was probably complete, for Dewing wrote again to Freer, urging a visit, "I have been painting a portrait of a lady up here that I want to show you."[6]

Elizabeth Platt Jencks, one of Dewing's most impressive and elegant portraits, evokes a compelling characterization. Many aspects of the painting —the opalescent hues, the close tonal range, the fluid brushwork and glazing, and the dependence on a carefully placed highlight to coalesce the suggestions of form—reflect the influence of James McNeill Whistler.* Freer, the patron of both men, had brought the two artists together in Paris in November of 1894, where they visited the galleries and got on, to quote Freer, "famously." In December both artists were in London, working together in a studio through March, "painting hard all the time," according to a letter Dewing wrote to Stanford White.[7]

Elizabeth Platt Jencks was the first work that Dewing undertook upon his return to America in July. In the painting Dewing has laid on pale, shimmering veils of mauves, grays, and browns and then has scraped and manipulated these thin layers of pigment so that all the figure's contours are softened within an indefinable aura. Here, then, is a painting of atmosphere, of the envelope of air and light that is displaced by the form. And yet this is not a misty evocation of Elizabeth Platt Jencks. Every aspect of her, from the cock of her head to the arresting jut of her elbow, signals a particular and definite personality.

The painting, which stayed in the family of the sitter until The Fine Arts Museums purchased it, remains in its original frame designed by Stanford White.

M.S.

Elizabeth Platt Jencks, 1895.
Oil on canvas, 23¼ × 16¾ in. Signed and dated lower left: *T. W. Dewing / 1895.* Gift of the Atholl McBean Foundation, 1987.40

John Frederick Peto
Philadelphia, Pennsylvania 1854–1907 New York, New York

Little known during his lifetime—living for most of his mature career away from American art centers—John Frederick Peto has been recognized as a still-life painter of compelling power only in the later twentieth century. A Philadelphia native, training briefly at the Pennsylvania Academy of the Fine Arts in 1878, Peto opened a studio in his hometown around 1880. During the early years of his career, Peto painted still lifes, became friendly with William M. Harnett,* the leading painter of trompe l'oeil, and exhibited periodically at the academy. At the end of the decade, however, Peto withdrew from the Philadelphia art world. After two years of shuttling between Philadelphia and Island Heights, New Jersey, where he augmented his meager earnings by playing the cornet at Methodist camp meetings, Peto settled with his family in the Atlantic coast resort town in 1889. Although continuing to paint for the remainder of his life, Peto displayed his works but rarely, selecting as his exhibition sites the informal atmosphere of the local drugstore. Peto made no written statement about his art, kept no records, and sold few paintings. He was rediscovered in 1949 when several of his paintings, previously accepted as the work of Harnett, were recognized as carrying forged "Harnett" signatures over Peto's original inscriptions.[1]

The Cup We All Race 4 is one of Peto's strongest trompe l'oeil paintings. With its solitary tin cup suspended from a weathered wooden plank, the work focuses on the natural play of highlight and shadow, the textures of aging wood, paper, and tin. By considering both the carefully arranged and artfully worn qualities of the image's few component elements as well as the abstract pattern they create on the flat surface set close to the picture plane, Peto creates a composition of simplicity and austere strength.

Humor and wit, however, the irreverent reversal of pictorial traditions, temper this still life's formal dignity. Historically, a painting's frame defines the boundary between the painted image and reality. Yet, by manipulating the frame in *The Cup We All Race 4*—the four wooden members bordering the central canvas—Peto has extended the painted image; on it he depicts the majority of the penknife inscription as well as the remaining corners of a notice tacked to the green wooden planks. The frame has become part of the painting, and the painting, with its striking naturalism, now encroaches on the viewer's world. The tiny metal label inscribed with the artist's name and nailed to the wooden "frame" adds an additional layer of complexity to the viewer's initial perception: the label is real and not, as it may at first appear, the result of the artist's canny artifice. Thus, Peto cleverly plays with the viewer's expectations by blurring the distinctions among painting, frame, reality, and illusion.

Not one to paint the new and expensive, Peto depicted instead the aged and ordinary. The well-used mug, the cracked, disfigured, and discolored wooden planking, and the torn notice of *The Cup We All Race 4* yield a sense of decay and hard knocks. Alluding to the race that the "we" of humanity run, Peto wryly enshrined as the prize and symbol of triumph not a glittering trophy but a dented tin cup. Powerful in composition and convincing in its naturalism, *The Cup We All Race 4* resonates with meditations on life, ambition, and success.

J.S.

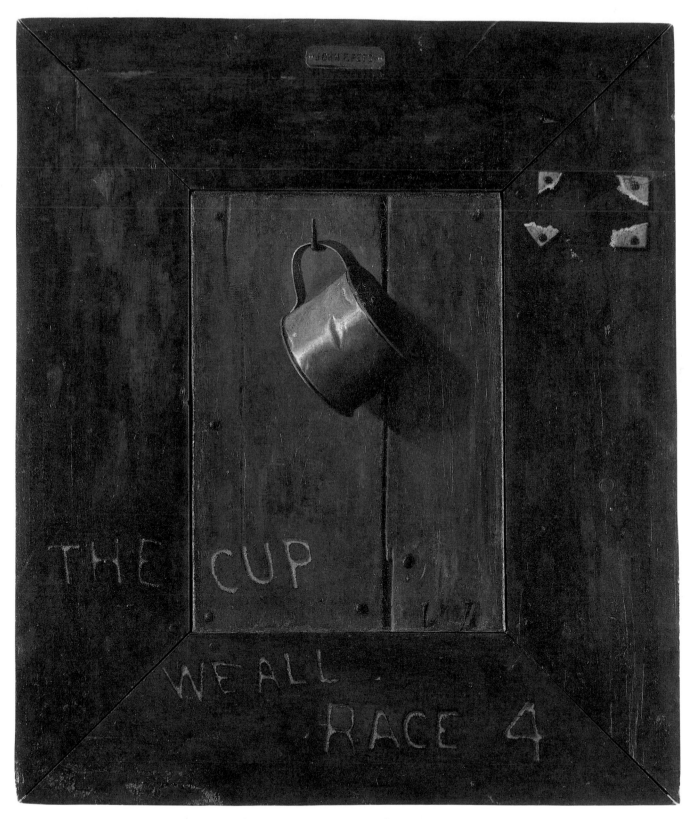

The Cup We All Race 4, ca. 1900
Oil on canvas and panel, 25½ × 21½ in. Metal plaque, top center, engraved: *JOHN F. PETO*
Gift of Mr. and Mrs. John D. Rockefeller 3rd, 1979.7.80

John Frederick Peto

Philadelphia, Pennsylvania 1854–1907 New York, New York

Books—whether on a table by themselves or with pipes, mugs, inkstands, and other objects of a gentleman's library, whether standing on a shelf, lying stacked in a box, or jumbled and on sale in a streetside window— were a subject to which John Frederick Peto returned throughout his career. A book collector with a library in his studio home in Island Heights, New Jersey, Peto even painted an illusory shelf of books on the wall of a room in his house. It was during the late 1880s and after, however, that he created some of his most complex still lifes of books, including *Job Lot Cheap*.[1] Here, with trompe l'oeil realism, a shutter opens to reveal an assortment of books piled in disarray on a tabletop; above, another book shelf is barely perceptible within the shadowed interior. Handmade signs on the shutter and window frame advertise the sale of books and two rooms to rent, suggesting that the disorderly placement of the volumes is a result of passersby examining and haphazardly replacing the books set out for consideration.

For Peto, books were not only repositories of knowledge and ideas; their simultaneous generic simplicity and unique sizes, shapes, and colors presented endless compositional possibilities.[2] In *Job Lot Cheap* Peto reinforces this formal emphasis by focusing on the component elements of the still life, truncating the margins of the window frame and shutter and eliminating any larger context. He not only details the natural world, but also creates a highly structured abstract framework of vertical, horizontal, and diagonal axes. The books are jumbled on the hidden tabletop, their balanced and counterbalanced placement playing off the immi-

nent slippage of one volume out the window. This calculated arrangement joined with the diverse colors and patterns of the bindings and page edges creates compositional contrasts of repetition and variation, tension and equilibrium. Space, too, is a formal element Peto manipulates through careful oppositions—open window and solid shutter, shallow recession and forward projection, and shadowy interior and illuminated foreground. The most artificial of an artist's subjects, the result of the artist's deliberate selection and organization, still lifes offer an unusual degree of freedom. *Job Lot Cheap* represents Peto approaching, if not achieving, his most complex play of shape, volume, light, and color.

Unlike his friend and contemporary William M. Harnett,* who often depicted beautifully crafted, expensive objects, Peto increasingly dwelt on the old and discarded. The window woodwork in *Job Lot Cheap* is weathered and cracked; the signs are torn and well-worn; the books are battered, falling apart, and up for sale. The job lot (or complete collection of sale objects) should go cheaply, but the various volumes appear already picked over and rejected. At the time of this work and other related paintings, Peto was living in Island Heights, isolated from and unnoticed by the mainstream of American art. Perhaps just a theme Peto appreciated for its general sense of picturesque aging, *Job Lot Cheap* may present as well a more personal iconography. Emblematic of abandonment and time's progress, the painting additionally seems laden with Peto's contemplation of the passage of his life and artistry.

J.S.

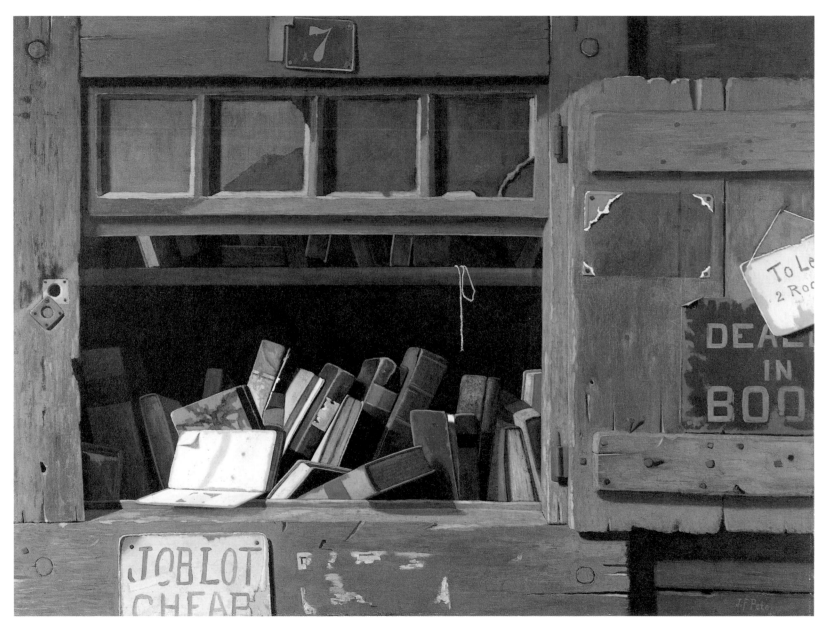

Job Lot Cheap, after 1900

Oil on canvas, 30 × 40⅛ in. Signed lower right: *J. F. Peto*. Gift of Mr. and Mrs. John D. Rockefeller 3rd, 1979.7.81

Cecilia Beaux

Philadelphia, Pennsylvania 1855–1942 Gloucester, Massachusetts

Cecilia Beaux, whose mother died twelve days after Beaux's birth and whose French father lived principally in Europe, was raised by maternal relatives in Philadelphia. In 1872 or 1873 Beaux studied art at the Van der Whelen School in that city and a decade later worked with William Sartain (1843–1924). She apparently entered the classes of the Pennsylvania Academy of the Fine Arts in 1877, although she later denied this.[1] She began exhibiting at the academy in 1879, where from 1885 on her portraits won considerable acclaim. In 1888 and 1889 Beaux traveled throughout Europe, studying in Paris both privately and at the Académie Julian, as well as taking evening classes at the Atelier Colarossi. She spent the summer of 1888 at the artists' colony of Concarneau in Brittany.

After her return to the United States in 1889, Beaux exhibited paintings, primarily portraits, in both Philadelphia and New York, earning medals and critical attention from 1893 to 1898 with a series of works that are among her strongest.[2] In 1895 she joined the faculty of the Pennsylvania Academy, where she taught through 1915, although after around 1900 she spent most of her time in New York or at her summer home in Gloucester, Massachusetts. Until the early 1920s Beaux exhibited widely, continuing to win medals and important portrait commissions, including appointment to the U.S. War Portraits Commission after the First World War. Beaux was a fluent practitioner of the international style of late-nineteenth-century portraiture; her friend William Merritt Chase* said categorically of her in 1899, "Miss Beaux is not only the greatest living woman painter, but the best that has ever lived."[3] A broken hip in 1924 forced a sharp reduction in her painting activities. She published her detailed memoirs, *Background with Figures*, in 1930.

Young Brittany Woman, "Lammerche" is a swiftly painted, assured work depicting a fair young woman in an interior. The strong contrasts between light and shadow as well as the dark background (with a touch of vibrant blue in the upper left) suggest that Beaux studied the face under lamplight. Taken in conjunction with the close focus and the suffused colors of the painting, the portrait's effect is peculiarly direct and intimate. Beaux sketched the planes of her model's face—high forehead, prominent cheekbones, short and pert nose—with great economy. The darkness of the woman's dress, likewise largely unmodulated, focuses attention on her face and traditional Breton headwear.

Beaux first visited Brittany in summer 1888. The effect of the region on her was profound. Later she noted the impact of that stay: "I learned what style there may be in simplicity; what subtle beauty in rude forms. . . . Here I learned the power of essentials and 'discard.' . . . I learned that a fumbling or uncertain conception, and above all a low vitality, were crimes in Art."[4]

In the painting Beaux does not refer to the genre subjects that artists had long concentrated on when in Brittany, with local subjects demonstrating regional pieties and religious customs. Instead, she focuses solely on the face of one compelling individual—a woman apparently nicknamed Lammercke. When Beaux described her visit of 1888, she recounted a failed attempt to have a young woman pose for her: "Beauty is an unpopular word now, but a face that halts the passing stranger, by its pure cool perfection of line and proportion, its color and texture like the inward slope of the seashell—well—if 'beauty' will not do, what will?"[5] The later model for San Francisco's painting clearly provided a comparable fascination.

Beaux dedicated *Young Brittany Woman, "Lammerche"* to Anne D. Blake (active 1897–1919), a Boston-born painter with whom Beaux traveled to Europe in 1902.[6]

M.S.

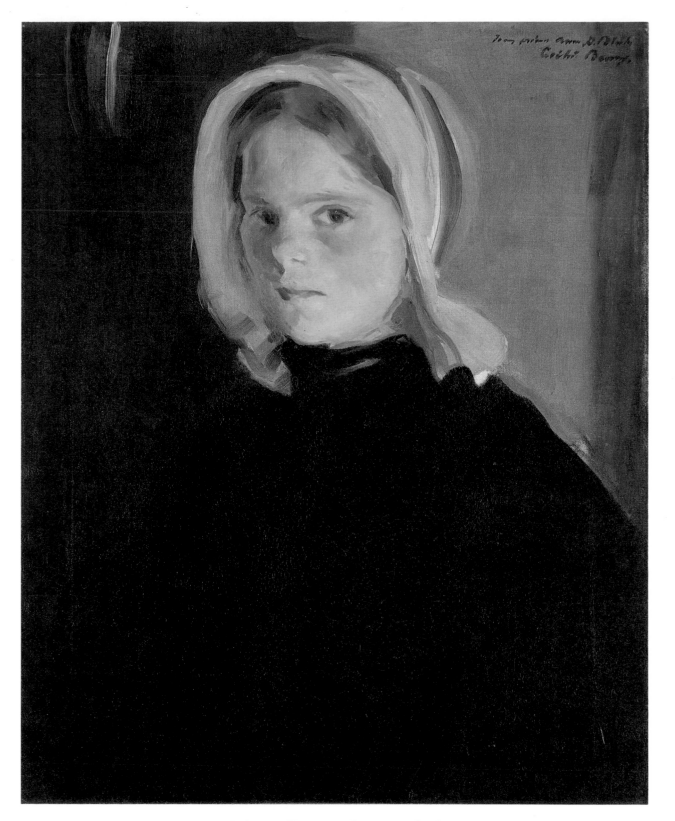

Young Brittany Woman, "Lammerche," ca. 1902
Oil on canvas, 24 × 19 in. Signed and inscribed upper right: *To my friend Anne D. Blake / Cecilia Beaux.*
Gift of Mr. and Mrs. John D. Rockefeller 3rd, 1979.7.7

Jefferson David Chalfant
Sadsbury Township, Chester County, Pennsylvania 1856–1931 Wilmington, Delaware

Jefferson David Chalfant learned the trade of cabinetmaking from his father, with whom he worked from 1870 to 1879, finishing railroad cars and painting their interiors. Upon moving to Wilmington, Delaware, Chalfant took up landscape painting as an avocation and opened a studio in 1883. In 1886, inspired by the example of William M. Harnett,* Chalfant began to paint trompe l'oeil still lifes of considerable skill and wit.[1] In 1886 Chalfant also acquired an agent in H. Wood Sullivan, who promoted the exhibition and purchase of Chalfant's art. Sullivan introduced the artist to the prominent New York art patron Alfred Corning Clark, who sent Chalfant to Paris in 1890 to acquire the professional training he thus far lacked.

Chalfant spent two years studying at the Académie Julian under William-Adolphe Bouguereau (1825–1905) and Jules-Joseph Lefebvre (1836–1911), an experience that encouraged him to attempt more ambitious figure paintings and interior arrangements. Upon his return to Wilmington in 1892, Chalfant devoted himself to small-scale genre works, whose subjects often reflected his interests in craftsmanship. At the same time Chalfant worked on mechanical inventions and obtained several patents. After the turn of the century he turned away from genre subjects, spending the last years of his career fulfilling portrait commissions.

In attending the Académie Julian, Chalfant was following the footsteps of many American students before him, including Arthur F. Mathews,* Childe Hassam,* and Cecilia Beaux.* The Julian was one of several private art academies founded in the later nineteenth century to accommodate the growing number of foreign art students coming to France for training. More liberal in its administrative policies than the older Ecole des Beaux-Arts, it yet followed the Ecole's tradition of offering academic training grounded in the study of the human figure. Despite an exacting regimen, students at the Julian worked long hours supervised only by a *massier*, or advanced student. Their instructors arrived at most two or three times a week to offer advice and criticism:[2]

On Wednesdays and Saturdays Bouguereau frequently arrived early and cloistered himself with M. Julian in order to question him about the students' work, their enthusiasm, their endeavors, the

progress they had made and what advice and encouragement to give them. After that . . . Bouguereau would stop in front of each easel, criticize the drawing and adjust the palette, and never leave without a word of encouragement: "We'll see how you've done by Saturday, my friend."[3]

Concerned as Chalfant was with craftsmanship and trompe l'oeil effects, he must have admired his French teacher's extraordinary draftsmanship and the near-photographic success of his illusionism. And yet this painting of Bouguereau's atelier does not feature the master but rather pays homage to the serious endeavor of art making (the studio is identified as Bouguereau's on the back of the panel).[4] The studio is crowded with easels and students, their focus riveted on the models before them and their work in progress. In the foreground, a painted nude on canvas and a charcoal drawing on paper indicate the end products of this effort. Finished studies line the studio, drawings on one wall, paintings on another, portraits on the rafters, other works stacked on shelves. Chalfant painted himself as the second student from the right, in a privileged position directly at the feet of the model.[5]

Not surprisingly, this precisely drawn and meticulously rendered view was the result of much labor and conscious effort. Chalfant often made elaborate, detailed drawings as preliminary studies for his paintings; placing charcoal on the reverse of these drawings, he would then trace the image onto his canvas or panel.[6] One such drawing exists for *Bouguereau's Atelier* (1891; Achenbach Foundation for the Graphic Arts, The Fine Arts Museums of San Francisco).[7] Of near-identical dimensions to the painting, it sets out the structure and contours of the composition in an impressive exercise of academic draftsmanship. But it is testimony to his skill as a painter that Chalfant was able to create the deep space of this atelier, to effect a heavy atmosphere complete with the haze of cigarette smoke, and to capture convincingly the light that pours through the skylights and highlights the students' faces, their artwork, and the strong back of the female model before them.

S.M.

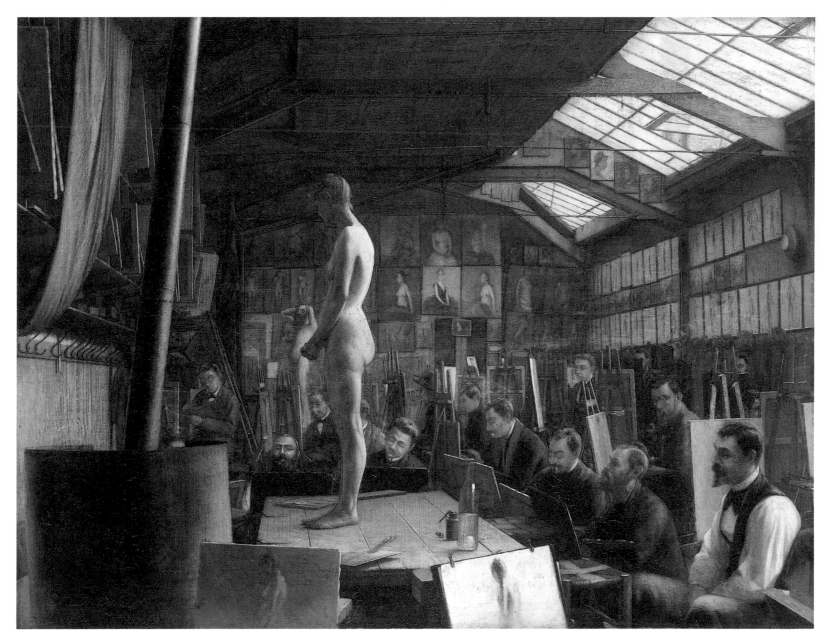

Bouguereau's Atelier at the Académie Julian, Paris, 1891
Oil on panel, 11¼ × 14½ in. Signed and dated lower left: *J. D. Chalfant / 1891.* Gift of Mr. and Mrs. John D. Rockefeller 3rd, 1979.7.26

John Haberle
New Haven, Connecticut 1856–1933 New Haven, Connecticut

John Haberle, the son of German immigrants, worked from the age of fourteen as a lithographer in New Haven; Montreal; Providence, Rhode Island; and New York City. From about 1880 to 1884 he worked with the paleontologist Othniel Charles Marsh at Yale University's Peabody Museum, cleaning, cataloguing, and apparently drawing precise illustrations of fossils for Marsh's publications.[1] Following a year's classes in New York at the National Academy of Design in 1884, he returned to New Haven, where he again worked for Marsh and during his spare time painted small still-life canvases. In 1887, "with much trepidation," he submitted a work to the annual exhibition of the National Academy of Design.[2] The painting, *Imitation* (art market, 1988), was a life-size depiction of paper money, torn stamps, coins, and a tintype self-portrait, all tucked into or surrounded by a cleverly done frame that was itself a painted illusion. The work created a stir at the academy, and with its purchase by Thomas B. Clarke, one of the preeminent collectors of American art, Haberle's career was launched. As a reporter of the period put it, "Mr. Haberle then determined to toil along the lines of close brush work, believing that in that field there was a ready market."[3]

A variety of trompe l'oeil paintings followed during the next seven years—wrapped packages with the paper torn, panels with small objects hung before them, and currency pasted to panels, for which Haberle was questioned by critics and Treasury agents alike, the former thinking that the money was real and simply glued into place, the latter suspecting counterfeiting.[4] Although their uncanny precision and minute detail aroused suspicions to the contrary, all of them were created, as he proudly proclaimed in a trompe l'oeil newspaper clipping depicted in one work, "entirely with the brush and with the naked eye."[5] He exhibited these works widely, finding a particularly eager audience in the Midwest. In 1894 he exhibited what many consider to be his finest work, *A Bachelor's Drawer* (Metropolitan Museum of Art, New York). The ambition and intricacy of that work, however, apparently strained his eyes; the *New Haven Evening Leader* reported on 15 May 1894 that "after this Mr. Haberle is to devote himself entirely to broader work and will make a specialty of figure composition."[6]

In fact, Haberle did not entirely abandon "close brush work." Three images of small slates date from about 1895, including The Fine Arts Museums' *The Slate: Memoranda*. All three (the other two are in the Museum of Fine Arts, Boston, and a private collection) are seemingly simple works—small wood-framed blackboards with mottoes emblazoned across their tops: "Leave your order here," "Orders," or, in elegant steel-blue Gothic script, "Memoranda." A piece of chalk hangs by a string before the scribbled words and partially erased messages. But of course everything is painted, including the "wooden" frame that is, in fact, canvas pulled over the stretchers as Haberle playfully and daringly extends the illusion into the third dimension. The apparently careless chalk scrawls are the most tantalizing aspect of the works. In one sense, the effort that has gone into replicating these faint messages seems an elaborate ruse—literally much ado about nothing—for they are smeared and fragmentary, no longer capable of carrying meaning. But with Haberle there is always an insistent sense that self-referential puzzles exist in even the simplest works.[7]

In *The Slate: Memoranda*, for example, the artist has included a stick figure as a self-portrait, using the broken syllables "HAB-ER-LE" both to label the figure and to sign the painting. Because it wears a feather, the figure has reminded some commentators of an Indian.[8] But the angular joints of its limbs and the string hanging between its legs make the figure resemble nothing so much as a jumping jack. Is there a correlation between the artist/puppet on a string and the chalk that hangs to the right of him? Who is the "FRED" that figures so prominently in the large inscription?[9] Amusing content seems to hover just beyond our grasp, and we are helpless (the chalk is fictional, after all) to note our theories and clarifications.

M.S.

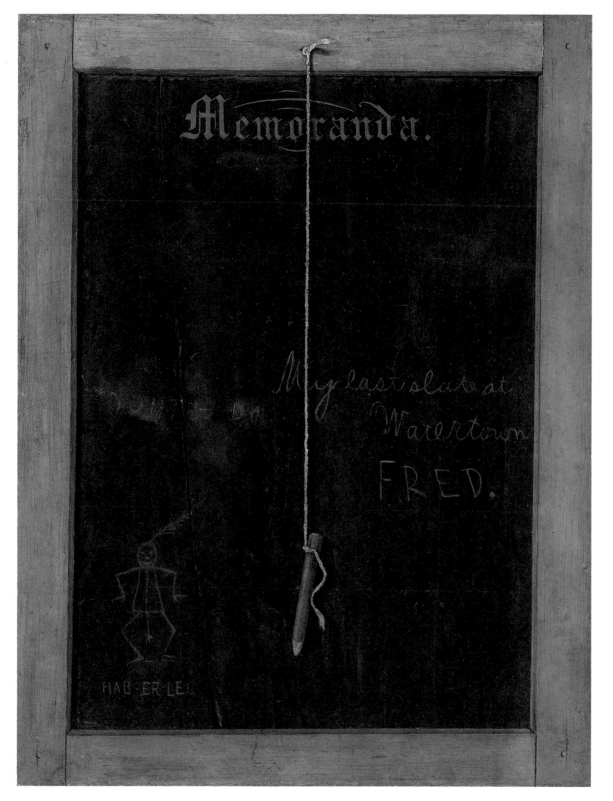

The Slate: Memoranda, ca. 1895
Oil on canvas, 12⅛ × 9⅛ in. Inscribed lower left: *HAB-ER-LE*
Museum purchase by exchange: Gift of Miss F. M. Knowles, Mrs. William K. Gutskow,
Miss Keith Wakeman, and the M. H. de Young Endowment Fund, 72.29

John Singer Sargent
Florence, Italy 1856–1925 London, England

John Singer Sargent, one of the most sought-after portraitists in America and Europe at the end of the nineteenth century, was described late in his life as "an American, born in Italy, educated in France, who looks like a German, speaks like an Englishman, and paints like a Spaniard."[1] Born in Florence of peripatetic American parents, the multilingual Sargent spent his childhood amid the art, culture, and society of the Continent. First encouraged in his artistic interests by his mother, a watercolorist, Sargent attended art classes in Rome and Florence before entering in 1874 the studio of the popular Parisian portraitist Carolus-Duran (1837–1917) and studying at the Ecole des Beaux-Arts. Under the instruction of Carolus-Duran, Sargent acquired a technique characterized by flashing brushwork and great style. Traveling frequently throughout Europe and North Africa, Sargent remained based in Paris during the 1870s and early 1880s. Although he painted landscapes as well as exotic figure subjects derived from these forays, it was for his portraiture that Sargent was most noted. Sargent moved permanently to England in 1886. Never giving up his American citizenship, Sargent made many trips to America to fulfill numerous portrait and mural commissions, the latter primarily for the Boston Public Library and the Museum of Fine Arts, Boston. At the beginning of the new century, frustrated by the demands of his prosperous portrait business, Sargent all but abandoned that side of his work; he traveled even more frequently, concentrating in his work on watercolors of landscape and genre scenes.

Sargent attained his greatest notoriety in 1884 when his portrait of Madame Gautreau—*Madame X* (1884; Metropolitan Museum of Art, New York)—was exhibited at the Salon, scandalizing the Parisian audience with its striking sensuality and startling affectations. Sometime during that same year Sargent painted this comparably haughty young woman, Caroline de Bassano (1847–1938). Daughter of the second Duc de Bassano—a diplomat and senator who became Grand Chamberlain to Napoleon III—and a maid-of-honor in the Imperial court, in 1871 Caroline married Marie-Louis-Antonin Viel de Lunas, Marquis d'Espeuilles—an officer and later senator who was sixteen years her senior.[2] The circumstances surrounding Sargent's commission for the portrait of Caroline de Bassano, an unusual commission for a young American given the sitter's social standing, remain unknown.[3]

Sargent presents Caroline de Bassano radiant in evening dress, set against a penumbral background. Shimmering creams, pale yellows, blues, and browns suggest the sheen of satin and lace, all dashed in with seeming freedom, yet with each stroke precisely placed. By contrast, Sargent described Caroline de Bassano's features in a much less summary fashion, carefully recording the physiognomy of arched eyebrow and direct gaze as well as evoking the translucence of flesh. The artist's emphasis on de Bassano's elongated figure as well as the gracefully sloping curve of her bared neck and shoulder (beautifully revealed and echoed by the edge of her slipping cloak) increase the impression of stylishness. As one critic noted in 1888: "Style is the predominant characteristic of [Sargent]; all of his pictures are permeated with it. Nothing is commonplace; nothing is conventional. There is an indefineable but palpable atmosphere of refinement, ease and—*tranchons le mot*—aristocracy, whatever that means nowadays."[4]

J.S.

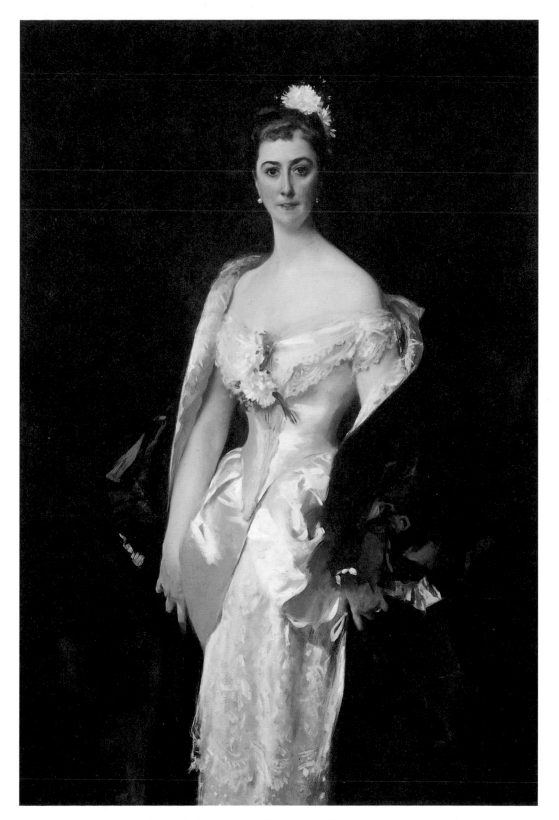

Caroline de Bassano, Marquise d'Espeuilles, 1884
Oil on canvas, 63¾ × 41¾ in. Signed and dated upper left: *John S. Sargent 1884*
Gift of Mr. and Mrs. John D. Rockefeller 3rd, 1979.7.90

John Singer Sargent
Florence, Italy 1856–1925 London, England

In 1881, 1884, and 1885 John Singer Sargent paid extended visits to England. Close friendships with American and English artists, as well as the urging of Henry James (who perceived in London an opportunity for substantial portrait commissions),[1] prompted the artist's move there in 1886. With the exception of trips abroad, London was his home for the rest of his life. Among Sargent's first English patrons were members of the Vickers family, whose wealth came from an engineering and munitions firm. During the summer of 1884 the artist went to Sheffield to paint the three daughters of Colonel T. E. Vickers (*The Misses Vickers*; Sheffield City Art Galleries). In the autumn he went to Lavington Rectory, near Petworth, to paint a portrait of Mrs. Albert Vickers.[2] Among the formal and informal works he did there, one of the boldest and most striking is *A Dinner Table at Night*, also called *The Glass of Claret*.

The canvas shows Mr. and Mrs. Albert Vickers at the end of a meal. They sit in their well-appointed dining room, where red walls and red-shaded lamps cast a rich glow over the table's white cloth and sparkling silver and crystal.[3] Mrs. Vickers, handsome and elegant in her black gown, stares out of the composition from the center of the picture. Mr. Vickers sits in profile at the far right, his form truncated by the edge of the canvas, his cigar hidden by a lampshade. The painting's design imposes a psychological isolation on each of the characters—there seems to be no possibility of communication between them. It also implies a spontaneity and dash on the part of the artist, as do similarly arbitrary framings in paintings by Edgar Degas (1834–1917). Robert Louis Stevenson probably voiced the sentiment of Sargent's English admirers when he referred, a year later, to the artist's double portrait of himself with Mrs. Stevenson (Mrs. John Hay Whitney Collection, New York), where again the couple is physically and psychologically distanced from one another: "All is touched in lovely, with that witty touch of Sargent's; but of course it looks damn queer as a whole."[4]

A Dinner Table at Night is thinly painted, with a dark and dramatically limited palette of reds, whites, and blacks. Veils of color block in the larger shapes, while the merest suggestions of line and dabbed highlights supply the details. And yet the effect is strikingly real. As one Parisian critic wrote when the work was shown, along with works by Claude Monet (1840–1926) and others, at the Galerie Georges Petit in 1885:

> What a marvelous sketch [M. Sargent] exhibits under the title: the *Verre de Porto*! A red dining room, illuminated by lamps shaded in the same color; a set table and two companions. It is the last word in dashing painting and is nevertheless definitive: when one puts oneself at the proper viewpoint, the illusion is complete.[5]

M.S.

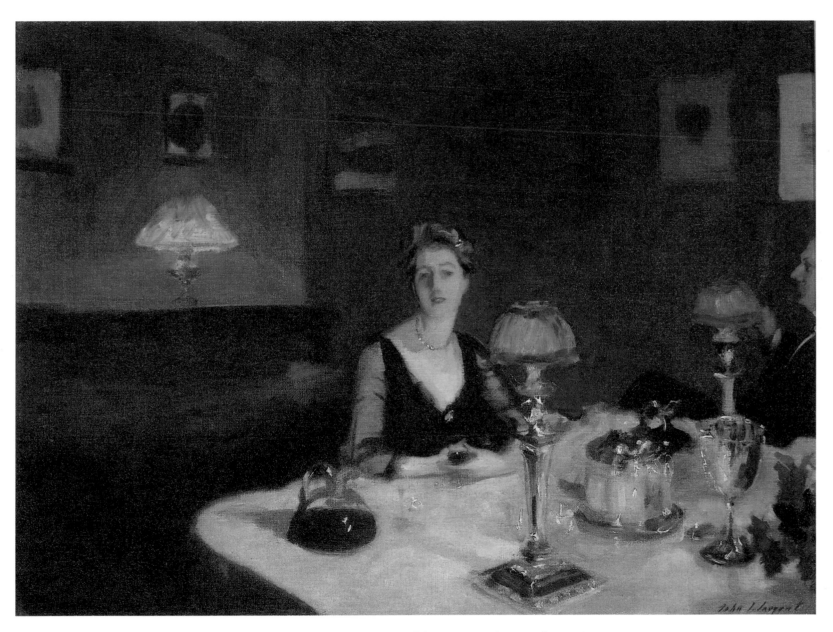

A Dinner Table at Night (The Glass of Claret), 1884
Oil on canvas, 20¼ × 26¼ in. Signed lower right: *John S. Sargent.* Gift of the Atholl McBean Foundation, 73.12

John Singer Sargent
Florence, Italy 1856–1925 London, England

After the turn of the twentieth century, secure in his position as the most sought-after portraitist in both Europe and America, John Singer Sargent could finally admit that he was tired of the whole business. As he exclaimed to a friend: "No more paughtraits whether refreshed or not. I abhor and abjure them and hope never to do another especially of the Upper Classes."[1] Following his mother's death in January 1906, Sargent cut back on new commissions; as a friend described it in 1907, Sargent had resolved "to absolutely stop painting portraits. Wasn't going to do one after this year. He is going to paint what he has a mind to. East and scenes and any old thing."[2]

Sargent's travel increased after 1906 until it became almost routine to leave London every autumn in the company of family or friends. In the ten years from 1906 to 1916 Sargent painted an unprecedented number of oils and watercolors inspired by the scenery and local activities in sites ranging from Corfu to the Canadian Rockies. As Sargent's cousin described the motivation for these pictures, "Other travellers wrote their diaries; he painted his."[3] While serving as a record of picturesque vacation sites, Sargent's paintings also reveal the artist's primary concern with the effects of sunlight and color that such locations provided.

In July 1914 Sargent traveled with Lt. Col. Ernest A. Armstrong to the Austrian Tyrol, where they joined the British painter Adrian Stokes (1854–1935) and his wife, Marianne (1855–1927), herself a watercolorist. Only days after their arrival, Austria declared war on Serbia, an event that at first cast few ripples in a pleasant holiday. Stokes later recalled that summer:

> There were Dolomite mountains rising like enormous castles from the pass, there was a lovely brook, and there were a few houses with large projecting eaves richly coloured below by reflected light. All of these, and other things, Sargent painted, apparently quite happy and content. As yet he took no interest in the War.[4]

But when England declared war on Austria, Stokes and Armstrong became enemy aliens. As an American citizen, Sargent was safe, but none of his party carried the passports required for travel within Austria. Armstrong was arrested when he tried to return to England; Sargent's pictures and painting supplies were confiscated and sent to Innsbruck for inspection. Still, as Stokes related: "Sargent's equanimity was disturbed by none of these things. He never grumbled, he never complained, but went out to work with what materials had been left to him."[5]

Indeed, little hint of the outside world or its turmoil intrudes upon *Trout Stream in the Tyrol*. If the composition, in its tipped perspective and lack of sky, seems in fact contrived to shut out that world,[6] it is also calculated to display Sargent's continuing fascination with color, light, and their reflections. As early as 1878, with his first major public success, *The Oyster Gatherers of Cancale* (Corcoran Gallery of Art, Washington, D.C.), Sargent demonstrated his attraction to outdoor settings and his fascination with the effects of shimmering sunlight, whether casting dark shadows or reflecting from pools. In the late 1880s Sargent had experimented with an Impressionist style close to that of Claude Monet (1840–1926),[7] but by the turn of the century he had developed a more synthetic, interpretive approach to color and light, resulting in what Henry James called "a comprehensive impression."[8] In *Trout Stream*, Sargent's true subject is not the fisherman, nor the splendid glade in which he walks, nor even the stream itself into which he peers for a spot to cast his line. Rather it is the light, and more specifically, the colors created by that light as it breaks through the tree boughs and glances off the gray rocks and rushing water. Vivid, saturated colors, applied with broad, heavily laden strokes, define the trees, rocks, and water. Purple and blue enliven the shadows, gold and yellow the sunlit spots, except at the center, where a thick pool of white impasto suggests the brilliance of sunlight beyond this sheltered grove. The viewer stands as spectator to this performance, much as the fisherman does, admiring the brilliant play of light no less than Sargent's masterful capturing of it.

S.M.

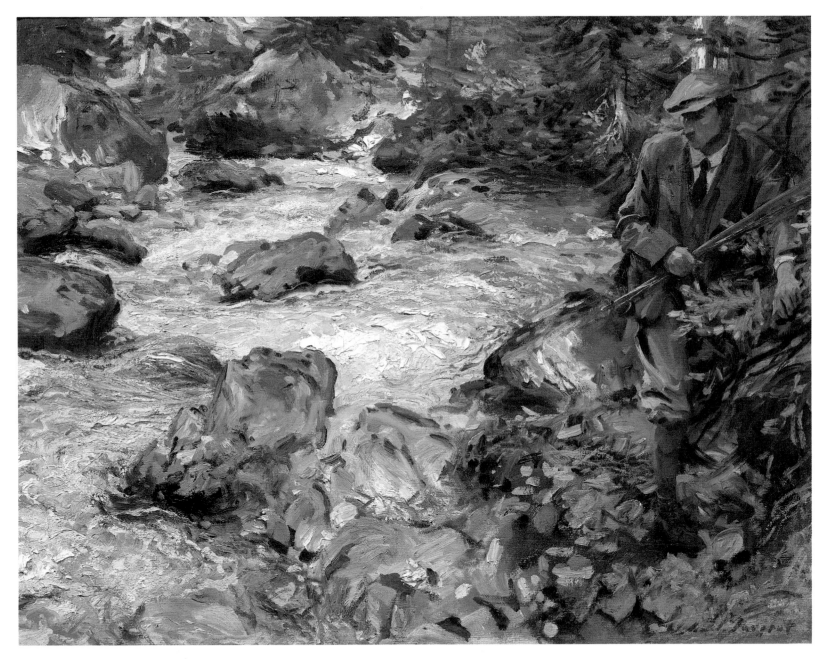

Trout Stream in the Tyrol, 1914
Oil on canvas, 22 × 28 in. Signed lower right: *John S. Sargent*. Bequest of Isabella M. Cowell, 1951.24

Charles Frederic Ulrich
New York, New York 1858–1908 Berlin, Germany

Charles Frederic Ulrich, son of a photographer, is best known for small, beautifully detailed scenes of workers, of craftsmen, and of women in domestic settings. After training briefly at the National Academy of Design in New York, in 1875 Ulrich enrolled at the Royal Academy in Munich. While studying under Ludwig von Löfftz (1845–1910) and Wilhelm von Lindenschmit (1829–1895), Ulrich developed a lasting appreciation for the "little masters" of seventeenth-century Holland and Flanders, developing a style of striking naturalism, rich color, and palpable atmosphere.[1] Returning to New York by 1882, two years later Ulrich won the National Academy's first Thomas B. Clarke prize for figure painting. A striking series of small, compelling genre scenes—many painted on panel—followed. In spite of critical and commercial success, in 1885 Ulrich resumed residence in Europe where, with the exception of a trip to New York in 1891, he spent the remainder of his career.

Moment Musicale dates from 1883, the year of Ulrich's election to the National Academy (signaled by the annotation "A.N.A.," Associate of the National Academy, that follows his signature). A young woman, playing music by Franz Schubert, sits in a well-furnished, middle-class interior. Diffuse light enters the room through the curtained window, reflecting from many smooth, gleaming surfaces—art glass, brass planter, polished wood—and filtered by the palm fronds. The rich colors of the darkened interior glow. Ulrich achieved the painting's luminous atmosphere by applying the paint with thin, carefully blended strokes over the smooth, uninterrupted surface of the wooden panel. The resulting naturalistic detail and surface finish are characteristic of a miniaturist, and were noted by his contemporaries as a distinctive and innovative style:

His cabinet pieces, full of character, minute in execution, and brilliant with their rendition of light, were entirely new to our art, and may be said to have marked a new departure in it. Without being in any sense imitations, they showed that the artist had been a close student of the old Dutch detail painters.... His manner and matter were, however, entirely modern.[2]

Ulrich's depiction of a woman engaged with her music reflects more than an appreciation for the genre themes of the earlier Dutch masters. Representations of women portrayed in quiet, domestic settings proliferated during the last quarter of the nineteenth century, making manifest the ideal of the leisurely, graceful woman accomplished in music, sewing, and other decorative activities.[3] In *Moment Musicale*, Ulrich's musical young woman is cloistered within the confines of her comfortable home. Hands spread across the keyboard, eyes on the sheet music, the sitter is poised, preparing to commence her piece. So closely surrounded by other references to the fine arts—a framed work on the wall as well as ceramic and glass vessels—and so deliberately placed in counterpoint to the vase and cut roses situated in the foreground, Ulrich's figure stresses the theme of feminine decorum, refinement, and artistry. Genteel in subject, exquisite in execution, *Moment Musicale* suggests the elevated sensibilities and creative accomplishments so admired in American women and so celebrated by contemporary society.

J.S.

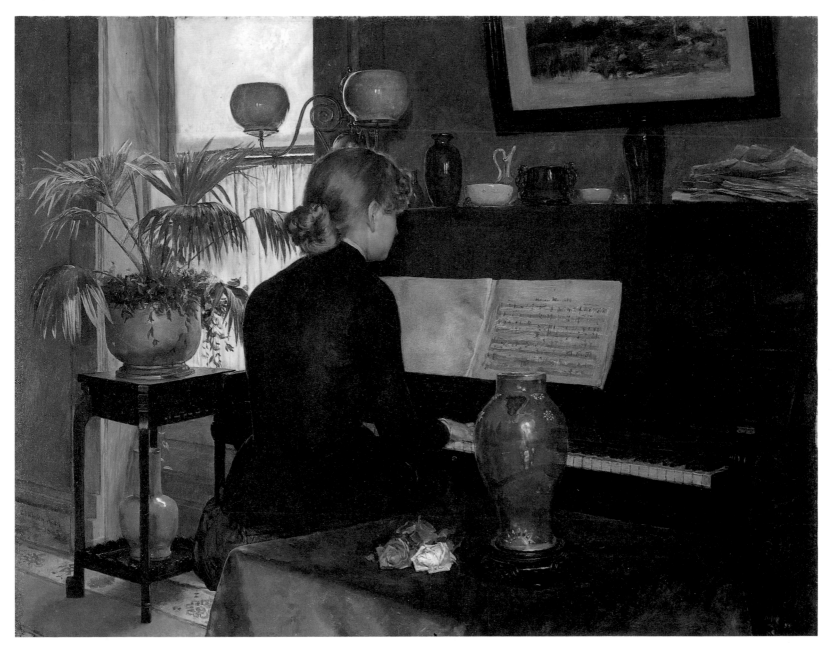

Moment Musicale, 1883

Oil on panel, 14⅞ × 19¼ in. Signed and dated lower left: *C. F. Ulrich A.N.A. / 1883.* Gift of Mr. and Mrs. John D. Rockefeller 3rd, 1979.7.99

Willard L. Metcalf
Lowell, Massachusetts 1858–1925 New York, New York

Willard L. Metcalf's parents, both believers in the occult, encouraged their son's painting career after a spiritualist, reportedly in communication with either Caravaggio or Correggio (the sources differ), told Mrs. Metcalf that her son would be a famous painter when "the snow of winter lay upon his brow."[1] Apprenticed in 1874 to a wood engraver, Metcalf began to study in 1875 with George Loring Brown (1814–1889), also taking evening classes at the Lowell Institute. Metcalf spent the summer of 1876 in New Hampshire's White Mountains, before enrolling that autumn as the first scholarship student at Boston's Museum of Fine Arts School.

In 1881 and 1883 Metcalf journeyed to the American Southwest to illustrate articles on the Zuñi Indians for *Harper's* and *Century* magazines. Taking the funds he raised from these illustrations and the sale of paintings in Boston, he traveled in the summer of 1883 to Europe, where he enrolled at the Académie Julian in Paris. Metcalf spent the next six years in France and England, with one trip to Tunis in 1887, being one of the first Americans to work in the artists' colonies of Grez and Giverny. He returned to New York in 1889.

Metcalf spent the next decade teaching, illustrating, and painting. In 1898 he exhibited as a founding member of the Ten—a group, including Childe Hassam,* Edmund Tarbell (1862–1938), John Twachtman (1853–1902), and J. Alden Weir (1852–1919), which was a major forum for America's Impressionist artists. From 1904 on, excepting a European campaign in 1913, Metcalf turned his attention almost exclusively to painting scenes of the New England countryside. The merging of this subject matter with his increasingly free technique prompted Metcalf to label 1904 his personal "renaissance."[2] The artist refused membership in the National Academy of Design and, although he enjoyed increasing success in his later years, seems to have had "thoughts," as he put it,

> for hardly anything but the making of, the giving everything in one's soul and being over to, the endless effort of putting paint on a canvas with a miserable little brush—and endeavoring to make it express thoughts and dreams—that will perhaps reach out and say something to someone, something that will make wandering souls—stop—and look—perhaps awaken something in them that may make them think of beautiful things—and so perhaps happiness.[3]

Metcalf painted *The Winter's Festival* in 1913. It is one of the most tremblingly beautiful of his several canvases showing the area around Cornish, New Hampshire. Metcalf had first visited Cornish—site of an artists' colony that included Thomas Wilmer Dewing,* Augustus Saint-Gaudens (1848–1907), and Maxfield Parrish,*[4]—in 1909. He returned in 1911 on the honeymoon of his second marriage, and periodically thereafter through 1920. The majority of Metcalf's Cornish paintings are winter scenes, the result of long hours spent in the out-of-doors painting in the bitter cold.[5] *The Winter's Festival* depicts a snowstorm blowing across a snow-covered meadow, with a gentle hill crowned by delicately figured trees closing the view in the distance.

In this work many layers of roughly applied paint stand as a sculptural equivalent of the snowstorm. Metcalf enlivens the heavy impasto of the whites and off-whites with lilacs, tans, bright and pale blues, and a vivid rose that, when added to the dusky green of the fir trees, create pale, chromatic harmonies. The dry, broken brushwork and the screen of falling snow fix attention on the surface of the canvas, creating tension between it and the painting's carefully wrought illusion of deep space. The nearly square format of the work further emphasizes its decorative aspects.

The poet Wallace Stevens evoked a scene similar to *The Winter's Festival* in "The Snow Man" (1921):

> One must have a mind of winter
> To regard the frost and the boughs
> Of the pine-trees crusted with snow,
>
> And have been cold a long time
> To behold the junipers shagged with ice,
> The spruces rough in the distant glitter
>
> Of the January sun, and not to think
> Of any misery in the sound of the wind,
> In the sound of a few leaves,
>
> Which is the sound of the land
> Full of the same wind
> That is blowing in the same bare place
>
> For the listener, who listens in the snow,
> And, nothing himself, beholds
> Nothing that is not there and the nothing that is.[6]

Metcalf, painting outdoors in the harshest weather, studying effects of light and color and transcribing them onto canvas "with a miserable little brush," apparently experienced Stevens's "mind of winter," a state of resigned despair nonetheless appreciative of beauty. While *The Winter's Festival* is in many ways a celebration of nature, it also details nature's obliterative power with knowing and objective vision.

M.S.

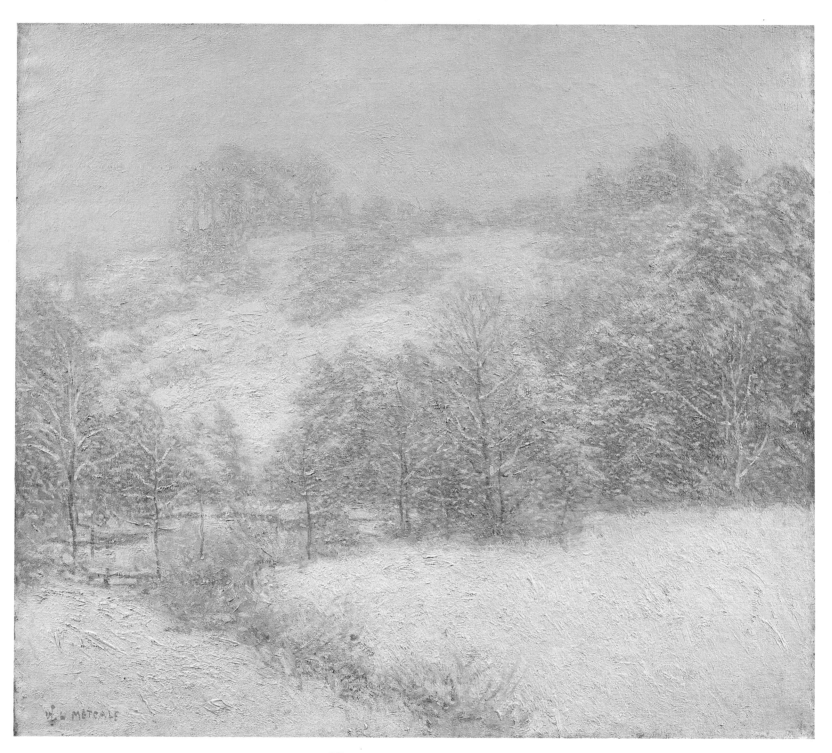

The Winter's Festival, 1913
Oil on canvas, 26 × 29 in. Signed lower left: *W. L. METCALF.* Gift of Mrs. Herbert Fleishhacker, 47.5.3

Childe Hassam
Dorchester, Massachusetts 1859–1935 East Hampton, New York

Known as the leading exponent of American Impressionism and a painter of brilliant color and light, Childe Hassam began his artistic career apprenticed to a Boston wood engraver. While free-lancing as an illustrator in the early 1880s, he attended classes sponsored by the Boston Art Club and took private lessons from the Munich-trained genre painter Ignaz Gaugengigl (1855–1932). His favored medium was watercolor. After a year's travel in Europe in 1883, he began to paint landscapes in the spirit of the French Barbizon School, as well as atmospheric renderings of street scenes that seem close to the works of conservative, popular painters in Paris such as Jean Béraud (1849–1936) and Giuseppe de Nittis (1846–1884).[1] In 1886 Hassam returned to France, enrolling briefly at the Académie Julian and working in Paris for three years. Although Hassam later told a writer, "I . . . cannot recall that I gained many new ideas in Paris,"[2] when he returned to America and settled in New York, his style showed an increasing debt to French Impressionism. During the 1890s he painted both city streets and country scenes, bringing to the American landscape the Impressionists' vibrant color, strong light, flat patterning, and broken brushstrokes. In 1898 Hassam joined J. Alden Weir (1852–1919) and John Twachtman (1853–1902) in seceding from the Society of American Artists and founding the group known as "the Ten." This group promoted new standards for exhibition selection and hanging arrangements, and its exhibitions became a major forum for American Impressionism. Hassam's progressive attitudes did not carry into the new century. He contributed twelve paintings to the Armory Show of 1913, where their underlying conservatism was all the more evident against the backdrop of avant-garde European art. While he continued to paint in oils, Hassam devoted his later years to printmaking and to developing the artists' colony in Old Lyme, Connecticut.

Hassam's family roots in Massachusetts went back to 1635, and the artist's residence in New York never diminished his attachment to New England. His favorite summer haunt was the island of Appledore, one of the Isles of Shoals off the coast of New Hampshire. Hassam visited the island as early as 1884 and spent nearly every summer there upon his return from France in 1889.[3] A large part of his attraction to Appledore was the presence there of poet and writer Celia Thaxter, whose renowned flower gardens no less than her circle of literary and artistic friends proved a source of earthly delights and creative inspiration.

Upon Thaxter's death in 1894, Hassam turned his painterly attention away from Appledore's gardens and toward its landscape and coastal views. Hassam painted the Appledore coast several times, returning again and again to its elemental contrasts of rock, sea, and sky. Like Claude Monet (1840–1926), but without the Frenchman's scientific insistence, Hassam painted the same subject to record its appearance under varying conditions of light.[4] An inscription on the reverse of *Seaweed and Surf, Appledore, at Sunset* marks this scene as a sunset view, underscoring Hassam's concern with the transient effects of light. As well, the handling of paint, with the short, broken strokes of color laid close to one another, remains close to the Impressionism of Monet.

Yet Hassam's later Appledore pictures, like this one from 1912, also explore various arrangements of color and pattern on a two-dimensional surface, suggesting the artist's knowledge of Post-Impressionism.[5] The nearly square dimensions of the canvas emphasize neither breadth nor height, while the horizon line, marked by a searing stripe of brilliant orange and placed high on the picture plane, effectively reduces the illusion of depth.[6] The vivid colors as well as the subtle outlines around rock forms accentuate their shapes as patterns rather than illusions. Both a decorative arrangement and an evocation of the New England coast, this painting recalls the lines of poet James Russell Lowell, himself a staunch New Englander and friend of Celia Thaxter:

> All the beautiful changes and chances
> Through which the landscape flits and glances . . .
> Till now you dreamed not what could be done
> With a bit of rock and a ray of sun.[7]

S.M.

Seaweed and Surf, Appledore, at Sunset, 1912
Oil on canvas, 25½ × 27¼ in. Signed and dated lower right: *Childe Hassam / 1912*
Gift of the Charles E. Merrill Trust with matching funds from The de Young Museum Society, 67.23.2

Maurice Prendergast
Saint John's, Newfoundland, Canada 1859–1924 New York, New York

Maurice Prendergast, praised in his later years as America's first modern artist, developed his art against the conservative backdrop of turn-of-the-century Boston. Having moved there with his family in 1861, Prendergast worked in a dry-goods store before finding employment with a painter of show cards. He traveled to Europe in 1886, accompanied by his brother, Charles (1868–1948),[1] and returned there in 1891, beginning formal art training in Paris around the age of thirty-two by enrolling in the Atelier Colarossi and the Académie Julian. Among the artists he befriended in Paris was the Canadian James Wilson Morrice (1865–1924), who introduced Prendergast to the contemporary French art that had such a decided impact on his style.[2] Prendergast returned to Boston in 1895 but made a third trip abroad in 1898, spending much of his time in Venice. Upon his return in 1899, he began to show his work outside Boston, and in 1904 he exhibited in New York with a group of artists who rebanded four years later and became known as "the Eight." Prendergast's work stood apart from the gritty realism of such painters as Robert Henri* or William Glackens*; one critic of the 1908 exhibition suggested that "the show would have been better if it were that of The Seven rather than The Eight."[3] Another unwittingly recognized Prendergast's strength when he criticized the artist's work as "a jumble of riotous pigment . . . [looking] for all the world like an explosion in a color factory."[4] More perceptive critics compared his canvases to cloisonné work, mosaics, and embroidery,[5] correctly acknowledging their decorative component if not their modernist underpinnings.

Three additional trips to Europe in 1907, 1909–10, and 1911–12 introduced Prendergast to the most advanced work of Paul Cézanne (1839–1906) and Henri Matisse (1869–1954). Prendergast had the opportunity to exhibit his paintings alongside the work of these and other avant-garde European artists in 1913 at the Armory Show in New York, which he helped organize. A one-man show the next year won him the patronage of adventurous collectors of modern art such as John Quinn and Albert Barnes. In 1914 he moved to New York, where, despite illness and progressive deafness, he continued to paint and exhibit for the remaining ten years of his life.

Before 1901 Prendergast's preferred medium was watercolor, although he had painted several *pochades*, small oil sketches on panel, with Morrice in Paris. *The Holiday* retains something of the freshness and transparency of those watercolors, despite the heavy application of pigment and the drier, impastoed surface. Prendergast's vivid, pastel colors are laid on in a brocade of separate, overlapping strokes, generally bound within a flowing outline that suggests form. Occasionally the strokes float free of any descriptive function, as do the brilliant touches of light blue that drift above the central figure. The figures in their stately procession form a frieze that emphasizes the horizontal; their faceless, generalized forms deny specificity and suggest a timeless calm.

Prendergast varied his subject matter little in his oils, returning over and over to the promenades, picnics, and holidays that enabled him to structure a dense group of figures within an idyllic landscape setting. The restricted subject matter allowed him to focus on expressions of color and form rather than narrative; as Prendergast's career progressed, his work became more abstract and lyrical. Yet it remained rooted in the natural world, even as it partook of an older tradition of arcadian or pastoral landscape. For all the modernist implications of his style, Prendergast's artistic vision maintained the ideal of harmony between man and nature. Duncan Phillips, the astute collector of modern art who began to purchase Prendergast's work in the 1920s, recognized both the novelty and the nostalgia in Prendergast's art when he eulogized the artist in 1924:

> Prendergast repeated his favorite fantasy, his midsummer daydreams, so delightfully inconsequential, with their strange air of being true to fact, true to real domesticated places and people, and yet very like fairy-tale towns, as if mortals had come down for a single happy holiday. . . . He lavished upon such themes his genius for infinitely various schemes of color—each concord of color-notes producing a tonality as subtle and as sumptuous as orchestral weaving of rare elfin sounds.[6]

S.M.

The Holiday, ca. 1907–9
Oil on canvas, 27 × 34⅜ in. Signed lower center left: *Prendergast*
Gift of the Charles E. Merrill Trust with matching funds from The de Young Museum Society, 68.14

Henry Alexander

San Francisco, California 1860–1894 New York, New York

While still in his early teens, Henry Alexander studied art in San Francisco with Virgil Williams (1830–1886), then left California around 1877, encouraged by the artist Toby Rosenthal (1848–1917) to continue his studies in Munich.[1] Alexander studied under Wilhelm von Lindenschmit (1829–1895) and Ludwig von Löfftz (1845–1910) at Munich's Royal Academy, at a time when these artists were practicing a meticulously realistic style of genre painting based on the work of the German artist Hans Holbein (ca. 1465–1524) and the "little masters" of seventeenth-century Holland and Flanders.[2] Alexander first exhibited in Munich in 1879 and four years later returned to America, intending to settle in New York. The San Francisco press acclaimed its native son:

> Henry Alexander, the young California artist, has just returned to this country. . . . He has brought with him a number of interesting studies of excellent conception and great merit. The accuracy of drawing, the quality of light and color, and altogether the remarkably realistic canvas representations, speak volumes for the future of the young artist.[3]

In New York, Alexander was welcomed by a studio reception hosted by Charles Frederic Ulrich,* one of the American artists he had befriended in Munich. Ulrich also introduced Alexander to the prominent collector Thomas B. Clarke, who eventually purchased three of Alexander's paintings. In 1885 Alexander returned to San Francisco, where he spent three years painting portraits and genre scenes (including The Fine Arts Museums of San Francisco's *Neglecting Business,* 1887),[4] many of them set in San Francisco's Chinatown, before once more departing for New York "with the intention of settling there permanently."[5] In addition to interiors and genre scenes, Alexander began a series of still-life paintings of antique glass, having received special permission to study the antiquities in the Metropolitan Museum of Art. Alexander continued to exhibit his work regularly but by 1894 had become increasingly troubled by financial difficulties, physical ailments, and the death of his friend Norton Bush (1834–1894). He committed suicide on 15 May 1894.[6] Many of the paintings of this talented but short-lived artist were destroyed in the 1906 San Francisco earthquake, when fire ravaged the warehouse in which his family had stored the works they had collected for a memorial exhibition.

To judge by the some thirty works extant today, Alexander was fascinated by the clutter of Victorian laboratory, shop, and parlor interiors, challenged by the complicated arrangements of shapes, patterns, and surfaces they offered. His finest paintings show a scientist or craftsman at work, surrounded by the implements of his trade; the intensity of the workman's concentration is matched by the artist's meticulous rendering of detail, light, and nuance. *The First Lesson* is one of these. Alexander reveals the interior of William Nolte's taxidermy shop at 110 Golden Gate Avenue in San Francisco, where Nolte is instructing his young apprentice William J. Hackmier, who watches with rapt attention.[7] Light fills the courtyard outside the studio and streams through the window into the darkened room. Falling across Nolte's hands, catching specks of dust in its path, the light spills into a pool in the left corner (the only impasto in an otherwise smoothly brushed surface) and casts an eerie glow around the edges of objects and figures. Restricting his palette to a few muted tones, Alexander draws the viewer's attention to the contrasts between interior and exterior, light and dark, living human and stuffed creature. Yet the artist's careful description of each element in this composition lends the painting a luminous but unsettling consistency, blurring the distinction between the animate figures and the supposedly still life around them.

S.M.

The First Lesson (The Taxidermist), 1885
Oil on canvas, 25 × 34 in. Signed lower right: *Henry Alexander*. Mildred Anna Williams Collection, 1952.76

Arthur F. Mathews
Markesan, Wisconsin 1860–1945 San Francisco, California

A versatile and influential artist, Arthur F. Mathews was a successful painter, architect, designer, and teacher, whose efforts bridged two centuries. His family having settled in Oakland, California, in 1867, Mathews worked as an apprentice in his father's architectural office before beginning work in 1881 for a San Francisco lithographer. Three years later he became a free-lance designer and illustrator and was able to save enough money to finance a trip to Paris. He enrolled in the Académie Julian in 1885; the next year he won the school's medal for distinction in the three disciplines of composition, drawing, and painting. Returning to San Francisco in 1889, Mathews taught life classes at the San Francisco Art Students League and in 1890 became the director of the California School of Design. During his sixteen-year tenure he emphasized excellence in draftsmanship and the study of the human figure; in the tradition of the Académie Julian, he also encouraged his students to work independently and advised many of them to travel to Europe. One of his best pupils, Lucia Kleinhans (1870–1955), became his wife and an integral collaborator in his career. The Mathewses spent most of 1899 in Paris; Lucia enrolled in James McNeill Whistler's* Académie Carmen while Arthur taught private classes. Upon their return from France, Mathews executed several commissions for public murals, ranging from the Oakland Free Library (1904) to the State Capitol in Sacramento (1914). His work in these years fits into the general atmosphere of building and progress evident throughout the nation and recognized today as an American Renaissance—a time when artists gave shape to the highest cultural aspirations of society and worked together to achieve a unity among the arts.[1] Mathews's own ideals carried the flavor of the Arts and Crafts movement, as evidenced by his response to the devastation of San Francisco after the 1906 earthquake and fire. Mathews resigned from his teaching posts and with his wife embarked on an ambitious three-fold program to rebuild San Francisco: the magazine *Philopolis* (1906–16) featured articles on art and city planning; the Philopolis Press (1906–18) published literature on art and California topics; and finally, the Furniture Shop (1906–20) produced furniture, frames, and decorative objects in the distinctive style sometimes called "California Decorative."[2]

Mathews's mural works and easel paintings alike reflect an aesthetic developed after his 1899 visit to Paris. Mathews's style matured under the influence of Whistler and the French mural painter Pierre Puvis de Chavannes (1824–1898), as well as the evocative fin de siècle aura of the French Symbolists. Whether they depict landscapes or quasi-mythological scenes, Mathews's paintings are simple in composition, elegant in line, generally low-keyed in palette, but bold in the use of decorative patterns of shape and color. Mathews described his approach to painting in 1909: "I consider the subject first, the color second, the arrangement of color third, the drawing last. I put most stress on composition, especially on composition of color and tone."[3]

The Grape is typical of Mathews's easel paintings in its decorative composition, flat patterning of color, and vaguely allegorical subject (see also The Fine Arts Museums of San Francisco's *Song of the Sea,* ca. 1909).[4] Like the titles of the artist's last two murals for the Oakland Free Library, *The Soil* and *The Grain*, *The Grape* was meant to denote a source of California's bounty, heritage, and agricultural pride. Likewise, Mathews's colors —dull reds, olive greens, and mustard yellows—suggest California's warm sunlight and fertile earth. Significantly, the young woman presses grapes by hand into a large earthenware bowl, a gesture surely not indicative of vineyard production methods at the turn of the century, but, rather, evocative of the harmonious relationship between man and nature, laborer and product, to which the Arts and Crafts movement aspired. The woman herself, half draped and half nude, stands somewhere between allegorical figure and actual model; her sturdy torso, broad features, and coarsely bound hair denote a particular ideal of indigenous Californian beauty. As the figure hovers between real and ideal, so representation borders on decoration. The same strong light that models the form of a knee or shoulder casts shadows that take on independent form; in the background, the arching branches of trees, the wall of a building, and a patch of blue sky create a decorative mosaic of color.

Integral to this work is the handsome frame that surrounds it. Like Whistler and Hermann Dudley Murphy,* Mathews believed in supplying his paintings with complementary frames that became part of the artworks themselves. In general, Mathews's frames present stylized motifs carved (or, less frequently, molded) in flat relief and colored in subdued tones. The frame around *The Grape* is one carved by the Furniture Shop,[5] with a poppy and medallion design, painted in a dull gold that harmonizes with the warm tones of the image itself.

S.M.

The Grape (The Wine Maker), ca. 1906
Oil on canvas, 26 × 24 in. Signed lower right: *Arthur F. Mathews*. Gift of Mrs. Henrietta Zeile, 37656

Irving R. Wiles
Utica, New York 1861–1948 Peconic, New York

A painter of portraits as well as plein-air landscapes and seascapes, and an illustrator for the American popular press, Irving R. Wiles encapsulated within his elegant and evocative figure studies the versatility and cosmopolitanism that were so popular at the century's end. Wiles began his artistic career under the tutelage of his father, Lemuel M. Wiles (1826–1905), a landscapist and art instructor. From 1879 to 1881 he studied at the Art Students League in New York. There his work with William Merritt Chase* sparked a personal and professional relationship between the two artists that was to last a lifetime. To complete his formal education, Wiles spent the following two years in Paris studying at the Académie Julian and in the studio of Carolus-Duran (1837–1917), the teacher of John Singer Sargent.* On his return to New York in 1884, Wiles established a successful career painting, illustrating, teaching (at the Art Students League, the Chase School, and with his father), and exhibiting regularly at the National Academy of Design and abroad.[1]

In *The Sonata*, with virtuoso brushwork that he would have learned from Chase and Carolus-Duran, Wiles depicts two women dressed in diaphanous gowns. As the violinist rests her instrument on a nearby table and gestures with her bow to the sheet music, the other woman (the artist's wife, May)[2] sits at the piano, fingers poised on the keyboard, contemplating the music score. The association Wiles infers among the physical, abstract, and visual qualities of music, an attunement of mind, mood, tone, and color, suggests an awareness of James McNeill Whistler's* thoughts on the analogous harmonic properties of painting and music.[3] Equally, at a time when women were revered for their sensitivity of spirit and gentility of pursuits in contrast to the troubles of a newly modern world, *The Sonata* reflects the peculiar affinity women were believed to have with art and music.[4]

Although perfectly integrated into the figure composition, the form of the standing violinist is reminiscent of Sargent's portrait of Madame Gautreau, the infamous *Madame X* (1884; Metropolitan Museum of Art, New York).[5] Exhibited at the annual Paris Salon in 1884, the last year of Wiles's study there, this full-length portrait of a celebrated society beauty scandalized the French public with its startling sensuality. Five years later Wiles incorporated into *The Sonata* many of the qualities that made the Sargent portrait so celebrated: low-cut bodice; elegant profile; sensuous line of bared neck, shoulder, and arm; even a round table truncated by the picture margin. In the context of the genre subject, however, that which had proved so provocative in the Sargent becomes graceful, demure, and unselfconscious. When exhibited at the National Academy in 1889, *The Sonata* earned for Wiles the coveted Thomas B. Clarke prize for figure painting. It subsequently entered the famous collection of William T. Evans. With its elegant execution and resonant mood, *The Sonata* stands today as one of Irving Wiles's masterpieces.

J.S.

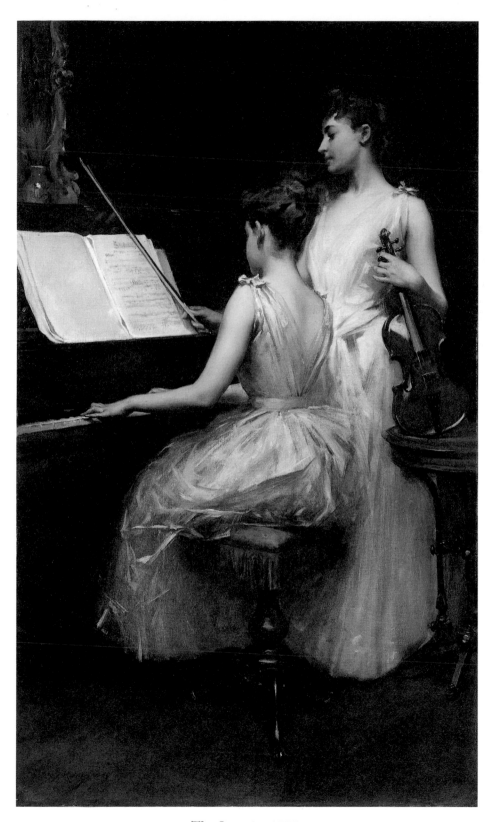

The Sonata, 1889
Oil on canvas, 44⅛ × 26¼ in. Signed and dated lower left: *Irving R. Wiles 1889*
Gift of Mr. and Mrs. John D. Rockefeller 3rd, 1985.7

Robert Henri
Cincinnati, Ohio 1865–1929 New York, New York

After his father shot a man in self-defense, then changed the family's name, Robert Henri Cozad became Robert Henri (pronounced Hen-rye) in 1882. In 1886 he enrolled in the Pennsylvania Academy of the Fine Arts in Philadelphia, studying two years with Thomas Anshutz* before leaving for Paris, where he studied at the Académie Julian and the Ecole des Beaux-Arts. He returned to Philadelphia in 1891 and began teaching at the School of Design for Women, but took evening classes at the academy and presided over informal sketching and criticism sessions at his own studio. During these sessions Henri met John Sloan (1871–1951) and eventually William Glackens,* Everett Shinn,* and George Luks,* all of them illustrators for the *Philadelphia Press*. Henri assumed the role as leader of the group, encouraging them to translate their journalistic skills into serious painting and urging them to develop personal styles that might express the vitality of life around them.

In 1901, following a second trip to Europe, Henri moved to New York, where Glackens and Luks had already settled. Teaching remained his primary activity, but Henri strove to place his own work as well as that of his friends in private galleries and competitive exhibitions. Henri's paintings were generally well received, and by 1907 he was himself a juror for the National Academy of Design. When that same jury rejected works by Sloan, Luks, Shinn, and Glackens for the annual spring show, Henri brought together those four artists and three others who shared their progressive outlook—Ernest Lawson,* Maurice Prendergast,* and Arthur B. Davies (1862–1928). Later dubbed "the Eight," the group rented William Macbeth's gallery in February 1908 to hold an independent show, their one and only exhibition together. This landmark event stood in defiant opposition to the National Academy's conservative grip over exhibition opportunities and individual styles, and in 1910 Henri produced an even larger Exhibition of Independent Artists, the country's first open, nonjuried, no-prize exhibition.[1] Henri withdrew from the management of the 1913 Armory Show when it became clear that the international section would overwhelm the accomplishments of the American artists he had worked so hard to encourage. Indeed, for some time after 1913 the various European avant-garde movements represented in the Armory Show exerted far more influence over the progress of American art than did Henri. Until his death, however, Henri continued to teach and inspire students and maintained an active schedule of painting and travel.

After his move to New York, Henri's interest in portraiture increased, no doubt as a result of his second European trip and his enthusiastic discovery of the art of Frans Hals (1580–1666), Velázquez (1599–1660), Francisco Goya (1746–1828), and Edouard Manet (1832–1883)—all of them masters of portraiture as well as energetic technique. Henri never earned a living from portrait commissions, but clearly he enjoyed studying the human form for its revelations of individual spirit. He executed several full-length portraits of friends and models between 1900 and 1912, each a study of character as evidenced by posture and attitude rather than props or background details. In such works Henri demonstrated his knowledge of the full-length portrait tradition as practiced by the previous generation of American artists—James McNeill Whistler,* William Merritt Chase,* and John Singer Sargent.* Henri would hardly have admitted an influence from these older men; his more immediate inspiration was the work of the seventeenth-century painters Velázquez and Hals (artists who, by the way, were admired by the previous generation as well).[2] Stylish though these portraits are, Henri's primary concern resided in the sitter. As he told his students: "An interest in the subject; something you want to say definitely about the subject; this is the first condition of a portrait.... Completion does not depend on material representation. The work is done when that special thing has been said."[3]

Henri had been a widower for two years when he met Marjorie Organ (1886–1930), a vivacious redhead who had become a cartoonist for the *New York Journal* at the age of seventeen. Her comic strip "Reggie and the Heavenly Twins" ran for three years, and her caricatures of theater personalities appeared in the *New York World*.[4] Henri and Organ were introduced in March 1908; they married in May after keeping their courtship a secret from even their closest friends. Painted two years after their marriage, Henri's portrait of his wife (whom he called O) ranks among his masterpieces. Cool and elegant, O stares directly out of the canvas, her body turned gently to form a slight but sinuous S-curve. The tall, narrow format of the canvas accentuates her height, which is further underscored by the long, vertical sweep of her scarf. The viewer's eye is led up by these light-colored lines toward her features—a face broadly but sensitively modeled, accented by the full red mouth and soft red hair. Neither the flat black of her dress nor the warm brown background compels attention, but against their darkness the white skin and red accents gleam dramatically. No professional model poses as Henri's epitome of elegant womanhood; in holding back her scarf, O prominently displays a warm spot of yellow—her wedding ring.

S.M.

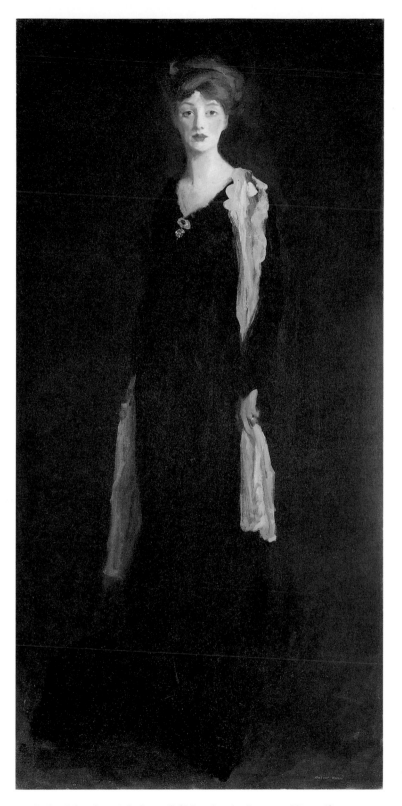

O in Black with Scarf (Marjorie Organ Henri), 1910
Oil on canvas, 77¼ × 37 in. Signed lower right: *Robert Henri*
Gift of The de Young Museum Society, purchased from funds
donated by the Charles E. Merrill Trust, 66.27

George Luks
Williamsport, Pennsylvania 1866–1933 New York, New York

Acquaintances remembered George Luks variously as "a one-man circus," "a glutton for existence," and "a Puck, a Caliban, a Falstaff—and a tornado."[1] The artist claimed that his flamboyant career began in Philadelphia at the Pennsylvania Academy of the Fine Arts in 1884, but no evidence of his registration there has been found. The account of his next ten years is likewise confused by inconsistencies; Luks certainly spent time in Düsseldorf, Munich, Paris, and London, but the extent of any art education there cannot be confirmed. Apparently he was back in the United States by 1891,[2] and in 1894 he joined the artistic staff of the *Philadelphia Press*. While working for the newspaper, Luks roomed with a fellow illustrator, Everett Shinn,* and the two attended evening sessions at the studio of Robert Henri.* Through these gatherings they met John Sloan (1871–1951) and William Glackens* and formed the nucleus of the group eventually known as "the Eight." In 1896 Luks was sent to Cuba as a war correspondent; when he was fired for negligence and drunkenness, he turned up in New York and immediately secured a job with the *New York World*. Luks's often outrageous comic flair, coupled with extraordinarily facile draftsmanship (Shinn described how Luks would draw with both hands simultaneously),[3] ensured his stature as "premier humorist artist" at the *World*.[4] With the encouragement of Glackens and under the indirect influence of Henri, Luks began to paint around 1898, finding his subjects in the shopkeepers, urchins, drunks, and bartenders of the New York streets.

Luks's rough, unsparing canvases epitomized the Eight's rejection of academic finish and idealized subject matter; among the works most disparaged by critics of the group's landmark 1908 exhibition at the Macbeth Galleries was Luks's picture of pigs. Luks took as his master the Dutch painter Frans Hals (1580–1666), finding in that artist's lusty portraits and dashing brushwork a suitable model for his own efforts, eventually boasting, "Look at Frans Hals and look at me. . . . The two greatest painters this world has ever seen."[5] Luks contributed to the 1910 Independent Exhibition and to the 1913 Armory Show, but like other members of the Eight, retreated from a radical stance after 1913. Although his later paintings are uneven in quality, Luks never lost the power of his graphic touch. Probably inspired by the European works he saw at the Armory Show, Luks took up watercolor in a bold and highly innovative fashion in his later career, creating energetic images that are intense in color and nearly expressionistic in their emotional impact.[6]

It has been observed that "all the Philadelphia bunch [Henri, Glackens, Sloan, and Shinn] could paint the New York streets, but only Luks could paint the people."[7] Luks was especially drawn to the subject of children; admirers of John George Brown's* well-scrubbed bootblacks must have been horrified by Luks's raw, unsentimental portraits of street beggars and gutter waifs. Yet these depictions were not without sympathy or understanding, nor was Luks attempting to make a social-reform statement in the manner of photographers Lewis Hine (1874–1940) or Jacob Riis (1849–1914). Rather, he gravitated toward the vitality and humanity of these subjects, claiming that "a child of the slums will make a better painting than a drawing-room lady gone over by a beauty shop."[8]

Innocence, painted a few years after the Armory Show, is more controlled and "pretty" than many of Luks's earlier images. Rather than the rags and hunger portrayed in many of his works from 1900 to around 1910, this well-dressed young girl appears properly, even elegantly protected against the cold. Her forthright stare and curious activity—she seems to be fingering gold coins—suggest a worldly awareness that belies the painting's title.[9] She may appear self-satisfied in her handsome winter garb, but she may also be fidgeting beneath its restraints. Certainly, energy bursts from the contours and surfaces of her form. Luks has described her coat with a few slashing strokes and suggested the blue ribbons about her bonnet with calligraphic squiggles. Her impish features and handsomely gloved hands are drawn more delicately but no less summarily. Luks's colors are bold; the blue used to outline the girl's scarf and eyes serves even more strongly to call attention to the bright touches of complementary orange that appear in her hands and in the artist's signature. A masterpiece of verve and economy, this portrait seethes with energy, recalling Luks's credo, "Guts! Guts! Life! Life! that's my technique."[10]

S.M.

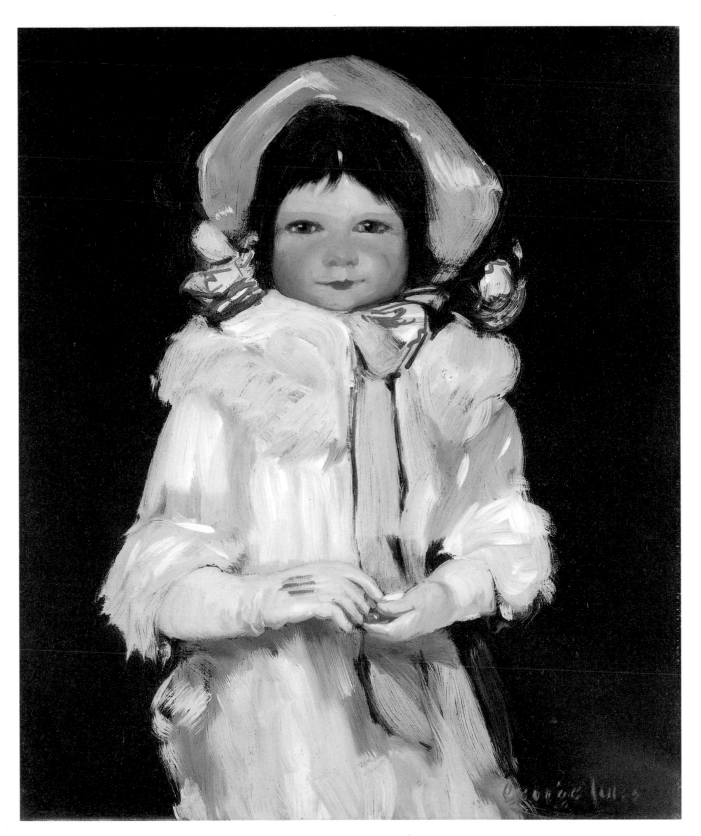

Innocence, ca. 1916

Oil on canvas, 30 × 25 in. Signed lower right: *George Luks*. Gift of Mrs. Horace L. Hill, 1967.2

Hermann Dudley Murphy

Marlboro, Massachusetts 1867–1945 Lexington, Massachusetts

A student at the Boston Museum School in 1886, Hermann Dudley Murphy studied painting under Otto Grundman (1844–1890) and Joseph DeCamp (1858–1923) before working as an artist and surveyor for the Nicaragua canal survey. Upon his return to Boston, he worked as an illustrator for newspapers and magazines and in 1891 traveled to Paris to study at the Académie Julian, achieving the rare distinction for an American student of becoming *massier* in the atelier of Jean-Paul Laurens (1838–1921).[1] He married a fellow student, and the couple returned to America in 1897, settling north of Boston in Winchester, Massachusetts. By 1900 Murphy had exhibited his work in Philadelphia, Boston, New York, and Chicago and had begun an active schedule of teaching. In 1899 he taught a summer class in painting on Cape Cod and in 1901 joined the faculty of Harvard's School of Architecture, an association he would maintain until 1937. Murphy spent the summer of 1903 in Woodstock, New York, offering instruction in both painting and frame making for the utopian Arts and Crafts colony of Byrdcliffe.[2] He returned to Winchester that fall to begin a frame-making venture with Charles Prendergast (1868–1948), which they called "Carrig-Rohane" after the Celtic name of Murphy's home.[3] From 1903 to 1907 Murphy taught painting at the Worcester Art Museum and in 1908 spent five months in Venice, still continuing to exhibit his work widely.

Following a divorce from his first wife in 1915, Murphy married the artist Nellie Littlehale Umbstaetter (1867–1941), a girlfriend from his youth. After the First World War, in which Murphy served as inspector of camouflage, the Murphys built a home and studio in Lexington, Massachusetts. Murphy's primary output in the 1920s and 1930s was floral still lifes, often exhibited along with watercolors by his wife. Murphy's later works, highly praised for their aesthetic delicacy, show the artist moving away from the aggressive experimentations of his youth and into the more conventional, genteel mode of such Boston painters as Frank Benson (1862–1951) and Lilian Westcott Hale (1881–1963).

The paintings of Murphy's early career reveal a distinctive sensibility, nurtured in the turn-of-the-century atmosphere of the Aesthetic, Symbolist, and Arts and Crafts movements. The most pervasive influence on his early career was James McNeill Whistler.*[4] As an active participant in the Boston art community upon his return from France, Murphy was at the center of several different art currents. His interests in frame making and regard for the unity of painting and frame allied him with the Arts and Crafts movement, whose concern with reform in aesthetics encouraged educators and proselytizers. Murphy seems to have belonged—if but briefly—to a special group of Boston painter-teacher-theorists that included Denman Ross (1853–1935) and Arthur Wesley Dow (1857–1922), both of whom were inspired by Oriental art and wrote influential treatises on art practice and art education. Both Ross and Dow sought to free art from conventional modes of representation by steering it toward the principles of beauty, harmony, and design.[5] Murphy's summer classes seem to have emphasized similar concepts, as one of his students described:

> Mr. Murphy is one of the active believers in a systematic progression in study which is as definitely scientific as a search for the beautiful can be.... Imitation or academic realism is the enemy to this development, where individual choice for tone and decorative qualities finds an important place.[6]

In *The Marshes*, Murphy emphasizes tonal values and decorative qualities to create an image true to Dow's conviction that painting "is essentially a rhythmic harmony of colored spaces."[7] The flat, boggy landscape along Boston's northern shore, punctuated by serpentine channels of sea water, was a favored locale of Dow and photographer Alvin Langdon Coburn (1882–1936), who, like Murphy, were concerned with stylizing the patterns of natural forms. With a simple, curved line that dips below and lifts back above the center of the canvas, Murphy sets off the darkly shadowed marshes of the foreground from the winding channel of water and the horizontal bands of land, trees, and sky above. A smaller pool in the foreground echoes the bend of the river above. Bands of gray suggest banks of clouds and their reflections; groves of trees are stylized ribbons of dark green. Short daubs of creamy paint indicate houses on the far horizon; touches of pink denote clouds rising above the fog. Setting these patterns on his canvas in a subtle yet masterful arrangement of line and color, Murphy approaches abstraction yet carefully maintains a representational structure by references to the actual landscape—the wisps of marsh grass, the suggestion of spatial recession. The overall effect is one of poetic design, as was recognized by reviewers of Murphy's 1900 exhibition at the Art Institute of Chicago, which included *The Marshes*: "Mr. Murphy uses space and color much as a composer uses sound and time in producing music. His subjects are but of little interest. It is the expression of himself in the arrangement of masses of harmonious color which renders his paintings interesting."[8]

S.M.

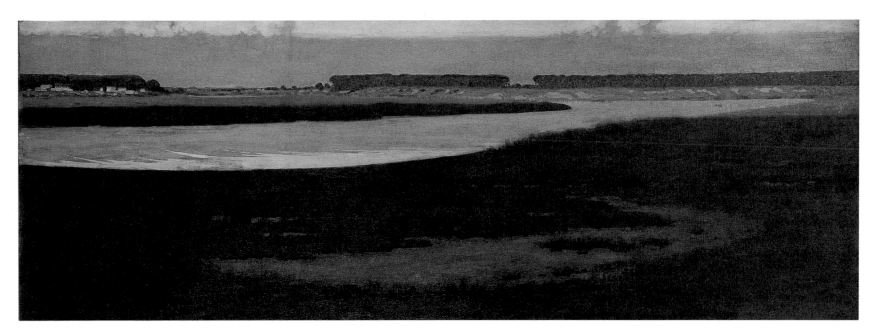

The Marshes, 1899

Oil on canvas, 23⅝ × 65⅜ in. Signed with monogram and dated lower left: 9 ⓜ 9
Museum purchase by exchange: Bequest of Elizabeth Leslie Roos in memory of her son, Leslie L. Roos,
with additional funds from the family of Leslie L. Roos, 1985.31

Clark Hobart
Rockford, Illinois 1868–1948 Imola, California[1]

Clark Hobart moved to California while he was still young. He enrolled at the Mark Hopkins Institute in San Francisco and studied for three years under Giuseppe Cadenasso (1853–1918) and privately under William Keith (1839–1911) before moving to New York to study at the Art Students League under Robert Blum (1857–1903) and Frederick Bridgman (1847–1928). While studying in New York, Hobart was selected in 1898 to paint four panels for the Ethnology Building of the 1901 Pan-American Exposition in Buffalo. After three years in New York, he left for Paris, where he studied an additional three years. Around 1903 he returned to New York and became the art director of the *Burr McIntosh Monthly*; in 1906 he became its editor. Soon after the magazine ceased publication in 1911, Hobart returned to California and settled in Monterey. By 1913 he was exhibiting monotypes and paintings along the Monterey peninsula and in San Francisco. His monotypes received a Silver Medal at the 1915 Panama-Pacific International Exposition in San Francisco, where they were praised as the "work of a man who is at once eclectic and original."[2] In 1916 he moved his studio to San Francisco and the next year took up portraiture in addition to landscape painting and monotype. During the early 1920s Hobart continued to paint and exhibit widely, at the same time accepting projects for both murals and interior design.

In 1923 he married Mary Young, an artist and historian who was head of the art department at San Francisco's Mission High School. The Hobarts opened an interior-design studio in San Francisco the next year, and after 1925 Clark Hobart's painting activity diminished sharply. He continued to exhibit his work until 1930 but resigned his membership on the board of directors of the San Francisco Art Association in 1926 and soon after moved to Campbell, California, where he lived in semiretirement.[3] Apparently he did not paint again.

Many of the sources of Hobart's "eclectic but original" style remain unexplored. When he appeared on the Monterey art scene around 1912, his style was well formed, and by 1916 he was hailed as "the Cézanne of the West."[4] Under Hobart's editorship, the *Burr McIntosh Monthly* ran occasional articles on progressive artists such as Paul Cézanne (1839–1906) and Auguste Rodin (1840–1917). In 1907 an article appeared praising "Modern American Art" and illustrating works by William Glackens,* Ernest Lawson,* and George Luks,* indicating that Hobart was aware of, and sympathetic to, the battles of independent painters.[5] Yet reproductions of Hobart's own work that appear in the magazine reveal a fanciful, decorative sensibility akin to popular illustrators such as Maxfield Parrish.* By

1919 the critic Willard Huntington Wright (brother of the Synchromist artist Stanton Macdonald-Wright [1890–1973]) called attention to the derivative nature of Hobart's portraiture, noting influences ranging from Edouard Manet (1832–1883) and John Singer Sargent* to the Spanish Post-Impressionist Ignacio Zuloaga (1870–1945). But in Hobart's landscape paintings, Wright found that the artist was

> concerned with more vital art principles. They are Cezannesque in vision and manner and possess . . . excellent structural qualities and harmonious linear design. . . . Once Hobart finds himself he will do important work, for he has undoubted technical facility. Even now he has achieved much in the difficult modern idiom.[6]

The Blue Bay: Monterey is one of those landscape works in which Hobart clearly found himself. Reducing the landscape to its simplest elements, Hobart describes the coastal town of Monterey against the brilliant backdrop of its blue bay. The foreground is made up of bright touches of color, applied distinctively to suggest the different structures at hand: the short touch of a single straight stroke defines the roof of a house, and the long, curved drag of a heavily laden brush suggests the rise of a low hill. While the foreground surface is rich with the staccato rhythms of this brushwork, the blue bay of the middle ground is smooth, its flat, glassy expanse setting off the landscape below. At the far horizon, two narrow slivers of color describe the outer edge of the bay. Above the horizon, clouds are brushed in with thick, flat strokes that give them a curious solidity and weight. In describing his approach to painting, Hobart stated:

> Everything has its own volumes, shapes and planes of significant proportions and relations, and each material has its own qualities of hardness and weight. This is what I strive to produce on my canvas. It is not impressionism, but a putting down of varied substances and volumes as Nature has given them to us.[7]

In describing these "varied substances and volumes" in *The Blue Bay: Monterey*, Hobart reveals not only his concern for structure and design, but also—in the rich, saturated colors and thick, even sensuous use of paint—his affinity for the physical act of painting itself.

S.M.

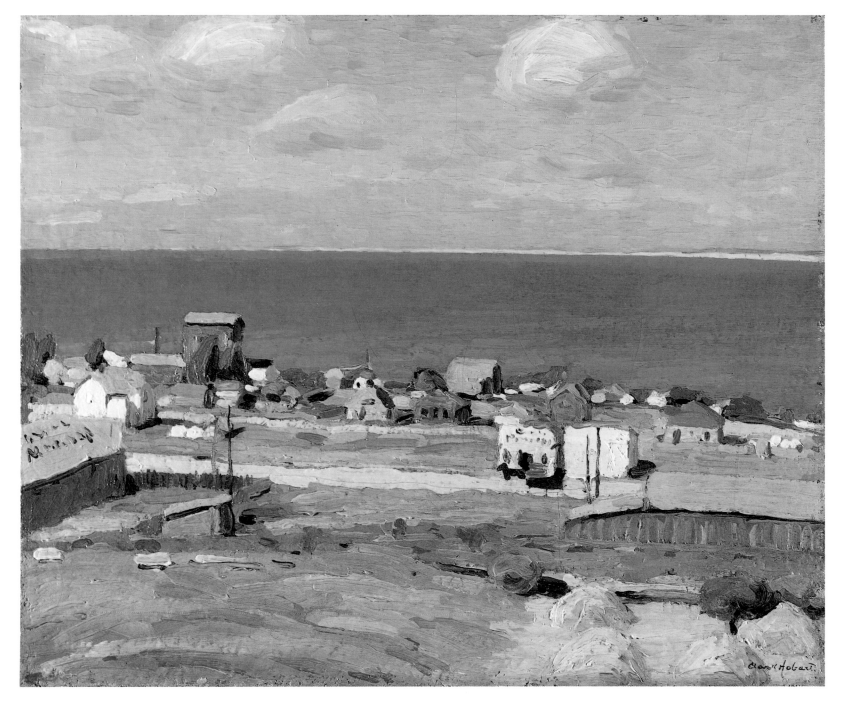

The Blue Bay: Monterey, ca. 1915

Oil on canvas, 20¼ × 24¼ in. Signed lower right: *Clark Hobart*. Museum purchase, Skae Fund Legacy, 41772

Maxfield Parrish
Philadelphia, Pennsylvania 1870–1966 Cornish, New Hampshire

Maxfield Parrish, the son of the landscape artist Stephen Parrish (1846–1938), grew up in a household surrounded by art and music. In 1877 and again from 1884 to 1886 he traveled with his family through Europe, drawing constantly. With the hope of becoming an architect, in 1888 he matriculated at Haverford College. In 1892 he decided instead upon a career as a painter and enrolled for the two-year course at the Pennsylvania Academy of the Fine Arts under Thomas Anshutz.[*1] From the beginning of his career, Parrish leaned toward a style of tightly drawn, richly patterned decoration directly at odds with the teachings of Anshutz and the more painterly work of his fellow students at the academy, such as William Glackens.[*] Instead, the illustrations of Howard Pyle (1853–1911) provided the stylistic model that Parrish followed throughout his long career, from his earliest mural, magazine, and poster commissions to his late landscape paintings.[2] He was successful from the first. In 1895 *Harper's* magazine published his work on the cover of one of its issues, and in 1897 his first book illustrations, for Frank Baum's *Mother Goose in Prose*, were published.

In 1898 Parrish built a home and studio in Cornish, New Hampshire, the artists' colony where summers were spent by leading figures of the American Renaissance, such as Augustus Saint-Gaudens (1848–1907) and Thomas Wilmer Dewing.[*] Working there year-round for the remainder of his long career, with occasional sojourns in the far West and in Europe, in 1904 Parrish began the first of several extraordinarily lucrative contracts with commercial publishers. Using models, photographs, stencils, projectors, and whatever other devices he could conceive of to capture moments of heightened reality, Parrish illustrated books such as *The Arabian Nights* and Edith Wharton's *Italian Villas and Their Gardens*, and created magazine covers, calendars, and designs for candy boxes, all of which brought his artwork before an enormous audience. In 1922 he painted his best-known work, *Daybreak* (private collection), specifically

for mass reproduction. Throughout these early decades he also worked on large-scale mural projects. Finally, in 1931, Parrish announced that he was going to paint only landscapes: "I'm done with girls on rocks. I've painted them for thirteen years and could paint them and sell them for thirteen more. That's the peril of the commercial art game. It tempts a man to repeat himself."[3]

One of Parrish's earliest versions of a girl on a rock, dating a full nineteen years before his renunciation, is *From the Story of Snow White*. The work was originally commissioned as one of twelve fairy-tale pictures to be used in the magazine *Good Housekeeping*.[4] The periodical's publisher, William Randolph Hearst, so liked the early parts of the series, however, that he used the paintings as covers for *Hearst's Magazine* instead. *From the Story of Snow White*, which appeared on the August 1912 issue, shows the scene after the princess has bitten the poisoned apple and fallen into a deathlike sleep: "And the coffin was placed upon the hill, and one of the dwarfs always sat by it and watched."[5] In the portentously glowing twilight, the dwarf stands like a gruesome, gnarled guardian spirit over the crystal casket of the princess. Her still, delicate beauty provides a startling contrast to the dwarf and the harsh world of rock and wind-scarred tree over which he presides.

It is the intensity of Parrish's luminous colors along with his detailed rendering of a scene that rivets attention. He achieved these color effects by spreading thin glazes of transparent color, each separated by a layer of varnish, over a bright white ground.[6] While laborious, the multiple layering allowed Parrish to build up intense color areas in which the light that strikes the surface of the painting penetrates to the white ground and is reflected back up through even the darkest colors. As a result, Parrish's visions glow, almost as if made of stained glass. Like the text of "Snow White" itself, within even the deepest gloom there is an underlying, magical brightness.

M.S.

From the Story of Snow White, 1912
Oil on panel, 30½ × 24½ in. Signed with initials and dated lower right: *M . P / 1912*. Bequest of Hélène Irwin Fagan, 1975.5.2

William Glackens
Philadelphia, Pennsylvania 1870–1938 Westport, Connecticut

Like so many members of the Eight, William Glackens began his career as a newspaper illustrator. He attended Philadelphia's Central High School, graduating a year ahead of John Sloan (1871–1951), and by the age of twenty-one had his first job at the *Philadelphia Record*. He switched back and forth between the *Record* and the *Philadelphia Press*, growing friendly with a convivial group of artist-reporters—including Sloan, George Luks,* and Everett Shinn*—and joining them at evening classes at the Pennsylvania Academy of the Fine Arts. Glackens later met Robert Henri* and began to attend his Tuesday evening studio sessions; by 1894 he was sharing Henri's studio and beginning to paint in oil. In 1895 Glackens traveled with Henri to Europe, where his appreciation of the Old Masters, especially Frans Hals (1580–1666), equaled his attraction to the more contemporary art of Edouard Manet (1832–1883). Upon his return Glackens settled in New York, where Luks had found him a job with the *New York World*. He was soon working for several newspapers and magazines. Always a sensitive observer, Glackens displayed realist tendencies even in his magazine work; *McClure's Magazine* received complaints that Glackens's work was "not sweet enough."[1]

Although Glackens continued working as a free-lance illustrator until 1915, by the turn of the century his major energies were devoted to painting. Taking to heart Henri's belief that artists should "learn the means of expressing themselves in their own time and in their own land,"[2] Glackens found his subjects in New York's streets, parks, waterways, restaurants, and parlors. As seen in such works as the Manet-inspired canvas *Chez Mouquin* (1905; Art Institute of Chicago), Glackens was attracted to the more genteel side of city life and urban recreation. Yet his early paintings burst with the vitality and immediacy that Henri promoted, and teem with the life that Glackens had observed so carefully and knew so well.

Following a second trip abroad in 1906, Glackens participated with Henri, Luks, Shinn, and four others in the landmark 1908 exhibition of the Eight, a nonjuried exhibition at the Macbeth Galleries in New York that showcased their predominantly realist, anti-academic approach to art. Shortly after this show, Glackens began to transform his style toward a lighter, more impressionistic mode.[3] By the time he served as chairman of the selection committee for American entries to the 1913 Armory Show, he had shifted completely to a bright, colorful approach especially reminiscent of, but not completely dependent on, Pierre-Auguste Renoir (1841–1919). In 1912 Glackens's old high-school classmate, Dr. Albert C. Barnes, sent him to Europe to buy contemporary French art for him. Those purchases—paintings by Renoir, Edgar Degas (1824–1917), and Henri Matisse (1869–1954)—remain the nucleus of the Barnes Foundation's collection in Merion, Pennsylvania. Glackens's later career

was quietly successful; he traveled often to France and was preparing work for the 1938 Carnegie International when he died suddenly at the age of sixty-eight.

May Day, Central Park is one of several views of New York's Central Park that Glackens painted around 1905.[4] The urban park was a favored subject of Glackens's friend and colleague Maurice Prendergast*[5] and would have been familiar to both artists from examples by Parisian painters of modern life, such as Manet.[6] Of particular interest to Glackens, who was known for his talent at illustrating crowds, were the May Day celebrations in Central Park.

May first was observed in turn-of-the-century New York as both the traditional moving day and an international labor holiday, but it was not always the date for organized May Day festivities. These were held on an appointed day (usually Saturday) early in the month, when springlike weather could be assured. As the local press described, certain celebrations were reserved for children:

> It was in Central Park that the biggest carnival was had. At Fifth avenue and Fifty-ninth street the parade of millionaires in their handsome coaches swept past one hundred little girls and boys marching toward the croquet grounds for a day of fun.

> The park fairly bristled with youngsters. They came from far and from near. . . . Presently the grass was so strewn with white frocks that at a little distance it looked as if household linen laid out to bleach had suddenly taken to skipping about.[7]

Not surprisingly, in this scene Glackens finds more interest in the party's aftermath than in the traditional May Day dance itself. Rowdy children cavort across the lower half of the canvas, while the maypole leans against a tree trunk, almost forgotten now that the dance has been completed and the dancers (young girls in white) have dispersed. Color and incident are scattered about the lower half of the canvas in a seemingly casual fashion. The vigor of human activity is echoed by the greenery above, the leaves brushed in with long strokes suggesting a windy afternoon. The colors are dark, as Glackens was still working under the spell of Manet and Henri, but the mood is light. Everett Shinn might have been thinking of this painting when he praised Glackens's "super achievement," noting: "All color is mingled in his mighty draughtmanship. . . . Paint is audible in children's games in square and park."[8] Glackens's vivid, energetic paint handling and his surefire execution yield an apt metaphor for the bustle and exuberance of a May Day in Central Park and celebrate life in the artist's "own time" and "own land."

<div align="right">S.M.</div>

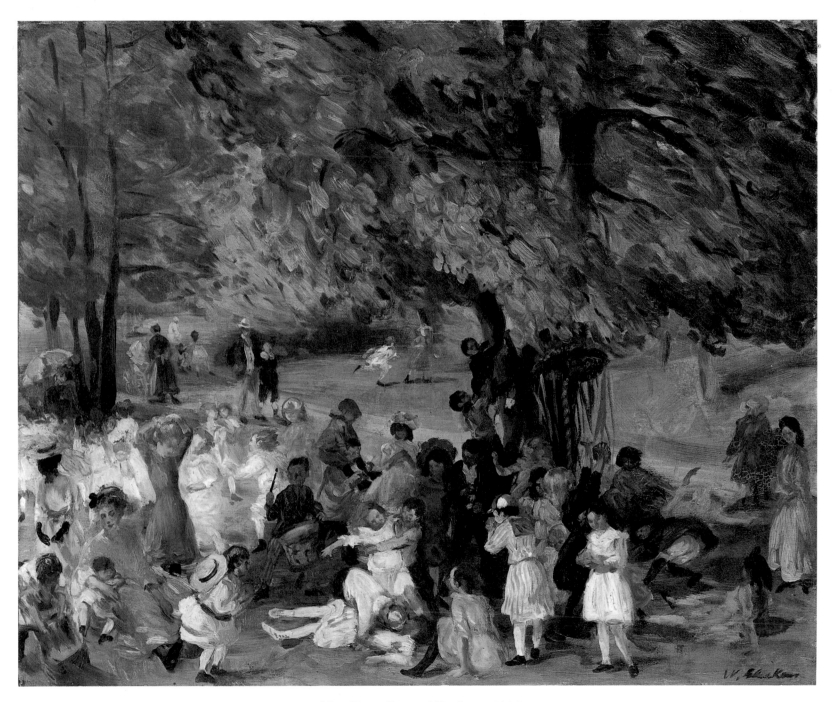

May Day, Central Park, ca. 1905

Oil on canvas, 25⅛ × 30¼ in. Signed lower right: *W. Glackens*

Gift of the Charles E. Merrill Trust with matching funds from The de Young Museum Society, 70.11

Ernest Lawson
Halifax, Nova Scotia, Canada 1873–1939 Miami, Florida

Although Ernest Lawson claimed to have spent his childhood in San Francisco, he was actually born in Nova Scotia and spent the early years of his life in Kingston, Ontario. After briefly attending art school in Kansas City and working as an engineering draftsman in Mexico, Lawson moved to New York in 1891 and studied painting at the Art Students League with John Twachtman (1853–1902). The following year he enrolled in an art school at Cos Cob, Connecticut; there, under the influence of Twachtman and the institution's other founder, J. Alden Weir (1852–1919), Lawson became acquainted with Impressionism and its emphasis on light and atmosphere. The young artist subsequently attended the Académie Julian in Paris in 1893 and that summer met the French Impressionist Alfred Sisley (1839–1899) while working outdoors. Lawson returned to America in 1895, ultimately settling in Washington Heights at the upper end of Manhattan, where he began his series of New York landscapes. Friendly with Robert Henri,* William Glackens,* and Everett Shinn,* Lawson participated as the sole landscapist in the landmark 1908 exhibition of the Eight, a group of eight painters dedicated to the principle of artistic freedom and the validity of the modern world as a legitimate subject for the fine arts. Within this progressive framework, which challenged the authority of the National Academy of Design, Lawson also showed his work at the 1910 nonjuried Exhibition of Independent Artists and the 1913 Armory Show. For the rest of his career, Lawson continued to work out of doors in a modified Impressionist style, depicting scenes of New York and other subjects drawn from travels to areas that included Spain, Colorado, and Florida.[1]

A theme that Lawson returned to numerous times, particularly during his years in Washington Heights, was the High Bridge over the Harlem River.[2] William Cullen Bryant described what Lawson was later to paint in *Harlem River at High Bridge* when he commented on the structure and its surroundings in his *Picturesque America*:

The banks of [the Harlem River] are high and well wooded. It is crossed by several bridges, and by a viaduct from the waters of the Croton, which are here brought into the town from the rural districts above for the use of the citizens, and which is known by the somewhat incorrect and prosaic designation of High Bridge. It is a handsome structure, however, of high granite piers and graceful arches, and shows from different points of view... with singular and even lofty beauty. The tall tower... is for the elevation of the Croton to an altitude sufficient to give it force for the supply of residences on the high banks in the upper part of the city. Tower and bridge make a fine effect.[3]

Early in his career Lawson developed a preference for landscape subjects, perhaps because of his training in Impressionist principles learned at Cos Cob and in France. *Harlem River at High Bridge* demonstrates Lawson's interests in both urban subjects and the changing conditions of light and air, time of day, and season of year. One of the multiple representations of the spot that he painted from various vantage points, this canvas depicts a sunny winter day. Hazy and shimmering, the light envelops man and nature in its radiance.

As did his Impressionist predecessors, Lawson adopted a technique of broken color and brushwork, applying tiny strokes of different hues to suggest the image's forms. He established a personal style, however, by using a heavy impasto to build a dense fabric of pigment and create an overall surface pattern. The multiple layers of rich and contrasting colors flickering across *Harlem River at High Bridge* give the effect of a tapestry; the energy of the brushwork activates the picture, while the consistency of its texture unifies the image. Painting with what critics subsequently called a palette of "crushed jewels,"[4] Lawson himself described his interests and experimentation: "Color is my specialty in art.... It affects me like music affects some persons—emotionally. I like to play with colors like a composer playing with counterpoint music."[5]

J.S.

Harlem River at High Bridge, ca. 1915
Oil on canvas, 25¼ × 30 in. Signed lower center: *[E]. Lawson.* Gift of Harry William and Diana Vernon Hind, 78.63.2

Everett Shinn

Woodstown, New Jersey 1876–1953 New York, New York

Everett Shinn began his artistic career studying industrial design and engineering in Philadelphia in 1888. As a youth he was mechanically oriented and had tried (unsuccessfully) to build a submarine. Shinn worked as a designer for a local gas-fixture company, but his supervisor apparently did not approve of the unrelated sketches he found scattered across the margins of his work, and Shinn lost his job. Shinn enrolled at the Pennsylvania Academy of the Fine Arts in 1893 and signed on as an illustrator for the *Philadelphia Press* the same year. While working as a newspaper artist allowed Shinn to develop sharp perceptions and a quick hand, the art department there and at other newspapers also acted as the meeting ground for artists such as John Sloan (1871–1951), William Glackens,* and George Luks,* with whom he formed lasting ties. In 1897 Shinn moved to New York, ultimately giving up newspaper illustration for more lucrative magazine work; his drawings of city life appeared in periodicals such as *Harper's Weekly, Critic,* and *Scribner's.* By the early years of the century, Shinn's newspaper-illustrator friends had also moved to New York, as had another Philadelphia acquaintance, Robert Henri.*

The Philadelphia artists formed the nucleus of the progressive group later called "the Eight," who showed their work in New York in 1908. Although Shinn participated in that landmark exhibition, as well as in the 1910 Exhibition of Independent Artists, he drifted away from his colleagues as he became more involved with illustration projects, mural commissions for private homes and public spaces, and his work as an art director for Hollywood. The youngest member of the Eight, Shinn outlived the others. Married four times during a long and active life, Shinn reputedly looked back over his career and said, "With every one of my wives I have had a complete set of new friends...and the first ones were the best."[1]

From his childhood in New Jersey, Shinn had been fascinated by the excitement of the theater. He made posters for dances at the local opera house and attended the carnivals and parades that passed through town. Shinn made his acting debut at Henri's Philadelphia studio in 1894, in the role of James McNails Whiskers in *Twillbe,* a spoof of George du Maurier's *Trilby.* On his move to New York, Shinn constructed a theater in his home to accommodate the productions that he wrote, directed, and starred in. Among the many farcical dramas Shinn wrote and produced were *Hazel Weston, or More Sinned Against than Usual* and *Lucy Moore, or the Prune Hater's Daughter.*[2]

Shinn translated his passion for the spectacle of the modern stage life into his art, and his drawings, pastels, and paintings of theatrical subjects are among his best-known works today. A 1901 trip to Paris, where Shinn was exposed to the art of Edgar Degas (1834–1917) and Jean-Louis Forain (1852–1931), had reinforced his interest in the theater. In work reminiscent of Degas and Forain, Shinn depicted aerialists swinging above the ground, comedians working their audiences, ballerinas gracing the boards, and, as in *Open Air Theater,* vocalists in mid-act. Showing the performer in this painting as she moves across the stage singing her song, Shinn places the viewer in the audience, capturing for him all the vitality and artifice of the theater. For instance, Shinn truncates the painting's margins so that a musician nearly slips out of the scene, and startles the viewer with a spectator who seems to have suddenly turned, all but crossing the picture plane into real space. By matching the spectator's movement with the awkward posturing of the off-center singer, Shinn promotes an impression of spontaneity. Further verisimilitude is contributed by the footlights that line the stage's edge, casting their spectral radiance onto the performer from below. In the facility of its execution, deceptively simple yet carefully contrived, *Open Air Theater* mimics the conceit and calculation that underlie the theater.

J.S.

Open Air Theater, ca. 1910

Oil on canvas, 24¾ × 21½ in. Memorial gift from Dr. T. Edward and Tullah Hanley, Bradford, Pennsylvania, 69.30.190

Marsden Hartley

Lewiston, Maine 1877–1943 Ellsworth, Maine

Poet and critic as well as painter, Marsden Hartley received his first artistic training in Cleveland, Ohio, in 1896. He moved to New York City in 1899, enrolling first in the Chase School and, after one year, in the National Academy of Design. In 1908 he dropped his given name of Edmund in favor of his stepmother's maiden name, Marsden. After initial recognition of his talent in Maine and Boston, in 1909 Hartley showed his most recent work to Maurice Prendergast,* who advised him to show his paintings in New York. There, Hartley met Alfred Stieglitz (1864–1946) in April 1909 and so impressed the dealer that he received a one-man show at Stieglitz's gallery in May. Later in the year he first saw the works of Albert Pinkham Ryder,* which were to have a profound and steady influence on his later development. Through his connection with Stieglitz and his circle of artists, his admiration for the emotional energy and dedication of Ryder, and his thickly impastoed canvases, Hartley was soon in the forefront of the American modernist movement. Not surprisingly, he was haunted by persistent poverty and lack of sales.

Hartley traveled in 1912 throughout Europe, forming a particular attachment to Berlin where, except for a trip to the United States in the winter of 1913–14, he immersed himself for two years in the artistic and bohemian society of the city. German military themes dominated his increasingly decorative work, some of the strongest and most adventurous by any American artist of the time. In October 1915 forty-five of his European paintings and a group of drawings were shown at the Grafik-Verlag in Munich—Hartley's sole one-man exhibition in Europe and one of the major exhibitions of his lifetime. Unfortunately, the Germanic themes and advanced style of his work found little favor when the works were shown after his return to New York in December 1915.

Hartley led a peripatetic life, without family or business ties to any one place. Throughout his life, however, he found inspiration for his work in Maine's lonely mountains and coastline, and he returned to the northeast coast frequently. He died there in 1943, just as he had begun to experience critical and commercial success.

The mountains of Maine were crucial to Hartley, providing him with subject matter throughout his career as well as with a focus for spiritual identification:

A mountain is not a space, it is a thing, it is a body surrounded by illimitable ethers, it lives its own life like the sea and the sky, and differs from them in that little or nothing can be done to it by the ravages of silent agencies....

Mountains are things, entities of a grandiose character, and the one who understands them best is the one who can suffer them best, and respect their profound loneliness.[1]

One of the first times he was to grapple with the subject of the mountains was in the autumn of 1908, when Hartley moved to a farm in Stoneham Valley, near North Lovell, Maine. Up to this time the artist had been working in an Impressionist style. Seeing illustrations of works by the Swiss artist Giovanni Segantini (1858–1899), however, inspired Hartley to experiment with a thicker application of paint laid on in a densely woven pattern, what critics would call Segantini's "stitch": "I personally am indebted to Segantini the impressionist, not Segantini the symbolist, for what I have learned in times past of the mountain and a given way to express it."[2] Concentrating on dense, claustrophobic views of mountain and sky, he developed a group of objects, including *The Summer Camp, Blue Mountain*, that combined a deep emotional response to the subject matter with a highly abstract, patterned surface. Hartley used a rich palette of deep blues, mauves, aquas, and pinks to describe the mountains with their patches of snow amid the pines. The buildings of the camp, a thickly daubed touch of yellow-orange at the lower right, are the only sign of man. Otherwise the entire canvas is given over to the looming mountains and their fringe of billowing storm clouds—an icy conflagration charged with brooding energy, each of Hartley's prominent strokes of paint standing upright as if it too carried a bolt of electricity.

The Summer Camp, Blue Mountain is one of the paintings that Hartley exhibited at Stieglitz's Little Galleries of the Photo Secession in 1909 and considered among his first mature works.[3]

M.S.

The Summer Camp, Blue Mountain, 1908 or 1909
Oil on canvas, 30⅛ × 34⅛ in. Gift of Mr. and Mrs. John D. Rockefeller 3rd, 1979.7.47

Marsden Hartley
Lewiston, Maine 1877–1943 Ellsworth, Maine

When Marsden Hartley returned from Berlin in December 1915, he found New York a cold and alienating city. Its citizens freely expressed their anti-German feelings (to the extent that the music of Beethoven and Mozart was banned in the city),[1] and Hartley's open admiration of the German military, as seen in works such as *The Warriors* (1913; private collection) or *Portrait of a German Officer* (1914; Metropolitan Museum of Art, New York), did not find favor. The lack of critical enthusiasm and sales left Hartley in serious financial straits. The invitation to summer in Provincetown as the guest of John Reed was, therefore, opportune. Reed, a journalist and soon-to-be revolutionary, was the center of a community of actors, writers, and painters who summered on Cape Cod, a group that included the playwright Eugene O'Neill and the painter Charles Demuth (1883–1935).

Over the summer Hartley, deprived of his German subject matter, developed radically simplified abstract works related to European Synthetic Cubism—works as advanced as any in Europe and more daring than any American would attempt for another decade.[2] With the autumn, and the still persistent need for inexpensive accommodations, Hartley and Demuth traveled to Bermuda. While Demuth explored the landscape through an intensifying Cubism, Hartley turned during the winter months to simplified representations of still lifes, including *A Bermuda Window in a Semi-tropic Character*, signaling a retreat from stylistic radicalism.[3]

The format is a simple one: a still life of fruit and one flower stands before an open window. In the bay visible beyond, a pink-sailed boat surges through an aquamarine sea. Using rich, saturated colors, Hartley creates broad fields of color broken only by the mosaic of his subtly patterned brushwork. Departing from the Expressionist aims of his early works, Hartley had come to believe in a cool formalism:

> Persons of refined feeling should keep themselves out of their painting. . . . I am interested then only in the problem of painting, of how to make a better painting according to certain laws that are inherent in the making of a good picture—and not at all in private extroversions or introversions of specific individuals.[4]

The contemporary critic Paul Rosenfeld perceived the formal distance that Hartley imposed between himself and his subject.[5] And yet Rosenfeld was no less aware of the emotions that seethed beneath the surface of these still lifes. As if he were thinking of *A Bermuda Window in a Semi-tropic Character*, he wrote of "a cold and ferocious sensuality [that] seeks to satisfy itself in the still-lives, with their heavy stiff golden bananas, their luscious figs, their erectile pears and enormous breast-like peaches."[6]

In May 1917 Hartley left Bermuda. The formulas he developed there served him well, however, in such conscious echoes of his island work as *Atlantic Window in a New England Character* (1919; ex coll. Edith Halpert), where both title and image reveal their source in *Bermuda Window in a Semi-tropic Character*.[7]

M.S.

A Bermuda Window in a Semi-tropic Character, 1917
Oil on board, 31¾ × 26 in. Memorial gift from Dr. T. Edward and Tullah Hanley, Bradford, Pennsylvania, 69.30.94

George Bellows

Columbus, Ohio 1882–1925 New York, New York

A varsity athlete as well as an illustrator for his college yearbook and journal, George Bellows might have played professional baseball had not a sympathetic professor encouraged his artistic ambition. Bellows arrived in New York in fall 1904 and enrolled in Robert Henri's* class at the New York School of Art. Readily accepting his teacher's instructions to paint expressively and to find subjects in the life around him, Bellows soon became Henri's disciple and eventually his lifelong friend.[1] Despite his associations with Henri's antiestablishment group, and despite his work—urban scenes painted in the gutsy, unbridled style advocated by Henri—Bellows was elected an associate of the National Academy of Design in 1909. The next year he participated in the Exhibition of Independent Artists, and he sent nine works to the Armory Show in 1913—the same year he was elected a full member of the National Academy. From 1913 to 1917, while painting vibrant scenes of the New York, New England, and California landscape (such as *Romance of Criehaven*, 1916, The Fine Arts Museums of San Francisco),[2] Bellows contributed illustrations to the *Masses*, a Socialist magazine championed by the artist John Sloan (1871–1951). Having taken up lithography in 1916, Bellows produced several lithographs and five oil paintings dealing with the atrocities of World War I. In 1920 he first visited Woodstock, New York, an artists' colony that was summer home to many New York painters; two years later he designed and built his own house there. His career was in full swing when he died suddenly, victim of a burst appendix.

As a member of the Association of American Painters and Sculptors, Bellows helped organize the Armory Show. Yet once the exhibition opened, he joined conservative groups in mocking the modern European art shown there.[3] Bellows was both confused and challenged by abstraction and Cubism, and in his struggle to understand this art he was forced to rethink his own. He wrote to his former college professor in January 1914:

> Since . . . November first I have painted just one thing so far, a dismal failure to be put away with those hopeless hopes that some day I may straighten out. Pipe after pipe, and cigarette after cigar I sit and rock in profound discontent. . . . Having got what I can out of the modernist movement for fresh, spontaneous pure color I am now turning my attention to the "Secrets of the Old Masters" (to be read with some humor). . . . The Old Masters got different results and I want to know how they did it. . . . I expect to change my methods entirely when I learn what I can in a new direction.[4]

Attempting to discover certain universal principles of art, Bellows, along with Henri, delved into the theories of Hardesty Maratta (1864–1924), a Chicago painter who devised a system of rationally ordered color harmonies. Around 1917 Bellows also took up Jay Hambidge's (1867–1924) theories of composition and proportion, which were based on the principle of "dynamic symmetry" that Hambidge claimed had been used by the ancient Greeks and Egyptians.[5] Bellows's quest for a greater solidity of form and structure may have been confirmed by his visit to the Metropolitan Museum of Art's 1917 Thomas Eakins* memorial exhibition, a show that included a number of Eakins's most probing and sensitive portraits. Writing to Henri, Bellows allowed that the exhibition was "the greatest one man show I've ever seen," and that Eakins's portrait of "'Mrs. Frishmuth,' the musical instrument collector, is the most monumental work I ever looked at."[6] Perhaps a memory of that show remained when Bellows began to take a serious interest in portraiture around 1919.

In February 1920 Bellows painted his colleague Waldo Peirce (1884–1970), a robust, irreverent painter, Harvard graduate, friend of John Reed and later Ernest Hemingway, who had spent most of the previous twelve years in Europe.[7] Peirce's work began to receive serious recognition in the mid-1920s, but he had been painting since 1911 and in 1915 had joined twelve other artists in an exhibition at the MacDowell Club in New York. Describing the other exhibitors, he wrote that "one, Bellows, is perhaps the best in America just now."[8] Bellows's respect for Peirce is equally evident in this portrait.

Seated squarely against a neutral background, Peirce's massive form fills and commands the picture space. The informality implied by Bellows's relaxed description of features and the rumpled, casual nature of Peirce's attire disguise a rigorous construction of parallel lines and intersecting geometrical shapes. Lines formed by the two arms echo one another as well as the line of Peirce's right leg; a triangle formed by the slope of Peirce's shoulders shares its apex with a thinner triangle formed by the lines of his coat. Although Bellows's brushwork here shows a restraint not present in his earlier works, it remains vigorous in its application. The colors, while subdued in tone, are rich and saturated in value. Bellows could be mannered in his applications of Maratta's color theories and Hambidge's compositional structures,[9] but in this work glowing color and solid geometry blend with the artist's own forceful sense of design to form a portrait that truly achieves the monumental.

S.M.

Waldo Peirce, 1920
Oil on canvas, 53 × 43 in. Signed lower center: *Geo Bellows*
Gift of the Charles E. Merrill Trust with matching funds from The de Young Museum Society, 67.23.1

Horace Pippin
West Chester, Pennsylvania 1888–1946 West Chester, Pennsylvania

As a black child growing up in rural Pennsylvania and New York at the turn of the twentieth century, Horace Pippin was isolated by both geography and economics from opportunities for traditional art instruction. At the age of seven he answered a magazine advertisement that offered a prize for copying their illustration.[1] The prize was a box of colored pencils, which Pippin used to draw biblical scenes on squares of muslin. Pippin refused an offer of formal art lessons from one of his first employers, needing to stay home to support his ailing mother. He worked at odd jobs before enlisting in the army and serving in World War I; his experiences as an infantryman would haunt him throughout his life. In Germany he was hit by a sniper's bullet and returned home with his right arm paralyzed. Teaching himself to paint in his early forties, Pippin overcame the lack of both instruction and mobility. He is said to have labored three years over his first work, *The Ending of the War: Starting Home* (1930; Philadephia Museum of Art), applying over one hundred coats of paint.

Pippin was "discovered" in 1937 by the scholar Christian Brinton, who noticed one of his paintings in a shoemaker's window. Soon Pippin became a cause célèbre, lionized by high society and the art world alike. Dr. Albert C. Barnes invited Pippin to his Barnes Foundation in Merion, Pennsylvania, to view his famous collection of modern French paintings and to attend some of the lectures held there. Pippin was basically unimpressed, and later asserted: "My opinion of art is that a man should have love for it, because my idea is that he paints from his heart and mind. To me it seems impossible for another to teach one of art."[2]

If Pippin's exposure to modern art had little influence on his style, the sudden glare of wealth and limelight disrupted his home life. While continuing to paint expressive, powerful works, he began to drink heavily and squander money. His marriage collapsed, and Pippin died of a stroke only nine years after being discovered.

Four years before his death, Pippin painted three works dealing with the story of John Brown, the fanatical abolitionist and leader of the ill-fated raid on Harper's Ferry in October 1859. Like Abraham Lincoln, Brown remained a familiar figure into the twentieth century: Robert Penn Warren's biography of Brown appeared in 1929, and Oswald Garrison Villard's landmark analysis of 1910, *John Brown, 1800–1859: A Biography Fifty Years After*, would go into its fifth printing in 1943. Brown's myth was especially revered by the black community, including such artists as Romare Bearden (1914–1988) and Jacob Lawrence (b. 1917); in 1941 Lawrence painted a series of twenty gouaches dealing with Brown's saga.[3] The story clearly held personal significance for Pippin, who repeatedly told his dealer that his grandmother had been present at Brown's hanging on 2 December 1859. Soon after finishing the John Brown trilogy, Pippin painted pictures of Abraham Lincoln and Jesus Christ— leaders who must have been in his mind, like Brown, martyrs in the struggle to overcome injustice.

It is Brown the martyr, not the hero, who appears in the central canvas of Pippin's trilogy.[4] John Brown lay on a cot during most of his trial, still suffering from wounds received when captured. He rose occasionally to offer arguments in his defense, but Pippin chose not to show him in any such dramatic moment. Rather, Brown lies passively while the state prosecutor points an accusing finger down at him. Twelve jurors sit behind this central action, forming an impassive frieze. None of them looks at the man they will condemn to death; one scratches his head, another looks away. The browns and grays of Pippin's restricted color scheme are relieved only by the purple of a carpetbag and the bright spot of red blood that stains the bandage around Brown's head. The artist's short brushstrokes and strong but irregular draftsmanship impart a nervous energy to the work and intensify its raw power. If Pippin lacked (and later rejected) the formal training and technical advantages of more sophisticated artists, it is clear that he was still able to forge a style entirely appropriate to his individual vision.

S.M.

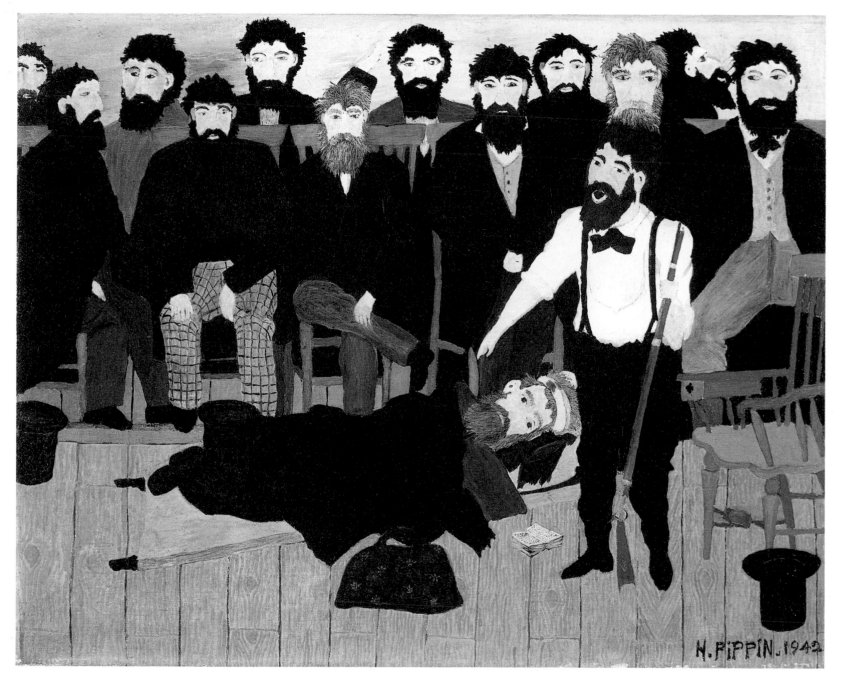

The Trial of John Brown, 1942

Oil on canvas, 16⅛ × 20⅛ in. Signed and dated lower right: *H. PIPPIN. 1942*. Gift of Mr. and Mrs. John D. Rockefeller 3rd, 1979.7.82

Thomas Hart Benton
Neosho, Missouri 1889–1975 Kansas City, Missouri

Thomas Hart Benton, the son of a prominent statesman and United States representative, began his art studies in Chicago and, from 1908 to 1911, continued them in Paris. From about 1910 to 1918 or 1919 he painted some of the most progressive and abstract works of any American artist. He later repudiated these works, writing, "I wallowed in every cockeyed ism that came along, and it took me ten years to get all that modernist dirt out of my system."[1] Instead, Benton began painting scenes based on his observations and the experiences of the common citizen. Seeking an indigenous American style, the artist developed a nervous, energetic colorism that animated his images of farmers and industrial workers, which he used for both easel paintings and mural projects. A vivid writer, Benton published two autobiographies that are important chronicles of his times and achievement.[2]

An updated version of the biblical tale in the Book of Daniel, *Susanna and the Elders* depicts the moment when two respected members of the community spy upon the beautiful Susanna as she prepares for her bath. The story continues with the virtuous woman refusing the men's propositions and, as revenge, their falsely accusing her of adultery. Only the divinely inspired wisdom of the young judge Daniel, who separates the two accusers and finds inconsistencies in their perjured testimony, saves the woman from an unjust death. Benton shifted the scene from Babylon to Missouri and modernized the trappings of the tale—epitomized by Susanna's high-heeled shoes, brightly polished nails, and the jalopy beside the church—yet the basic narrative of innocence threatened by lust and hypocrisy remains.

The painting caused a sensation when it was exhibited in 1939. Protesting that it was "very nude" and an example of "saloon painting," art critics from across the country reviled the work.[3] Only a few critics concentrated their remarks on Benton's fluent technique and draftsmanship, or noted his uncharacteristic use of traditional subject matter.[4]

Benton was an inspired self-publicist and mythmaker. Seeking to project the image of a wild-living frontiersman, he wrote with crude gusto about the model for *Susanna* as

> that delightful hillbilly girl (*a true Ozark product, gone wrong,*) who became the model for "Susannah"—My boy—what a skin, what a blood pulsing skin,—just enough yellow in the belly to make the "tits" look pink—we don't find models like that anymore.[5]

His hyperbole does not detract from the basic seriousness of his art making. In the above letter, for example, Benton went on for two and one-half pages about the proper care and treatment of the surface of the painting. A series of splendid drawings for portions of *Susanna* (Thomas Hart and Rita P. Benton Trusts, Kansas City) also testifies to the effort expended on the work's development.[6]

In one of his frequent magazine interviews, Benton discussed the goal of his art and that of his fellow Regionalists Grant Wood* and John Steuart Curry (1897–1946):

> We were different in our temperaments and many of our ideas, but we were alike in that we were all in revolt against the unhappy effects which the Armory Show of 1913 had had on American painting. We objected to the new Parisian aesthetics which was more and more turning art away from the living world of active men and women into an academic world of empty pattern.[7]

Susanna and the Elders, with its biblical theme, its tempera technique, and its mannerist stylizations, is a work that grows from centuries-old traditions of art. Yet in its setting and in its depiction of a timeless drama, it clearly transcribes "the living world of active men and women."

M.S.

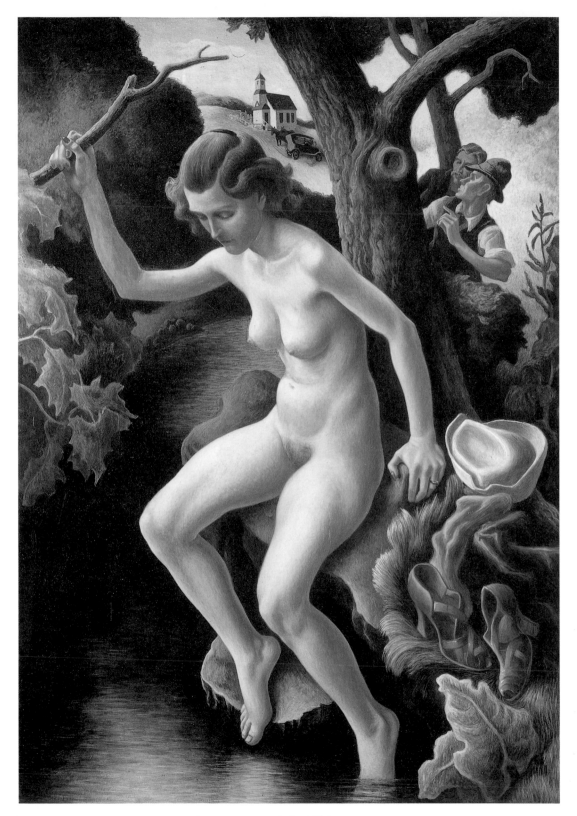

Susanna and the Elders, 1938
Oil and tempera on canvas mounted on panel, 60⅛ × 42⅛ in.
Signed lower right: *Benton.* Anonymous gift, 1940.104

George C. Ault
Cleveland, Ohio 1891–1948 Woodstock, New York

George C. Ault moved to London in 1899, when his father became the European representative for the family's ink-manufacturing firm.[1] There he received his initial instruction in art, while frequently traveling to France, becoming familiar with various contemporary art movements and executing landscapes in oil and watercolor. On his return to America in 1911, Ault settled close to New York City in Hillside, New Jersey, where he continued to paint landscapes, often introducing architectural elements. By the early 1920s he had developed his mature style, which focused on a Precisionist rendering of urban themes—city streets, skyscrapers, cityscapes, and, to a lesser extent, industrial subjects. (For a less typical rural view, though one still emphasizing industrial forms, see The Fine Arts Museums of San Francisco's *Highland Light,* 1929.)[2] In the years between the two world wars, Ault shared with other Precisionists such as Charles Sheeler (1883–1965) and Charles Demuth (1883–1935) an appreciation for modern technology and city scenes. Although not a coherent group unified by a codified doctrine, these American painters often examined in their art the theme of advancing mechanization. By representing industrial subjects and other symbols of mechanical development in a style characterized by geometric simplification, crisp linearity, and pristine surfaces, Ault explored the subject of technological progress. Although he was an active exhibitor in New York, New Jersey, and Provincetown, Massachusetts (where he spent five summers in the early 1920s), poor health ultimately led Ault to relocate to Woodstock, New York, in 1937. At this time his work became increasingly suggestive and melancholy in mood as the artist turned to painting evocative nocturnes and mysterious, surreal landscapes.

Dating from 1923, *The Mill Room* is an early expression of Ault's mature style. Its contemporary industrial setting is typical of the Precisionist outlook popular at the decade's beginning. Yet this representation of a laborer at work in a plant that manufactures printing ink must also reflect Ault's observation of his family's business.[3] Under pressure from his father, who then owned the Jaenecke-Ault Printing Ink Company, Ault worked briefly at the New Jersey plant.[4] When Ault first considered technological subjects, he turned to this familiar area. On the other hand, while an additional canvas also relates to the printing-ink plant (*The Engine Room Door* [date and location unknown]),[5] and two others bear details of industrial subjects (*The Machine* [1922; private collection] and *The Propeller* [date and location unknown]), *The Mill Room* appears to be unique in Ault's oeuvre as the only depiction of an industrial interior.[6]

Smooth, round, and rectilinear, the machinery in *The Mill Room* lends itself to Ault's stylistic simplifications. Applying his pigments thinly and evenly, Ault carefully effaced his brushwork so that each cylinder, barrel, and brick maintains a linear integrity. Concurrently, his naturalistic yet methodical modulation of tone (down to the highlights on the roller's end rings) defines their volumetric character. Ault's reduction of objects to basic geometric forms and elimination of surface detail further emphasize the purity and precision of the new machine technology.

So simple and clear are the forms, so reasoned is the compositional abstraction, and so motionless is the figure, that the work, in its very static isolation from the real world, borders on the iconic. Yet Ault seems to withhold judgment on the value of technological change to American life. It is true that in the spotless shop the crankshaft would spin, the fanbelt turn, and the cylinders roll under the watchful eye of the worker and thus embody the industrial perfection of the modern age. However, qualities such as the unselfconscious pose of the laborer—whose presence in a Precisionist work is unusual and not often repeated in Ault's oeuvre—the relatively small scale of the foreground machine, and the removed vantage point from which the viewer looks down on the scene dilute the potential for thematic exploitation. Indeed, similar to many of his Precisionist colleagues, Ault has maintained a certain distance from the sociological questions concerning contemporary mechanization. Instead, he has responded to the pictorial possibilities of the abstracted image. With its repetition of geometric forms and volumes, *The Mill Room* becomes a complex puzzle of interrelated shapes and colors that flatten the image and reveal the compositional sophistication integral to so much of progressive American art.

J.S.

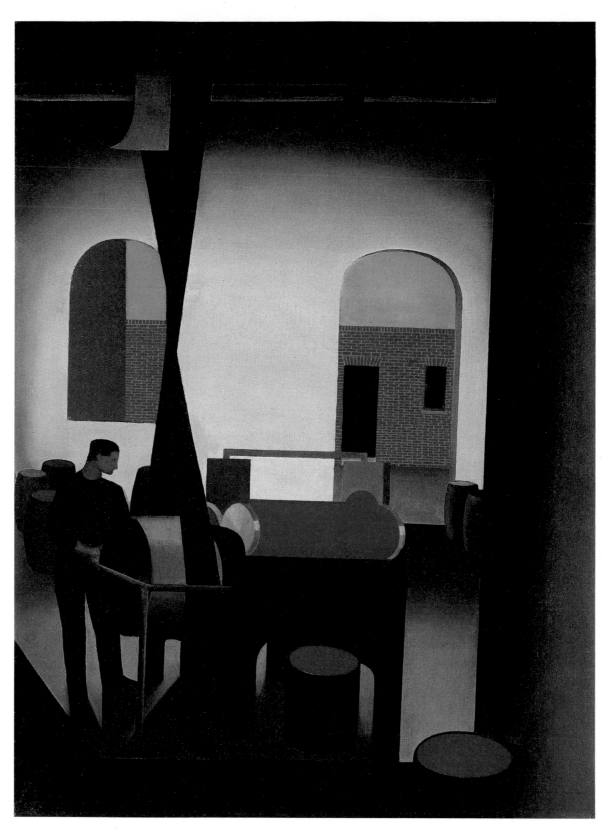

The Mill Room, 1923
Oil on canvas, 22 × 16 in. Signed and dated upper right: *G. C. Ault '23*. Gift of Max L. Rosenberg, 1931.26

Edwin Dickinson
Seneca Falls, New York 1891–1978 Wellfleet, Massachusetts

Edwin Dickinson, the son of a Presbyterian minister, was raised in Buffalo, New York. From 1910 to 1913 he studied in New York City, first at Brooklyn's Pratt Institute and then at the National Academy of Design and, with William Merritt Chase,* at the Art Students League. During the summers from 1912 to 1914 he worked with Charles Hawthorne (1872–1930) in Provincetown, Massachusetts. In 1913 Dickinson decided to live year-round on Cape Cod. That barren spit of land was to be Dickinson's spiritual home for the rest of his life, although war service, European travel, and (increasingly after 1935) teaching responsibilities frequently took him away from the Cape.

In *The Cello Player*, his masterpiece, Dickinson explored the radical spatial arrangements and seeming monochromaticism of Analytic Cubism, while continuing the American tradition of surface-oriented realism. The painting's compelling mystery derives at least in part from the reconciliation of these divergent tendencies and from the looming nature of its personal symbolism.

In wintery gray-toned colors, *The Cello Player* shows an old man, cello resting against his leg, surrounded with books, shells, pots, sheet music, and instruments. The painting's central focus is the man's head, its boldly contoured planes and deep furrows the canvas's most detailed and tonally varied passage. The other precisely rendered objects, depicted with the care of a trompe l'oeil practitioner, convincingly suggest form and the quality of dim light falling on specific materials. Yet Dickinson positions each object so as to complicate and ultimately deny the suggestion of a coherent spatial setting for the sitter.[1]

The artist, who maintained full and minutely accurate diaries throughout his life, later described the process of working on *The Cello Player*:

> It was commenced on 4 March 1924 and completed on 27 August 1926. . . . It occupied 290 execution-sittings (half days). My age was 32–34. . . . Everything in the piece was "posed-for" by the objects present. Many of them represented interests at the time, specifically the trilobite fragment, the quartette sheet, the photograph, several of the books, the organ, the piano, the music-stand, the book on Nansen. . . . After the piece was about 50 sittings along I decided to show the 'cellist to be in a bowl comprised of the floor and the objects on it. . . . The time given to the piece was, of course, several times greater than that of the 870 hours execution sittings.[2]

Although the artist finally covered over many of the original elements of the design, such as the full form of the cello to the right, their thickly painted contours still mark the painting's surface.

Dickinson's painting acknowledges many art traditions. Works by Charles Burchfield,* Paul Cézanne (1839–1906), Thomas Eakins,* El Greco (1541–1614), Pablo Picasso (1881–1973), and Charles Sheeler (1883–1965) are reflected in the image. And yet *The Cello Player* is not a direct homage to paintings by these or any other artist. The rich and mysterious work blends echoes of various styles and individual images with Dickinson's distinctive, even quirky mode of seeing.

The art historian John Driscoll has placed *The Cello Player* at a pivotal point in Dickinson's oeuvre, summarizing it "as a compelling self-inventory and a poignant memorial to Ludwig van Beethoven (1770–1827) and . . . to Dickinson's deceased brother Burgess."[3] Dickinson began the painting, according to Driscoll, shortly after seeing relics of Beethoven—a cup, saucer, letters, and music—on display in New York. Entwined with his respect for Beethoven is the artist's admiration for Mozart. While this is clear from the word "Figar[o]" at the lower right,[4] it is made even more overt to those who know Beethoven's work, since Beethoven's Quartet opus 18, no. 5 (the work that is so prominent at the center of the canvas), is itself the most Mozartean of Beethoven's works, modeled on a quartet in the same key by the earlier composer. Thus the theme of the painting becomes the continuity of the artistic experience.

The somber quality of *The Cello Player* suggests that a further meaning lies hidden. The artist once said, "[My] brother Burgess was the chief influence on my entire career."[5] The influence was not only that "Burgess . . . awoke an appreciation of aesthetic concerns in Edwin," as Mrs. Edwin Dickinson later said,[6] but also that through Burgess the artist experienced one of the greatest traumas of his life. In January 1913, after spending a happy weekend together in New York, Dickinson and his older brother Howard left Burgess in Dickinson's Washington Square studio. When the two brothers returned, they found that Burgess had committed suicide by throwing himself from one of the sixth-floor windows.[7]

The link with the musicians and the two Dickinsons is provided by Burgess's nickname. A promising composer and pianist, Burgess was called "Beethoven" by friends, family, and colleagues at the Yale School of Music. Mozart to Beethoven, Burgess ("Beethoven") to Edwin Dickinson—the painting simultaneously celebrates the chain of artistic inspiration while, by depicting a silent cellist without the other members of his quartet, it mourns the shattered ensemble and the absence of companions.

M.S.

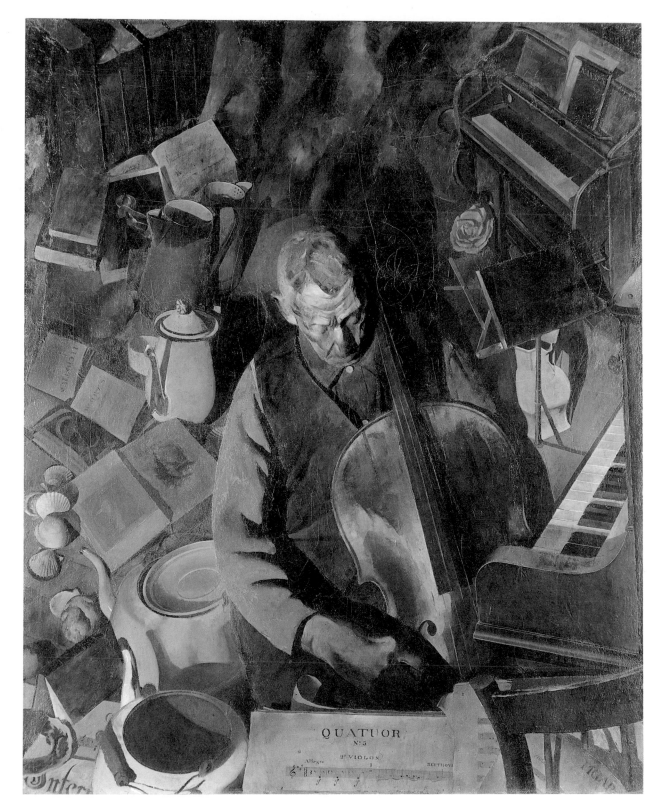

The Cello Player, 1924–26

Oil on canvas, 60 × 48¼ in. Signed and dated lower right (on chair back, incised): *E. W. Dickinson / 1924–6*
Museum purchase, Roscoe and Margaret Oakes Income Fund, 1988.5

Grant Wood

near Anamosa, Iowa 1891–1942 Iowa City, Iowa

Grant Wood spent the first ten years of his life on a small Iowa farm before moving with his mother to the growing city of Cedar Rapids.[1] He early decided on art for his career and, starting in 1910, attended art schools in Minneapolis, Iowa City, and Chicago. After serving with the army during World War I, Wood returned to Cedar Rapids and made a living first teaching art in the local public school system from 1919 to 1925 and later as a painter and interior decorator. Wood made four trips to Europe. During the last of these in 1928 he studied the Flemish Old Masters at the Alte Pinakothek in Munich; this experience proved crucial to his artistic development. On his return to Cedar Rapids, his previously eclectic style clarified into a hard-edged realism, grounded in contemporary subjects, static compositions, and repetition of decorative detail.

An early work in this new style, *American Gothic* (1930; Art Institute of Chicago), catapulted Wood to national attention and made him, together with Thomas Hart Benton* and John Steuart Curry (1897–1946), a leader of American Regionalism. For the remainder of his life, Wood lived in Iowa where he continued to paint, make lithographs, and teach at the University of Iowa. During the summers of 1932 and 1933 he ran an artists' colony in Stone City.

Dinner for Threshers represents a ritual of American agrarian life before the days of widespread mechanization. Every summer, late in July or August, after the grain had been cut and shocked, the threshing machine would arrive. Working cooperatively, the farmers assisted one another in bringing in crops to be processed. A welcome point in each threshing day was noontime—the midday break when all the workers gathered together for a specially prepared meal.[2] To accommodate all the men, Wood recalled how his family organized a dining area by setting "three tables end-to-end in the sitting room, covering them with neatly overlapped cloths so that they looked like one. All available chairs, including the piano stool . . . were placed around the table."[3]

Down to the piano stool, Wood includes in *Dinner for Threshers* the rites and details that characterized this important social occasion.[4] On the left side of the tripartite composition, draft horses enjoy their own midday break in the barnyard while the last farmhands clean up, awaiting their turn to be seated. Inside, on the right, two women cook at the stove under the watchful eye of a cat as another woman steps into the dining area with her overfilled serving dish ceremoniously held high. The workers themselves, hats off, hair combed, faces tanned, sit in their coveralls elbow to elbow around the banquet table sharing their noontime repast. Wood embellished the scene of these festivities with commonplace items that, for him, symbolized the basic, honest values of midwestern country life[5]—a rag rug; lace-trimmed curtains, decorative crockery. Believing that the artist had the right to draw valid subjects from his own experience, Wood said that *Dinner for Threshers* stemmed from "my family and our neighbors, our tablecloths, our chairs, and our hens. . . . It is of me and by me."[6]

Serious in mood and imposing in demeanor, *Dinner for Threshers* typifies Wood's mature work. Its muted palette of ocher, green, red, and blue evokes a coloristic harmony rich with agrarian associations. A sense of order, balance, and equilibrium characterizes the horizontally oriented composition, with the reduction of the solemn figures and homey setting to simple geometric forms, the slow deliberation of the figures' movements, and regular repetition of their basic shapes across the picture plane. In this way, Wood monumentalizes his forebears' rural ethic of dedicated labor and communal concern.

The sociological traumas of the depression had sparked a renewed interest in the American past, particularly its heritage of continuity and traditionalism.[7] Although Wood depicted scenes and events that in many ways had become obsolete—threshing days with heavy draft horses had become a thing of the past after the advent of combines, just as gas lamps, kitchen pumps, and wood-burning stoves had been replaced by more modern appliances—he offered solace to the American public by revitalizing the agrarian myth of self-sufficiency and cooperative farm labor.[8] Healthy, wholesome, and hard working, Wood's figures assume almost deific proportions in their celebration of rural values. By combining in *Dinner for Threshers* a tripartite composition reminiscent of an early Renaissance triptych, with a grouping of men who, by their ritual repast, suggest the traditional Christian theme of the Last Supper, Grant Wood sanctifies the strength and simple dignity of American midwestern life.

J.S.

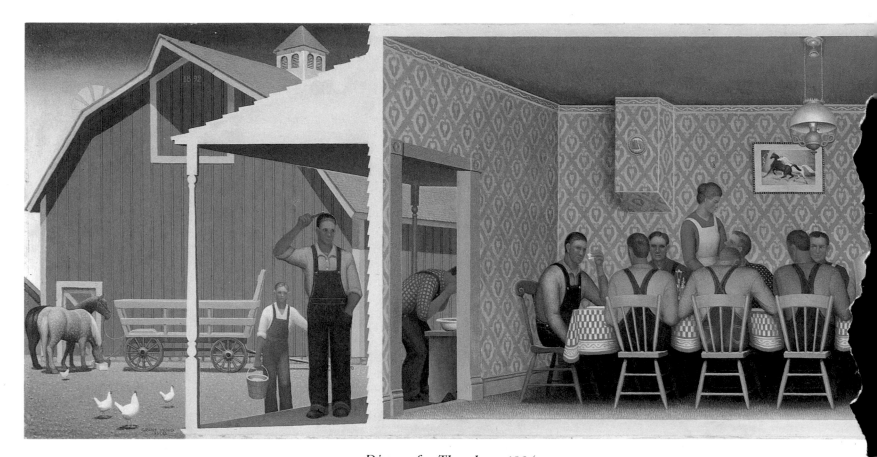

Dinner for Threshers, 1934

Oil on hardboard, 19½ × 79½ in. Signed and dated lower left: *Grant Wood / 1934* ©. Gift of Mr. and Mrs. John D. Rockefeller 3rd, 1979.7.105

Charles Burchfield
Ashtabula, Ohio 1893–1967 West Seneca, New York

Raised in the small midwestern town of Salem, Ohio, Charles Burchfield early displayed a talent for drawing and a profound sensitivity to nature. A shy and often lonely child, he spent long hours wandering through the woods or reading the works of the naturalists Henry David Thoreau and John Burroughs. After high school he worked one year at a desk job in a factory before entering in 1912 the Cleveland School of Art, where he encountered the more exotic inspirations of costume designs, fanciful illustrations, and Oriental art. In the fall of 1916 Burchfield went to New York, thinking "it was the thing to do."[1] He felt isolated as a student at the National Academy of Design, unable to find "an artist in the school to feel the beauty and poetry of nature as existing for its own sake."[2] He stayed only two months before homesickness overcame him. Returning to Salem, he began to paint watercolors evoking the memories and feelings of his childhood. Inducted into the army in 1918, he served in South Carolina before his discharge in 1919, and then returned to his factory job and continued to paint. In fall 1921 Burchfield accepted a design position with a wallpaper company in Buffalo, New York; he later became head of the design department, but resigned in 1929 to devote himself full time to painting. In 1936 and 1937 he was commissioned by *Fortune* magazine to depict railroad yards in Pennsylvania and coal mines in West Virginia. He began to teach summer classes in 1949 and painted nearly until the time of his death at the age of seventy-three.

Critics have noted, and the artist himself remarked on, three periods in Burchfield's career. The first, from 1915 to 1918, is characterized by romantic and mystical expressions of landscape forms and natural forces. During this time Burchfield created a personal vocabulary of imaginative symbols that signaled emotions and sensations.[3] In his last period, after 1940, Burchfield returned to these early watercolors, creating powerfully lyrical paintings by recalling the magical feelings and bringing to his youthful compositions a mature vision and experienced technique. Between 1918 and 1940 Burchfield turned his attention to the urban scene, especially around Buffalo, painting in a more realist, less expressionistic manner. Having begun to "feel the great epic poetry of midwest American life, and my own life in connection with it,"[4] he focused on the appearance of the contemporary world as well as the interior moods of nature. For such tendencies he was later linked with the American Regionalists, such as Thomas Hart Benton,* although Burchfield always resisted the association.

In the 1930s Burchfield also began to experiment with technique. Having previously worked almost exclusively in watercolor, he told his dealer in 1930, "I'm going to turn out some good oils or die in the attempt." Two years later he announced: "I intend to dedicate my larger themes to oil."[5] In certain instances, such as the 1931 *Spring Flood*, Burchfield was able to paint with oil as freely and thinly as he could with watercolor, but he was never comfortable with the medium and eventually gave it up altogether. Still, the few oils from this decade demonstrate Burchfield's attempts at "larger themes" and reflect his experiments with more monumental effects and serious subjects.

Spring for Burchfield was not only the season of budding flowers and glorious sunlight, but also the time when winter died, leaving behind a wake of rain, torrents, and mud. Of March, Burchfield wrote, "a songsparrow sings and a wave of yearning sweeps over me. I never get used to this season, it is always agony."[6] This "agony" is implicit in Burchfield's description of a spring flood, surging beneath a city bridge, threatening the man-made constructions that seek to contain it. The viewpoint is precipitous, cropped at the left by the bridge itself, blocked at the top by a wall and embankment that afford no access to sky. Without landing or foothold from which comfortably to watch this spectacle, the viewer is thrown headlong into the brown-green current. At the same time, Burchfield restricts the recession of three-dimensional space by his placement of the barren tree branches that stretch across and press against the picture plane.

Subdued in its monochromatic tonality, almost decorative in its arrangement of wave patterns and tree boughs, the painting recalls Burchfield's admiration for Oriental art, especially Chinese scroll paintings and Japanese woodblock prints. Implicit in the Oriental aesthetic and pulsing beneath Burchfield's decorative arrangement is a deep feeling for nature, an intimacy born of many years' communion with her forms and forces. Despite Burchfield's concentration on industrial and urban subjects in the 1920s and 1930s, his passion for nature was never far away. Some twelve years after *Spring Flood* was painted, Burchfield returned to landscape painting, embarking on his last great phase of monumental watercolors. In 1943 he went back to a particularly potent, but unfulfilled, compositional idea of 1917, *The Coming of Spring*, and recalled that "doing so seemed to release something in me: namely a long pent-up subconscious yearning to do fanciful things, and once started, it seemed to sweep onward like a flooded stream; there was no stopping it."[7]

S.M.

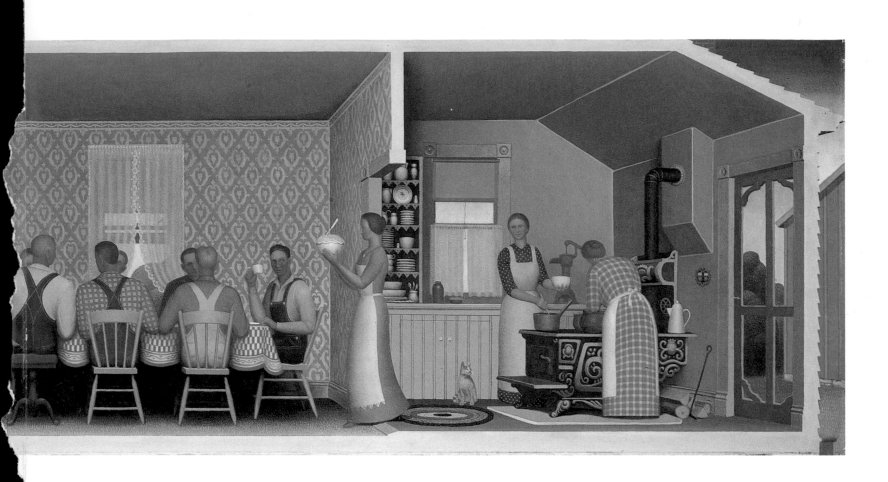

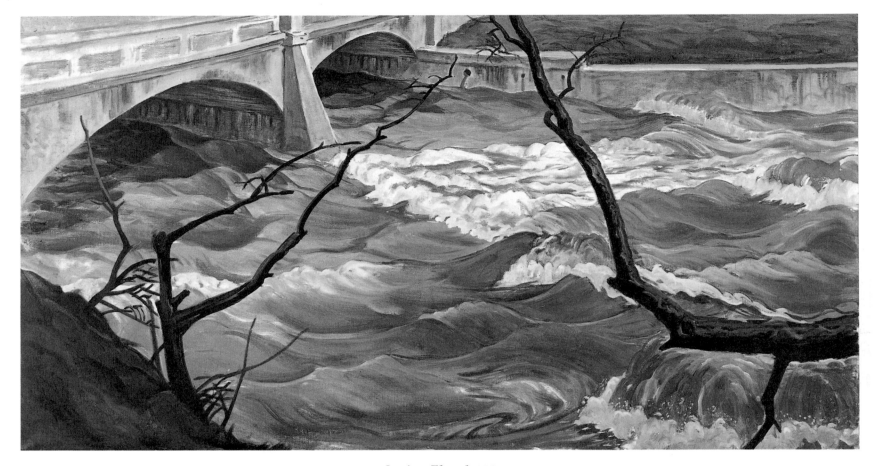

Spring Flood, 1931
Oil on canvas, 25⅝ × 49⅝ in. Signed with monogram and dated lower left: *CEB / 1931.* Gift of Mr. and Mrs. John D. Rockefeller 3rd, 1979.7.20

Ben Shahn

Kovno, Lithuania, Russia 1898–1969 New York, New York

Ben Shahn spent the first eight years of his life with his tight-knit Jewish family in Czarist Russia. Both his father and grandfather were wood-carvers. The family moved to Brooklyn in 1906. From 1913 to 1917 Shahn attended high school at night; during the day he was apprenticed to his uncle, a lithographer. He continued to earn a living from lithography while studying both biology and art. Shahn attended the National Academy of Design from 1919 to 1922, but found its life classes restrictive and uninspiring. He traveled to Europe and North Africa in 1924–25 and upon his return declined the offer of an exhibition, feeling his work was too derivative.[1] After a second trip abroad in 1927–29, Shahn met the photographer Walker Evans (1903–1975), with whom he later shared a studio. In 1930 Shahn produced his first works with overt social content in a series of watercolors on the Dreyfus case. Twenty-three gouaches finished in 1931 dealing with the controversial trial of the anarchists Sacco and Vanzetti brought Shahn to the attention of Diego Rivera (1886–1957), who hired him as an assistant on the ill-fated mural project for Rockefeller Center.[2] In 1933 Shahn enrolled with the U.S. government's Public Works of Art Project; he provided mural designs for two uncompleted projects, including the Rikers Island Penitentiary. From 1935 to 1938 Shahn traveled throughout the rural Midwest as an artist and photographer for the Farm Security Administration; he took over three thousand photographs, many of which served as compositional sources throughout his later career. He executed his first mural in 1939, thirteen panels for the Bronx Central Annex Post Office. While continuing mural work in the 1940s, Shahn produced posters for the Office of War Information until 1943, and devoted more time to easel painting, working exclusively in tempera. After 1948 Shahn, like many artists, professed a greater interest in symbolism and allegory. He later described this shift: "I was not the only artist who had been entranced by the social dream, and who could no longer reconcile that view with the private and inner objectives of art.... My own painting then had turned from what is called 'social realism' into a sort of personal realism."[3]

In his later career Shahn continued to execute murals, some in mosaic, for schools, synagogues, and private homes; he also produced posters and designed sets for ballets and drama. In 1956–57 he was named Charles Eliot Norton Professor of Poetry at Harvard University; his lectures were collected and published in 1957 by Harvard University Press as *The Shape of Content*.

Shahn's 1945 work, *Ohio Magic*, would seem to derive from his Farm Security Administration travels in Ohio, yet its very title suggests a source apart from everyday observation.[4] A young boy sits in an upper-story window of a storefront apartment house, leaning his head on his shoulder; a single basket of flowers hangs in a bottom window. Shades seem to be drawn over the remaining windows. The boy stares off to the left, but to the right, veering off at an improbable angle, unfolds a drama from some archetypal Main Street, U.S.A. The jaunty yellow bus, bedecked with American flags, and the old-fashioned street lamps and cobblestone pavement lend a festive air to the scene. Yet the cobblestone pattern continues past the sidewalks and extends to cover the entire scene up to a jagged line of rooftops, as if this main street were actually painted on the side of the brick building. But it is unlikely that Shahn intended such a literal interpretation. Several of the works he executed in the mid-1940s have ambiguous, even surreal content:

> The paintings which I made toward the close of the war... had become more private and more inward-looking. A symbolism which I might once have considered cryptic now became the only means by which I could formulate the sense of emptiness and waste that the war gave me, and the sense of the littleness of people trying to live on through the enormity of war.[5]

Ohio Magic relates most clearly to these war paintings, especially the ones that juxtapose children against crumbling architecture, and like those works, it provides unsettling conjunctions of reality and fantasy. Who is the young boy? Are the white patches in the window emblems on his sleeve, or perhaps a telegram? Does the bricked-in street scene represent a dream of what might be, or a memory now frozen? The riders of the bus are all men; are they going to war? Shahn's composition juxtaposes several vantage points, offering images of both isolation and community that are simultaneously nostalgic and disturbing, and ultimately beyond the reach of simple explanation.

S.M.

Ohio Magic, 1945
Tempera on board, 26 × 39 in. Signed lower right: *Ben Shahn*. Mildred Anna Williams Collection, 1948.14

Notes

Introduction

1. The bulk of the Garbisch collection is now in the National Gallery of Art, Washington, D.C.

2. Hanley was an industrialist who devoted a major portion of his resources to collecting art and manuscripts. His literary treasures, with especial strength in William Blake and Samuel Beckett, form the core of the manuscript collection at the Research Center at the University of Texas, Austin. Mrs. Hanley, one of the most colorful donors the de Young Museum has ever known, was chiefly responsible for giving a major portion of their art collection to the de Young and to the Denver Art Museum.

3. E. P. Richardson, Preface to *American Art: An Exhibition from the Collection of Mr. and Mrs. John D. Rockefeller 3rd*, exh. cat. (San Francisco: The Fine Arts Museums of San Francisco, 1976), 11.

4. Alfred V. Frankenstein (1979–80); Donald L. Stover (1980–82); Margaretta M. Lovell (1982–85).

Freake-Gibbs Painter (attr.), *The Mason Children*

1. These are the *Self-Portrait* of Thomas Smith (Worcester Art Museum, Worcester, Mass.) and three portraits attributed to him. See Jonathan Fairbanks, "Portrait Painting in Seventeenth-Century Boston: Its History, Methods, and Materials," in *New England Begins*, 3 vols., exh. cat. (Boston: Museum of Fine Arts, 1982), 3: 413, 419–20.

2. Scholars have speculated that the painter Augustine Clement (died 1674) and his servant/apprentice Thomas Wheeler, who are recorded as migrating from Reading, England, to New England in 1635, might be associated with the Freake, Gibbs, and Mason portraits. To date, however, there has been no way of confirming or disproving this theory. See Louisa Dresser, "Portraits in Boston, 1630–1720," *Archives of American Art Journal* 6, nos. 3–4 (July–August 1966): 1–6; and E. P. Richardson, *American Art: An Exhibition from the Collection of Mr. and Mrs. John D. Rockefeller 3rd*, exh. cat. (San Francisco: The Fine Arts Museums of San Francisco, 1976), 16.

3. The Adams Memorial Society in Quincy, Mass., now has two related portraits in its collection: one of Alice Mason (born 1668), clearly by the same hand as the San Francisco painting, and one tentatively identified as the eldest Mason child, Mary. No portraits of the parents are known or recorded.

4. Louisa Dresser, *Seventeenth-Century Painting in New England* (Worcester, Mass.: Worcester Art Museum, 1935), 21: "As early as 1637 Governor Winthrop had received a letter from England complaining that the colonists in their *'pride'* were *'going as farr as they may'* and writing over for lace *'though of the smaller sort'* since any other was prohibited."

Wayne Craven has recently underscored the rivalry between the secular and the sacred authorities in colonial New England and has provided an excellent cultural overview of the period, in *Colonial American Portraiture* (Cambridge: Cambridge University Press, 1986).

De Peyster Painter, *Maria Maytilda Winkler*

1. James Thomas Flexner, *American Painting: First Flowers of Our Wilderness* (Boston: Houghton Mifflin Company, 1947), 69–76. Three of the five portraits of the De Peyster children are owned by the New-York Historical Society.

2. In 1959 Flexner attempted to identify the De Peyster Painter as Pieter Vanderlyn (ca. 1687–1778), an attribution not widely accepted; see James Thomas Flexner, "Pieter Vanderlyn, Come Home," *Antiques* 75, no. 6 (June 1959): 546–49, 580. In 1980 Mary Black presented the name of Gerardus Duyckinck I (1695–1746) as the elusive painter, based on a then recently discovered signed religious painting. Black asserted that "with the discovery of this [religious] subject signed by Gerardus Duyckinck the portraits traditionally credited to him were confirmed." Yet the case for such confirmation has not been explicitly explained or published, and debate continues regarding the proper identity of the De Peyster Painter. See Mary Black, "Contributions toward a History of Early Eighteenth-Century New York Portraiture: Identification of the Aetatis Suae and Wendell Limners," *American Art Journal* 12, no. 4 (Autumn 1980): 5–6; and Tom Wolf et al., *A Remnant in the Wilderness*, exh. cat. (Albany, N.Y.: Albany Institute of History and Art, 1980), 9, 22.

Smibert, *John Nelson*

1. *The Notebook of John Smibert* (Boston: Massachusetts Historical Society, 1969), 22, 90.

2. Henry Wilder Foote, *Annals of King's Chapel from the Puritan Age of New England to the Present Day*, 3 vols. (Boston: Little, Brown, and Co., 1882–1940), 1: 181.

Feke, *Mrs. Charles Apthorp*

1. Quoted in Henry Wilder Foote, *Annals of King's Chapel from the Puritan Age of New England to the Present Day*, 3 vols. (Boston: Little, Brown, and Co., 1882–1940), 2: 144. Feke's companion portrait of Mr. Apthorp, also painted in 1748, is in the collection of the Cleveland Museum of Art; his portrait of the Apthorps' daughter Grizzell (Mrs. Barlow Trecothick), 1748, is in the Wichita Art Museum, Wichita, Kans.

2. Lawrence Park, "Joseph Blackburn—Portrait Painter," *Proceedings of the American Antiquarian Society*, n.s., 32 (October 1922): 280–81. Blackburn (active in North America 1752–1763/64) painted portraits of Mr. and Mrs. Apthorp (both private collection) in 1758 and their daughter Susan (Mrs. Thomas Bulfinch; Museum of Fine Arts, Boston) in 1757.

3. See discussion of the relationship to mezzotint of *Catherine of Braganza*, dated ca. 1705, in Ralph Peter Mooz, "The Art of Robert Feke," Ph.D. diss., University of Pennsylvania, 1970, 141.

4. John Milton, *Paradise Lost*, ed. Merritt Y. Hughes (New York: Odyssey Press, 1962), 227, lines 896–916.

Badger, *Mrs. Nathaniel Brown*

1. Frank W. Bayley, *Five Colonial Artists of New England* (Boston: privately printed, 1929), 1.

2. See Waldron Phoenix Belknap, Jr., *American Colonial Painting: Materials for a History* (Cambridge: Belknap Press of Harvard University Press, 1959), 273–329.

Copley, *Mrs. Daniel Sargent*

1. For further discussion, see Waldron Phoenix Belknap, Jr., *American Colonial Painting: Materials for a History* (Cambridge: Belknap Press of Harvard University Press, 1959), 273–329; and Trevor J. Fairbrother, "John Singleton Copley's Use of British Mezzotints for His American Portraits: A Reappraisal Prompted by New Discoveries," *Arts Magazine* 55, no. 7 (March 1981): 122–30.

2. Copley to [Benjamin West or Captain R. G. Bruce?]; quoted in John W. McCoubrey, *American Art, 1700–1960* (Englewood Cliffs, N.J.: Prentice-Hall, 1965), 18.

3. Captain R. G. Bruce to Copley, 4 August 1766; quoted in Jules David Prown, *John Singleton Copley*, 2 vols. (Cambridge: Harvard University Press, 1966), 1: 48.

4. William Dunlap, *A History of the Rise and Progress of the Arts of Design in the United States*, 3 vols. (1834; Boston: C. E. Goodspeed, 1918), 1: 144.

5. Fairbrother, "Copley's Use of British Mezzotints," 122–30.

6. Copley painted other women near fountains, including *Mrs. Jonathan Belcher (Abigail Allen)* (1756; Beaverbrook Art Gallery, Fredericton, New Brunswick) and *Alice Hooper (Mrs. Jacob Fowle, Mrs. Joseph Cutler)* (ca. 1763; State Department, Washington, D.C.).

7. Although Copley borrowed costumes as well from print sources, it seems that Mary Sargent's dress was an actual garment, for it appears at different angles and over different lacey undergarments in two other portraits of 1763: *Mrs. James Warren (Mercy Otis)* (Museum of Fine Arts, Boston) and *Mrs. Benjamin Pickman (Mary Toppan)* (Yale University Art Gallery, New Haven). See also Fairbrother, "Copley's Use of British Mezzotints," 126–27, 130 n. 16.

Copley, *Joshua Henshaw*

1. "A Sketch of the Life of Hon. Joshua Henshaw . . . ," *New England Historical and Genealogical Register* 22, no. 2 (April 1868): 108.

2. Quoted in "Sketch of the Life," 108–9.

3. For Copley's frames, see Barbara M. Ward and Gerald W. R. Ward, "The Makers of Copley's Picture Frames: A Clue," *Old-Time New England* 67, nos. 1–2 (Summer–Fall 1976): 16–20.

Copley, *William Vassall and His Son Leonard*

1. Benjamin West to Copley, 4 August 1766, quoted in *Letters & Papers of John Singleton Copley and Henry Pelham, 1739–1776* (1914; New York: Da Capo Press, 1970), 44.

2. In 1773 and 1774 Copley painted two portraits of husband and wife pairs: *Mr. and Mrs. Thomas Mifflin* (Historical Society of Pennsylvania, Philadelphia) and *Mr. and Mrs. Isaac Winslow* (Museum of Fine Arts, Boston).

3. Quoted in Clifford K. Shipton, *Biographical Sketches of Those Who Attended Harvard College in the Classes 1731–1735, Sibley's Harvard Graduates*, vol. 9 (Boston: Massachusetts Historical Society, 1956), 356.

4. Ibid.

5. Ibid.

6. In addition to the Copley portrait, these included portraits of Vassall; his first wife; his eldest daughter, Sarah; and a son who died in infancy. All were painted by John Smibert* in 1743 and 1744; none are located today.

West, *Genius Calling Forth the Fine Arts*

1. The Queen's Lodge stood on the south terrace outside the castle proper and in the late 1770s was the preferred residence of George III, Queen Charlotte, and many of their fifteen children.

2. Helmut von Erffa and Allen Staley, *The Paintings of Benjamin West* (New Haven: Yale University Press, 1986), 409–11.

3. Sylvia Groves, "The Art of Sand Painting," *Country Life* 109, no. 2825 (March 1951): 696.

Charles Willson Peale, *Mordecai Gist*

1. Peale's dual allegiance to art and science led to his many years of work with his natural-history museum, wherein portraits of great men and geological and animal specimens were juxtaposed. This allegiance is perhaps most graphically demonstrated in the names Peale chose for his children—Raphaelle, Rembrandt, and Linnaeus, for example.

2. Quoted in Katherine Walton Blakeslee, *Mordecai Gist and His American Progenitors* (Baltimore: Mordecai Gist Chapter, Daughters of the American Revolution, 1923), n.p. Gist and his battalion were crucial to the American effort at Long Island, Brandywine, Germantown, Camden, and Combahee. He was ultimately promoted to the rank of brigadier general. A later biographer wrote of him, "It was certainly this type of American who won the Revolution" (*Dictionary of American Biography*, Allen Johnson et al., eds., 11 vols. [1928–37; New York: Charles Scribner's Sons, 1946(?)–58], 4: 324).

3. Sally Wister, "Journal of Miss Sally Wister," *Pennsylvania Magazine of History and Biography* 9 (1885); quoted in E. P. Richardson, *American Art: An Exhibition from the Collection of Mr. and Mrs. John D. Rockefeller 3rd*, exh. cat. (San Francisco: The Fine Arts Museums of San Francisco, 1976), 42.

4. Journal entry for 4 September 1788; reprinted in Lillian B. Miller, ed., *The Selected Papers of Charles Willson Peale and His Family*, vol. 1 (New Haven: Yale University Press, 1981), 529. A date of ca. 1774 for one of the two portraits of Mordecai Gist is thus established. Sally Mills (departmental files, The Fine Arts Museums of San Francisco) has suggested that a Peale portrait often called *Mrs. Gist* (1774; Milwaukee Art Museum), which apparently descended in the family along with the San Francisco painting but which, though stylistically close, does not act as a pendant to it, might in fact be the unlocated portrait of Elizabeth McClure. As the McClures were related to the family, and as there was no "Mrs. Gist" in 1774 (Gist's first wife died in 1769, and he did not remarry until 1778), this seems reasonable.

Benbridge, *Pascal Paoli*

1. Quoted in Robert G. Stewart, *Henry Benbridge (1743–1812): American Portrait Painter*, exh. cat. (Washington, D.C.: Smithsonian Institution Press for the National Portrait Gallery, 1971), 15. The house was torn down during Peale's lifetime.

2. William Dunlap, *A History of the Rise and Progress of the Arts of Design in the United States*, 3 vols. (1834; Boston: C. E. Goodspeed, 1918), 1: 165.

3. "The Journal of a Tour to Corsica," in *Boswell on the Grand Tour: Italy, Corsica, and France*, Frank Brady and Frederick A. Pottle, eds. (New York: McGraw-Hill, 1955), 165.

4. The desire for such a portrait in England was keen. In 1767 the *London Chronicle* reported, "We hear that an eminent Printseller in the city has given commission to his correspondent in Italy to send over a young painter to Corsica, in order to take a set of views in that island, and, if possible, to obtain a picture of General Paoli" (26–28 March 1767).

5. John Dick to James Boswell, 30 June 1768; quoted in Stewart, *Benbridge*, 45.

6. *London Chronicle*, 6–9 May 1769.

7. Andrew Caldwell to James Boswell, 25 August 1769; quoted in Stewart, *Benbridge*, 47.

8. The portrait of Paoli has many echoes of a tradition that goes back to Sir Godfrey Kneller (1646–1723) and also seems to quote, in the manner fashionable among portraitists of the 1750s and 1760s who wished to display their antiquarian knowledge, the famous antique statue of the Apollo Belvedere. Its closest parallel may be to Batoni's portrait of Colonel the Hon. William Gordon (1766; National Trust for Scotland, Fyvie Castle, Aberdeenshire). Interestingly, James Boswell observed Batoni working on this portrait in 1765; see Anthony M. Clark, *Pompeo Batoni: A Complete Catalogue of His Works with an Introductory Text* (New York: New York University Press, 1985), 303.

James Peale, *Still Life with Fruit*

1. Quoted in Charles Coleman Sellers, "James Peale: A Light in Shadow," in *Four Generations of Commissions: The Peale Collection of the Maryland Historical Society*, exh. cat. (Baltimore: Maryland Historical Society, 1975), 30.

2. See John I. H. Baur, "The Peales and the Development of American Still Life," *Art Quarterly* 3, no. 1 (Winter 1940): 80–92; and William H. Gerdts, *Painters of the Humble Truth: Masterpieces of American Still Life, 1801–1939* (Columbia, Mo.: Philbrook Art Center and University of Missouri Press, 1981).

3. *Still Life #2* (1821; Pennsylvania Academy of the Fine Arts, Philadelphia) and *Fruit in a Chinese Basket* (1822; sale, Christie's, New York, 24 April 1981).

4. John Wilmerding, "The American Object: Still-Life Paintings," in *An American Perspective: Nineteenth-Century Art from the Collection of JoAnn & Julian Ganz, Jr.*, exh. cat. (Washington, D.C.: National Gallery of Art, 1981), 88–90.

Stuart, *Josiah Quincy*

1. *Boston Daily Advertiser*, 21 July 1828; quoted in Mabel Munson Swan, *The Athenaeum Gallery, 1827–1873* (Boston: Boston Athenaeum, 1940), 60, 63.

2. For a recent discussion of Stuart, see Richard McLanathan, *Gilbert Stuart* (New York: Harry N. Abrams in association with the National Museum of American Art, Smithsonian Institution, 1986).

3. Quoted in Daniel Munro Wilson, *Three Hundred Years of Quincy, 1625–1925* (Boston: Wright and Potter, 1926), 68.

4. Quoted in William T. Whitley, *Gilbert Stuart* (Cambridge: Harvard University Press, 1932), 172.

5. Quoted in Henry T. Tuckerman, *Book of the Artists: American Artist Life* (1867; New York: James F. Carr, 1966), 112.

Stuart, *William Rufus Gray*

1. Two portraits of William Gray and a portrait of Mrs. Gray, all executed in 1807, are in private collections.

2. Henry T. Tuckerman, *Book of the Artists: American Artist Life* (1867; New York: James F. Carr, 1966), 111.

3. Quoted in Helen Comstock, "Review of Gilbert Stuart," *Panorama* 3 (March 1948): 76.

4. Quoted in William Dunlap, *A History of the Rise and Progress of the Arts of Design in the United States*, 3 vols. (1834; Boston: C. E. Goodspeed, 1918), 1: 217.

Trumbull, *Philip Church*

1. For these two works Trumbull received fifteen guineas; he also painted a "small whole length of Mrs. Church, child & Servant," for which he received twenty guineas. See John Trumbull, "List of Pictures Done in London 1784"; quoted in Theodore Sizer, "An Early Check List of the Paintings of John Trumbull," *Yale University Library Gazette* 22 (April 1948): 121–22. The large *Philip Church* is now in a private collection; the group portrait is in the collection of Mrs. Amy Olney Johnson, Farmington, Conn. For a discussion of the friendship between Church and Trumbull, see Theodore Sizer, ed., *The Autobiography of Colonel John Trumbull: Patriot-Artist, 1756–1843* (New Haven: Yale University Press, 1953), 93–95.

2. Trumbull may have been familiar with the educational theories of John Locke, the eighteenth-century English philosopher whose writings praise the natural innocence and educable potential of children. For a general discussion of these theories, see Karin Calvert, "Children in American Family Portraiture, 1670 to 1810," *William and Mary Quarterly*, 3d ser., 39, no. 1 (January 1982): 101–13.

3. Quoted in Oswaldo Rodriguez Roque, "Trumbull's Portraits," in Helen Cooper, *John Trumbull: The Hand and Spirit of a Painter*, exh. cat. (New Haven: Yale University Art Gallery, 1982), 97.

4. Ibid., 97–98.

5. Quoted in Mary Gay Humphreys, *Catherine Schuyler* (New York: Charles Scribner's Sons, 1901), 238.

6. Ibid.

Wright, *John Coats Browne*

1. See Charles Coleman Sellers, *Patience Wright: American Artist and Spy in George III's London* (Middletown, Conn.: Wesleyan University Press, 1976).

2. Monroe H. Fabian, *Joseph Wright: American Artist, 1756–1793*, exh. cat. (Washington, D.C.: Smithsonian Institution Press for the National Portrait Gallery, 1985), 35.

3. Ibid., 114.

4. Frank Willing Leach, "Old Philadelphia Families, CXLVIII: Browne," *North American*, 2 February 1913.

5. Gainsborough's portrait was not publicly exhibited during Wright's residence in London and was not engraved until 1821. Wright might have known the painting by visiting the Buttall home, a hypothesis advanced by Fabian, *Wright*, 26, 114.

Earl, *Mrs. John Rogers*
1. Frederic Fairchild Sherman, "James Earl: A Forgotten American Portrait Painter," *Art in America & Elsewhere* 23, no. 23 (June 1935): 143–53; and *The American Earls: Ralph Earl, James Earl, R. E. W. Earl*, exh. cat. (Storrs, Conn.: William Benton Museum of Art, 1972), xxi.
2. Although Earl is traditionally cited as a student of West, Dorinda Evans notes the lack of documentary evidence for the relationship and concludes that he probably did not study with the master; see *Benjamin West and His American Students*, exh. cat. (Washington, D.C.: Smithsonian Institution Press for the National Portrait Gallery, 1980), 110–11.
3. Quoted in Anna Wells Rutledge, "Artists in the Life of Charleston: Through Colony and State from Restoration to Reconstruction," *Transactions of the American Philosophical Society* (Philadelphia), n.s., 39, part 2 (1949): 124.

Salmon, *British Merchantman in the River Mersey*
1. Henry T. Tuckerman, *Book of the Artists: American Artist Life* (1867; New York: James F. Carr, 1966), 551.
2. In England Salmon had made a copy of a Turner painting, which he hung in his Boston studio. See Henry Hitchings, "Report," *Proceedings of the Bostonian Society*, annual meeting, 8 January 1895; quoted at length in John Wilmerding, *Robert Salmon: Painter of Ship & Shore* (Salem and Boston: Peabody Museum and Boston Public Library, 1971), 10–11.
3. Tuckerman, *Book of the Artists*, 551.
4. Quoted in Wilmerding, *Salmon*, 113. The entire transcription of the daybook is reprinted on pages 89–98.

Vanderlyn, *Caius Marius amid the Ruins of Carthage*
1. Given the eventual outcome of Burr's career, a connection between his political glories, disappointments, and eventual exile and the story of Caius Marius is inevitable. For a detailed discussion, see William T. Oedel, "John Vanderlyn: French Neoclassicism and the Search for an American Art," Ph.D. diss., University of Delaware, 1981, 301–5.
2. The theme was a popular one. See, for instance, paintings such as John Hamilton Mortimer's (1741–1779) *Caius Marius on the Ruins of Carthage* (1774; private collection) and Pierre-Nolasque Bergeret's (1782–1863) *Marius Meditating on the Ruins of Carthage* (1807; art market) and plays such as Thomas Otway's *History and Fall of Caius Marius* of 1680 and Antoine-Vincent Arnauld's *Marius à Minturnes* of 1791.
3. Vanderlyn to Nicholas Vanderlyn, 18 December 1807, Vanderlyn Papers, New-York Historical Society; quoted in Louise Hunt Averill, "John Vanderlyn: American Painter, 1775–1852," Ph.D. diss., Yale University, 1949, 209.
4. Marius Schoonmaker, *John Vanderlyn, Artist, 1775–1852, Biography* (Kingston, N.Y.: Senate House Association, 1950), 24.
5. Plutarch, *Fall of the Roman Republic, Six Lives by Plutarch*, trans. Rex Warner (Harmondsworth, Middlesex: Penguin Books, 1972), 54–55.
6. Quoted in Kenneth C. Lindsay, *The Works of John Vanderlyn*, exh. cat. (Binghamton, N.Y.: University Art Gallery, 1970), 71.

Allston, *Dr. John King*
1. Quoted in John R. Welsh, "Washington Allston, Cosmopolite and Early Romantic," *Georgia Review* 21, no. 4 (Winter 1967): 498–99.
2. Quoted in ibid., 499.
3. A signature and date, *W. Allston 1814*, on the back of the canvas were visible before lining. Allston also executed in 1814 an as yet unlocated likeness of Mrs. King. For more information about King and the two portraits, see William H. Gerdts and Theodore E. Stebbins, Jr., *"A Man of Genius": The Art of Washington Allston*, exh. cat. (Boston: Museum of Fine Arts, 1979), 80–81, 84–86.
4. Ibid., 49. The painting in Dr. King's collection was *Morning in Italy* (ca. 1805–8; Shelburne Museum, Shelburne, Vt.).
5. William Dunlap, *A History of the Rise and Progress of the Arts of Design in the United States*, 3 vols. (1834; Boston: C. E. Goodspeed, 1918), 2: 316. The other portrait was that of Samuel Taylor Coleridge (1814; National Portrait Gallery, London).

Birch, *The Narrows, New York Bay*
1. Quoted in Marion Carson, "Thomas Birch," in *The One Hundred and Fiftieth Anniversary Exhibition*, exh. cat. (Philadelphia: Pennsylvania Academy of the Fine Arts, 1955), 34.
2. William H. Gerdts, *Thomas Birch, 1779–1851*, exh. cat. (Philadelphia: Philadelphia Maritime Museum, 1966), 12.
3. Edward J. Nygren, "From View to Vision," in Edward J. Nygren et al., *Views and Visions: American Landscape before 1830*, exh. cat. (Washington, D.C.: Corcoran Gallery of Art, 1986), 22–28.
4. Gerdts, *Birch*, 14.
5. Ibid., 11.
6. Birch painted many views of the New York harbor and environs; most of them date from the 1820s or later. A view of *The Battery and Harbor, New York*, dated to 1810–11, appeared at auction in New York (Sotheby's, 6 December 1984, lot 14).

Jarvis, *Philip Hone*
1. William Dunlap, *A History of the Rise and Progress of the Arts of Design in the United States*, 3 vols. (1834; Boston: C. E. Goodspeed, 1918), 2: 208–28.
2. Harold Edward Dickson, "Where Inman Began His Apprenticeship," *Antiques* 50, no. 6 (December 1946): 396–97.
3. Included among Jarvis's apprentices were Henry Inman (1801–1846) and John Quidor;* the latter successfully sued him for failing to teach the mysteries of the craft. For a full account of that case, see Ernest Rohdenburg, "The Misreported Quidor Court Case," *American Art Journal* 2, no. 1 (Spring 1970): 74–80.
4. According to one advertisement of 1810, Jarvis charged from three hundred dollars for a full-length portrait and sixty dollars for a portrait with hands, to three dollars for a colored profile on paper. The advertisement closes with the not unusual note, "Those who wish to have Portraits of their deceased friends should be particular to apply time enough before they inter them." See Leah Lipton, "William Dunlap, Samuel F. B. Morse, John Wesley Jarvis, and Chester Harding: Their Careers as Itinerant Portrait Painters," *American Art Journal* 13, no. 3 (Summer 1981): 38–44.

5. See Harold Edward Dickson, ed., *Observations on American Art: Selections from the Writings of John Neal (1793–1876)* (State College: Pennsylvania State College, 1943), 80; and Dunlap, *History*, 2: 222.
6. Allen Johnson et al., eds., *Dictionary of American Biography*, 11 vols. (1928–37; New York: Charles Scribner's Sons, 1946[?]–58), 9: 192.
7. The manuscript is now in the collection of the New-York Historical Society.
8. Dunlap, *History*, 2: 215.
9. Dickson, *Observations on American Art*, 7.
10. Harold Edward Dickson, *John Wesley Jarvis: American Painter, 1780–1840* (New York: New-York Historical Society, 1949), 329.

Doughty, *View on the St. Croix River*
1. William Dunlap, *A History of the Rise and Progress of the Arts of Design in the United States*, 3 vols. (1834; Boston: C. E. Goodspeed, 1918), 3: 175.
2. Frank Goodyear, Jr., *Thomas Doughty, 1793–1856: An American Pioneer in Landscape Painting*, exh. cat. (Philadelphia: Pennsylvania Academy of the Fine Arts, 1973), 12.
3. Harold Edward Dickson, ed., *Observations on American Art: Selections from the Writings of John Neal (1793–1876)* (State College: Pennsylvania State College, 1943), 82–83.
4. This aesthetic is ably summarized in Edward J. Nygren et al., *Views and Visions: American Landscape before 1830*, exh. cat. (Washington, D.C.: Corcoran Gallery of Art, 1986), 17–21.
5. Quoted in Clara Endicott Sears, *Highlights among the Hudson River Artists* (Boston: Houghton Mifflin Company, 1947), 10.
6. Nygren, *Views and Visions*, 75–76.

Catlin, *Fire in a Missouri Meadow*
1. Quoted in George M. Cohen, "George Catlin: Indian Painter with a Noble Mission," *Art & Antiques* 4, no. 1 (January–February 1981): 53.
2. Quoted and discussed in William H. Truettner, *The Natural Man Observed: A Study of Catlin's Indian Gallery*, exh. cat. (Washington, D.C.: National Collection of Fine Arts, Smithsonian Institution, 1979), 70, 73–79.
3. The buyer's widow, Mrs. Joseph Harrison, ultimately donated Catlin's Indian Gallery to the Smithsonian Institution, Washington, D.C., in 1878.
4. Marjorie Halpin, *Catlin's Indian Gallery: The George Catlin Paintings in the United States National Museums* (Washington, D.C.: Smithsonian Institution, 1965), 21.
5. Quoted in Truettner, *Natural Man Observed*, 248.
6. James T. Callow, *Kindred Spirits* (Chapel Hill, N.C.: University of North Carolina Press, 1967), 156.

Quidor, *Tom Walker's Flight*
1. Ernest Rohdenburg, "The Misreported Quidor Court Case," *American Art Journal* 2, no. 1 (Spring 1970): 74–80.
2. The Cleveland Museum of Art has a Quidor work, signed and dated 1856 and closely related in tone and size to the San Francisco painting, which depicts the initial meeting of the Devil and Tom Walker.
3. Washington Irving, *Tales of a Traveller, Part 4* (Philadelphia: H. C. Carey and I. Lea, 1824), 451.
4. See, for example, David Sokol, "John Quidor, Literary Painter," *American Art Journal* 2, no. 1 (Spring 1970): 63–64.

Prior, *Isaac Josiah and William Mulford Hand*

1. Beatrix T. Rumford, ed., *American Folk Portraits: Paintings and Drawings from the Abby Aldrich Rockefeller Folk Art Center* (Boston: New York Graphic Society, 1981), 176.
2. Nina Fletcher Little, "William M. Prior, Traveling Artist, and His In-Laws, the Painting Hamblens," *Antiques* 53, no. 1 (January 1948): 44.
3. Ibid., 45.
4. The label is reproduced in Selma F. Little, "Phases of American Primitive Painting," *Art in America* 39, no. 1 (February 1951): 8.
5. In later years Prior may have offered his cut-rate style in response to competition from the daguerreotype, but he was advertising this style years before such photography was introduced in America. John Vanderlyn* revealed something about client preference when he complained in 1825, "Were I to begin life again, I should not hesitate to follow this plan, that is, to paint portraits cheap and slight, for the mass of folks can't judge of the merits of a well finished picture, I am more and more persuaded of this" (quoted in Barbara C. Holdridge and Lawrence B. Holdridge, *Ammi Phillips: Portrait Painter, 1788–1865* [New York: Clarkson N. Potter, 1968], 14).
6. One of Rosamund's brothers, Sturtevant (active 1837–1856), also set up a studio in Boston and painted portraits in a style close to Prior's.
7. Little, "William M. Prior," 47.
8. Clara Endicott Sears, *Some American Primitives: A Study of New England Faces and Folk Portraits* (Boston: Houghton Mifflin Company, 1941), 38.

Huge (attr.), *Composite Harbor Scene with Volcano*

1. Jean Lipman, *Rediscovery: Jurgan Frederick Huge (1809–1878)* (New York: Archives of American Art, 1973), 4. See also Jean Lipman, "Jurgan Frederick Huge," *Antiques* 132, no. 3 (September 1987): 546–49.
2. Lipman, *Rediscovery*, 4.
3. Jean Lipman first attributed *Composite Harbor Scene with Volcano* to Huge in 1985. I then suggested a relationship between the San Francisco and National Gallery paintings, which was later confirmed by documents from Edgar William and Bernice Chrysler Garbisch housed at the National Gallery of Art.
4. *The Howard and Jean Lipman Collection*, sales cat., Sotheby's, New York, 14 November 1981, lot 32.
5. *American Primitive Painting* (1942); quoted in Jean Lipman et al., *Young America: A Folk-Art History* (New York: Hudson Hills Press, 1986), 8–9.

Page, *Cupid and Psyche*

1. "Living American Artists, No. III: William Page, President of the National Academy of Design," *Scribner's Monthly* 3, no. 5 (March 1872): 599–600.
2. Henry James, in his biography of Story, wrote in 1903 of "that strange dim shade of William Page, painter of portraits, who peeps unseizably, almost tormentingly out of others' letters, who looms so large to Story's and Lowell's earlier view, who offers the rare case of an artist of real distinction, an earnest producer, almost untraceable less than half a century after his death." Quoted in "The William Page Papers," *Archives of American Art Journal* 19, no. 2 (1979): 7.
3. Henry T. Tuckerman, *Book of the Artists: American Artist Life* (1867; New York: James F. Carr, 1966), 296.

4. The fullest account of his life and work is Joshua Taylor, *William Page: The American Titian* (Chicago: University of Chicago Press, 1957).
5. See ibid., 46–50. Copies were banned from academy exhibitions. That Page drew his figures not from life but from a cast of the famous sculpture was well recognized; reproductions of the group were common. Page wrote to Lowell on 21 March 1843: "I am just finishing a small picture of Cupid and Psyche from the cast you may remember to have seen in my room—kissing in a wood—I would like you to see it, but you can't" (quoted in ibid., 48).
6. Quoted in ibid., 63.
7. Twentieth-century commentators are consistent in assessing this work as among the more erotic images in American art. See, for example, Abraham A. Davidson, *The Eccentrics and Other American Visionary Painters* (New York: E. P. Dutton, 1978), 101.

Bingham, *Boatmen on the Missouri*

1. *Missouri Intelligencer*, 14 March 1835; quoted in Albert Christ-Janer, *George Caleb Bingham: Frontier Painter of Missouri* (New York: Harry N. Abrams, 1975), 34.
2. Bingham to his future bride, Sarah E. Hutchinson, 16 December 1835; quoted in E. Maurice Bloch, *George Caleb Bingham: The Evolution of an Artist* (Berkeley: University of California Press, 1967), 26.
3. *Bulletin of the American Art-Union* 2 (August 1849); quoted in Bloch, *Bingham*, 36.
4. Both *Boatmen on the Missouri* and *Country Politician* (see pp. 78–79) were lottery prizes offered by the American Art-Union in 1846 and 1849, respectively.
5. Henry T. Tuckerman, *Book of the Artists: American Artist Life* (1867; New York: James F. Carr, 1966), 494.
6. "Song of the Broad Axe" (1856); quoted in Theodore E. Stebbins, Jr., et al., *A New World: Masterpieces of American Painting, 1760–1910*, exh. cat. (Boston: Museum of Fine Arts, 1983), 107.
7. E. P. Richardson has written about *Boatmen on the Missouri*: "Bingham's imagination, his strangely beautiful, luminous color, his largeness of drawing, give these outrageous characters a grand poetry, making them part of the epic of America" (*American Art: An Exhibition from the Collection of Mr. and Mrs. John D. Rockefeller 3rd*, exh. cat. [San Francisco: The Fine Arts Museums of San Francisco, 1976], 84).

Bingham, *Country Politician*

1. Bingham to Major James S. Rollins, 21 February 1841; quoted in E. Maurice Bloch, *George Caleb Bingham: The Evolution of an Artist*, 2 vols. (Berkeley: University of California Press, 1967), 1: 56.
2. Bingham to Major James S. Rollins, 2 November 1846; quoted in Robert F. Westervelt, "The Whig Painter of Missouri," *American Art Journal* 2, no. 1 (Spring 1970): 48; and quoted with variant in Barbara S. Groseclose, "Painting, Politics, and George Caleb Bingham," *American Art Journal* 10, no. 2 (November 1978): 5.
3. Issues of particular importance included the Whig defense against Jacksonian democracy, the Jackson resolutions concerning slavery in U.S. territories, and the Kansas-Nebraska Act of 1854 that sparked the so-called border wars in Kansas and Missouri that presaged the Civil War. Bingham, fervently pro-Union and antislavery, switched from the Whig to the Democratic party in 1854.

For a thorough review of Bingham's political career, see Groseclose, "Painting, Politics, and George Caleb Bingham," passim.
4. *Saint Louis Missouri Republican*, 17 April 1849; quoted in Albert Christ-Janer, *George Caleb Bingham of Missouri: The Story of an Artist* (New York: Dodd, Mead and Co., 1940), 49.
5. Bloch, *Bingham*, 138.
6. Five drawings of the three seated figures are in the collection of the Saint Louis Mercantile Library Association.
7. E. Maurice Bloch, "A Bingham Discovery," *American Art Review* 1, no. 1 (September–October 1973): 24.

Browere, *Stockton*

1. Browere's name has suffered various misspellings; the now-accepted spelling, used here, corresponds to that on an invitation to the artist's fiftieth wedding anniversary celebration, a copy of which is preserved in the Greene County Historical Society, Coxsackie, New York.
2. Quoted by George Ezra Dane in "Stockton," *Coast and Valley Towns of Early California* 8 (San Francisco: Book Club of California, 1938), n.p.
3. Browere's 1856 painting is historically accurate, but seems to be based on a smaller work painted two years earlier (16 x 28 in.; Oakland Museum, Oakland, Calif., Kahn Collection). A third version dated 1858 also exists (19 x 30½ in.; private collection). The 1856 work is the largest of the three and the only one that includes the single fisherman on the shore.
4. An 1852 city directory boasted that the "Stockton slough and the San Joaquin River contain an abundance of every description of fish. . . . We have seen children stand on the city wharves and fill their baskets with small fish in the course of an hour, amid the busy hum of commerce" (quoted in George H. Tinkham, *A History of Stockton* [San Francisco: W. M. Hinton and Co., 1880], 7–8).

Thompson, *Recreation*

1. Henry T. Tuckerman, *Book of the Artists: American Artist Life* (1867; New York: James F. Carr, 1966), 490.
2. "Jerome B. Thompson," *Cosmopolitan Art Journal* 1 (June 1857): 127.
3. Ibid., 129.
4. "The National Academy of Design Exhibition (Second Notice)," *New-York Daily Tribune*, 27 May 1857.
5. See Roxana Barry, *Land of Plenty: Nineteenth Century American Picnic and Harvest Scenes*, exh. cat. (Katonah, N.Y.: Katonah Gallery, 1981).
6. "Art Gossip," *Home Journal*, ser. 11, no. 579 (14 March 1857): 3; quoted with variants in Lee M. Edwards, "The Life and Career of Jerome Thompson," *American Art Journal* 14, no. 4 (Autumn 1982): 13.

Kensett, *Sunrise among the Rocks of Paradise*

1. For additional biographical information, see John Paul Driscoll and John K. Howat, *John Frederick Kensett, An American Master*, exh. cat. (Worcester, Mass.: Worcester Art Museum, 1985); and Ellen H. Johnson, "Kensett Revisited," *Art Quarterly* 20, no. 1 (Spring 1957): 71–92.
2. Henry T. Tuckerman, *Book of the Artists: American Artist Life* (1867; New York: James F. Carr, 1966), 514.
3. John Wilmerding, " 'Under Chastened Light': The Landscape of Rhode Island," in Robert G. Workman, *The Eden of America: Rhode Island Landscapes, 1820–1920*, exh. cat. (Providence: Museum of Art, Rhode Island School of Design, 1986), 13.

4. For fuller discussion of the site, see Workman, *Eden of America*, 28. A related canvas, *Paradise Rocks: Newport* (ca. 1865), is in the Newark Museum, Newark, N.J.
5. Tuckerman, *Book of the Artists*, 512.

Miller, *Still Life—Study of Apples*
1. Grace Miller Carlock, "William Rickarby Miller (1818–1893)," *New-York Historical Society Quarterly* 31, no. 4 (October 1947): 200.
2. Ibid., 200–201. Miller's earliest known American work, a drawing in the New-York Historical Society (no. 1871), *Mountain Landscape*, is inscribed *W. R. Miller, Buffalo/ 1845*; see Richard J. Koke, *A Catalogue of the Collection, Including Historical, Narrative, and Marine Art*, 3 vols. (New York: New-York Historical Society, 1982), 2: 342–77.
3. Carlock, "Miller," 201.
4. Ibid., 203.
5. Ibid., 204.
6. As noted in *Nature's Bounty & Man's Delight*, exh. cat. (Newark, N.J.: Newark Museum, 1958), 7.
7. William H. Gerdts, *Painters of the Humble Truth: Masterpieces of American Still Life, 1801–1939* (Columbia, Mo.: Philbrook Art Center and University of Missouri Press, 1981), 106.
8. Meyer Schapiro, "The Apples of Cézanne: An Essay on the Meaning of Still-Life" (1968), in *Modern Art, Nineteenth and Twentieth Centuries: Selected Papers* (New York: George Braziller, 1978), 20.

Nahl, *Sacramento Indian with Dogs*
1. See Moreland L. Stevens, *Charles Christian Nahl: Artist of the Gold Rush, 1818–1878*, exh. cat. (Sacramento: E. B. Crocker Art Gallery, 1976), 25–27.
2. Charles Christian Nahl, *The Rape of the Sabines: The Abduction (The Capture)*, 1870. Oil on canvas, 55⅞ x 44⅛ in. Signed and dated lower right: *Charles C. Nahl 1870*. Gift of Mrs. E. B. Crocker, 6383.

3. Quoted in ibid., 89.
4. Quoted in ibid., 51.

5. See, for example, Arthur Nahl's description of the Nahl Brothers' portrait work:

> The work we do is of a quite different kind than that which is understood in Europe by the name of "retouched photos." With our pictures photography serves only to print a weak outline on the paper; afterwards it is either completed in water colors or in black ink. By doing this carefully a real artistic piece of work comes into being, sometimes with animals or landscapes as background. We also mostly have to enlarge small cards or Daguerreotypes of deceased people, sometimes as large as life-size.

Letter from Arthur Nahl to his uncle, 22 October 1867, translation from original German in Moreland Stevens Papers, Crocker Art Museum, Sacramento.
6. According to art historian Patricia Trenton, "Wahla" is a generic term meaning "chief," and it is unlikely that this Sacramento Indian was the chief of any tribe; conversation with the author, 9 October 1987.
7. As yet no documentation can be found to substantiate Stevens's claim that Wahla was Latham's protégé, educated by Latham and employed as his personal coachman (Stevens, *Nahl*, 136), or that Latham "may have commissioned the work to show his friends that Indians . . . were equally capable of becoming 'refined young men'" (69).

Heade, *Allen Clapp*
1. Henry T. Tuckerman wrote of Heade that "the love of travel was strong within him" (*Book of the Artists: American Artist Life* [1867; New York: James F. Carr, 1966], 542).
2. For a full discussion of Heade's life and career, see Theodore E. Stebbins, Jr., *The Life and Works of Martin Johnson Heade* (New Haven: Yale University Press, 1975).
3. Stebbins (ibid., 16) identified this portrait as William R. Clapp (1797–1883), Allen Clapp's son, who lent the work to the annual exhibition of the National Academy of Design, New York, in 1859. However, family documents clearly identify this as a portrait of Allen Clapp; current scholars, including Stebbins, now agree that the image is a posthumous one, probably based on a daguerreotype (departmental files, The Fine Arts Museums of San Francisco). Such portraits were common during the nineteenth century; see Phoebe Lloyd, "Posthumous Mourning Portraiture," in *A Time to Mourn: Expressions of Grief in Nineteenth-Century America*, exh. cat. (Stony Brook, N.Y.: The Museums at Stony Brook, 1980), 71–89.
4. Ebenezer Clapp, comp., *The Clapp Memorial: A Record of the Clapp Family in America* (Boston: David Clapp and Son, 1876), 285.
5. "Death of Estimable Man," *Philadelphia Public Ledger*, 3 March 1851; transcript in departmental files, The Fine Arts Museums of San Francisco.

Heade, *Orchid and Hummingbird*
1. Yet the Emperor Dom Pedro II so admired Heade's canvases that he honored the artist by making him a knight of the Brazilian Order of the Rose. Sixteen of the projected twenty paintings for "The Gems of Brazil" are today in the Manoogian Collection, Detroit.
2. For a complete discussion of Heade's interest in orchids and hummingbirds, see Theodore E. Stebbins, Jr., *The Life and Works of Martin Johnson Heade* (New Haven: Yale University Press, 1975), 126–54.

3. Theodore E. Stebbins, Jr., *Martin Johnson Heade*, exh. cat. (College Park: University of Maryland Art Gallery, 1969), no. 48.
4. Recently, scholars have associated Heade's later still lifes with the theories of Charles Darwin; see Ella M. Foshay, *Reflections of Nature: Flowers in American Art* (New York: Alfred A. Knopf in association with the Whitney Museum of American Art, 1984), 51–57; and William H. Gerdts, *Painters of the Humble Truth: Masterpieces of American Still Life, 1801–1939* (Columbia, Mo.: Philbrook Art Center and University of Missouri Press, 1981), 129–30.
5. Stebbins, *Life and Works*, 138.
6. Ibid., 138–39.
7. Ibid., 138.

Durrie, *Winter in the Country*
1. Whitney's painting, now in a private collection, is reproduced in Martha Hutson, *George Henry Durrie (1820–1863)* (Santa Barbara, Calif.: Santa Barbara Museum of Art and American Art Review Press, 1977), 162.
2. Markings on the back of the canvas indicate that Irwin purchased the painting from M. Knoedler and Company. Unfortunately, we have not been able to ascertain a date for this transaction, although a handwritten list of Irwin's art collection, including the notation "Durrie 'Winter landscape,'" was found with a group of his papers (now in the Ekstrom Library, Department of Rare Books and Special Collections, University of Louisville, Kentucky) dating from 1855 to 1871.
3. The literary response to the incursion of industrialization in the nineteenth century has been best discussed by Leo Marx in his now classic text, *The Machine in the Garden: Technology and the Pastoral Ideal in America* (New York: Oxford University Press, 1964).
4. *Cosmopolitan Art Journal*; quoted in Hutson, *Durrie*, 167.

Whittredge, *On the Cache la Poudre River, Colorado*
1. *The Autobiography of Worthington Whittredge, 1820–1910*, ed. John I. H. Baur (1942; rev. ed., New York: Arno Press, 1969), 39, 42.
2. Ibid., 45.
3. Ibid., 46.
4. Whittredge often misdated his works. The basis for the 1871 supposition is a report in the *Greeley (Colorado) Tribune* of 19 July 1871:

> Whittredge, a New York artist of no little celebrity. . . has been stopping several weeks in our town, making sketches of mountain and river scenery. . . . A large cottonwood has been sketched and partly painted, and it now looks as though it would become a remarkably fine picture. . . . Some of his views of the Cache la Poudre are charming, for there can be no more picturesque stream in the world; these, however, have been painted this summer, and are not wholly completed.

Quoted in Patricia Trenton and Peter Hassrick, *The Rocky Mountains: A Vision for Artists in the Nineteenth Century* (Norman: University of Oklahoma Press, 1983), 214. The painting served as the basis for a large work of 1876, *On the Cache la Poudre River, Colorado* (40⅜ x 60⅜ in.; Amon Carter Museum, Fort Worth, Tex.).

5. The term, like many in the history of art, began as a condemnation. Whittredge, whose writings were in part responsible for popularizing the name, discusses it in his *Autobiography*, 54–55.
6. E. P. Richardson, *Painting in America: From 1502 to the Present* (New York: Thomas Y. Crowell Company, 1965), 223.

Fuller, *Girl and Calf*
1. Quoted in Sarah Burns, "A Study of the Life and Poetic Vision of George Fuller (1822–1884)," *American Art Journal* 13, no. 4 (Autumn 1981): 16.
2. Mariana G. Van Rensselaer, "George Fuller," *Century Magazine* 27, no. 2 (December 1883): 236.
3. See especially Charles De Kay, "George Fuller, Painter," *Magazine of Art* 12 (1889): 354. Of the sixty-three paintings auctioned at Fuller's estate sale in 1884, *Girl and Calf* was one of only four that held a high reserve.
4. See "Artful Animals and Pleasant Peasants," in Peter Bermingham, *American Art in the Barbizon Mood*, exh. cat. (Washington, D.C.: Smithsonian Institution Press for the National Collection of Fine Arts, 1975), esp. 79–81. Breton's famous *Song of the Lark* (Art Institute of Chicago), which resembles *Girl and Calf* in its depiction of a solitary young peasant girl pausing from her labors to lift her eyes skyward, was painted in France a year later than Fuller's work.
5. By 1900 *Girl and Calf* belonged to Ichabod T. Williams, a prominent New Yorker who also collected works by Inness, Ryder, and Blakelock. When the Williams collection was auctioned in 1915, a critic noted that the works by Fuller and Blakelock were paintings "in which realism and mysticism are strangely fused, and which are moving to a degree out of proportion to the merely technical achievement" (*New York Times*, 31 January 1915).
6. Quoted in Van Rensselaer, "George Fuller," 231.
7. Sarah Burns, "George Fuller: The Hawthorne of Our Art," *Winterthur Portfolio* 18, nos. 2–3 (Summer/Autumn 1983): 141–45.
8. For example, *Turkey Pasture in Kentucky* (1878; Chrysler Museum, Norfolk, Va.); *Quadroon* (1880; Metropolitan Museum of Art, New York); and *Fedalma* (1883–84; National Museum of American Art, Smithsonian Institution, Washington, D.C.).

Thomas Waterman Wood, *Moses*
1. For Wood's career, see Leslie A. Hasker and J. Kevin Graffagnino, "Thomas Waterman Wood and the Image of Nineteenth-Century America," *Antiques* 118, no. 5 (November 1980): 1032–42.
2. Lesley Wright, "Thomas Waterman Wood and the Artful Cloak of Sentiment," lecture delivered at the annual meeting of the College Art Association, San Francisco, 18 February 1989.
3. James W. Palmer, "The City of Monuments (Second Paper)," *Lippincott's Magazine of Popular Literature and Science* 8, no. 4 (October 1871): 371.
4. Ibid. In recent literature (see, for example, Elizabeth Johns in *350 Years of Art and Architecture in Maryland*, exh. cat. [College Park: University of Maryland Art Gallery, 1984], 40), Moses the news vendor has been confused with another Baltimore character, Moses Johns (ca. 1790–1847), a hawker of oysters and ice cream, who was renowned for his musical sales pitches and reviled for his practice of beating his wife "every morning, whether she had offended or not." Palmer ("City of Monuments," 371)

clearly meant to distinguish the upright character of Moses the newspaper vendor from the more colorful, but ultimately disreputable Moses Johns when he began his description of the former by saying, "But Baltimore rejoiced in another 'Old Moses,' more lovely in his life than the bivalvular paragon of the whistle and the melodious outcry and the muscular 'adwice.'"
5. Palmer, "City of Monuments," 371.
6. Thomas Waterman Wood Papers, roll 2809, Archives of American Art, Smithsonian Institution, Washington, D.C.
7. Ibid. The other three paintings, all dated 1858, are *Market Woman* (The Fine Arts Museums of San Francisco); *Hindoo John* (possibly Wunderlich and Company, New York, 1986, as *Apple Vendor*); and a portrait of Brune's butler Charles Fleetwood (location unknown; formerly collection of Edith Fleetwood, Washington, D.C.).

Thomas Waterman Wood, *Market Woman,* 1858. Oil on canvas, 23⅜ x 14½ in. Signed and dated lower center right: *T. W. WOOD. / 1858.* Mildred Anna Williams Collection, 1944.8

8. Wood describes the confusion in a letter to Nicholas M. Matthews (a later owner of the painting), 24 April 1895; quoted in Jermayne McAgy, "Three Paintings by Thomas Waterman Wood," *Bulletin of the California Palace of the Legion of Honor* 2, no. 2 (May 1944): 12.
9. A lithograph after Wood's painting of Moses was also produced. Palmer ("City of Monuments," 371) mentions one published by "the Messieurs Lucas, the stationers" as a benefit for Moses, who had by the end of his life gone blind; the Maryland Historical Society has in its collection a lithograph of *Moses* published by A. Hoen & Co.

Cropsey, *View of Greenwood Lake, New Jersey*
1. "The Fine Arts: Exhibition at the National Academy," *Literary World* 1, no. 15 (15 May 1847): 347.
2. Peter Bermingham, *Jasper F. Cropsey: A Retrospective View of America's Painter of Autumn*, exh. cat. (College Park: University of Maryland Art Gallery, 1968), 7–8, 33.
3. Cropsey to John W. Ketchell, 21 August 1897, John W. Ketchell Papers, roll 1356, Archives of American Art, Smithsonian Institution, Washington, D.C.
4. William Cullen Bryant, *Picturesque America; or, The Land We Live In*, 2 vols. (New York: D. Appleton and Company, 1874), 2: 56.
5. *Appletons' Illustrated Hand-Book of American Travel* (New York: D. Appleton & Co., 1857), 179.
6. William S. Talbot, "Jasper F. Cropsey, 1823–1900," Ph.D. diss., New York University, 1972, 19, 26–27.

Gifford, *Windsor Castle*
1. Gifford to O. B. Frothingham, 6 November 1874; quoted in Ila Weiss, *Sanford Robinson Gifford, 1823–1880* (New York: Garland, 1977), 26.
2. *The Autobiography of Worthington Whittredge, 1820–1910*, ed. John I. H. Baur (1942; rev. ed., New York: Arno Press, 1969), 59.
3. Gifford to John F. Weir, March 1873; quoted in Ila Weiss, "Reflections on Gifford's Art," in *Sanford R. Gifford* (New York: Alexander Gallery, 1986), n.p. George W. Sheldon, "How One Landscape-Painter Paints," *Art Journal* (1877); quoted in Nicolai Cikovsky, Jr., *Sanford Robinson Gifford*, exh. cat. (Austin: University of Texas Art Museum, 1970), 16.
4. Gifford's journal is in the Archives of American Art, Smithsonian Institution, Washington, D.C., roll D21. A panel fitting the latter description and dated 11 July is in the collection of the Museum of Art, Rhode Island School of Design, Providence. Gifford left Windsor at ten o'clock on the morning of 12 July.
5. In addition to the small panel at the Rhode Island School of Design, other depictions of the site include the 1859 *Windsor Castle* (10½ x 19½ in.; George Walter Vincent Smith Art Museum, Springfield, Mass.) and *Windsor Castle* (n.d., 16¼ × 25¼ in.; art market, 1988). Two other works of the subject extant in 1881 have yet to come to light; they are listed in *Memorial Catalogue of the Paintings of Sanford Robinson Gifford, N.A.* (New York: Metropolitan Museum of Art, 1881; repr., New York: Olana Gallery, 1974), nos. 66, 253.
6. These can be seen clearly in the 1859 Springfield *Windsor Castle*.
7. Henry T. Tuckerman, *Book of the Artists: American Artist Life* (1867; New York: James F. Carr, 1966), 525.

Gifford, *A View from the Berkshire Hills*
1. April–June 1861, June–August 1862, and July 1863. For a discussion of Gifford's war service and the works done during the war years, see Ila Weiss, *Sanford Robinson Gifford, 1823–1880* (New York: Garland, 1977), 206–25.
2. Drawings and the financial account of the trip are in a small sketchbook now in the Albany Institute of History and Art, Albany, N.Y. (1966.13.4).
3. The other is recorded in *Memorial Catalogue of the Paintings of Sanford Robinson Gifford, N.A.* (New York: Metropolitan Museum of Art, 1881; repr., New York: Olana Gallery, 1974), no. 277.

4. Quoted in "Sanford R. Gifford," *Harper's Weekly* 24, no. 1238 (18 September 1880): 605.

5. John Ferguson Weir, "Sanford R. Gifford: Artist and Man," *New-York Daily Tribune*, 12 September 1880.

Bradford, *The Coast of Labrador*

1. For additional information about Bradford's photography, see Frank Horch, "Photographs and Paintings by William Bradford," *American Art Journal* 5, no. 2 (November 1973): 61–71; and Sandra S. Phillips, "The Arctic Voyage of William Bradford," *Aperture*, no. 90 (1983): 16–27.

2. For a more complete discussion of Bradford, see John Wilmerding, *William Bradford, 1823–1892, Artist of the Arctic: An Exhibition of His Paintings and Photographs*, exh. cat. (Lincoln, Mass.: DeCordova Museum, 1969).

3. "Fine Arts: The Artists' Fund Society," *Albion* 42, no. 51 (17 December 1864): 610.

4. "The Fine Arts," *New York Evening Post*, 16 November 1864. Tuckerman later used this passage to conclude his discussion of Bradford in *Book of the Artists: American Artist Life* (1867; New York: James F. Carr, 1966), 556.

5. Lewis A. Shepard, "American Painters of the Arctic," *Antiques* 107, no. 2 (February 1975): 291–92.

6. For a discussion of the theme of man's hubris in relation to the Arctic in nineteenth-century literature and art, see Lewis A. Shepard, *American Painters of the Arctic*, exh. cat. (Amherst, Mass.: Mead Art Gallery, Amherst College, 1975), n.p.

Johnson, *The Pension Claim Agent*

1. For a discussion of these works in the context of Johnson's career, see Patricia Hills, *The Genre Paintings of Eastman Johnson: The Sources and Development of His Style and Themes* (New York: Garland, 1977), 79ff.

2. Henry T. Tuckerman, *Book of the Artists: American Artist Life* (1867; New York: James F. Carr, 1966), 469.

3. Russell Sturgis, Jr., "American Painters," *Galaxy* 4, no. 2 (June 1867): 230–32.

Johnson, *The Brown Family*

1. Allen Johnson et al., eds., *Dictionary of American Biography*, 11 vols. (1928–37; New York: Charles Scribner's Sons, 1946[?]–58), 2: 126–27.

2. Although the fourth of five sons, by 1869 John Crosby Brown was the only one active in the family banking firm. James Brown's eldest sons died in 1847 and 1854; John's elder and younger brothers retired from partnership in 1862 and 1868. See Frank R. Kent, *The Story of Alexander Brown & Sons* (Baltimore: privately printed, 1925), 183–85.

3. John Crosby Brown to James Clifton Brown, 22 December 1870, typescript of letter in departmental files, The Fine Arts Museums of San Francisco.

4. *Appleton's Journal* 1 (5 June 1869): 309; quoted in Patricia Hills, *The Genre Painting of Eastman Johnson: The Sources and Development of His Style and Themes* (New York: Garland, 1977), 120.

5. Johnson's portrait bears a striking resemblance to a photograph attributed to Mathew Brady (1822/23–1896) (Museum of the City of New York), which records a closely related view of the parlor and the elder Browns. It seems likely that Johnson used the photograph as a source for the position of Mrs. Brown (Hills, *Genre Painting of Eastman Johnson*, 118–19) and perhaps for details of the room. Hills also notes a similarity between Johnson's domestic grouping and that in a popular Currier and Ives

print, *The Four Seasons of Life: Old Age (The Season of Rest)*, suggesting an underlying sentiment in *The Brown Family*.

6. Hills, *Genre Painting of Eastman Johnson*, 112–15.

7. Johnson's painting *The Blodgett Family* (1864; Mr. and Mrs. Stephen W. Blodgett), showing New York banker William Tilden Blodgett surrounded by his family, was exhibited at the National Academy of Design in 1865. His command of this type of group portrait is sumptuously expressed in *The Hatch Family* (1871; Metropolitan Museum of Art, New York).

Church, *Rainy Season in the Tropics*

1. For a complete discussion of Church and the development of his art, see David C. Huntington, *The Landscapes of Frederic Edwin Church: Vision of an American Era* (New York: George Braziller, 1966).

2. Elizabeth Lindquist-Cock, *The Influence of Photography on American Landscape Painters, 1839–1880* (New York: Garland, 1977), 120, notes that Church, an artist who used photographs to aid him as he painted, was familiar with composite photography.

3. Huntington, *Church*, 56.

4. Henry T. Tuckerman, *Book of the Artists: American Artist Life* (1867; New York: James F. Carr, 1966), 383.

5. Huntington, *Church*, 71.

6. Ibid., 56–57.

7. "American Studio Talk," *International Studio* (suppl.) 11 (September 1900): xiv.

Hill, *Fishing Party in the Mountains*

1. "The Yo-Semite Valley by Mr. Thomas Hill," *Boston Transcript*, 24 February 1868; quoted in Marjorie Dakin Arkelian, *Thomas Hill: The Grand View*, exh. cat. (Oakland, Calif.: Oakland Museum Art Department, 1980), 17.

2. *Overland Monthly*, May 1874; quoted in Birgitta Hjalmarson, "Thomas Hill," *Antiques* 126, no. 5 (November 1984): 1204.

3. Benjamin Champney, *Sixty Years' Memories of Art and Artists* (Woburn, Mass.: Wallace and Andrews, 1900), 145–46.

4. See, for example, *Thomas Hill and Virgil Williams with Wives, Fishing*, or *Picnic near Mount Chocorua* (both John H. Garzoli Fine Art, San Rafael, Calif.). Mr. Garzoli has related *Fishing Party in the Mountains* to this latter work, thus identifying the background peak as New Hampshire's Mount Chocorua (departmental files, The Fine Arts Museums of San Francisco).

Hahn, *Sacramento Railroad Station*

1. Marjorie Arkelian, "William Hahn: German-American Painter of the California Scene," *American Art Review* 4, no. 1 (August 1977): 105, 114 n. 14.

2. This motivation is suggested by Marjorie Arkelian in *William Hahn: Genre Painter, 1829–1887*, exh. cat. (Oakland, Calif.: Oakland Museum, 1976), 36.

3. Raymond L. Wilson, "Painters of California's Silver Era," *American Art Journal* 16, no. 4 (Autumn 1984): 71–92.

4. A third passenger station was built in 1879 to handle ever-increasing traffic; see *Central Pacific Railroad: The Passenger Station, Sacramento* (North Highlands, Calif.: History West for the California State Railroad Museum, 1977), 6–9.

5. Contemporary reviews indicate that these horses were originally white; present-day conservation examinations confirm the presence of white pigment under the brown.

6. Unattributed newspaper clipping, ca. August 1874, typescript in departmental files, The Fine Arts Museums of San Francisco.

Bierstadt, *Sunlight and Shadow*

1. See Gordon Hendricks, "The First Three Western Journeys of Albert Bierstadt," *Art Bulletin* 46, no. 3 (September 1964): 333–65.

2. For a more complete discussion of Bierstadt and his career, see Gordon Hendricks, *Albert Bierstadt: Painter of the American West* (New York: Harry N. Abrams in association with the Amon Carter Museum of Western Art, Fort Worth, Tex., 1974).

3. Wend von Kalnein et al., *The Hudson and The Rhine: Die amerikanische Malerkolonie in Düsseldorf im 19. Jahrhundert*, exh. cat. (Düsseldorf: Kunstmuseum Düsseldorf, 1976), 40.

4. *The Autobiography of Worthington Whittredge, 1820–1910*, ed. John I. H. Baur (1942; rev. ed., New York: Arno Press, 1969), 26–27.

5. "Fine Arts: National Academy of Design, Second Notice," *Albion* 40, no. 19 (10 May 1862): 225. See also *New York Evening Post*, 22 April 1862; quoted in Hendricks, *Bierstadt*, 104. Henry T. Tuckerman (*Book of the Artists: American Artist Life* [1867; New York: James F. Carr, 1966], 388) also reviewed the painting favorably.

Bierstadt, *View of Donner Lake, California*

1. Quoted in Gordon Hendricks, "The First Three Western Journeys of Albert Bierstadt," *Art Bulletin* 46, no. 3 (September 1964): 348.

2. According to Hendricks (ibid., 353), the Bierstadts left San Francisco on 11 October 1873.

3. *San Francisco Daily Evening Bulletin*; quoted in ibid., 350.

4. *San Francisco Chronicle*, 12 January 1873.

5. R. C. R., "Bierstadt's 'Donner Lake,'" *California Art Gallery* 1, no. 2 (February 1873): 22 (*California Art Gallery*, roll 2798, Archives of American Art, Smithsonian Institution, Washington, D.C.).

6. "Two California Landscapes," *Overland Monthly* 10, no. 3 (March 1873): 286.

7. The painting is close in composition to the contemporaneous view of the spot recorded by Thomas Moran in 1872 and included in *Picturesque America; Or, The Land We Live In . . .* , ed. William Cullen Bryant, 2 vols. (New York: D. Appleton and Company, 1874), 2: 195.

Bierstadt, *California Spring*

1. Gordon Hendricks, *Albert Bierstadt, Painter of the American West* (New York: Harry N. Abrams in association with the Amon Carter Museum of Western Art, Fort Worth, Tex., 1974), 233–36. Among the works Bierstadt completed in Waterville were two historical pictures for the United States Capitol that had been commissioned in 1867.

2. *Utica Morning Herald and Daily Gazette*, 17 September 1874; quoted in Hendricks, *Bierstadt*, 240.

3. *Art Journal* [New York], n.s., 1, no. 4 (April 1875): 124.

4. James L. Yarnall and William H. Gerdts, comps., *The National Museum of American Art's Index to American Art Exhibition Catalogues, From the Beginning to the 1876 Centennial Year*, 6 vols. (Boston: G. K. Hall, 1986), 1: 301.

5. *Art Journal* [New York], n.s., 1, no. 5 (May 1875): 158; John Ferguson Weir, *Official Report of the American*

Centennial Exhibition of 1876; quoted in Clara Erskine Clement and Laurence Hutton, *Artists of the Nineteenth Century and Their Works,* 6th ed., 2 vols. (Boston: Houghton, Mifflin and Company, 1893), 1: 62.
6. To view a river at one's left and the Capitol in the right distance, one would need to stand somewhere south or west of the city of Sacramento; the closest foothills are about twenty miles to the east.
7. This relation was suggested to the author by Marc Simpson.

Bierstadt, *Nassau Harbor*
1. *New York Evening Mail,* 10 April 1874; quoted in Gerald Carr, "Albert Bierstadt, Big Trees, and the British: A Log of Many Anglo-American Ties," *Arts Magazine* 60, no. 10 (Summer 1986): 66.
2. See ibid.; also Allan Pringle, "Albert Bierstadt in Canada," *American Art Journal* 17, no. 1 (Winter 1985): 2–27.
3. Quoted in L. D. Powles, *The Land of the Pink Pearl, or Recollections of Life in the Bahamas* (London: Sampson Low, Marston, Searle, & Rivington, 1888), 179.
4. Ibid., 191.
5. See, for example, Florence Lewison, "The Uniqueness of Albert Bierstadt," *American Artist* 28, no. 7 (September 1964): 28–33, 72, 74.
6. Quoted in Gordon Hendricks, *Albert Bierstadt: Painter of the American West* (New York: Harry N. Abrams in association with the Amon Carter Museum of Western Art, Fort Worth, Tex., 1974), 10.

Brown, *On the Hudson*
1. Henry T. Tuckerman, *Book of the Artists: American Artist Life* (1867; New York: James F. Carr, 1966), 487.
2. George W. Sheldon, *Hours with Art and Artists* (New York: D. Appleton and Company, 1882), 152.
3. By virtue of these bootblack paintings, as well as his own shrewd business tactics, Brown became one of the most financially successful artists of the nineteenth century; see Philip Grime and Catherine Mazza, *John George Brown, 1831–1913: A Reappraisal,* exh. cat. (Burlington: Robert Hull Fleming Museum, University of Vermont, 1975).
4. "Mr. John G. Brown, Artist, Dies of Pneumonia at 81," *New York Herald,* 9 February 1913.
5. *Fort Lee, New Jersey—Steamboat "Thomas E. Hulse" in the Distance,* 1865, listed as no. 8 in *Catalogue of the Finished Pictures and Studies left by . . . the Late J. G. Brown, N. A.* (New York: American Art Association, 1914), is unlocated today. Brown had strong ties to the Fort Lee area. Although his studio was in New York, directories from 1863 to 1867 list his home in New Jersey; he became a naturalized citizen in 1864 in Bergen County (Martha Hoppin [Curator of American Art, Museum of Fine Arts, Springfield, Mass.] to author, 14 August 1987, departmental files, The Fine Arts Museums of San Francisco). In 1865 Brown and Seymour J. Guy (1824–1910) were "making studies of youthful American character in the vicinge of Fort Lee" ("Art Notes," *Round Table,* n.s., 1, no. 1 [9 September 1865]: 7). An 1876 map in the New Jersey Historical Society, Newark, marks the residence of "J. G. Brown" in the town of Fort Lee.
6. See Linda S. Ferber and William H. Gerdts, *The New Path: Ruskin and the American Pre-Raphaelites,* exh. cat. (New York: Schocken Books for the Brooklyn Museum, 1985), 242–44.

7. "The Palisades," *Watson's Weekly Art Journal* 3, no. 12 (15 July 1865): 179–80.
8. Ferry traffic ran between Fort Lee and New York City as early as 1825, carrying first supplies and later commuters and vacationers. By 1885 the Fort Lee Park Hotel and Pavilion had been built on the site of Burdett's Landing, and the town was known as a prime amusement and resort area. Today the George Washington Bridge spans the Hudson River from a point just north of Burdett's Landing.

Whistler, *The Gold Scab: Eruption in Frilthy Lucre*
1. For a good discussion and illustrations of *The Peacock Room,* see Susan Hobbs, *The Whistler Peacock Room* (Washington, D.C.: Freer Gallery of Art, Smithsonian Institution, 1980); and David Park Curry, "Artist and Architect," in *James McNeill Whistler at the Freer Gallery of Art* (Washington, D.C.: Freer Gallery of Art, Smithsonian Institution, 1984): 52–69.
2. Concerning *Nocturne in Black and Gold: The Falling Rocket* (1875; Detroit Institute of Arts), John Ruskin wrote of Whistler's "cockney impudence," declaring that he "never expected to hear a coxcomb ask two hundred guineas for flinging a pot of paint in the public's face." Whistler sued for libel. The trial was a showcase pitting the progressive against the reactionary; to Whistler's credit, he used the public forum for a spirited and persuasive defense of his art-for-art's-sake philosophy. The verdict was for Whistler, but the damages awarded were minimal, and Whistler found himself in severe financial straits.
3. Andrew McLaren Young et al., *The Paintings of James McNeill Whistler,* 2 vols. (New Haven: Yale University Press, 1980), 1: 50, 120–21. See also Ira M. Horowitz, "Whistler's Frames," *Art Journal* 39, no. 2 (Winter 1979–80): 129–30.

Haseltine, *Indian Rock, Narragansett, Rhode Island*
1. Henry T. Tuckerman, *Book of the Artists: American Artist Life* (1867; New York: James F. Carr, 1966), 556–57.
2. The English art critic John Ruskin was perhaps the best-known advocate of a minute, objective recording of the physical world in the mid-nineteenth century. In an elaboration of Ralph Waldo Emerson's "transparent eyeball," Ruskin asked that the artist be "a glass of rare strength and clearness too, to let us see more than we could ourselves, and bring nature up to us and near to us" (John Ruskin, *Modern Painters I* [1843], reprinted in Robert Herbert, ed., *The Art Criticism of John Ruskin* [Garden City, N.Y.: Anchor Books, 1964], 30).
3. Haseltine's close observation and neutral rendering were confirmed in his own day by the frequent assumption of his training in geology; see Helen Haseltine Plowden, *William Stanley Haseltine: Sea and Landscape Painter, 1835–1900* (London: Frederick Muller, 1947), 83.
4. Tuckerman, *Book of the Artists,* 557.
5. Herman Melville, *Moby Dick: or, the Whale* (1851; New York: Modern Library, 1950), 2.

Haseltine, *Ruins of the Roman Theatre at Taormina*
1. Helen Haseltine Plowden, *William Stanley Haseltine: Sea and Landscape Painter, 1835–1900* (London: Frederick Muller, 1947), 150. Haseltine exhibited paintings of the ruins of Taormina at the National Academy of Design at least as early as 1874. One of his two paintings in the 1876 Centennial Exposition in Philadelphia was of

the same site, and his daughter records a comparable large work, a twilight scene with light from the setting sun falling upon the rising moon, dating from 1882 (Plowden, *Haseltine,* 150).
2. Karl Baedeker, *Italy: Handbook for Travellers, Third Part: Southern Italy and Sicily,* 14th rev. ed. (Leipzig: Karl Baedeker, 1903), 347. Baedeker supplies what is almost a text for the painting: "The View from the hill on which the theatre stands is one of the most beautiful in Italy. . . . The view is even more beautiful in the morning, when the sun rises above Calabria or from the sea, imparts a rosy hue to the snowy peak of Mt. Ætna, and then gilds the rocky heights beyond the theatre."
3. These are reaffirmed by the formal dichotomies he uses to construct the painting, ranging from the structure of near and far views without benefit of any mediating middle ground, to the pairs of complementary colors, primarily blue/orange, that cover the majority of the canvas.
4. Quoted in Louis Legrand Noble, *The Life and Works of Thomas Cole* (Cambridge: Belknap Press of Harvard University Press, 1964), 242.
5. Quoted in ibid.
6. For a particularly rich and full consideration of Thomas Cole's paintings of Mount Etna, see Franklin W. Kelly, "Myth, Allegory, and Science: Thomas Cole's Paintings of Mount Etna," *Arts in Virginia* 23, no. 3 (1983): 2–17.
7. As Barbara Novak has written: "The American landscape artists [in Italy] felt no special need to excuse their preoccupation with the landscape through the use of mythological themes. The landscape *was* the myth" ("Arcady Revisited: Americans in Italy," in *Nature and Culture: American Landscape and Painting, 1825–1875* [New York: Oxford University Press, 1980], 216).

Homer, *The Bright Side*
1. Henry James, "On Some Pictures Lately Exhibited" (1875); reprinted in John L. Sweeney, ed., *The Painter's Eye* (Cambridge: Harvard University Press, 1956), 96–97.
2. "National Academy of Design," *New-York Daily Tribune,* 3 July 1865.
3. Winslow Homer, *The Bright Side,* 1866, from *Our Young Folks* 2, no. 6 (July 1866): 396. Wood engraving, 2¾ x 3⅝ in. Achenbach Foundation for Graphic Arts, Gift of Dr. and Mrs. Robert A. Johnson, 1983.1.46.

4. For a full discussion of this work, see Marc Simpson et al., *Winslow Homer: Paintings of the Civil War,* exh. cat. (San Francisco: The Fine Arts Museums of San Francisco, 1988), 46–63, 198–207.

5. "Paris International Exhibition, No. VI.—National Schools of Painting," *Art-Journal* (London) 19 (1867): 248.

Vedder, *The Sphinx of the Seashore*

1. Quoted in Regina Soria, "Elihu Vedder's Mythical Creatures," *Art Quarterly* 26, no. 2 (Summer 1963): 188.
2. Ibid., 181.
3. For American artists in Italy, see Barbara Novak, "Arcady Revisited: Americans in Italy," in *Nature and Culture: American Landscape and Painting, 1825–1875* (New York: Oxford University Press, 1980), 203–25. Vedder's life and work are discussed fully in Regina Soria, *Elihu Vedder: American Visionary Artist in Rome (1836–1923)* (Rutherford, N.J.: Fairleigh Dickinson University Press, 1970); and Joshua C. Taylor et al., *Perceptions and Evocations: The Art of Elihu Vedder*, exh. cat. (Washington, D.C.: Smithsonian Institution Press for the National Collection of Fine Arts, 1978).
4. Of Vedder's many paintings of sphinxes (for example, *The Questioner of the Sphinx*, 1863; Museum of Fine Arts, Boston), *The Sphinx of the Seashore* is the only one to depict a live creature rather than the ancient Egyptian statue.
5. Taylor, *Perceptions and Evocations*, 146.
6. *Rubáiyát of Omar Khayyám, the Astronomer-Poet of Persia... with an Accompaniment of Drawings by Elihu Vedder*, trans. Edward Fitzgerald (Boston: Houghton, Mifflin and Company, 1884).
7. Quoted in Taylor, *Perceptions and Evocations*, 146.

Moran, *Grand Canyon with Rainbow*

1. Nathaniel P. Langford, "The Wonders of the Yellowstone," *Scribner's Monthly* 2, nos. 1–2 (May–June 1871): 1–17, 113–28.
2. For additional information about Moran's career depicting the West, see Thurman Wilkins, *Thomas Moran: Artist of the Mountains* (Norman: University of Oklahoma Press, 1966); and Carol Clark, *Thomas Moran Watercolors of the American West* (Austin: University of Texas Press for the Amon Carter Museum of Western Art, Fort Worth, Tex., 1980). Perhaps his best-known depiction of the Grand Canyon is *The Chasm of the Colorado* (1874; United States Department of the Interior, Washington, D.C.), purchased by Congress in 1874 for ten thousand dollars.
3. Thomas Moran, "American Art and American Scenery," in C. A. Higgins et al., *The Grand Canyon of Arizona* (1902); quoted in Wilkins, *Moran*, 216.
4. Quoted in Wilkins, *Moran*, 89.
5. Ibid., 218–19.
6. Moran, "American Art and American Scenery"; quoted in ibid., 220.

Hovenden, *Taking His Ease*

1. Hovenden's most famous painting on this theme is *The Last Moments of John Brown* (1884; Metropolitan Museum of Art, New York); a reduced version (ca. 1884) of this canvas is in The Fine Arts Museums of San Francisco.

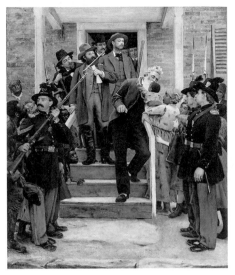

Thomas Hovenden, *The Last Moments of John Brown*, ca. 1884. Oil on canvas, 46⅛ x 38⅛ in. Gift of Mr. and Mrs. John D. Rockefeller 3rd, 1979.7.60

Eakins, *The Courtship*

1. Eakins also studied briefly with Léon Bonnat (1833–1922) and, in 1869, with Augustin Dumont (1801–1884).
2. He was perhaps partially inspired by the Philadelphia Centennial Exposition, a celebration of the centenary of the signing of the Declaration of Independence. The explicit interest in America's early history surrounding the fair brought into focus a widespread colonial revival in the fine and decorative arts and in architecture. For the colonial revival, see Rodris Roth, "American Art: The Colonial Revival and 'Centennial Furniture,'" *Art Quarterly* 27, no. 1 (1964): 57–81; and William B. Rhoads, *The Colonial Revival*, 2 vols. (New York: Garland, 1977).
3. The earliest in the series was *In Grandmother's Time* (1876; Smith College Museum of Art, Northampton, Mass.). Others in this group include the watercolors *Homespun* (1881; Metropolitan Museum of Art, New York) and *Spinning* (1881; private collection), and the relief sculpture *Spinning* (1882–83; Philadelphia Museum of Art).
4. Translation from the original French mine. Quoted in Lloyd Goodrich, *Thomas Eakins*, 2 vols. (Cambridge: Harvard University Press for the National Gallery of Art, Washington, D.C., 1982), 1: 61–62.
5. William Dean Howells, "A Sennight of the Centennial"; quoted in Darrel Sewell, *Thomas Eakins: Painter of Philadelphia* (Philadelphia: Philadelphia Museum of Art, 1982), 59.
6. Goodrich, *Eakins*, 1: 148–51. A large study of Williams (ca. 1878) in the pose of the figure in *The Courtship* is in the Worcester Art Museum, Worcester, Mass.
7. This is the closest that Eakins came to painting an anecdotal scene, providing an interesting foil to his illustration of "Mr. Neelus Peeler's Condition" (*Scribner's Monthly* 18, no. 2 [June 1879]: 256); monochromatic watercolor in

the Brooklyn Museum, Brooklyn, N.Y.), where again a man implores the attention of a woman, intent on her handcraft, ignores him.
8. The study appeared at auction at Christie's, New York, 3 June 1983, lot 90. Since The Fine Arts Museums' painting is signed (although the pigments have become transparent) and, according to Goodrich, was sold shortly after Eakins stopped working on it, the artist must in some sense have considered the painting finished. See Lloyd Goodrich, *Thomas Eakins: His Life and Work* (New York: Whitney Museum of American Art, 1933), 171–72.
9. He wrote of an earlier project, the ca. 1874 *Hiawatha*, "It got so poetic at last... that I gave it up" (Phyllis D. Rosenzweig, *The Thomas Eakins Collection of the Hirshhorn Museum and Sculpture Garden*, exh. cat. [Washington, D.C.: Smithsonian Institution Press for the Hirshhorn Museum and Sculpture Garden, 1977], 53–54).

Eakins, *Frank Jay St. John*

1. Lloyd Goodrich, *Thomas Eakins: Retrospective Exhibition*, exh. cat. (New York: Whitney Museum of American Art, 1970), 29.
2. Lloyd Goodrich, *Thomas Eakins*, 2 vols. (Cambridge: Harvard University Press for the National Gallery of Art, Washington, D.C., 1982), 2: 80.
3. Quoted in Elizabeth Johns, *Thomas Eakins: The Heroism of Modern Life* (Princeton: Princeton University Press, 1983), 148.
4. Among the few other works from his later career using this format are *The Artist's Wife and His Setter Dog* (ca. 1885; Metropolitan Museum of Art, New York); *Home Ranch* (1892; Philadelphia Museum of Art); and *Robert M. Lindsay* (1900; Detroit Institute of Arts).
5. The photograph by Murray of Eakins at work is in the archives of the Hirshhorn Museum and Sculpture Garden, Smithsonian Institution, Washington, D.C. Eakins's photograph of Murray working, with St. John standing, is in the collection of Mr. and Mrs. Daniel W. Dietrich II, Philadelphia.
6. Lloyd Goodrich, *Thomas Eakins: His Life and Work* (New York: Whitney Museum of American Art, 1933), no. 337, records St. John simply as "Business man & inventor; died 1900."
7. *Specifications and Drawings of Patents Issued from the United States Patent Office for March, 1894*, 2 vols. (Washington, D.C.: Government Printing Office, 1894), 1: 189, with drawing in 2, fig. 45.

Cassatt, *Mrs. Robert S. Cassatt, the Artist's Mother*

1. Although she was not to return to the United States except for visits in 1898 and 1908, she began her major biographical interview by stating, in her lightly accented French, "I am American, distinctly and frankly American" (Achille Segard, *Mary Cassatt: Un Peintre des enfants et des mères*, 3rd ed. [Paris: Librairie Paul Ollendorf, 1913], 2 [my translation]).
2. The two had earlier admired one another's work. In 1874 Degas had seen Cassatt's Salon entry and declared of it: "It is true. There is someone who feels as I do" (Segard, *Cassatt*, 35 [my translation]). Cassatt saw Degas's work probably one year later. Writing in 1915, she recalled:

How well I remember, nearly forty years ago, seeing for the first time Degas' pastels in the window of a picture dealer on the Boulevard Haussmann. I used to go and flatten my nose against that window and ab-

sorb all I could of his art. It changed my life. I saw art then as I had wanted to see it.

Cassatt to Louisine Havemeyer; quoted in Nancy Mowll Mathews, *Mary Cassatt* (New York: Harry N. Abrams, 1987), 33.
3. Charles S. Moffett et al., *The New Painting: Impressionism, 1874–1886*, exh. cat. (San Francisco: The Fine Arts Museums of San Francisco, 1986).
4. Segard, *Cassatt*, 8 (my translation).
5. See Frances Weitzenhoffer, *The Havemeyers: Impressionism Comes to America* (New York: Harry N. Abrams, 1986); Charles S. Moffett, *Impressionist and Post-Impressionist Paintings in the Metropolitan Museum of Art* (New York: Metropolitan Museum of Art and Harry N. Abrams, 1985), 10; and Suzanne G. Lindsay, *Mary Cassatt and Philadelphia*, exh. cat. (Philadelphia: Philadelphia Museum of Art, 1985), 12–18.
6. *Pennsylvania Museum Bulletin* 22, no. 113 (May 1927): 373.
7. Segard, *Cassatt*, 3–4 (my translation).
8. Quoted in Griselda Pollock, *Mary Cassatt* (London: Universal Books, 1980), 7.
9. In addition to a soft-ground etching and aquatint version (Adelyn Dohme Breeskin, *Mary Cassatt: A Catalogue Raisonné of the Graphic Work* [Washington, D.C.: Smithsonian Institution Press, 1979], no. 122), a pencil drawing (private collection), and a pastel head (private collection) directly related to The Fine Arts Museums' painting, other oil portraits of Mrs. Cassatt include a portrait of 1873; *Reading "Le Figaro"* (ca. 1878); and *Mrs. Cassatt Reading to Her Grandchildren* (1880), all in private collections.
10. Segard, *Cassatt*, 166–67 (my translation).
11. Adelyn Dohme Breeskin, *The Art of Mary Cassatt (1844–1926)*, exh. cat. (New York: American Federation of Arts, 1981), 14.

Blakelock, *Indian Encampment on the James River*
1. For a more complete discussion of Blakelock, see Norman A. Geske, *Ralph Albert Blakelock, 1847–1919*, exh. cat. (Lincoln: Sheldon Memorial Art Gallery, University of Nebraska, 1975).
2. Ibid., 25.
3. "Some Characteristics of Blakelock's Pictures," *New York Times*, 17 August 1919; quoted in David Gebhard and Phyllis Sturman, *The Enigma of Ralph A. Blakelock, 1847–1919*, exh. cat. (Santa Barbara: Art Galleries, University of California at Santa Barbara, 1969), 15.

Ryder, *The Lone Scout*
1. Many scholars see Ryder, Winslow Homer,* and Thomas Eakins* as America's three greatest nineteenth-century painters. See Lloyd Goodrich, "Realism and Romanticism in Homer, Eakins, and Ryder," *Art Quarterly* 12, no. 1 (Winter 1949): 17–28. For a good source on Ryder's early life, see Frank Jewett Mather, Jr., "Albert Pinkham Ryder's Beginnings," *Art in America* 9, no. 3 (April 1921): 121–27.
2. The attention over many years that he devoted to single paintings limited the size of Ryder's oeuvre to around 160 works. Unfortunately, Ryder has proven to be one of the most frequently copied American artists, and many forgeries exist in public and private collections. The art historian Lloyd Goodrich in the 1930s began to tackle the problem of sorting the real from the dross and arranging the works in a chronological order. William Innes Homer

has now taken on this much-needed project; Elizabeth Broun is working independently toward an exhibition on Ryder for the National Museum of American Art, Smithsonian Institution, Washington, D.C.
3. Quoted in Goodrich, "Realism and Romanticism," 26. For a compendium of personal observations, see Sadakichi Hartmann, "Albert Pinkham Ryder," *Magazine of Art* 31, no. 9 (September 1938): 500–503ff.
4. Lloyd Goodrich, "Ryder Rediscovered," *Art in America* 56, no. 6 (November–December 1968): 32ff.
5. "Paragraphs from the Studio of a Recluse," *Broadway Magazine*, September 1905; quoted in Lloyd Goodrich, *Albert P. Ryder* (New York: George Braziller, 1959), 13. The resultant paintings were akin to those of the British artists William Blake (1757–1827) and Samuel Palmer (1805–1881) in their intensely personal vision and their pastoral, often literary themes.
6. Quoted in Goodrich, *Albert P. Ryder*, 22.
7. Suggested by Goodrich in ibid., 114.
8. D. Dodge Thompson, "American Artists in North Africa and the Middle East, 1797–1914," *Antiques* 126, no. 2 (August 1984): 303–12.
9. Reported by Ryder's friend, the sea captain John Robinson, in Frederic Fairchild Sherman, "Notes on the Art of Albert P. Ryder," *Art in America* 25, no. 4 (October 1937): 167. The full quartet from "The Day Is Done" reads: "And the night shall be filled with music, / And the cares, that infest the day, / Shall fold their tents, like the Arabs, / And as silently steal away."

Harnett, *After the Hunt*
1. Quoted in Alfred Frankenstein, *After the Hunt: William Harnett and Other American Still Life Painters, 1870–1900* (1953; rev. ed., Berkeley: University of California Press, 1969), 55.
2. Other versions are in the collections of the Amon Carter Museum, Fort Worth, Tex. (1883); Columbus Museum of Art, Columbus, Ohio (1883); and the Butler Institute of American Art, Youngstown, Ohio (1884). A painting of the dead rabbit alone, *Trophy of the Hunt* (1885), is in the Carnegie Museum of Art, Pittsburgh, Pa.
3. Frankenstein, *After the Hunt*, 66.
4. In *After the Hunt*, Frankenstein quotes an obituary notice from the *Philadelphia Times*:

> But Harnett had neither a frame nor the money to buy one. Then an inspiration seized him. He got four strips of wood, nailed them roughly together around the canvas, painted them a deep black and the painting was brought out with marvelous life-likeness. In that shape it was sent to the Paris Salon, was placed in the line and Harnett's fame was made.

On the same page (70), Frankenstein quotes three Paris critics commenting on the work.
5. *Commercial Gazette* (London); quoted in Frankenstein, *After the Hunt*, 79–80.
6. Quoted in ibid., 81.
7. *New York News*; quoted in ibid., 55.

Pope, *The Trumpeter Swan*
1. Quoted in Donelson F. Hoopes, "Alexander Pope, Painter of 'Characteristic Pieces,'" *Brooklyn Museum Annual* 8 (1966–67): 131.
2. Frank T. Robinson, "An American Landseer"; quoted in Hoopes, "Pope," 140.
3. Hoopes, "Pope," 137.

4. Pope to George Washington Stevens, 12 May 1910; G. W. Stevens Papers, roll D34, frame 485, Archives of American Art, Smithsonian Institution, Washington, D.C.
5. A second version of *The Trumpeter Swan* appeared on the Houston art market in 1972. In this painting (undated), the swan is displayed against wooden panels that could represent a fence rather than a door; behind the bird appear leafy, ivylike vines and a single rifle.
6. Howard J. Cave, "Alexander Pope, Painter of Animals"; quoted in Hoopes, "Pope," 143–44.
7. *Boston Sunday Globe*, 2 November 1902; quoted in *American Paintings & Historical Prints from the Middendorf Collection*, exh. cat. (New York: Metropolitan Museum of Art, 1967), 60.

Chase, *A Corner of My Studio*
1. Unfortunately, the building was demolished in 1955.
2. Quoted in Mary Sayre Haverstock, "The Tenth Street Studio," *Art in America* 54, no. 5 (September–October 1966): 57.
3. Nicolai Cikovsky, Jr., "Impressionism and Expression in the Shinnecock Landscapes: A Note," in D. Scott Atkinson and Nicolai Cikovsky, Jr., *William Merritt Chase: Summers at Shinnecock, 1891–1902*, exh. cat. (Washington, D.C.: National Gallery of Art, 1987), 35.
4. "In the World of Art: William M. Chase's Studio Sale," *New York Times*, 5 January 1896.
5. Nicolai Cikovsky, Jr., "William Merritt Chase's Tenth Street Studio," *Archives of American Art Journal* 16, no. 2 (1976): 7–12.

Anshutz, *The Ironworkers' Noontime*
1. Lloyd Goodrich, *Thomas Eakins*, 2 vols. (Cambridge: Harvard University Press for the National Gallery of Art, Washington, D.C., 1982), 1: 292–94.
2. Frank H. Goodyear, Jr., "Ironworkers: Noontime," *American Art Review* 1, no. 1 (January–February 1974): 39–45, illustrates pages from two small sketchbooks filled with pencil drawings relating to *The Ironworkers' Noontime* (Pennsylvania Academy of the Fine Arts, Philadelphia). The only figural study in oil now known to be extant is in a New York private collection. An oil study of the factory scene is in the Hirshhorn Museum and Sculpture Garden, Smithsonian Institution, Washington, D.C.
3. See, for example, *Forging the Shaft* (1877; Metropolitan Museum of Art, New York) by John Ferguson Weir (1841–1926).
4. *Harper's Weekly* 28, no. 1445 (30 August 1884): 570.
5. The first illustrated advertisement for Procter & Gamble's Ivory Soap, appearing in 1883, is clearly based on *The Ironworkers' Noontime*, despite its being an interior factory scene. Ruth Bowman speculates that Anshutz felt that this popular imitation degraded his efforts and robbed the work of its dignity; see her "Nature, the Photograph, and Thomas Anshutz," *Art Journal* 33, no. 1 (Fall 1973): 32–40.

Dewing, *Elizabeth Platt Jencks*
1. Susan Hobbs, "Thomas Wilmer Dewing: The Early Years, 1851–1885," *American Art Journal* 13, no. 2 (Spring 1981): 7–10.
2. See Kathleen Pyne, "*Classical Figures*: A Folding Screen by Thomas Dewing," *Bulletin of the Detroit Institute of Arts* 59, no. 1 (1981): 5–15.
3. Sadakichi Hartmann, *A History of American Art*, 2 vols. (Boston: L. C. Page and Company, 1902), 1: 301–2.

4. It was probably through Charles Platt's influence that the Jenckses first summered in New Hampshire. Among Platt's first architectural commissions were villas and gardens for the artists and patrons of the artists' colonies of Cornish and Dublin, New Hampshire. One journalist described Cornish as "'far from the madding crowd,' in an atmosphere of modern antiquity, yet not dangerously distant from the intellectual Boston, nor more than a day's ride from commercial New York.... Essentially the atmosphere of Cornish is one of culture and hard work" (*New-York Daily Tribune*, 11 August 1907; quoted in *A Circle of Friends: Art Colonies of Cornish and Dublin*, exh. cat. [Durham: University Art Galleries, University of New Hampshire, 1985], 39–40).
5. Dewing to Freer, letter 64, Freer Gallery of Art, Smithsonian Institution, Washington, D.C.; microfilm in Freer Gallery Papers, roll 453, Archives of American Art, Smithsonian Institution, Washington, D.C.
6. Dewing to Freer, letter 66; Freer Gallery Papers, roll 453.
7. Freer and Dewing quoted in Susan Hobbs, "*Elizabeth Platt Jencks* by Thomas W. Dewing," *Triptych* 41 (April– May 1988): 9.

Peto, *The Cup We All Race 4*

1. For a recent discussion of Peto and his work, see John Wilmerding, *Important Information Inside: The Art of John F. Peto and the Idea of Still-Life Painting in Nineteenth-Century America*, exh. cat. (Washington, D.C.: National Gallery of Art, 1983). Concerning the Harnett/Peto confusion and its resolution, see Alfred Frankenstein, *After the Hunt: William Harnett and Other American Still Life Painters, 1870–1900* (1953; rev. ed., Berkeley: University of California Press, 1969).

Peto, *Job Lot Cheap*

1. John Wilmerding, *Important Information Inside: The Art of John F. Peto and the Idea of Still-Life Painting in Nineteenth-Century America*, exh. cat. (Washington, D.C.: National Gallery of Art, 1983), 129. Peto's painting is probably inspired by an identically titled work by William M. Harnett (1878; Reynolda House, Winston-Salem, N.C.). A more traditional tabletop composition involving books is also in the collection of The Fine Arts Museums of San Francisco.

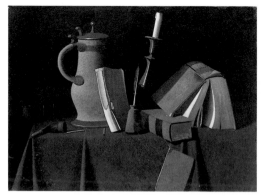

John Frederick Peto, *Still Life with Pitcher, Candle, and Books*, ca. 1900. Oil on canvas, 22¼ x 30¼ in. Gift of The de Young Museum Society and Patrons of Art and Music, 72.32

2. Wilmerding, *Important Information Inside*, 121.

Beaux, *Young Brittany Woman, "Lammerche"*

1. Cecilia Beaux, *Background with Figures* (Boston: Houghton Mifflin Company, 1930), 95. Beaux, however, is listed in the registry of students from 1877 to 1879; see *Cecilia Beaux: Portrait of an Artist*, exh. cat. (Philadelphia: Pennsylvania Academy of the Fine Arts, 1974), 11.
2. *Sita and Sarita* (originally painted in 1893–94; the best-known version of the painting is a copy Beaux painted ca. 1921, now in the Corcoran Gallery of Art, Washington, D.C.); *The Dreamer* (1894; Butler Institute of American Art, Youngstown, Ohio); *Ernesta with Nurse* (1894; Metropolitan Museum of Art, New York); *New England Woman* (1895; Pennsylvania Academy of the Fine Arts, Philadelphia); and *Man with a Cat* (1898; National Museum of American Art, Smithsonian Institution, Washington, D.C.).
3. *Philadelphia Public Ledger*, 3 November 1899; quoted in Frank H. Goodyear, Jr., Introduction to *Cecilia Beaux: Portrait of an Artist*, 17.
4. Quoted in Goodyear, Introduction, 19.
5. Beaux, *Background with Figures*, 145–46.
6. Ibid., 223–25. The middle decades of Beaux's career are largely undocumented. Although the most thorough chronology of her career (*Cecilia Beaux: Portrait of an Artist*, 11–15) does not mention a European trip of 1902, her unspecific description of the trip with Blake—three paintings sent over to Europe and the opportunity in London to meet John Singer Sargent* and see him at work on the central bas-relief for *Christianity* in the Boston Public Library mural cycle—seems best to match a 1902 date.

Chalfant, *Bouguereau's Atelier*

1. For example, in *Which Is Which?* (ca. 1889; private collection) Chalfant affixed a genuine postage stamp beside a meticulously painted one, challenging the viewer to distinguish between them; see Joan H. Gorman, *Jefferson David Chalfant, 1856–1931*, exh. cat. (Chadds Ford, Pa.: Brandywine River Museum, 1979), 14.
2. David B. Cass, *In the Studio: The Making of Art in Nineteenth-Century France*, exh. cat. (Williamstown, Mass.: Sterling and Francine Clark Art Institute, 1981), 41. See also Derrick Cartwright, *The Studied Figure: Tradition and Innovation in American Art Academies, 1865–1915*, exh. brochure (San Francisco: The Fine Arts Museums of San Francisco, 1988).
3. Alfred Nettement (a student at the Académie Julian, b. 1877); quoted in Mark Steven Walker, "Biography," in *William Bouguereau, 1825–1905*, exh. cat. (Montreal: Montreal Museum of Fine Arts, 1984), 56.
4. Jefferson David Chalfant, *Bouguereau's Atelier at the Académie Julian*, 1891, inscription on reverse of panel.

5. Derrick Cartwright, "Embodying Change: Reconsidering Academic Viewpoints," *Triptych* 44 (November–January 1988–89): 14–16. Classes at the Julian were ranked, and the most accomplished students received the preferred seats closest to the model.
6. Gorman, *Chalfant*, 20. Chalfant also made extensive use of photography as an aid to his work.
7. Jefferson David Chalfant, *Study for "Bouguereau's Atelier at the Académie Julian,"* 1891. Pencil on paper, 14¼ x 17⅜ in. Achenbach Foundation for Graphic Arts, Gift of Mr. and Mrs. John D. Rockefeller 3rd, 1979.7.27.

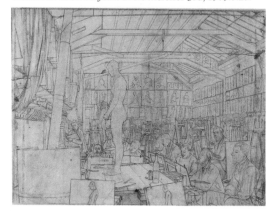

Haberle, *The Slate: Memoranda*

1. Gertrude Grace Sill, *John Haberle: Master of Illusion*, exh. cat. (Springfield, Mass.: Museum of Fine Arts, 1985), 6.
2. Jane Marlin, "John Haberle: A Remarkable Painter in Detail" (1898); quoted in Sill, *Haberle*, 8.
3. Marlin, "Haberle"; quoted in Sill, *Haberle*, 8.
4. See Alfred Frankenstein, *After the Hunt: William Harnett and Other American Still Life Painters, 1870–1900* (1953; rev. ed., Berkeley: University of California Press, 1969), 116–17.
5. Cited by Alfred Frankenstein in his analysis of *The Changes of Time* (1888; Manoogian Collection, Detroit), in *The Reality of Appearance: The Trompe l'Oeil Tradition in American Painting*, exh. cat. (Boston: New York Graphic Society, 1970), 114.
6. Quoted in Doreen Bolger Burke, *American Paintings in the Metropolitan Museum of Art*, vol. 3 (Princeton: Princeton University Press and the Metropolitan Museum of Art, New York, 1980), 278.
7. With the slate headed "Leave your order here," for example (Museum of Fine Arts, Boston), it can be construed from the chalk message "Painting / 'A Bachelors Drawer' is FOR RENT / Inquire of John Haberle / Studio / New Haven, / Ct." that *The Bachelor's Drawer* has been finished, or at least that Haberle will have no more use for it, and thus a date of ca. 1895 can be assigned to the work. It is unclear whether this is a valedictory to the painting, to Haberle's own bachelorhood, to trompe l'oeil painting, or to some combination of them all. But the glimmering of portentous meaning is there.
8. Frankenstein, *Reality of Appearance*, 114.
9. Although scholars have recently dated the painting to about 1895, they have suggested that "FRED" could be Anthony Fresneda, Haberle's son-in-law. The theory is that the painting was unsold "and so [Haberle] added the inscription and presented the painting to his son-in-law,

nicknamed Fred, when he graduated from Yale in 1923" (Sill, *Haberle*, 50). However, Frankenstein—who rediscovered Haberle for the twentieth century, knew Mrs. Fresneda and her collection, and included *The Slate* in his exhibition *The Reality of Appearance*—did not attribute this meaning to the scrawl.

Sargent, *Caroline de Bassano, Marquise d'Espeuilles*
1. William Starkweather, "The Art of John S. Sargent," *Mentor* 12, no. 9 (October 1924): 4.
2. E. P. Richardson, *American Art: An Exhibition from the Collection of Mr. and Mrs. John D. Rockefeller 3rd*, exh. cat. (San Francisco: The Fine Arts Museums of San Francisco, 1976), 210; and Roman D'Amat, ed., *Dictionnaire de biographie française*, 15 vols. (Paris: Librairie Letouzey et Ane, 1933–87), 5: 745, 12: 1513.
3. It seems likely that Sargent would have gained entrée into this conservative Bonapartist circle through Carolus-Duran, the portraitist of many of the Third Republic's elite; see Albert Boime, "Sargent in Paris and London: A Portrait of the Artist as Dorian Gray," in *John Singer Sargent*, exh. cat. (New York: Whitney Museum of American Art and Harry N. Abrams, 1986), 82.
4. *Boston Evening Transcript*, 30 January 1888; quoted in Richard Ormond, *John Singer Sargent: Paintings, Drawings, Watercolors* (New York: Harper and Row, 1970), 41.

Sargent, *A Dinner Table at Night*
1. James wrote of Sargent, "I want him to come here and live and work—there being in London such a field for a *real* painter of women, and such magnificent subjects of both sexes" (Leon Edel, *Henry James: The Middle Years, 1882–1895* [New York: Avon Books, 1978], 110).
2. Although earlier writers have claimed that the visit to Lavington Rectory took place in July, Stanley Olson quotes a letter dated 21 October from Henry James saying, "I dined with the plastic John, who was in town from Petworth" (Stanley Olson, *John Singer Sargent: His Portrait* [New York: St. Martin's Press, 1986], 113).
3. In the mid-1880s Sargent was clearly intrigued by the compositional problems presented by people seated at table. In addition to *A Dinner Table at Night*, he also painted *The Breakfast Table* (1884; Harvard University Art Museums [Fogg Art Museum], Cambridge, Mass.) and *Fête Familiale: The Birthday Party* (1885; Minneapolis Institute of Arts); the latter is very close in effect and color to the San Francisco painting.
4. Stevenson to W. H. Low, 22 October 1885; quoted in John Rewald, *The John Hay Whitney Collection*, exh. cat. (Washington, D.C.: National Gallery of Art, 1983), 170.
5. Alfred de Lostalot, "Exposition internationale de peinture," *Gazette des Beaux-Arts* 31, no. 6 (1 June 1885): 531 (my translation).

Sargent, *Trout Stream in the Tyrol*
1. Quoted in the Hon. Evan Charteris, K.C., *John Sargent* (New York: Charles Scribner's Sons, 1927), 155.
2. Jane von Glehn to Rosina Emmett; quoted in Patricia Hills, "'Painted Diaries': Sargent's Late Subject Pictures," in *John Singer Sargent*, exh. cat. (New York: Whitney Museum of American Art and Harry N. Abrams, 1986), 183. As Sargent's painted portrait commissions decreased, he turned to charcoal portraits to satisfy his audience.

3. Mary Newbold Patterson Hale, "The Sargent I Knew"; quoted in Carter Ratcliff, *John Singer Sargent* (New York: Abbeville Press, 1982), 237.
4. Adrian Stokes, "John Singer Sargent, R.A., R.W.S.," *Old Water-Colour Society's Club: 1925–1926* 3 (1926): 57.
5. Ibid., 58.
6. See Stanley Olson, *John Singer Sargent: His Portrait* (New York: St. Martin's Press, 1986), 246–47.
7. For Sargent's Impressionism, see William H. Gerdts, "The Arch-Apostle of the Dab-and-Spot School: John Singer Sargent as an Impressionist," in *John Singer Sargent*, exh. cat., 111–45.
8. Quoted in Annette Blaugrund, "'Sunshine Captured': The Development and Dispersement of Sargent's Watercolors," in *John Singer Sargent*, exh. cat., 226.

Ulrich, *Moment Musicale*
1. Michael Quick, Eberhard Ruhmer, and Richard West, *Munich and American Realism in the Nineteenth Century*, exh. cat. (Sacramento: E. B. Crocker Art Gallery, 1978), 32–33.
2. *Catalogue of the Private Art Collection of Thomas B. Clarke, New York*, sales cat., American Art Association, New York, 14–17 February 1899, 110.
3. Charles Eldredge, *American Imagination and Symbolist Painting*, exh. cat. (New York: Grey Art Gallery and Study Center, New York University, 1979), 71. For an interesting discussion of the international aestheticization of women at the turn of the century (with an emphasis on paintings done in Boston), see Trevor J. Fairbrother, "Painting in Boston, 1870–1930," in *The Bostonians: Painters of an Elegant Age, 1870–1930*, exh. cat. (Boston: Museum of Fine Arts, 1986), 77–78.

Metcalf, *The Winter's Festival*
1. Elizabeth de Veer and Richard J. Boyle, *Sunlight and Shadow: The Life and Art of Willard Leroy Metcalf* (New York: Abbeville Press, 1987), 18.
2. Ibid., 68–69.
3. Metcalf to his daughter Rosalind, 5 February 1925; quoted in de Veer and Boyle, *Sunlight and Shadow*, 154.
4. See *A Circle of Friends: Art Colonies of Cornish and Dublin*, exh. cat. (Durham: University Art Galleries, University of New Hampshire, 1985).
5. Elizabeth de Veer, "Willard Metcalf in Cornish, New Hampshire," *Antiques* 26, no. 5 (November 1984): 1211.
6. Francis Murphy (Introduction to *Willard Leroy Metcalf: A Retrospective*, exh. cat. [Springfield, Mass.: Museum of Fine Arts, 1976], xi) cites the closing stanzas of "The Snow Man" as a literary parallel to what he perceives as Metcalf's combined sense of threat and appreciation when confronted with an alien but beautiful nature. The full text of the poem is in *The Collected Poems of Wallace Stevens* (New York: Alfred A. Knopf, 1923); copyright 1923 and 1951 by Wallace Stevens and reprinted by permission of Alfred A. Knopf, Inc.

Hassam, *Seaweed and Surf, Appledore, at Sunset*
1. See Jennifer A. Martin Bienenstock, "Childe Hassam's Early Boston Cityscapes," *Arts Magazine* 55, no. 3 (November 1980): 168–71.
2. J. Walker McSpadden, *Famous Painters of America* (New York: Dodd, Mead and Co., 1916), 401–2.
3. William H. Gerdts, *American Impressionism* (New York: Abbeville Press, 1984), 99–100.

4. Hassam's views of Appledore bear particular affinity with Monet's views of Belle-Ile-le-Mer, a rocky coast in the south of Brittany, known as "Le Côte Sauvage," which Monet visited in 1886; see Daniel Wildenstein, *Claude Monet: Biographie et catalogue raisonné*, 3 vols. (Lausanne and Paris: Bibliothèque des Arts, 1979), 2: 50–58, nos. 1084–1119.
5. See Peter Morrin, Judith Zilczer, and William C. Agee, *The Advent of Modernism: Post-Impressionism and North American Art, 1900–1918*, exh. cat. (Atlanta, Ga.: High Museum of Art, 1986), 132–35, 147. *Seaweed and Surf* may also pay homage to another painter of the New England coast, Winslow Homer,* whose *West Point, Prout's Neck* (1901; Sterling and Francine Clark Art Institute, Williamstown, Mass.) is marked by a vivid stripe of sunset at its horizon and a decorative spray of sea foam.
6. For a study of the square format and its decorative appeal, see William H. Gerdts, "The Square Format and Proto-Modernism in American Painting," *Arts Magazine* 50, no. 10 (June 1976): 70–75.
7. James Russell Lowell, "Pictures from Appledore" (1868); reprinted in *The Poetical Works of James Russell Lowell* (Boston: Houghton Mifflin Company, 1978), 304.

Prendergast, *The Holiday*
1. Charles Prendergast, who later became a painter and frame maker, supported and collaborated with Maurice throughout his career; see Richard J. Wattenmaker, *The Art of Charles Prendergast*, exh. cat. (Boston: Museum of Fine Arts, 1968).
2. See Hedley Howell Rhys, *Maurice Prendergast*, exh. cat. (Cambridge: Harvard University Press for the Museum of Fine Arts, Boston, 1960), 24–26; and Peter Morrin, Judith Zilczer, and William C. Agee, *The Advent of Modernism: Post-Impressionism and North American Art, 1900–1918*, exh. cat. (Atlanta, Ga.: High Museum of Art, 1986), 132–35, 147.
3. Quoted in Rhys, *Prendergast*, 44.
4. Quoted in Richard J. Wattenmaker, "Maurice Prendergast," *Allen Memorial Art Museum Bulletin* 40, no. 1 (1982–83): 32.
5. Ibid.
6. Duncan Phillips, "Maurice Prendergast," *Arts* 5, no. 3 (March 1924): 127–28.

Alexander, *The First Lesson*
1. Many of the dates and details of Alexander's life are still unknown. The best current information, although incomplete, can be found in Raymond L. Wilson, "Henry Alexander: Chronicler of Commerce," *Archives of American Art Journal* 20, no. 2 (1980): 10–13; and Paul J. Karlstrom, "The Short, Hard, and Tragic Life of Henry Alexander," *Smithsonian* 12, no. 12 (March 1982): 108–17.
2. Michael Quick, "Munich and American Realism," in Michael Quick, Eberhard Ruhmer, and Richard West, *Munich and American Realism in the Nineteenth Century*, exh. cat. (Sacramento: E. B. Crocker Art Gallery, 1978), 32.
3. "A Successful California Artist," *San Francisco Chronicle*, 23 December 1883.

4. Henry Alexander, *Neglecting Business*, 1887. Oil on canvas, 22⅛ x 18⅛ in. Signed lower right: *Henry Alexander*. Gift of J.W. Lilienthal, 69.9.

5. *San Francisco Argonaut*, 16 April 1887. Alexander later told John George Brown,* whose studio adjoined his in the Tenth Street Building in New York, that he hoped to "get enough money to return to Munich, for there . . . he had passed his happiest days" ("Misfortune Leads to Death," *San Francisco Examiner*, 16 May 1894).
6. *San Francisco Examiner*, 16 May 1894; "Suicide of an Artist," *San Francisco Chronicle*, 16 May 1894.
7. Nolte has been described as skinning the meadowlark in his hand, or slitting its belly, but it has been pointed out that "no skillful taxidermist would handle the bird as we see here, nor would he hold his knife in such a peculiar manner to slit the skin on the bird's sternum" (Jonathan Fairbanks, "Craft Processes and Images: Visual Sources for the Study of the Craftsman," in Ian M. Quimby, ed., *The Craftsman in Early America* [New York: W. W. Norton and Company, 1984], 328).

Mathews, *The Grape*

1. See Richard Guy Wilson et al., *The American Renaissance, 1876–1917*, exh. cat. (Brooklyn, N.Y.: Brooklyn Museum, 1979).
2. Harvey L. Jones, *Mathews: Masterpieces of the California Decorative Style* (Santa Barbara, Calif.: Peregrine Smith, 1980), 24, 82–93.
3. Quoted in Harvey L. Jones, "Arthur Mathews / Lucia Mathews," in Ruth Lilly Westphal, ed., *Plein-Air Painters of California: The North* (Irvine, Calif.: Westphal, 1986), 108.

4. Arthur F. Mathews, *Song of the Sea (The Three Graces)*, ca. 1909. Oil on panel, 18⅜ x 12 in. Signed lower right (incised): *Arthur F. Mathews*. The Collection of May and Paul Sinsheimer, 1957.163.

5. Jones, *Mathews*, 104. *The Grape* was a gift to the de Young Museum in 1910 from Henrietta Zeile, whose son John Zeile was Mathews's partner and business manager in the Furniture Shop.

Wiles, *The Sonata*

1. For additional discussion of Wiles and his career, see Gary A. Reynolds, *Irving R. Wiles*, exh. cat. (New York: National Academy of Design, 1988) and *Irving Ramsey Wiles, 1861–1948*, exh. cat. (New York: Chapellier Gallery, 1967).
2. Reynolds, *Wiles*, 17. Reynolds reproduces a photograph of Mrs. Wiles and the other, unidentified, model wearing the gowns shown in *The Sonata* and discusses works in which the same models appear.
3. Margaretta M. Lovell and Marc Simpson, "Essay on a Painting: 'The Sonata,'" *Triptych* 30 (June–July 1986): 21.
4. Charles Eldredge, *American Imagination and Symbolist Painting*, exh. cat. (New York: Grey Art Gallery and Study Center, New York University, 1979), 71.
5. Lovell and Simpson, "Essay," 21.

Henri, *O in Black with Scarf*

1. Mahonri Sharp Young, *The Eight: The Realist Revolt in American Painting* (New York: Watson-Guptill, 1973), 36.
2. William Innes Homer, *Robert Henri and His Circle* (Ithaca, N.Y.: Cornell University Press, 1969), 237.
3. Robert Henri, *The Art Spirit* (Philadelphia: J. B. Lippincott, 1930), 5.
4. *City Life Illustrated, 1890–1940: Sloan, Glackens, Luks, Shinn—Their Friends and Followers*, exh. cat. (Wilmington: Delaware Art Museum, 1980), 55–56. After her marriage to Henri, Organ continued to draw occasionally but basically set aside her career in order to attend to her husband's.

Luks, *Innocence*

1. Ira Glackens, *William Glackens and the Ashcan Group: The Emergence of Realism in American Art* (New York: Crown, 1957), 5; "Everett Shinn on George Luks: An Unpublished Memoir," *Archives of American Art Journal* 6, no. 2 (April 1966): 5; "George Luks, Lusty Proponent of American Individualism, Is Dead," *Art Digest* 8, no. 4 (15 November 1933): 5.
2. In that year nine of his cartoons were reproduced in *Puck* magazine; see *City Life Illustrated, 1890–1940: Sloan, Glackens, Luks, Shinn—Their Friends and Followers*, exh. cat. (Wilmington: Delaware Art Museum, 1980), 63.
3. "Everett Shinn on George Luks," 6.
4. Glackens, *William Glackens*, 16.
5. Quoted in Bennard B. Perlman, *The Immortal Eight: American Painting from Eakins to the Armory Show, 1870–1913* (Cincinnati: North Light, 1979), 97. This remark snubs Robert Henri, whose outlook and style exerted more influence over Luks than Luks was ever willing to admit.
6. Theodore E. Stebbins, Jr., *American Master Drawings and Watercolors* (New York: Harper and Row, 1976), 288–89.
7. Mahonri Sharp Young, *The Eight: The Realist Revolt in American Painting* (New York: Watson-Guptill, 1973), 122.
8. Quoted in Perlman, *Immortal Eight*, 78.
9. The girl may be in her Sunday best, fingering coins destined for a church offering. Luks claimed to have painted another young child just after his mother had given him a haircut on Sunday morning: "He was ready for church, but Luks pulled him in and painted him then and there" (see *American Reflections: Paintings 1830–1940 from the Collections of Pomona College and Scripps College, Claremont, California*, exh. cat. [Claremont, Calif.: Pomona College and Scripps College, 1984], 112).
10. Quoted in Perlman, *Immortal Eight*, 97.

Murphy, *The Marshes*

1. William A. Coles, "Hermann Dudley Murphy: An Introduction," in *Hermann Dudley Murphy (1867–1945): "Realism Married to Idealism Most Exquisitely"* (New York: Graham Gallery, 1982), 7. The *massier* was that art student entrusted with supervision of classes.
2. See Robert Edwards, *Life by Design: The Byrdcliffe Arts and Crafts Colony*, exh. cat. (Wilmington: Delaware Art Museum, 1984).
3. After two years in Winchester, the frame shop moved into Boston and enjoyed considerable success and influence. Murphy withdrew from active participation in the shop in 1911, and the venture was absorbed by the Vose Galleries.
4. Murphy knew of Whistler's work as early as 1886; see Coles, *Murphy*, 9.
5. See Marianne W. Martin, "Some American Contributions to Early Twentieth-Century Abstraction," *Arts Magazine* 54, no. 10 (June 1980): 158–65.
6. M. K., "Notes on Hermann Dudley Murphy's Sketching Class," *Brush and Pencil* 5 (November 1899): 57.
7. Arthur Wesley Dow, *Composition: A Series of Exercises* (1899; 7th ed., Garden City, N.Y.: Doubleday, Page and Company, 1913), 4.
8. *Chicago Tribune*, 7 January 1900.

Hobart, *The Blue Bay: Monterey*
1. Although Hobart's death certificate states that he was born in Seattle, Washington, family records indicate that he was born in Rockford, Illinois. The artist was never more specific about the year of his birth than noting that it was "around 1870." However, both his death certificate and family records indicate that he was born in 1868.
2. Robert Harshe; quoted in Gene Hailey, ed., *California Art Research*, 20 vols. (San Francisco: Works Progress Administration, 1937), 12: 77.
3. Hailey, *California Art Research*, 12: 93.
4. Ibid., 82–83.
5. "Modern American Art," *Burr McIntosh Monthly* 14 (October 1907): n.p. It seems, however, that either the readership or the governing board of *Burr McIntosh Monthly* did not agree with Hobart's sympathies. Despite an editorial that appeared in October 1907 promising future articles on the "Modern American School," no such coverage appeared in subsequent issues.
6. Quoted in Hailey, *California Art Research*, 12: 87.
7. Quoted in ibid., 85.

Parrish, *From the Story of Snow White*
1. Parrish himself considered his father to be his most valued teacher. See Maxfield Parrish to Jerome Connolly, 5 May 1952; quoted in Coy L. Ludwig, "Maxfield Parrish: Sharp-Focus Visionary," *American Art Review* 3, no. 2 (March–April 1976): 82.
2. Although some accounts report that Parrish studied with Pyle at the Drexel Institute in 1893, there is no record of formal matriculation. Pyle is supposed to have said, upon seeing Parrish's portfolio, that there was nothing left for the younger man to learn; see Coy Ludwig, *Maxfield Parrish* (New York: Watson-Guptill, 1973), 14.
3. Associated Press general release, 27 April 1931; quoted in Ludwig, "Sharp-Focus Visionary," 88. Parrish and his commercial, illustrative art have often been seen as outside the bounds of the fine arts. Yet his inspired improvisation in the method of his image-making, and especially the fantastical atmosphere of his scenes struck critics of his time as noteworthy and meriting serious consideration:

> Mr. Parrish has absorbed, yet purified, every modern oddity, and added to it his own strong original identity.... He has been able to infuse into the most uncompromising realism the decorative element —an extraordinary feat in itself.... He will do much to reconcile the extreme and sober elements of our times.

Hubert von Herkomer, *International Studio* (1906); quoted in Ludwig, *Parrish*, 28.
4. Parrish decided to paint only six of the series; see Ludwig, *Parrish*, 88–96.
5. Quoted in ibid., 96.
6. For a full discussion of Parrish's technique, see ibid., 189–200. The method and effect, familiar from at least the Renaissance, are much the same as those used by the English Pre-Raphaelite Brotherhood fifty years earlier.

Glackens, *May Day, Central Park*
1. Forbes Watson, *William Glackens* (New York: Duffield and Company, 1923), 19.
2. Robert Henri, "Insurgency in Art"; quoted in Bennard Perlman, *The Immortal Eight: American Painting from Eakins to the Armory Show, 1870–1913* (Cincinnati: North Light, 1979), 195.

3. Richard J. Wattenmaker, "William Glackens's Beach Scenes at Bellport," *Smithsonian Studies in American Art* 2, no. 2 (Spring 1988): 75. For one example of Glackens's changing style, see The Fine Arts Museums of San Francisco's *Rocks and Lighthouse*, ca. 1908.

William Glackens, *Rocks and Lighthouse,* ca. 1908. Oil on canvas, 25 x 30 in. Signed lower right: *W Glackens*. Gift of Mr. and Mrs. John D. Rockefeller 3rd, 1979.7.45

4. Others include *The Drive, Central Park* (ca. 1905; Cleveland Museum of Art); *Central Park in Winter* (ca. 1905; Metropolitan Museum of Art, New York); and *Little May Day Procession* (ca. 1905; Manoogian Collection, Detroit), a work directly related to *May Day, Central Park.*
 May Day, Central Park was one of six paintings that Glackens sent to the Macbeth Galleries in 1908 for the exhibition that gave the Eight their name. Since there was only room for five paintings by Glackens, *May Day* was not hung. See Ira Glackens, *William Glackens and the Ashcan Group: The Emergence of Realism in American Art* (New York: Crown, 1957), 86. However, the painting did travel with the exhibition when it toured nine cities across the United States. See Judith Zilczer, "The Eight on Tour, 1908–1909," *American Art Journal* 16, no. 2 (Summer 1984): 21–48.
5. Prendergast became affiliated with the Macbeth Galleries in New York in 1900 and eventually moved to that city from Boston in 1914. He painted several watercolors of Central Park, including *May Day*, ca. 1901; see Patterson Sims, *Maurice B. Prendergast: A Concentration of Works from the Permanent Collection*, exh. cat. (New York: Whitney Museum of American Art, 1980), 15–16.
6. Glackens also painted the Luxembourg Gardens in Paris during his 1906 visit, in works that are similar in composition and mood to his Central Park views. These works are now in the Corcoran Gallery of Art, Washington, D.C., and the Wichita Art Museum, Wichita, Kans.
7. "May Queens Ruled Tiny Subjects in City Parks," *New York World*, 8 May 1904; "Happy Youngsters Celebrate May Day," *New York World*, 2 May 1903.
8. Everett Shinn, "Recollections of the Eight," in *The Eight*, exh. cat. (Brooklyn, N.Y.: Brooklyn Museum, 1943), 19.

Lawson, *Harlem River at High Bridge*
1. For further discussion of Lawson and his career, see Henry Berry-Hill and Sidney Berry-Hill, *Ernest Lawson: American Impressionist* (Leigh-on-Sea, England: F. Lewis, 1968).
2. The High Bridge was constructed between 1837 and 1848 as part of the Croton Aqueduct System. It is no longer in use.
3. William Cullen Bryant, *Picturesque America, or, the Land We Live In*, 2 vols. (New York: D. Appleton and Company, 1874), 2: 558–59.
4. This often-repeated phrase seems to have been coined by the critic James G. Huneker; see F. Newlin Price, "Lawson, of the 'Crushed Jewels,'" *International Studio* 78, no. 321 (February 1924): 367.
5. Quoted in Peter Morrin, Judith Zilczer, and William C. Agee, *The Advent of Modernism: Post-Impressionism and North American Art, 1900–1918*, exh. cat. (Atlanta, Ga.: High Museum of Art, 1986), 109.

Shinn, *Open Air Theater*
1. Quoted in Ira Glackens, *William Glackens and the Ashcan Group: The Emergence of Realism in American Art* (New York: Crown, 1957), 146.
2. For additional discussion of Shinn and the theater, see Edith Deshazo, *Everett Shinn, 1876–1953: A Figure in His Time* (New York: Clarkson N. Potter, 1974), 71–81.

Hartley, *The Summer Camp, Blue Mountain*
1. Marsden Hartley, "On the Subject of Mountains"; quoted in Carol Rice, *The Mountains of Marsden Hartley*, exh. cat. (Minneapolis: University Gallery, University of Minnesota, 1979), n.p.
2. Marsden Hartley, "Art—and the Personal Life" (1928); reprinted in *On Art by Marsden Hartley*, ed. Gail R. Scott (New York: Horizon Press, 1982), 72.
3. Barbara Haskell, *Marsden Hartley*, exh. cat. (New York: Whitney Museum of American Art, 1980), 14.

Hartley, *A Bermuda Window*
1. Barbara Haskell, *Marsden Hartley*, exh. cat. (New York: Whitney Museum of American Art, 1980), 52.
2. Ibid., 55.
3. Haskell writes of the trip to Bermuda: "This excursion marked the beginning of Hartley's separation from avant-garde issues and from a committed stylistic direction.... Hartley's abstract style faltered" (ibid.).
4. Marsden Hartley, "Art—and the Personal Life" (1928); reprinted in *On Art by Marsden Hartley*, ed. Gail R. Scott (New York: Horizon Press, 1982), 71.
5. There is no imitation of nature in the representation. You are not snared by violent lights and shades into believing you have before you the solids of sculpture. You are left, by the subtlety and lightness of the painting, in wide-eyed awareness that each object is the symbol of a volume, and that every plane is as sheer as a sheet of tissue paper.

Paul Rosenfeld, *Port of New York* (1924); quoted in *Marsden Hartley, 1908–1942: The Ione and Hudson D. Walker Collection*, exh. cat. (Minneapolis: University Art Museum, University of Minnesota, 1984), 26.
6. Paul Rosenfeld, "American Painting," *Dial* 71 (December 1921): 658; quoted in Haskell, *Hartley*, 56.
7. The San Francisco painting belonged for many years in the collections of two of Hartley's most distinguished patrons: Alfred Stieglitz owned the work until his death in 1946, and it was later in the possession of Hudson Walker.

Bellows, *Waldo Peirce*

1. Bellows did not join the Eight in their landmark 1908 exhibition; as Robert Henri later reminisced: "George would naturally have been of the group but it antedated him. Many people now believe he was a member" (Henri diary, 15 February 1927; quoted in William Innes Homer, *Robert Henri and His Circle* [Ithaca, N.Y.: Cornell University Press, 1969], 130).

2. George Bellows, *Romance of Criehaven*, 1916. Oil on panel, 18 x 22 in. Signed lower left: *Geo. Bellows*. Gift of Mr. and Mrs. W. Robert Phillips in honor of Ian McKibbin White, 1986.43.

3. Milton W. Brown, *The Story of the Armory Show* (New York: Joseph H. Hirshhorn Foundation, 1963), 115, 195.

4. Quoted in Charles H. Morgan, *George Bellows: Painter of America* (New York: Reynal and Company, 1965), 173–74.

5. Both the Hambidge and Maratta systems are summarized in Homer, *Robert Henri and His Circle*, 184–92.

6. Quoted in Morgan, *Bellows*, 215.

7. See Diana Emery Hulick and Robert F. Brown, *Waldo Peirce: A New Assessment*, exh. cat. (Orono: University of Maine, 1985).

8. Quoted in ibid., 25.

9. See, for example, the discussion in Mahonri Sharp Young, *The Paintings of George Bellows* (New York: Watson-Guptill, 1973), 148–49.

Pippin, *The Trial of John Brown*

1. Horace Pippin, "My Life's Story," in Selden Rodman, *Horace Pippin: A Negro Painter in America* (New York: Quadrangle Press, 1947), 77.

2. Horace Pippin, "How I Paint"; quoted in Holger Cahill et al., *Masters of Popular Painting: Modern Primitives of Europe and America*, exh. cat. (Museum of Modern Art, New York, 1938), 126. Opinions differ on the effect that modern art had on Pippin's style. See Selden Rodman, "Horace Pippin," in Jean Lipman and Tom Armstrong, eds., *American Folk Painters of Three Centuries* (New York: Hudson Hills Press in association with the Whitney Museum of American Art, 1980), 216.

3. Bearden never painted John Brown but recalled from his childhood yearly commemorations for the abolitionist, including ceremonies at the Pittsburgh Shiloh Church in which his grandfather would read Brown's last speech to the court; see *Horace Pippin*, exh. cat. (Washington, D.C.: Phillips Collection, 1977), n.p.

4. The others are *John Brown Reading His Bible* (private collection) and *John Brown Going to His Hanging* (Pennsylvania Academy of the Fine Arts, Philadelphia).

Benton, *Susanna and the Elders*

1. Quoted in Thomas Craven, *Thomas Hart Benton* (New York: Associated American Artists, 1939), 11.

2. Thomas Hart Benton, *An Artist in America*, 3rd ed., rev. (Columbia: University of Missouri Press, 1968); and *An American in Art: A Professional and Technical Autobiography* (Lawrence: University Press of Kansas, 1969).

3. When the work was shown in New York in 1938, the reviews were benign; see *Art Digest* 13, no. 1 (1 October 1938): 5; and *Time*, 24 October 1938, 38. But on a tour of the western states in the next year, the painting drew vigorous criticism; see, for example, *Art Digest* 13, no. 10 (15 February 1939): 9; 13, no. 15 (1 May 1939): 18; and 14, no. 16 (15 May 1940): 13; see also *Art News* 37, no. 32 (6 May 1939): 14.

4. In 1939 Benton painted a companion piece to *Susanna* entitled *Persephone* (Nelson-Atkins Museum of Art, Kansas City). Again, it is a scene of an imperiled nude in the out-of-doors, its meaning augmented by the resonance of a literary title, in this case drawn from Greek mythology rather than the Bible.

5. Benton to Bert Granet, 1 November 1954; copy of letter in departmental files, The Fine Arts Museums of San Francisco.

6. For illustrations and discussion, see Karal Ann Marling, *Tom Benton and His Drawings* (Columbia: University of Missouri Press, 1985), 58–59, 168–69, 177; figs. 3-7, 15-1, 15-2.

7. "What's Holding Back American Art," *Saturday Review of Literature* 34 (15 December 1951); quoted in *A Thomas Hart Benton Miscellany*, ed. Matthew Baigell (Lawrence: University Press of Kansas, 1971), 104.

Ault, *The Mill Room*

1. Susan Lubowsky, *George Ault*, exh. cat. (New York: Whitney Museum of American Art, 1988), 8.

2. George C. Ault, *Highland Light*, 1929. Oil on canvas, 24 x 16 in. Signed and dated lower left: *G. C. Ault '29*. Gift of Max L. Rosenberg, 1931.27.

3. Louise Ault, "Louise Ault's Writings Mss," 12, in George C. Ault Papers, roll D247, frame 921, Archives of American Art, Smithsonian Institution, Washington, D.C.

4. Information kindly provided to author by Susan Lubowsky, telephone conversation, 7 August 1987.

5. Ault, "Mss," 12.

6. Lubowsky, conversation with author.

Dickinson, *The Cello Player*

1. As James Schuyler wrote: "*The Cello Player* describes itself visually, and to trace through the varying of round forms in it gives a key to its structure. It is much more abstract than it looks" ("U.S. Painters Today, No. 2: Edwin Dickinson," *Portfolio and Art News Annual* 2 [1960]: 101).

2. Quoted in Lloyd Goodrich, *Edwin Dickinson*, exh. cat. (New York: Whitney Museum of American Art, 1965), 7.

Fridtjof Nansen (1861–1930), the author mentioned in this passage, was a Norwegian statesman and polar explorer. In 1922 Nansen won the Nobel Peace Prize for repatriation of soldiers and relief of Russian famine. At the time of the painting he was a representative at the League of Nations. On 4 March 1926 Dickinson wrote, "Nansen, I receive word, spent his entire time between deliberations at the League in Geneva, dancing in a nearby café 'with every girl available'" (Esther Hoyt Sawyer Papers, roll 901, frame 753, Archives of American Art, Smithsonian Institution, Washington, D.C.). Dickinson evidenced a lifelong interest in Arctic exploration, maintaining friendships with Arctic explorers, painting on the theme, and acquiring a sizable library on the subject.

3. John Paul Driscoll, "Edwin Dickinson: An Iconological Interpretation of the Major Symbolical Paintings," Ph.D. diss., Pennsylvania State University, 1985, 66.

4. One must remember that, in addition to any reference to *Le Nozze de Figaro*, collage elements, including snippets culled from the Paris newspaper *Figaro*, appeared prominently in the Analytic Cubist still lifes of Pablo Picasso and Georges Braque (1882–1963) fifteen years earlier.

5. Transcript of interviews with oral historian Carol S. Gruber, November 1957–January 1958; quoted in Driscoll, "Dickinson," 46.

6. Interview between Mrs. Edwin Dickinson and John Driscoll, 27 May 1983; quoted in Driscoll, "Dickinson," 45.

7. "Burgess Dickinson a Suicide," *New York Times*, 29 January 1913; quoted in Driscoll, "Dickinson," 45.

Grant Wood, *Dinner for Threshers*

1. For Wood and his career, see Wanda Corn, *Grant Wood: The Regionalist Vision*, exh. cat. (New Haven: Yale University Press for the Minneapolis Institute of Arts, 1983).

2. Ibid., 104.

3. Park Rinard, quoting Grant Wood; in ibid.

4. Sketches relating to the left and right thirds of *Dinner for Threshers* date from 1933 and are in the Whitney Museum of American Art, New York. A complete drawing is in a private collection.

5. Wanda Corn, "The Birth of a National Icon: Grant Wood's *American Gothic*," in *Art the Ape of Nature*, Moshe Barasch and Lucy Freeman Sandler, eds. (New York: Harry N. Abrams, 1981), 754–55.

6. Quoted in E. P. Richardson, *American Art: An Exhibition from the Collection of Mr. and Mrs. John D. Rockefeller 3rd*, exh. cat. (San Francisco: The Fine Arts Museums of San Francisco, 1976), 236. As Corn (*Regionalist Vision*,

104) has observed, the scene re-creates an idealized vision of Wood's childhood; the barn bears the falsely remembered date of his birth (1892).

7. Corn, *Regionalist Vision*, xiv.

8. James M. Dennis, *Grant Wood: A Study in American Art and Culture* (Columbia: University of Missouri Press, 1986), 218.

Burchfield, *Spring Flood*

1. Charles Burchfield, "On the Middle Border," *Creative Art* 3 (September 1928): xxvii.

2. Quoted in John I. H. Baur, *The Inlander: Life and Work of Charles Burchfield, 1893–1967* (Newark: University of Delaware Press, 1984), 36.

3. Baur has called these symbols "conventions for abstract thoughts"; see *Inlander*, 70–73.

4. Burchfield, "On the Middle Border," xxx.

5. Quoted in Baur, *Inlander*, 157–58.

6. Quoted in ibid., 177.

7. Charles Burchfield to John I. H. Baur, 1955; quoted in Baur, *Inlander*, 193.

Shahn, *Ohio Magic*

1. Shahn also feared that this work might prove popular, and if so, that he "might be tempted to go on painting stuff like that the rest of my life" (Selden Rodman, *Portrait of the Artist as an American, Ben Shahn: A Biography with Pictures* [New York: Harper & Brothers, 1951], 135).

2. Rivera wrote a foreword to the catalogue of Shahn's second one-man exhibition in 1933, praising Shahn as "a typical example of the modern artist" who would find "an autonomous cultural expression that will serve . . . as a vehicle of unification," and his style as one that "has humanized the technical methods of the Paris painters" (ibid., 105).

3. Ben Shahn, *The Shape of Content* (Cambridge: Harvard University Press, 1957), 40.

4. Shahn photographed several street scenes while he was in Ohio in 1938, but none of these bears a direct or even especially close relationship to the scene in *Ohio Magic*.

5. Shahn, *Shape of Content*, 47. Shahn was thinking of such works as *Liberation* (1945; Museum of Modern Art, New York), *The Red Staircase* (1944; Saint Louis Art Museum), and *Cherubs and Children* (1944; Whitney Museum of American Art, New York), a work that Selden Rodman described as "a dream fantasy in the manner of the surrealists. . . . The children are sleeping in the park . . . but the tilted golden lamp and ghostly statuary profiled against the shattered red bridge are a nightmare hovering menacingly between past and future" (*Portrait*, 61).

Index

Page numbers in *italics* refer to illustrations.